Digital Landscape & Nature Photography

FOR

DUMMIES®

Digital Landscape & Nature Photography

FOR

DUMMIES®

by Doug Sahlin

WILEY

John Wiley & Sons, Inc.

Digital Landscape & Nature Photography For Dummies®

Published by
John Wiley & Sons, Inc.
111 River Street
Hoboken, NJ 07030-5774

www.wiley.com

For general information on our other products and services, please contact our Customer Care Department within the U.S. at 877-762-2974, outside the U.S. at 317-572-3993, or fax 317-572-4002.

For technical support, please visit www.wiley.com/techsupport.

Wiley also publishes its books in a variety of electronic formats and by print-on-demand. Not all content that is available in standard print versions of this book may appear or be packaged in all book formats. If you have purchased a version of this book that did not include media that is referenced by or accompanies a standard print version, you may request this media by visiting http://booksupport.wiley.com. For more information about Wiley products, visit us at www.wiley.com.

Library of Congress Control Number: 2011934632

ISBN: 978-1-118-06512-9 (pbk); 978-1-118-14628-6 (ebk); 978-1-118-14629-3 (ebk); 978-1-118-14630-9 (ebk)

Manufactured in the United States of America

10 9 8 7 6 5 4 3 2 1

About the Author

Doug Sahlin is an author and photographer living in Venice, Florida. He is a professional photographer specializing in fine-art photography. He also photographs weddings and events and writes books about computer applications like Adobe Acrobat and Adobe Photoshop. Doug's latest books have been about digital photography. In the past years, he's written *Digital Photography Workbook For Dummies, Digital Portrait Photography For Dummies,* and *Canon EOS 7D For Dummies.* To find out more about Doug and see some of his work, check out www.dasdesigns.net.

Dedication

Dedicated to Roxanne, the nicest girl on the face of the earth, the love of my life, and one of the best photographers I know.

Author's Acknowledgments

Thanks to Steve Hayes for bringing this project to fruition. Kudos to Nicole Sholly for spearheading this project and making sure nothing slipped through the cracks. Many thanks to Debbye Butler for making sure the text was letter perfect. A tip of the hat to Ron Rockwell for posing insightful questions and making sure the work is technically accurate.

Thanks to Margot Hutchison for working out the contractual end of the project. Thanks to my friends, fellow authors, and fellow photographers for their never-ending support. A tip of the paw to Niki and her little brother Micah for being great furballs and a never-ending source of comic relief. Thanks to Ted and Karen for their friendship and support. And many thanks to Roxanne, the best photographer I know and the nicest girl on the face of the earth. I love you, "Nature Girl."

Publisher's Acknowledgments

We're proud of this book; please send us your comments at http://dummies.custhelp.com. For other comments, please contact our Customer Care Department within the U.S. at 877-762-2974, outside the U.S. at 317-572-3993, or fax 317-572-4002.

Some of the people who helped bring this book to market include the following:

Acquisitions, Editorial

Project Editor: Nicole Sholly

Executive Editor: Steve Hayes

Copy Editor: Debbye Butler

Technical Editor: Ron Rockwell

Editorial Manager: Kevin Kirschner

Editorial Assistant: Amanda Graham

Sr. Editorial Assistant: Cherie Case

Composition Services

Senior Project Coordinator: Kristie Rees

Layout and Graphics: Joyce Haughey, Clint Lahnen, Jill A. Proll, Erin Zeltner

Proofreaders: Laura Bowman, Jessica Kramer

Indexer: Christine Karpeles

Publishing and Editorial for Technology Dummies

Richard Swadley, Vice President and Executive Group Publisher

Andy Cummings, Vice President and Publisher

Mary Bednarek, Executive Acquisitions Director

Mary C. Corder, Editorial Director

Publishing for Consumer Dummies

Kathy Nebenhaus, Vice President and Executive Publisher

Composition Services

Debbie Stailey, Director of Composition Services

Contents at a Glance

Contents

Introduction

*T*he world in which we live is a beautiful place. But as far as many people are concerned (including me), nothing quite beats a beautiful natural landscape filled with trees, flowers, and wildlife. Communing with nature is a wonderful experience. When you do it with a digital SLR (single lens reflex) camera around your neck, the experience is even more rewarding, because you get a chance to slow down and really see the beauty. You also get to capture the beauty as digital photographs. But having a camera with you and capturing great images is another story. When you photograph landscapes, nature, and wildlife, you not only need the right equipment, but you also need to know how to use it.

About This Book

My goal in writing this book was to demystify landscape, nature, and wildlife photography. The ability to observe and capture beautiful images doesn't always come easy, but if you understand the equipment and techniques involved, you're one step closer to becoming a competent photographer of the wonders of nature.

This book will help you

- Understand the various aspects of nature photography
- Know which equipment you need to become a competent landscape, nature, and wildlife photographer
- Learn how to safely and effectively photograph wildlife in state parks
- Master photography of nesting, wading, and flying birds
- Discover and use creative tips and techniques

Conventions Used in This Book

To help you navigate this book as efficiently as possible, I use a few style conventions:

- Terms or words that I *truly* want to emphasize are *italicized* (and defined).
- Website addresses, or URLs, are shown in a special monofont typeface, `like this`.
- Numbered steps that you need to follow and characters you need to type are set in **bold.**

What You Don't Have to Read

This book is designed to show you how to photograph nature, landscapes, and wildlife effectively. They all go hand in hand, which is why they're all in the book. However, you might only be interested in photographing landscapes, or perhaps birding is your thing. Although I'd like you to read each and every chapter of this book, you can let your fingers do the walking and fast-forward to the table of contents or index. Find a topic you want to know more about and then read the section. If you really want to cut to the chase, you don't have to read the introductory paragraph in each chapter.

You can also fast-forward through each chapter. The images will give you an idea of what the content is about. The icons are another landing point. If you see an icon that piques your curiosity, put your feet up, relax, and read the associated content.

Pay special attention to the "Choosing the Right Focal Length for the Job" section in Chapter 1, especially if you own a camera that has a sensor that is smaller than a 35mm frame of film. This section takes about five minutes to read and demystifies what different focal lengths will do and how these focal lengths react on various camera sensors.

Foolish Assumptions

There are certain prerequisites for using this book effectively. You should own a digital SLR and a wide-angle to medium telephoto zoom lens for landscape and nature photography. You should have a long telephoto lens to effectively photograph wildlife and birds. You can photograph nature with a point-and-shoot camera, but I recommend getting a decent digital SLR for the best results.

How This Book Is Organized

Digital Landscape and Nature Photography For Dummies is split into five parts. You don't have to read it sequentially, and you don't even have to read all the chapters in any particular part. Use the table of contents and the index to find the information you need and quickly get your answer. Following are brief descriptions of what you'll find in each part.

Part 1: Nature Photography and You

Every book has to start somewhere, and this book begins in earnest — whoever he was — in Part I. In this part, I introduce you to the wonderful world of landscape and nature photography. I introduce some basic photography techniques, discuss the equipment you need, show you how to use your equipment, and much more. Even if you know your equipment, there are certain things about it that you need to know for this type of photography. If you think you're a competent photographer, but are new to landscape, nature, and wildlife photography, I suggest you at least skim through this part of the book.

Part II: Honing Your Skills

After you learn how to use your equipment, you still need to know some skills specific to this type of photography. You can't simply point the camera at something and shoot. Well, you can, but . . . there are certain tried and true rules of composition that are designed to help you capture better images. I discuss the rules as they apply to landscape, nature, and wildlife photography.

Of course, rules are made to be broken. I also discuss the creative use of shadow and light. A photograph without light is like a blackboard with no chalk. I discuss the times of day that are best for this type of photography, and I also show you how to photograph during inclement weather. The last chapter in this section is designed to get your creative juices flowing. I give you some tips to inspire you and help you develop your unique photography style.

Part III: Photographing Nature

Birds, animals, and flowers are citizens of the natural landscape. Many photographers prefer this trifecta of photography to landscape photography, while other photographers add landscapes to the mix of their photo portfolios. If you like furry, feathered, stamened, or scaled creatures, this section is for you. I reveal tips and techniques for capturing compelling pictures of birds and animals. I also show you how to effectively photograph flowers and insects. In fact, I devote a large section of Chapter 9 to Lensbaby photography. A Lensbaby and flower photography go hand in hand.

Part IV: Photographing Landscapes

If a beautiful landscape is within driving distance of your home, or if you're vacationing in an area like Yosemite National Park, this section of the book has lots of good stuff that will interest you. In this section, I show you how to photograph landscapes, mountain ranges, and seascapes. I also explain how to photograph the sunrise and sunset. In addition, I introduce you to the wide, wide world of panorama photography and the dynamic world of HDR photography.

Part V: The Part of Tens

In this section, you'll find three chapters with ten sections: the time-honored Part of Tens chapters. In this section, I show you ten techniques for processing images and sharing them with friends. I also show you how to troubleshoot your images in-camera. In addition, in Chapter 15, I dissect ten of my favorite photographs from this genre and share the settings I used, the inspiration behind the photographs, and more.

Icons Used in This Book

What's a *For Dummies* book without icons pointing you in the direction of really great information that's sure to help you along your way? In this section, I briefly describe each icon I use in this book.

The Tip icon points out helpful information that is likely to make your job as a photographer easier.

This is like a virtual piece of string. When you see this icon, it contains a fact that you should remember to help you perform the task at hand more efficiently.

This icon notes a pitfall that your friendly author has discovered so that you won't make the same wrong move.

Where to Go from Here

Now that you've read the Introduction, you have a good idea of what's ahead. You can start with the first paragraph of Chapter 1, or delve into the table of contents to find a chapter that contains information you need to know. If you want to get really specific, refer to the index to find a topic you need to know more about.

After you read a chapter or section, I suggest you grab your camera and take some pictures. Photography is about doing. After you assimilate information, it's time to put it to use. Take lots of pictures and take them often.

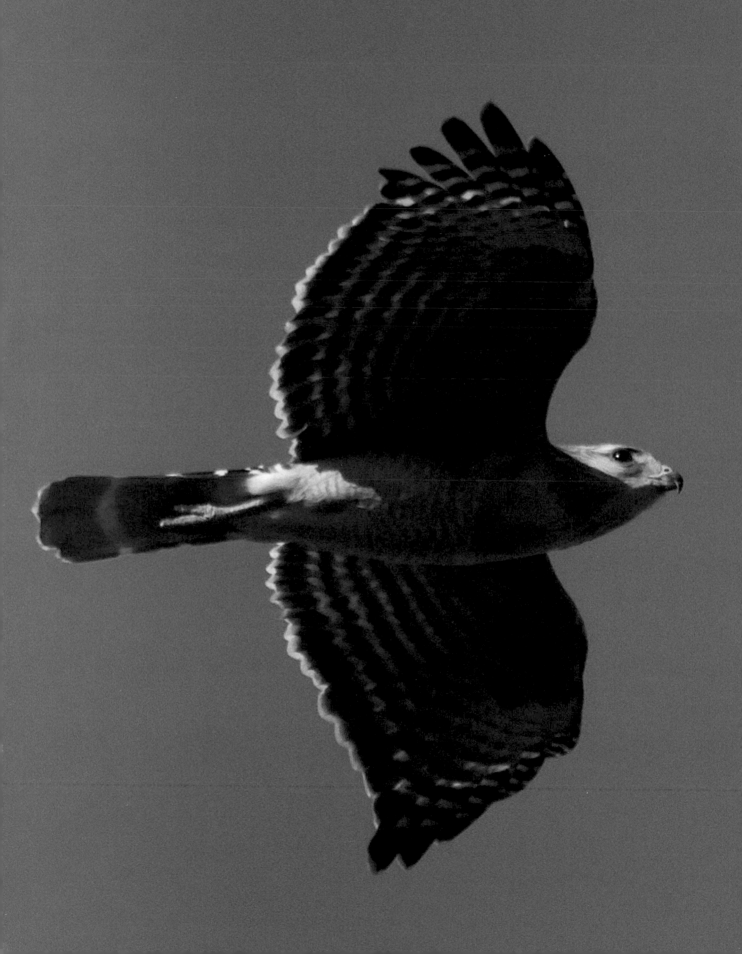

Part I

Nature Photography and You

You have a camera, a vision, and a lot of lovely landscapes with birds and flowers near your home. And you just want to shoot something. But before you do, it's important to know some facts about digital photography as it relates to the landscapes and animals you want to photograph. That's what this part is all about.

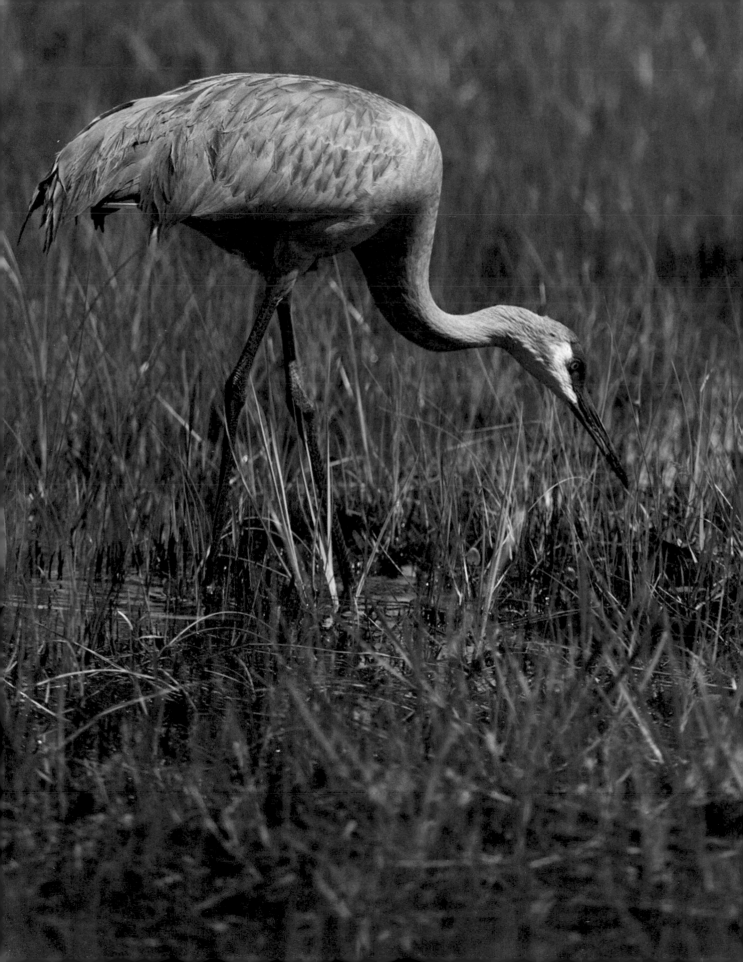

1

Nature and Digital Photography

The camera and nature have been inexorably married since the beginning of photography. A camera in the hands of a nature lover is like an extension of his very being, a sixth sense if you will, ready to record the beauty, mystery, and grandeur of the places he visits. When photography was invented, cameras were available only for the privileged few. The tools used to create compelling photographs of nature were big and cumbersome. Ansel Adams trekked through Yosemite with an 8-x-10-inch view camera and tripod. Equipment improved and became smaller, and soon photography was available for anyone who was interested in recording his world. In 1994 the first consumer digital cameras became available. In its infancy, digital photography was horrifically expensive and not really suited for capturing certain subjects like birds in flight. Now digital cameras are available in many flavors and the prices are steadily dropping as camera manufacturers add more bells and whistles to their shiny boxes.

With today's digital cameras, you can literally take the camera out of the box, charge the battery, insert a memory card, and start taking pictures. The cameras are so well designed you can get a properly exposed picture by pointing the camera at something and pressing the shutter button. But that recipe doesn't yield a photograph someone will want to spend some time viewing. To accomplish that goal, you must know something about photography.

In this chapter, I bring you up to speed on the art and science of photography, which really hasn't changed all that much. The basics are still the same, but your camera records the scene on a sensor and transfers the image to a memory card. The big difference is that you don't need to send film out to be processed. You can let the camera do the processing for you, and then tweak your images in your favorite image-editing application. Or you can download RAW images (see "RAW versus JPEG," later in this chapter) to your computer and then process them in your "digital darkroom." It's a wonderful time to be a photographer. So if you're ready to take your knowledge of photography to the next level, read on.

Mastering Your Camera Controls

If you've just graduated from a point-and-shoot camera to your first digital SLR, you may be wondering what each bell and whistle on the camera is used for. This information may also be useful if you've had your digital SLR for a while but have used only the automatic settings. To master your camera, you have to know it like the back of your hand. You must know what each control does and know where each control is in order to master a specific picture-taking situation. I explain which control to use for a picture-taking scenario, but the position of these controls varies from camera to camera. The following is a list of important camera controls and what they do:

- **Mode dial:** On most cameras this is a round dial on top of the camera. This is the shooting mode dial. On Canon cameras, the dial is on the left side when you hold the viewfinder to your eye and take pictures. On Nikon cameras, it's on the right side. You use the dial to choose the desired shooting mode. I show you which shooting mode to use for each picture-taking scenario in this book.

- **Shutter button:** You press this button to prefocus the camera and take a picture.

- **ISO setting:** You use this feature to change the ISO setting of the camera. The ISO determines how sensitive the sensor is to light. You use higher ISO settings to take pictures in low light conditions. On many cameras, a dial is used to change the ISO. Some cameras use a menu command to change the ISO setting.

- **Aperture setting:** The aperture determines how much light enters the camera. When you choose Aperture Priority as the shooting mode, you use a dial to change the aperture, and the camera automatically selects the shutter speed to properly expose the image.

- **Shutter speed setting:** The shutter speed setting comes into play when you shoot in Shutter Priority mode. After choosing Shutter Priority for the shooting mode, you use a dial to change the shutter speed, and the camera automatically selects the correct f/stop to properly expose the image.

✔ **Exposure compensation setting:** This is used to increase or decrease the exposure. You increase or decrease the exposure when the camera gets it wrong. When you review an image on your LCD monitor and it looks too dark or too bright, you use this option to correct the problem by increasing or decreasing the exposure.

✔ **Histogram display:** This option displays a graph that shows you the distribution of pixels from the lightest parts of the image to the darkest parts of the image. If you notice a spike on the right side of the histogram, your image is overexposed. In other words, some of the highlights are blown out to pure white and no details are visible. If you see a spike on the left side of the histogram, part of the shadows are pure black, and no details are visible.

✔ **White balance:** You use this setting to set the white balance. The human eye can compensate for different lighting scenarios to see white as white. In most cases, your camera's default white balance setting, Auto White Balance (AWB), can get the job done. If the camera gets confused due to multiple light sources, the whites have a color cast to them and may have an green, orange, or blue tint. You can rectify this problem by choosing a preset white balance (such as Fluorescent, Tungsten, or Shade) or by manually setting the white balance. Refer to your camera manual for detailed information on how to set the white balance for your specific camera.

✔ **Metering mode:** This feature is a button on Canon cameras and a menu control on Nikon cameras. The metering mode determines which area of the viewfinder is used to meter the image. In most instances, your camera's default metering mode does an excellent job. However, in some picture-taking scenarios, you may need to change the metering mode.

✔ **Flash control:** If your camera has a built-in flash unit, you push this button to pop the flash unit up and enable it. You can use flash to light the scene or add additional light to a scene by filling in the shadows. The latter is known as *fill flash*.

✔ **Hot shoe:** You slide a flash unit that's compatible with your camera into this slot. The contacts in the hot shoe communicate between the camera and flash unit. Canon flash units are called Speedlites; Nikon calls its flash units Speedlights.

✔ **LCD panel:** This panel shows you all the current settings. When you change a setting such as the shutter speed or ISO setting, the panel updates to show you the new settings. If your camera doesn't have an LCD panel, these settings are visible in most camera viewfinders.

I show you which settings to use for specific picture-taking scenarios. However, each digital SLR is different. The location of the controls you use to change these settings depends on the camera model you have. Refer to your camera manual for detailed instructions regarding the location of camera controls.

Digital Photography 101

Photography can be compared to cooking. You start out with a goal and end up with a result. Anyone can create a meal by popping a box or bag into a microwave and pushing a button, which is similar to leaving the camera in Auto mode and then pressing the shutter button. The camera does the grunt work for you and then you download the images. Then there are master chefs. They go into the kitchen to prepare a gourmet meal. They know which tools to use, which ingredients work well together, what temperature to set the oven at, which spices to use, how long the meal must stay in the oven, and so on. The result is a feast of which every bite is savored.

A master chef's meal is similar to a photograph taken by a master photographer. He knows which settings to use, which lens to use, how to compose the picture, and so on. A photograph captured by a master photographer is a visual feast, one which viewers spend time looking at. If you were to compare an image of Colorado's Maroon Bells captured by David Muench, for example, to a snapshot of the same scene captured by a vacationer with a point-and-shoot camera. Many people will say the difference is the fact that David uses expensive equipment. Yes, good equipment will give a photographer a leg up. In addition to his professional digital SLRs, however, David also uses relatively simple point-and-shoot digital cameras to get phenomenal pictures.

The difference between David and the casual photographer is that David has spent years learning his craft. He understands the art and science of photography to the point where it is second nature to him. Add this to the fact that he knows his equipment like the back of his hand and he photographs frequently, and you can understand why he is a master of landscape photography. With a bit of practice, a digital camera, and a basic knowledge of photography, you, too, can capture compelling photographs of nature wherever you go (see Figure 1-1).

The fact that you have this book in your hands means you want to capture compelling photographs of nature. You must understand the basics of photography before you can call yourself a photographer. The first thing you need to know is how a camera works. Cut to its lowest common denominator, a camera is a box with a hole that lets light in and then a medium captures the light and converts it to a recognizable image. Your digital camera performs the same basic functions. The light enters your camera through a lens which contains an aperture (the hole) and is captured by a sensor. When you press the shutter button, the shutter opens, and the sensor captures the light. The light is then converted into an image that is stored on a memory card. When you take a picture, you expose the sensor to light. To get a properly exposed image, the light funnels through the lens, which has an adjustable aperture. The size of the aperture (f-stop value) and the amount of time the shutter stays open (shutter speed) are determined by the amount of available light. There are lots of combinations of f-stop and shutter speed that can yield a properly exposed image for the available amount of light. Understanding exposure is the subject of the next section.

Understanding exposure

To capture a photograph, you need four things: a subject you want to photo-graph, a camera, light, and someone to press the shutter button (that would be you, dear reader). Your subject reflects light and casts a shadow. When you press the shutter button, your camera records everything in the frame and renders an image. If you just point the camera and shoot without visualizing the end result, you still end up with a picture. In most instances, however, the image won't be something you'd want to frame and hang on your wall.

The first step to understanding photography is to know the basic ingredients used to expose an image. The holy trinity — as some photographers refer to it — of exposure are shutter speed, aperture size, and the sensitivity of the digital camera's sensor to light. The shutter speed is the amount of time the shutter stays open. A typical digital camera has shutter speed ranges from 1/8000 of a second to 30 seconds. The aperture is the size of the hole through which light is admitted to the sensor. The size of the aperture is referred to by a value known as the *f-stop*. The concept of the f-stop confuses

Figure 1-1: Understanding the basics is the first step to becoming a good nature photographer.

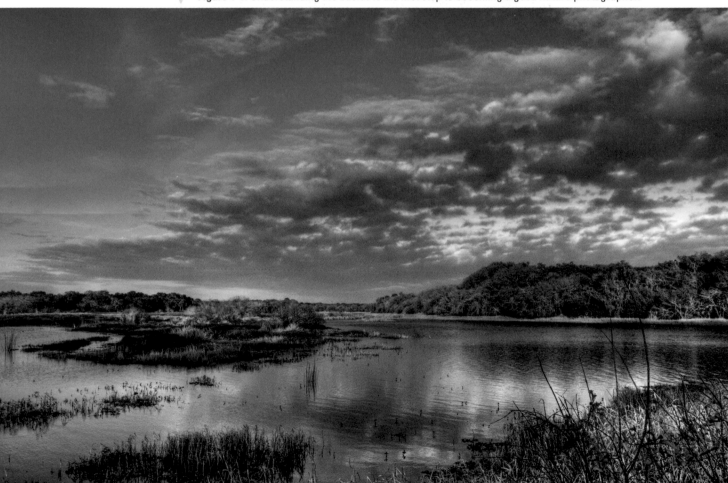

some beginning photographs. A large aperture is designated by a small f-stop number, and a small aperture is designated by a large f-stop number. An aperture with a value of f/2.8 lets gobs of light into the camera, and an aperture with a value of f/22 lets only a small amount of light into the camera.

To properly expose an image for a given amount of ambient light, sufficient light must reach the sensor to produce a distribution of pixels from dark to light. The darkest parts of the subject in your frame are the shadows and the brightest parts of the subject are the highlights. If too little light reaches the sensor, the image is underexposed; details in the shadow areas become black and all detail is lost. If too much light reaches the sensor, the image is overexposed; details in the brightest areas are blown out to pure white and all detail is lost.

For a given amount of light, there are many combinations of shutter speed and f-stop that will produce a properly exposed image. You can let a little bit of light reach the sensor (small aperture, large f-stop number), which means the shutter needs to remain open longer (slow shutter speed). Or you can let a copious amount of light into the camera (large aperture, small f-stop number), which means the shutter will remain open for a short duration (fast shutter speed). The camera's light-metering device measures the amount of light and then does all the math and comes up with a shutter speed/f-stop combination that will properly expose the image. The combination of shutter speed and aperture is known as the Exposure Value. There are myriad shutter speed and aperture combinations for a given Exposure Value. But will the combination the camera chooses when you shoot in Auto mode yield the type of image you envision? If it doesn't, then you take matters into your own hands by switching from automatic to a different shooting mode. Camera modes as they relate to nature photography are covered in detail in Chapter 3. But you're probably wondering where the third member of the holy trinity, camera sensitivity to light, enters into the equation. This topic is covered in the next section.

Understanding ISO

If you photograph wildlife or landscapes on a bright sunny day, you have lots of light. Therefore you can use the combination of a relatively fast shutter speed with a relatively small aperture to properly expose the image. Add some clouds to the equation, and you have less light (a lower Exposure Value). In that case, you'll either need to use a larger aperture (known as opening the aperture in photo speak) or a slower shutter speed to properly expose the image. If the shutter speed is too slow for the subject you're photographing (see "Photographing Objects in Motion," later in this chapter), or the aperture is too large for the landscape you're photographing (see the "Controlling depth of field with aperture" section), you have two choices: Come back when there's more light or increase the sensitivity of the camera sensor.

If you come from a film background, you may remember something known as film speed. When you were photographing in bright sunny conditions, you used a slow speed film. When you were photographing in low light situations, you used a fast film. The problem with film was you were stuck with the film speed until you shot all the frames. This posed a problem if conditions changed rapidly. This is one of the beauties of shooting digitally. You can change the sensitivity of your camera sensor on the fly using a menu command or camera dial.

To increase the sensitivity of your camera sensor, you increase the ISO (International Organization for Standardization) setting. Use a low ISO setting in bright conditions. Increase the ISO setting when shooting in dim lighting conditions, or when you need a smaller aperture or a faster shutter speed. For example, if you need to use the shutter speed to freeze the motion of a bird in flight on a cloudy day (see Figure 1-2), increase the ISO setting.

Increasing the ISO setting is a dual edged sword. When you increase the ISO setting, you can capture photographs in lower light conditions. Increasing camera sensitivity, however, also increases digital noise. Some people equate digital noise to film grain, but they are not the same. Because film grain has a pattern, it adds interest and character to a photograph. Digital noise, however, is random mishmosh created by electric circuitry that degrades an image. The amount of noise a digital camera generates varies depending on the age of the camera and the size of the sensor. Smaller sensors and cameras built with older technology are noisier than newer cameras. The amount of megapixels a camera captures is also a determining factor. When a camera manufacturer crams lots of pixels onto a small sensor, the size of each pixel is smaller. This results in a noisier image at any ISO setting. Digital noise is readily apparent in the shadow areas of an image when the image is enlarged.

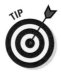

To determine the highest ISO at which your camera delivers acceptable images, place your camera on a tripod and take a series of images at night. Make sure that part of the scene you capture has dark shadows. Take the series of pictures starting with your lowest ISO rating up to your highest. Download the images to your computer, increase the magnification to 200 percent, and then scroll to the shadow areas of each image. When you see an image that has unacceptable noise, note the ISO setting and never use this setting or higher unless you absolutely have to.

RAW versus JPEG

There are two formats commonly used to capture images, RAW and JPEG (Joint Photographic Experts Group). Each has its advantages and disadvantages. I discuss the JPEG format first. When you capture images in the JPEG format, the camera processes the image. The image is compressed to a smaller file size when compressed. The good things about the JPEG format are that you can

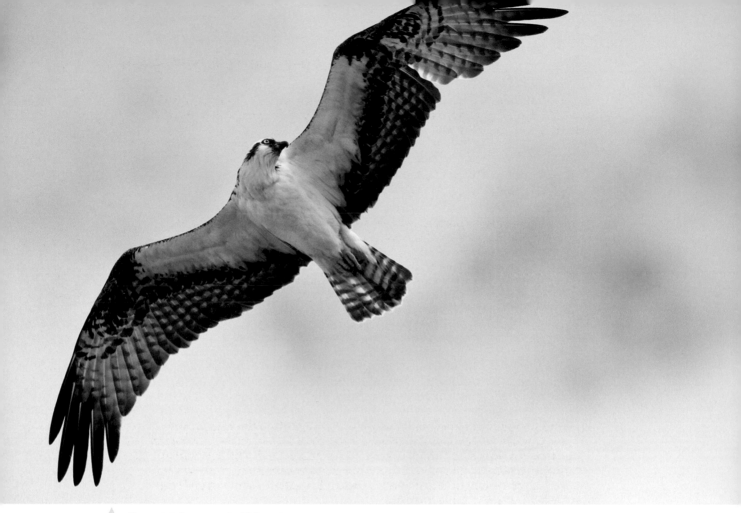

Figure 1-2: Increase the ISO settings to photograph in low light.

Photo courtesy of Roxanne Evans: http://www.dougplusrox.com

fit more images on a card and you don't have to process the images when you download them to your computer. The negative is the fact that you're stuck with what the camera gives you. If the camera gets it wrong, you've lost the image. You can do minimal editing to a JPEG image in an application like Photoshop, Lightroom, or Aperture. I think of JPEGs as digital Polaroid images. It would be like shooting a roll of film, taking it to a camera store for processing, and getting images back — but no negatives.

When you photograph in your camera's RAW format, the image is converted into a format that can be processed by the software included with your camera or in an application like Photoshop, Aperture, or Lightroom. You have complete control over this format when you get it in your computer. You can change the exposure, brightness of the image, contrast, white balance, and much more. The drawback is that you have to process each and every image. However, when you get the knack of processing RAW images in an application like Lightroom or Aperture, you can automate certain tasks, copy settings from one image to the next, and so on. The only other

drawback is you can't fit as many images on a card. But cards are cheap. If you'd prefer to have more control over your images, try your camera's RAW format. You'll like what you get.

Understanding Depth of Field

Depth of field is an important concept to understand. It is the area of the image in front of and behind the area on which you focused that is sharp. You use depth of field to lead your viewers through an image. The human eye is drawn like a magnet to things that are in sharp focus. Figure 1-3 shows a landscape with a huge depth of field, and Figure 1-4 shows an image with a shallow depth of field. The choice of whether to have a large or shallow depth of field depends on your subject matter. You control depth of field with your choice of lens and aperture (outlined in the upcoming sections).

Controlling depth of field with aperture

The aperture is the opening in the lens that lets light into the camera. The size of aperture you choose determines how much of your image is in sharp focus from front to back, which is known as depth of field. The aperture in your camera lens is adjustable. The size of the aperture is referred to as the f-stop. A large f-stop number designates a small aperture, and a small f-stop number designates a large aperture.

The range of available f-stops varies depending on the lens you have and whether the lens is a telephoto lens. For example, a Canon EF 50mm f/1.4 has an aperture range from f/1.4 to f/22. A lens with an f-stop value of f/2.8 (large aperture) or lower is considered a fast lens because you can open the aperture (choose a low f-stop value) to let a lot of light into the camera. Lenses shed light on your sensor. I illuminate the subject of lenses in Chapter 2.

You don't need to know all the science that determines whether an f-stop gives you a large depth of field or a small depth of field. All you need to remember is that a small f-stop value (large aperture) gives you a shallow depth of field, and a large f-stop value (small aperture) gives you a large depth of field. The depth of field gradually increases as you choose a smaller aperture (larger f-stop value), which is also known as closing down the aperture. The easiest way to learn what a specific lens will do at a given f-stop value is to experiment with the lens while shooting in Aperture Priority mode. Take a picture of the same subject from the same distance with different f-stop values. When you examine the images on your computer, you'll grasp the relationship of f-stop and depth of field. ***Remember:*** The focal length is also a determining depth of field factor. I shed more light on the relationship between focal length and depth of field in the next section of this chapter.

Depth of field plays a vital role in nature photography. Some subjects warrant a large depth of field, and other subjects beg for a shallow depth of field. When you photograph a wonderful landscape that seems to go on forever, such as the beautiful vista from Tunnel View in Yosemite Valley (see Figure 1-3), you need a large depth of field and an f-stop of f/11 or larger. When you photograph an animal or a flower, choose a relatively shallow depth of field to draw your viewer's attention to your subject (see Figure 1-4). The focal length you choose is also a factor, as I show you in the next section.

Figure 1-3: Choose a small aperture (large f-stop value) for a large depth of field.

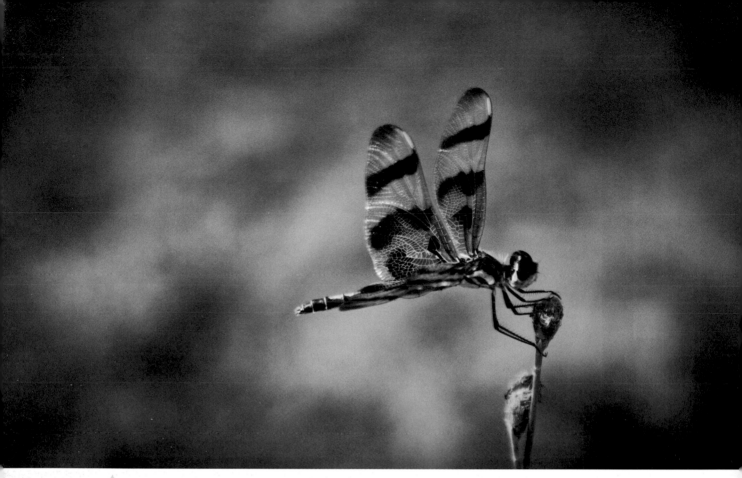

Figure 1-4: Choose a large aperture (small f-stop value) for a shallow depth of field.

Depth of field, focal lengths, and distance

There's a wide variety of lenses out there, each suited for specific tasks. Lenses fall into the following categories: super wide-angle lenses that have a focal length from 10mm to 20mm, wide-angle lenses that have a focal length from 20mm to 35mm, normal lenses with a focal length of 50mm and that are close to the range of vision of the human eye, short telephoto lenses with a focal length from 85mm to105mm, and long telephoto lenses that have a focal length of 150mm or greater. A short focal length captures a wider view of what's in front of the lens. When you photograph a scene with a wide-angle lens, you always get a larger depth of field than you would with a longer focal length. Figure 1-5 shows an example of a scene photographed with a 24mm lens.

A long focal length zooms in on your subject, capturing a narrow angle of view. Telephoto lenses are ideal for taking pictures of subjects you can't get close to, such as birds and wildlife. Telephoto lenses are also great for capturing details of a scene. When you photograph a scene with a telephoto lens, you end up with a shallower depth of field than you would when photographing with a lens with a shorter focal length. Remember this when you photograph subjects like birds and animals (see Figure 1-6).

Another way to control your depth of field is to get closer to your subject. Get close to your subject with a telephoto lens, and you compress the distance between objects in front of and behind your subject, which brings your subject into clear focus. The combination of being close to your subject, shooting it with a telephoto or macro lens, and using a large aperture (small f-stop number) yields an extremely shallow depth of field (see Figure 1-7). Notice that the butterfly's head and antennae and the flower are in focus, but the tips of the insect's wings are not.

Photographing Objects in Motion

The recipe for a perfect exposure can be obtained in many ways. You can choose a small aperture (large f-stop number) to get a huge depth of field. This approach generally yields a fairly slow shutter speed, even in bright light. You can choose a fast shutter speed, which means a large aperture (small f-stop number) when you want to freeze motion. There are a couple of schools of thought on photographing objects in motion.

Figure 1-5: Photographing a scene with a wide-angle lens yields images with a large depth of field.

Figure 1-6: A telephoto lens renders images with a shallow depth of field.

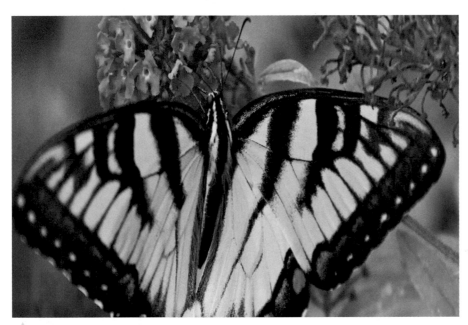

Figure 1-7: Get close to your subject with a telephoto lens for an extremely shallow depth of field.

Figure 1-8: Freeze a subject in motion with a fast shutter speed.

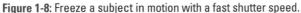

Many people like to use a fast shutter speed and freeze the motion of the subject they are photographing. Freezing motion creates a dynamic picture, such as when photographing a bird catching its dinner (see Figure 1-8). A number of factors determine the shutter speed that you need to freeze motion. Use a shutter speed of 1/500 of a second or faster

when photographing a subject such as an eagle in flight when you're zoomed in tight with a telephoto lens. You have to choose an even faster shutter speed of 1/2000 of a second to freeze the motion of a hummingbird flapping its wings. The telephoto lens magnifies any movement, which results in a less than sharp image if you don't choose a fast enough shutter speed.

There's another school of thought when photographing subjects in motion. This technique shows the beauty of motion, yielding a subject that is in sharp focus with a blurred background (see Figure 1-9). This is known as panning with your subject, a technique I cover in detail in Chapter 7.

When you photograph some subjects, you want to express the beauty of motion in an abstract manner. Fast-moving wildlife or birds are great subjects when you want to create an artistic depiction of motion. To achieve this goal, use a slow shutter speed (see Figure 1-10).

Figure 1-9: Panning with your subject.

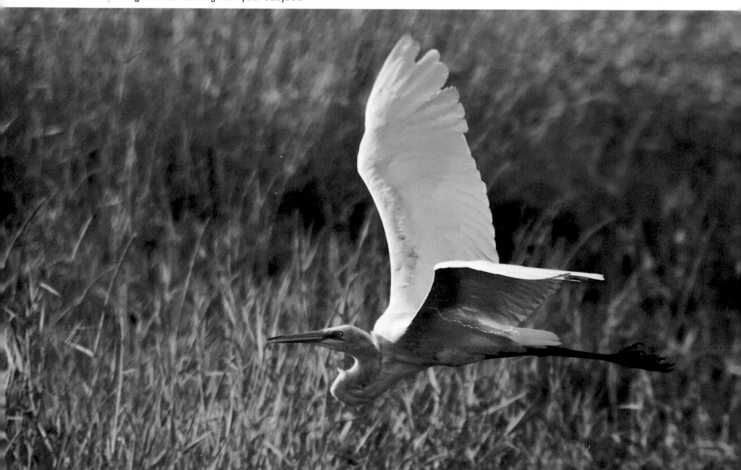

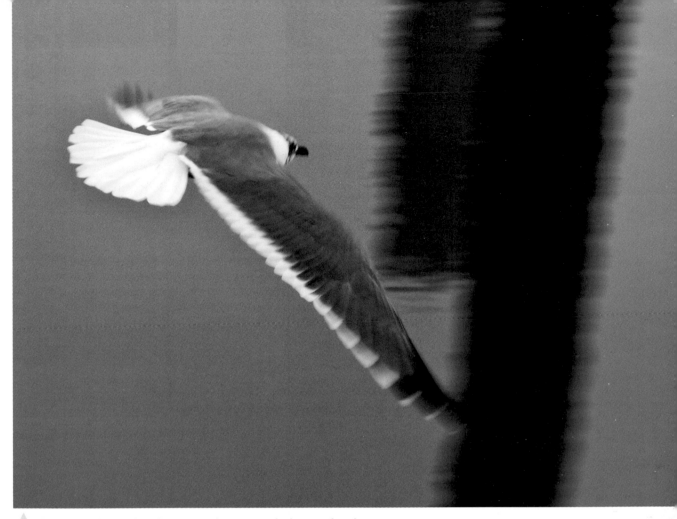

Figure 1-10: Use a slow shutter speed to capture the beauty of motion.

Choosing the Right Focal Length for the Job

It would be a wonderful thing if you could do all of your photography with one focal length. Well, actually you could, using a little thing called *foot zoom,* which is when you move closer to or farther from your subject. But even with foot zoom, you would be hard-pressed to duplicate the effects you can achieve with different focal lengths. For example, using a lens with a long focal length compresses the distance between things, making them seem like they're closer to each other than they really are. In the following sections, I offer recommendations regarding specific focal lengths for different types of nature photography.

Photographing landscapes

Landscapes are wonderful vast expanses of scenery that should be captured fully. **Remember:** If you capture only half of a vast landscape, the resulting photograph is half vast. The best lens for landscape photography captures

every subtle detail in stunning clarity. To capture the beauty and grandeur of a landscape, use a wide-angle lens. But even wide-angle lenses come in a wide variety of focal lengths.

Super wide-angle lenses begin with a focal length of 10mm and go to 20mm. A super wide-angle lens captures an impressive amount of real estate in a picture. However, some photographers go over the top and try to include too much in the frame when they shoot with a super wide-angle lens — so much information that viewers don't know where to look.

If you use a super wide-angle lens to photograph landscapes, make sure you include something large in the foreground. It serves as an anchor that gives your viewers a place to start their exploration of the image and gives the viewer a sense of scale. You can also use the visual anchor as a compositional element.

Wide-angle lenses begin with a focal length of 24mm and go to 35mm. This focal length range also captures an impressive amount of real estate in a single image. You still need to be careful with your composition because of the sheer amount of visual information you can pack in a frame. Composition is a lofty topic, especially when photographing landscapes at high altitudes. I cover the different aspects of composition in Chapter 4.

Another thing about wide-angle lenses you must consider is distortion. When you photograph with an ultra-wide-angle lens, verticals at the sides of the picture have a tendency to lean in. Tilting the lens up or down exacerbates the problem. But no matter what focal length your lens has, pay attention to what's in the frame.

If you really want to take a walk on the wild side, you can photograph landscapes with a fish-eye lens. A fish-eye lens gives you a 180-degree view of the scene. The amount of information you can provide when using a fish-eye lens is staggering. But be careful when composing an image with a fish-eye lens. Tilt the lens up or down, and the horizon line bends. Vertical objects like trees at the sides of the frame will bend in, even when you hold the lens level. You can capture some wonderful landscapes with a fish-eye lens when you use it with discretion. But there's no rule that says you can't use the distortion if it suits your artistic vision.

Don't just look inside your viewfinder and snap a picture. Take a bit of time to see what's in the frame and make sure the information you want to include is in the frame and nothing more. You can always move to the left or right, crouch down, or get to a higher vantage point to get the image you envision. It may simultaneously take care of any potential problems. Do this and you'll get a much better picture.

Photographing wildlife

Wildlife comes in all shapes and sizes. The type of lens you use depends on whether your subject is close to you or far away. It also depends on the type

of wildlife you're photographing. Let's face it: Common sense dictates you can't photograph a grizzly bear from a distance of four feet (that is, unless the grizzly bear is in a zoo or you are safe inside your car, in Yellowstone National Park gazing at the bear through a long telephoto lens).

The focal length you use is also determined by how many animals you're photographing. Use a focal length of about 50mm, maybe even a wide-angle lens with a focal length of 35mm, when photographing a flock of flamingoes or any group of animals you can get close to. And if you're photographing Florida's state bird, the Pink Lawn Flamingo, you can get really close and use a fish-eye lens for comic effect. But seriously, folks, the state bird of Florida is the mockingbird.

When photographing wildlife like large birds that are fairly tame, you can get pretty close and use a shorter focal length. For tame wildlife or large birds you can get close to, I recommend using a normal focal length of 50mm or a short telephoto lens in the 80mm to 105mm range.

For landscape and wildlife photography, consider purchasing a zoom lens that includes wide-angle and telephoto focal lengths. A focal length range from 24mm to 105mm is an ideal walkabout lens for landscape and wildlife photography, provided the animals are used to human presence.

When you photograph potentially dangerous wildlife, you need to distance yourself from your prey; otherwise you may become the prey. If you want to photograph elusive wildlife such as bald eagles that roost in nests atop tall trees, you'll also need some way to get in close. The solution: a long telephoto lens. Your local camera store doesn't exactly give away long telephoto lenses, but with a bit of judicious shopping, you should be able to find a lens to fit your budget. When you need to zoom in on distant subjects, the shortest focal length to consider is 200mm. You can find this focal length on a very popular zoom lens that incorporates a range of 70mm to 200mm. If your primary interest is bird photography and your budget can stand it, consider purchasing a 300mm or 400mm prime lens. A *prime lens* has one focal length and is sharper than a telephoto lens that contains the same focal length.

Macro photography

When you want to photograph flowers, insects, and other miniscule things, you need to get close — real close. You can do this with some telephoto lenses. However, the best way to get great pictures of things that creep and crawl is to use a macro lens. You may own a macro lens and not know it. Macro lenses often have a flower symbol or the word "Macro" on the lens. A macro lens will focus much closer than a standard lens with the same focal length. For example, the Canon 50mm f/1.4 lens has a minimum focusing distance of 18 inches, and the Canon 50mm f/2.5 Macro lens has a minimum focusing distance of 10 inches. Many point-and-shoot digital cameras also have a macro mode.

If you photograph small insects or insects that are potentially dangerous, you need a macro lens with a longer focal length so that you can put some distance between you and your subject. Keep in mind that a macro lens with a longer focal length has a shallower depth of field that will require you to use smaller apertures in order to keep the entire subject in sharp focus.

Understanding Auto-Focus Modes

If you've been into photography for a long time, you may remember the time when you had to manually focus to get a clear image. Thankfully, those days are behind us, especially considering the fact that your friendly author has looked at enough computer screens and taken enough photographs to warrant a fairly strong pair of glasses. Your camera focuses by detecting areas with well-defined edges. Auto-focus is a wonderful thing. You point your camera at something, and then press the shutter button halfway. A light then illuminates in the viewfinder (LCD monitor if you're using a point-and-shoot camera or shooting in your digital SLR's Live View mode). Some cameras even beep. This is all well and good when photographing a stationary object, but when the object is moving, focusing is a whole different kettle of fish. That's why your camera has different auto-focus modes. The following auto-focus modes are available on most digital SLR cameras and many point-and-shoot digital cameras. The name of the focus mode varies depending on which company manufactured your camera.

- **One Shot Auto-Focus:** Use this mode when you're taking a photo of an object that is stationary. When you press the shutter button halfway, the camera focuses once.

- **Continuous Auto-Focus:** Use this mode when you're taking photos of moving objects. When you press the shutter button halfway, the camera focuses on your subject, but continually updates auto-focus as the subject moves, up until the time you press the shutter button fully. On Canon cameras, this is known as AI-Servo.

- **Automatic Switching:** If your camera has this mode, it achieves focus using one shot auto-focus mode, but switches to continuous auto-focus if the subject begins to move. On Canon cameras, this is known as AI-Focus.

Choosing Auto-Focus Points

Digital cameras are smart, sleek, and sophisticated. Many cameras have more auto-focus points than you can shake a stick at. Having multiple auto-focus points is good, with a caveat. Say, for example, the camera selects an auto-focus point that is over a twig in the foreground, but the important part of your image — all of the majestic mountains — is out of focus. In spite of the fact that every dSLR (digital single lens reflex) camera I've ever owned has multiple focus points, I always select the one in the middle. With one

auto-focus point, I can position the auto-focus point over the focal point (the area I want viewers to notice) in the scene, press the shutter button halfway to achieve focus, and then move the camera to compose my picture.

Another acceptable alternative is to use a group of auto-focus points if your camera has this feature. My Canon EOS 7D has a group of auto-focus points in the center of the frame. I often use this group when photographing landscapes. However, when I need critical focus, such as when I'm photographing a bird and need to achieve focus on the eye closest to the camera, I switch back to a single auto-focus point when using my EOS 7D. When I shoot with my EOS 5D, the auto-focus point in the center of the frame is the only one I choose to have active.

Mastering Metering Modes

In the old days, photographers used a handheld exposure meter to determine the shutter speed/aperture combinations that could be used to capture a properly exposed image. Fortunately, your camera has a built-in exposure meter that determines the correct Exposure Value that will render a properly exposed image based on the amount of available light. This is another area where you have a choice. Most cameras have four metering modes. You can use your camera's default metering mode, which works well in most cases, or switch to a different metering mode for a specific picture-taking scenario. The following modes are available on most digital SLR cameras and some point-and-shoot cameras:

- **Evaluative or Matrix metering:** The camera meter evaluates everything in the frame to set the exposure.

- **Partial metering:** The camera meters the area around the center of the frame. This metering mode is effective when the background is considerably brighter than the subject, such as when your subject is backlit.

- **Spot metering:** The camera meters a small part of the scene, approximately 4 percent to 5 percent. This metering mode is useful when you want to set the exposure based on a small part of the scene. For example, you can set the camera to spot metering mode and then set the exposure based on an object that is about half as bright as the brightest part of the scene.

 Some photographers also use spot metering to use the *Zone System* developed by Ansel Adams and Fred Archer. The Zone System assigns a value of 0 to 10, with 0 being solid black areas with no detail and 10 being pure white with no detail. For example, a photographer metering a scene with bright clouds would expose the image for the brightest clouds to be zone 9. In digital photography, the Zone System can also be used. However due to the difference in dynamic range between film and a camera sensor, the range is from zone 3 to zone 7.

- **Center Weighted metering:** The camera metering is weighted toward the center and then averaged for the entire scene.

Delving into Drive Modes

When you photograph using your camera's default drive mode, you take one picture each time you press the shutter. This is great when photographing landscapes. But when photographing things that move, like birds in flight, you may lose a shot if the shutter opens only once when you press the shutter button. Digital SLR cameras and many point-and-shoot cameras have a drive mode that enables you to shoot pictures as long as you have the shutter button pressed fully. This is known as Continuous Drive mode.

The number of frames you can record per second depends on your camera model. Your camera may have a low-speed (typically 3 frames per second) and a high-speed (6–9 frames per second) continuous shooting mode. The maximum number of pictures you can record before the camera buffer (memory) is full is known as the *maximum burst*, which is determined by the image format and, if you shoot JPEG, the quality. The maximum burst for RAW images is less than the maximum burst for JPEG images because RAW images have a larger file size.

Continuous Drive mode is useful when photographing animals in motion and birds in flight. When you use Continuous Drive mode, you hedge your bet that you'll get a couple of good pictures out of the sequence. Continuous Drive mode is also useful when photographing things like moving insects and flowers on a windy day when you're using a macro lens.

Your Safety and the Safety of the Environment

Photography — especially nature photography — is a lot of fun. You get to take photographs of beautiful things in beautiful places. But there are also issues you need to be aware of. You need to be an environmentally friendly photographer. Consider the following points to keep you and the environment safe:

- **Watch where you step.** It's easy to get in the moment when you see something beautiful that you want to photograph. But be aware of what is beneath your feet. Don't trample wildflowers just to get a better vantage point for your trophy shot. And don't step on something that could harm you (small poisonous snakes come to mind).

- **Stay downwind from dangerous animals.** Most animals have a keen sense of smell. Even if you can only see the animals through a powerful set of binoculars or a long telephoto lens, the animals will know you're there if you're upwind from them.

- **Never approach an animal and her offspring.** Animals are fiercely protective of their young. Even the most docile animals can be provoked when they feel their young are in danger.

- **Don't venture into water if you can't see the bottom or if you see dangerous wildlife in the distance.** This is common sense. If you can't see the bottom, you don't know what's lurking there. Even if you're just crossing a small stream, something dangerous could be on the bottom, like a slippery rock.

- **Pay attention to the weather.** This is another no-brainer, but photographers can get so entranced with what they're doing that they neglect to see an approaching storm until it's too late to find cover.

- **Always let someone know where you are.** If you're traveling into a wilderness area, let a loved one or friend know where you're going and when she can expect you back. You may think your cellphone will be all the protection you need. However, in many wilderness areas, there are no nearby cell towers.

If you do a lot of photography in remote regions, consider investing in a mobile phone on a satellite network. If you're visiting a remote area for a short period of time, you can rent a satellite phone or a device that emits a radio beacon that indicates where you are in an emergency.

- **Don't leave anything behind.** If you carry water or food on your photo walkabout, bring a plastic bag with you to store any trash and deposit it when you get home.

- **Remember the sunscreen.** Even on a relatively cloudy day, you can get sunburned. Slather yourself with sunscreen before spending an extended amount of time outdoors.

- **Drink plenty of fluid.** This is another common-sense rule. If you're going to be out for several hours, you need to replenish any fluid lost through sweat.

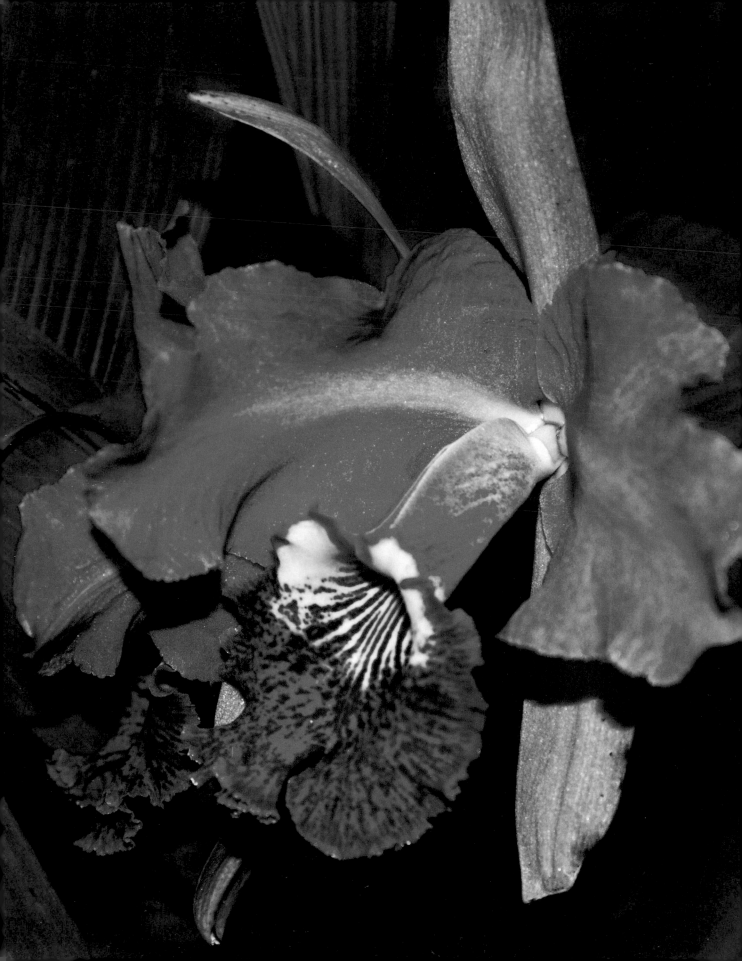

2

Choosing Your Equipment

*Y*ou may already own a digital SLR camera. Or perhaps you're in the market to get a digital SLR that's well suited for nature photography. If you fall into either category, you'll find useful information in this chapter. At the beginning of the chapter, I share information with you regarding the perfect nature photography camera. After choosing a camera, you need lenses to capture photographs of your prey. You may want an all-around lens that is suited for landscape and wildlife photography. Or maybe you want to photograph flowers or birds in flight. I show you how to choose these lenses and share information about specialty lenses. Then you need a place for your stuff, which of course is your camera bag. If you have a lot of stuff, you need a big camera bag. If you have a lot of stuff, but don't always take it with you, an additional, smaller camera bag may be also useful. I share the good, bad, and ugly about camera bags in the latter part of this chapter. Some photographers find it useful to have a second camera. I discuss this topic as well in this chapter.

Choosing the Perfect Nature Photography Camera

The title of this section is a tad misleading. There really is no perfect camera for nature photography. There is, however, a perfect camera for *you*. Your perfect camera is easy to handle, has the options you need, and fits your budget. A digital SLR with interchangeable lenses gives you complete control over your photography. You can choose the lens that best suits the type of nature photography you enjoy most. A digital SLR has sophisticated controls for controlling depth of field and freezing action. The fact that you can use sophisticated lenses with a digital SLR, in addition to the camera having a larger sensor than point-and-shoot cameras, ensures you get higher quality images than possible when photographing with a point-and-shoot camera. You can, however, still use a

point-and-shoot camera to shoot nature photography. In the upcoming sections, I give you pointers for choosing the perfect camera for nature photography.

Photographing nature with a digital SLR

Digital cameras come in many flavors. For nature photography, a digital SLR is preferable. You can change lenses with a digital SLR (see Figure 2-1). If your goal is to photograph a red-shouldered hawk, but he's not in his usual spot, you can change to a macro lens and photograph wildflowers. Then you can switch to your telephoto when the hawk returns. When you consider the fact that a digital SLR lens is bigger than most point-and-shoot cameras, you understand why you get higher quality images with a digital SLR. Digital SLRs also have larger sensors, which produce higher quality images.

Figure 2-1: A digital SLR is the preferred choice for nature photography.

There are lots of digital SLRs with myriad features. Canon, Nikon, Olympus, Pentax, and Sony all manufacture great cameras. The camera you choose should have the following options:

- **Shooting modes:** Most digital cameras give you the option to manually set exposure or to expose the scene based on the aperture (Aperture Priority mode) or shutter speed (Shutter Priority mode) you choose.

- **Exposure compensation:** This option lets you increase or decrease the exposure from what is automatically metered by the camera. Use exposure compensation if the resulting image is too dark or too light.

- **Histogram:** This option displays a graph on your LCD monitor that lets you judge whether the exposure is correct.

- **Maximum shutter speed of 1/2000 of a second or faster:** A fast shutter speed gives you the power to stop action.

- **RAW file format:** The option to shoot RAW images gives you complete control over the final outcome of the image while processing the photo.

- **Multiple drive modes:** Get a camera that takes one picture with each press of the shutter button and that also has a continuous drive mode. The latter keeps taking pictures as long as you hold the shutter button down. It's a bonus if the camera has a fast drive mode that can capture six to nine frames per second.

- **Auto-exposure lock:** This feature enables you to lock exposure to a specific part of the scene instead of metering exposure based on the center of the frame. This option is useful when you have a dynamic range that is more than the camera can handle, such as a sunset. With auto-exposure lock, you point the camera at the part of the scene that you want to be perfectly exposed, press a button, and then move the camera to get the desired composition.

- **Self-timer:** This feature delays the shutter actuation for a given period of time. Many cameras have two intervals for delays: 2 seconds and 10 seconds. The self-timer has many uses and is discussed when applicable in the book.

The following options are not necessary, but useful:

- **Depth of field preview:** This is usually a button on the side of the camera that when pressed stops the lens down to the selected f-stop. This lets you analyze the depth of field you'll get with the current settings.

- **Custom settings:** A camera with custom settings gives you the option to modify which functions a button performs and to enable other options like long exposure noise reduction, mirror lock-up, and highlight. The custom settings are too numerous to list here.

- **Register camera settings:** This feature lets you save the current camera settings. This option is useful when you use specific camera settings for specific types of picture-shooting tasks. For example, if you use a menu option like locking the mirror for long exposures, you can register this menu option and any other settings. You can then call up these settings when you need them by using the camera dial or menu option. The manner in which the registered settings are recalled and used differ depending on the camera manufacturer and, in some instances, on the camera model.

- **Built-in flash:** This is useful when you need to add a little light to a scene. Built-in flash is not very powerful, but it can be useful when you're photographing small objects like flowers. If the camera you're buying has built-in flash, flash exposure compensation is very useful. This lets you increase or decrease the power of the flash. Another useful option is if the camera can control external flash units through a menu command.

- **Dual memory cards:** This feature lets you take pictures with two memory cards in the camera at the same time. The options for dual memory cards differ with each camera manufacturer that offers the option.

- **Live View:** This feature enables you to compose images using the LCD monitor. This option locks the mirror up, and you view the scene through the sensor. Live View is useful when shooting close-ups.

 The only drawback to Live View is that when it is enabled, some cameras take longer to focus than when you compose the scene through the viewfinder.

- **Video recording:** The capability to record video of your nature photography expeditions is yet another way to create a lasting memory. If you intend to record a lot of video, consider purchasing a camera that will record HD (high-definition) video with dimensions of 1920 x 1080 or 1280 x 720. Having multiple frame rates of 24 fps (frames per second), 25 fps, 30 fps, and 60 fps is also a useful option.

- **Custom menu:** If you purchase a camera with this option, you can save your most frequently used menu options to a custom menu. The capability to create a custom menu makes it easy to find a frequently used menu command quickly, thereby saving you time.

- **Self-cleaning sensor:** Dust on a digital SLR sensor is a fact of life unless you change lenses in a hermetically sealed room. This option vibrates the camera sensor when you turn the camera on and off, which shakes any loose dust off the sensor.

✏ **Two image formats:** If you purchase a camera that records images in the RAW format, the camera may have the option to record RAW and JPEG images simultaneously. This option is useful if you need to deliver processed images quickly. For example, you can post the JPEG images in an online gallery for client review, and then process RAW images that friends or clients choose for print.

✏ **High-speed continuous shooting:** The option to capture six to eight frames per second is useful when you're photographing wildlife on the move or birds in flight.

Also consider a couple of issues related to your camera's sensor:

✏ **Sensor size:** If you shoot landscapes, a full-frame sensor is extremely useful because it captures more of the scene with any focal length. Only a handful of digital SLRs have full-frame sensors. The term *full frame* is used to indicate that the sensor is the same size as a frame of 35mm film. The other option is known as a *cropped frame* sensor, which is smaller than a frame of 35mm film. These sensors capture less of the scene than a full-frame sensor, which in effect increases the range of a telephoto lens.

The amount by which a sensor increases the range is discussed in the upcoming "What's my focal length multiplier?" section of this chapter.

✏ **Digital noise and ISO settings:** Cameras with smaller sensors have more circuitry packed on a smaller surface area. That increases the possibility that the camera will show more digital noise in images than a camera with a larger sensor using the same exposure settings. The amount of visible noise increases as you increase the camera sensor's sensitivity to light by increasing the ISO setting. A camera with a full-frame sensor exhibits low or very little digital noise at ISO 1000, while a camera with a smaller sensor will show digital noise at settings as low as ISO 400.

Although the information in this section gives you an idea of the things you should look for when purchasing a digital SLR camera, remember that the proof is in the pudding. If you look at specs on a website and order a camera, the camera may not feel comfortable in your hands, or the menu may not be easy to understand. People often ask me which camera I would recommend for their needs. I give them a couple of model numbers and then tell them to try out the camera at their local retail camera store or department store, such as Best Buy, that specializes in electronic equipment.

If you can't get a knowledgeable photographer to recommend a camera to you, go to the websites of major camera manufacturers like Canon, Nikon, Pentax, Sony, or Olympus. Jot down the model numbers of their latest cameras and then check out reviews of the cameras you're interested in. One website that offers authoritative camera reviews is www.dpreview.com.

Armed with the model numbers of cameras, visit your local camera retailer or a store that specializes in electronic equipment. Ask a sales rep to show you the camera you're interested in purchasing. If the rep knows the equipment, she'll start telling you about the features. After the rep says her piece, pick up the camera and try it out. Does it feel comfortable in your hands? Are the controls easy to find and use? That last question is important: Small camera controls are hard to use for people with medical challenges like arthritis. Another thing to look for is the menu. Is the menu easy to read and understand? If you're satisfied with the camera after trying it, you're ready to buy it.

Photographing nature with a point-and-shoot camera

Point-and-shoot cameras (see Figure 2-2) can be used to photograph nature. The type of nature photography you intend to pursue will dictate the type of camera you purchase. Point-and-shoot cameras have smaller sensors than digital SLRs and are more susceptible to generating digital noise that is noticeable in rendered images. The optics of point-and-shoot cameras are smaller and are not as good as digital SLR lenses. Depth of field is also an issue with point-and-shoot cameras. Because of the small sensor size, they have a much greater depth of field than digital SLRs. This is fine when photographing landscapes, but not when you're photographing something like a bird, when you'd rather have a shallow depth of field.

Figure 2-2: A good point-and-shoot camera can be used to photograph nature.

If you have your heart set on a point-and-shoot camera, you need one with a zoom lens with a range from wide-angle to telephoto. Remember, digital point-and-shoot cameras have much smaller sensors than digital SLRs. Because of the small sensor size, these cameras use a much smaller focal length but get the same field of view as a digital SLR lens. Most point-and-shoot camera manufacturers show the 35mm equivalent focal length. When you use a point-and-shoot camera to photograph landscapes, you need a camera with a lens that is the 35mm equivalent of 28mm or wider. Most point-and-shoot cameras feature a 3X or 4X optical zoom. This gives you a 35mm equivalent range from 28mm to 105mm or 140mm. This is a good range for photographing landscapes and relatively tame birds. However, this won't get you close enough when you need to maintain a safe distance between you and potentially dangerous wildlife. There are cameras that have 12X to 18X optical zoom and that will get you closer in these situations. (The resulting photo will make it seem as though you were closer anyway.) However, a point-and-shoot camera with that large of a focal length range may not deliver images that are as sharp as images taken on cameras with a less optimistic focal length range, due to the amount of glass elements they're packaging in a relatively small area.

The best advice I can offer is to visit your local retailer or do some research online to find models that you may consider purchasing. Armed with that list, visit a camera review site such as www.dpreview.com. You may also find customer reviews at major camera retail sites like B&H Photo (www.bhphoto.com). After reading reviews, your list of candidates will be shorter. Then I recommend visiting a local camera retailer and trying one or two of the top candidates on your list. Just as I suggest earlier for people considering digital SLR cameras, note how the camera feels in your hands. Can you find all of the controls easily? Are the menus easy to read? If possible, take a couple of pictures and review the results on the camera LCD monitor.

Many point-and-shoot cameras offer digital zoom, which is designed to zoom in even farther than the optics are capable of. The problem with digital zoom is the camera crops to a smaller portion of the sensor and then enlarges the image to the standard size. As a result, the camera redraws pixels. This almost always results in image degradation and increases the noise. Digital zoom is not an acceptable option if you want sharp images.

The megapixel myth

Some people believe that the path to a good photograph is a camera that has a sensor that can capture a huge amount of megapixels. This is only partially true. Not all megapixels are created equal. If you remember back in the dark ages when photographers used film, there were different film formats. Each film format designated the size of the negative. Negative sizes ran the gamut from the miniscule 110 film, which was used in miniature cameras and had a negative about the size of your thumbnail, to large format cameras with negatives as large as 8 x 10 inches. When you start with a larger negative, you can create a larger size print.

The same is true of digital cameras. The miniscule point-and-shoot cameras (which can fit in your shirt pocket) have small sensors. Digital SLR cameras have larger sensors, full-frame dSLRs have even larger sensors, and medium-format digital cameras have even bigger sensors. If you cram a lot of pixels onto a small sensor and put the same number of pixels on a larger sensor, the pixels on the larger sensor are bigger. All other things equal, you end up with better image quality when you enlarge images captured with the camera that has the larger sensor.

When you have a camera with a smaller sensor, a lot of circuitry is confined to a very small space. As a result, the smaller sensor is likely to create more digital noise than you'd find on an image created with a camera with a bigger sensor. The increase in digital noise becomes more apparent when you increase the sensor's sensitivity to light by increasing the ISO. At low ISO settings, most point-and-shoot cameras yield acceptable pictures. When you push the envelope and take photographs in low light situations at higher ISO ratings, though, digital noise becomes apparent, especially in the shadow areas of the image. The digital noise may not be noticeable when you create a 4 x 6 print of the image; when you create an 8 x 10 print of the same image, however, the digital noise will be visible.

Focal lengths and sensors that are not full frame

There's one important thing to remember about focal lengths: They don't act the same as they did on 35mm film cameras if you have a sensor that is smaller than a 35mm frame of film. If you have a camera with a smaller sensor, your camera doesn't capture as much of the scene in front of you as

a 35mm film camera. In essence, the focal length crops to a smaller area of the scene, which is the same as zooming in. This is great when you're photographing wildlife. You can get closer to your subject without having to break the bank on an expensive telephoto lens with a long focal length. However, when you shoot landscapes, you're at a disadvantage if you own a camera with a sensor that is smaller than a frame of 35mm film. A full-frame sensor has dimensions of 36mm x 24mm. If your sensor is smaller than that, you need to calculate your *focal length multiplier* and apply it to the focal length of the lens you're using to get the 35mm equivalent focal length. You may also see the focal length multiplier referred to as the *crop factor*.

What's my focal length multiplier?

If you own a camera with a sensor smaller than a frame of 35mm film (36mm x 24mm), the sensor records only part of what the lens sees. The net result is that the lens acts like a longer focal length would on a full-frame sensor. The focal length multiplier depends on the size of your camera's sensor in relation to a full-frame sensor. The focal length multiplier generally falls in a range from 1.3 to 2.0.

If you slap a lens with a 50mm focal length on a camera with a focal length multiplier of 1.6, the resulting 35mm equivalent is 80mm (50×1.6). If you put the same lens on a camera with a focal length multiplier of 1.5, you end up with a 35mm equivalent of 75mm (50×1.5).

Knowing your camera's focal length multiplier is important when choosing accessory lenses. Most Canon cameras that don't have full-frame sensors have a focal length multiplier of 1.6, with the exception of the Canon EOS-1D Mark IV. That model has a focal length multiplier of 1.3. Nikon cameras without full-frame sensors have a focal length multiplier of 1.5.

If you can't find the focal length multiplier for your camera, you can easily calculate it. For example, the sensor on a Canon EOS 7D is 22.3mm x 14.9mm. To find the focal length multiplier for the camera, divide the width or height of a 35mm frame of film by the width or height of your camera sensor. In the case of the EOS 7D, 36 divided by 22.3 equals 1.614, which rounded off is 1.6. The focal length multiplier for that camera is 1.6.

Getting the Right Lenses for Your Camera

A lens is a round barrel with several pieces of glass inside. The glass guides the light to the sensor. The quality of the glass used in the lens and other factors determine the quality of the image you get from the lens. Lenses come in a wide variety of focal lengths. They also come in a wide variety of aperture ranges. A lens that has a large aperture with an f-stop value of f/2.8 or lower is considered a *fast lens*. It's capable of taking pictures in low light at fairly fast shutter speeds. A fast lens also creates an image with a deliciously shallow depth of field.

This is one consideration when purchasing lenses. Another factor to consider is the number of elements used to create the lens and the number of groups within which those elements lie. An element is a piece of glass. When you have more elements, you have a more sophisticated lens that, as a rule, will capture sharper images.

So how do you know a good lens from a mediocre lens from a bad lens? You do some research. You can find reviews of popular lenses at `www.dpreview.com/lensreviews`.

When you buy your digital SLR, you may be tempted to buy a kit. A digital SLR kit includes the camera body and a lens. The "kit" lens usually includes a wide-angle focal length (usually 18mm) and a normal (55mm) or medium telephoto (105mm) focal length. A kit lens usually isn't fast (a lens with an aperture that has an f-stop of f/2.8 or lower). It's also not the sharpest optic your camera manufacturer creates either. If possible, purchase the camera body only and purchase better lenses separately.

Prime versus zoom lenses

A prime lens has one focal length. If you want to get closer to or farther from your subject when you're using a prime lens, you have to use good old-fashioned *foot zoom.* (That's right; you have to take a few steps forward or back.) A telephoto lens has a range of focal lengths. Some manufacturers create zoom lenses that try to capture everything from the grand expanse of the Grand Canyon to the hummingbird flitting around your bird feeder.

Some zoom lenses that have a focal length range from wide angle (28mm) to long telephoto (300mm) are convenient but not as sharp at either extreme of the focal length or aperture range when compared to zoom lenses with a more conservative focal length range. A lens with a large focal length range is often referred to as a "vacation lens."

Choosing lenses for wildlife photography

The focal length you need to photograph wildlife depends on your prey. If you're going to photograph birds that are fairly tame, you can get by with a focal length of 150mm to 200mm. If your goal is to photograph wildlife like deer, bobcats, or grizzly bears, you're going to need more reach — a lens with a focal length of 300mm or greater. These lenses are expensive, but if you intend to pursue wildlife photography, they are well worth the investment.

When you're looking for lenses, you may find a breed of lens known as a *mirror reflex* lens. These lenses have a fixed aperture and are shorter than conventional zoom lenses with the same focal length. Mirror reflex lenses are also less expensive because they don't use as much glass as a conventional telephoto lens. Keep in mind that the quality of a mirror reflex lens does not compare to a conventional lens and is not suitable for serious wildlife photography.

A telephoto zoom lens can be a different breed of cat. The majority of telephoto lenses have different maximum apertures depending on the focal length. For example, a Nikkor (Nikon lens) 70–300 AF-S zoom lens has a minimum f-stop value of f/4.5 at 70mm and a minimum f-stop value of f/5.6 at 300mm. You can also purchase a telephoto zoom lens that has a fixed minimum f/stop value across the entire focal length range. These are more expensive than a lens with a variable minimum f-stop value, but they are worth considering if you want a zoom lens that has the same maximum aperture at all focal lengths.

Telephoto lenses are expensive, especially when you get into the longer focal lengths. You can, however, purchase a device known as a *tele-extender* that increases the range of your telephoto lens. You attach a tele-extender to your camera in the same manner as a standard lens, and then attach your lens to the tele-extender. Tele-extenders are available in the following strengths: 1.4, 1.5, and 2.0. Multiply the power of the tele-extender by the focal length of the lens you're using it with to determine the combined focal length. The tele-extender also decreases the aperture by the same amount as it increases the focal length. For example, if you add a 2.0X tele-extender to a 200mm lens with a maximum aperture of f/4.0, you end up with a 400mm f/8.0 lens. If you decide to invest in a tele-extender, get the best you can afford to minimize the loss of image quality that is inevitable when you use a tele-extender.

You can purchase lenses that are made by the same company that manu-factured your camera or purchase third-party lenses. When you decide to purchase any lens, go online and look for reviews. The old adage that you get what you pay for applies here. Camera manufacturers and third-party lens manufacturers have prime lenses that have more elements and better glass than their less expensive brethren. And remember, if the price seems too good to be true, it probably is. There are, however, some excellent third-party lens manufacturers if you're on a budget. Tamron and Sigma have some excellent lenses in their lineups. The best way to find out whether a third-party lens will live up to your standards and expectations is to find an authoritative review of the lens in a magazine or on the web.

Choosing a macro lens for close-up photography

When you want to get close, really close, nothing beats a macro lens. Macro lenses come in a variety of focal lengths. Prime macro lenses have a range from 50mm to 200mm. The longer focal lengths are useful when you want to photograph small subjects like insects from a distance. The shorter focal lengths are great for close-ups of subjects like flowers.

You can also purchase a zoom lens with macro capabilities. A macro zoom lens has a shorter minimum focusing distance than a regular zoom lens with the same focal lengths.

When you photograph objects with a macro lens, you've got a very shallow depth of field at any f-stop. This is because you're much closer to your sub-ject. Focus can also be an issue with macro lenses because of your proximity to the subject. When you're looking for a macro lens, the best alternative, if possible, is to test the lens on your camera. Photograph something like a flower. This will tell you if the lens has any focusing issues.

If you intend to do a lot of macro photography, your best option is a dedicated prime macro lens. With so many macro lenses available, it's impossible to recommend one. Check out the specifications of lenses that pique your curiosity. If one focuses closer than another with the same focal length, see if you can find a review for the lens. You may also find customer reviews for lenses at online photography stores like Adorama (www.adorama.com) and B&H Photo Video (www.bhphotovideo.com).

If your budget prohibits you from purchasing a macro lens, or if you just want to dip your feet into the shallow end of the macro pool, you can purchase extension tubes at a fraction of the cost of a macro lens. An extension tube attaches to the camera body and then you attach a lens to the extension tube. The combination lets you focus at a closer distance, thereby filling a large portion, or the entire frame, with a small object. You won't get the same quality pictures you'd get with a true macro lens, but it beats the alternative, which is no macro photography.

Using specialty lenses

If you drew outside of the lines as a kid, and still like to draw outside of the lines, specialty lenses may be just what you're looking for. Specialty lenses give you a different look, or a different perspective. The following sections describe some cool alternatives to traditional lenses.

Fish-eye lenses

A *fish-eye lens* enables you to capture a huge amount of what's in front of your camera. Many fish-eye lenses have a 180-degree field of vision. Some fish-eye lenses give you a circular image surrounded by black, while other fish-eye lenses give you the wide view with a frame-filling image. Fish-eye lenses are not without their quirks. Vertical lines at the side of the frame will bend inward, and horizontal lines at the top or bottom of the image will bend as well. If you tilt the lens, you'll get a curved horizon line. Objects that are close to the camera are also distorted when you use a fish-eye lens. There are plug-ins available that are used to correct these quirks, but some photographers leave them in for effect. Used with discretion, you can get some very interesting photographs with a fish-eye lens (see Figure 2-3).

Lensbaby lenses

The Lensbaby was invented by Craig Strong, a wedding photographer and photojournalist who wanted to achieve the dreamy look photographers got with Diana or Holga film cameras on digital cameras. A Lensbaby lens has less glass than a traditional lens, and the optic glass is curved to achieve a sweet spot of focus surrounded by blur.

The size aperture you use with the lens determines the size of the sweet spot of focus. To change an aperture on a Lensbaby, you remove an aperture disk with the magnetic aperture disc removal tool and then insert the desired disk. A larger aperture disk (small f-stop number) gives you a small sweet spot, and a smaller aperture (larger f-stop number) gives you a larger sweet spot of focus.

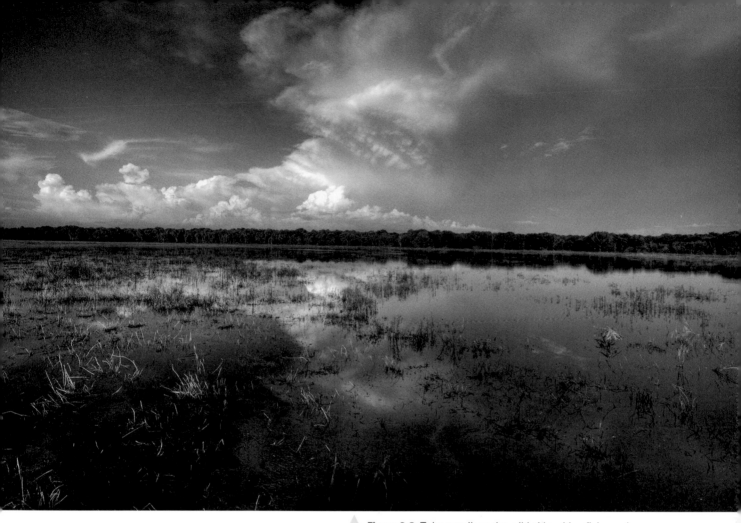

▲ **Figure 2-3:** Take a walk on the wild side with a fish-eye lens.

Lensbaby makes four lens bodies: Composer, Control Freak, Muse, and Scout. The lenses feature the optic swap system, which enables you to change lens inserts to get a different look. The following optics are available: Plastic Optic, Single Glass Optic, Double Glass Optic, Fisheye Optic, and Zone Plate/ Pinhole optic. The Lensbaby is available for five lens mounts: Canon EF, Nikon F, Olympus, Pentax K, and Sony Alpha.

Lensbaby also makes a product called the Composer with Tilt Transformer for Micro 4/3 and Sony NEX cameras. This is two products in one — a Composer for use on these mirrorless cameras, as well as a tilt adapter that accepts Nikon lenses. The Lensbaby is great for landscapes, flowers (see Figure 2-4), and close-up photography with the macro extensions. Prices range from $100 to $250 for Lensbaby lenses, depending on the model.

The easiest lenses to use are the Composer and the Scout. The Composer ships with the Double Optic, and the Scout ships with the Fisheye Optic. The other optics can be used in both lenses. The Composer has a ball joint between the lens mount and the optic, and a focusing ring. You focus the lens by turning the focus barrel. After the lens is in focus, you move the outer portion of the lens left, right, up, or down to move the sweet spot of focus. The Scout does not have the capability to move the sweet spot. You achieve focus by turning the focus barrel.

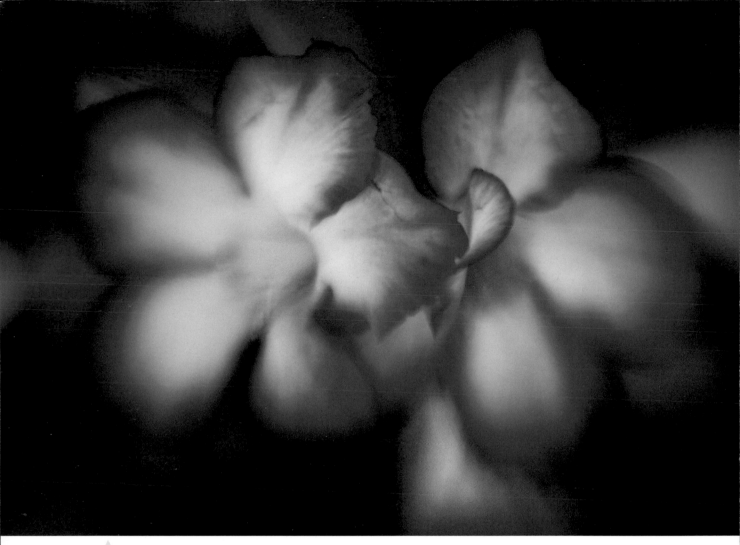

▲ **Figure 2- 4:** Lensbaby gives you soft dreamy images with a sweet spot of focus.

Accessorizing Your Camera

You've got a camera and a couple of lenses. So what's next? Well, you've got to have a place to store your stuff, and you may want to use filters to get special effects in the camera. A tripod is also a useful accessory for an avid nature photographer. In fact, many nature photographers, including your friendly author, think that tripods are a necessity. In the following sections, I discuss some essential accessories and others you may want to consider.

Choosing a camera bag

When you get your first digital SLR, you won't need a big camera bag, but it's always good to think ahead. A camera bag is a place for your stuff. It protects the gear and is a place to store your equipment when you aren't using it. It should also be practical.

A popular type of camera bag is the sling bag. You wear the camera bag over one shoulder. When you need a piece of equipment, you sling the bag to the front, open the bag, and grab the equipment you need. Think Tank Photo (www.thinktankphoto.com) has taken this concept one step further and

invented a bag that can be slung over either shoulder (see Figure 2-5). When one shoulder gets tired, take the bag off, move the padded strap along the rails and then sling it over the other shoulder.

Many photographers own more than one camera bag. One bag is used for short trips with a minimum amount of gear and some personal items. Lowepro has a bag known as the Versapack that is ideal for this purpose. The top part of the bag is used to store personal gear like a jacket, cellphone, and a snack or two. The bottom part of the bag is used to store gear and can be slung off your shoulder to quickly access your equipment. The other type of bag, such as the Lowepro Pro Runner 300 AW (see Figure 2-6), is used to store everything and the kitchen sink. This bag is used for extended hikes, and it also functions as carry-on luggage for all your camera gear. A big bag like this should have padded strips so that you can wear it comfortably for long periods. It also should be fully adjustable to fit your torso.

The previously mentioned bags are just the tip of the iceberg when it comes to camera bags. Here are some additional tips for finding the perfect bag for your digital gear:

- **Get a bag that's big enough for the gear you now own and also any additional equipment you anticipate buying in the near future.**

- **Purchase a bag that's comfortable.** Make sure you try the bag on for size in the camera store. Place your camera and any accessories you currently own in the bag and put it over your shoulder. If it isn't comfortable, ask the salesperson to show you a different bag. There's nothing worse than a chafed neck after a daylong photography adventure.

Figure 2-5: Sling bags are popular with nature photographers.

- **Make sure the bag has enough pockets for your stuff.** The bag should have a place where you can park extra memory cards, spare batteries, and other accessories. It should also have removable inserts that enable you to customize the bag to fit your camera and lenses.

- **Make sure the bag is sturdy enough to protect your gear.** If you load up a bag that isn't constructed well, it may fail. Sometimes it pays to spend a little more for a bag that will stand the test of time.

Figure 2-6: A big camera bag is a place for all your stuff.

- **Make sure the bag is made so that you can get to your gear quickly.** If you're like me, you don't enjoy searching for a piece of gear that you need right now. Fumbling for a piece of equipment as your digital Kodak moment disappears is frustrating. If you've got an accessible bag, and your gear is neatly arranged, you'll be able to quickly find the right piece of gear when you need it.

- **Divide your equipment into manageable portions.** If you have a lot of gear, consider purchasing two items: a hard-shell case that's big enough for all of your equipment, and a soft bag to use for day trips.

- **Prepare for the elements.** If it rains a lot where you live, purchase a water-resistant camera bag or one with a built-in rain cover.

There are other types of camera bags that may be more suitable for you. Think Tank Photo has what is known as a *belt pack*. The bag (Speed Freak V2.0) has a sturdy belt to which the bag is attached. The pack is worn in front or to the side of your body. You gain access to your equipment from the zipper on the top of the bag or the main zipper. The bag also has a strap that you wear over your shoulder to evenly distribute the weight across your chest. I own one and have used it extensively on long hikes with a lot of gear packed inside. It is by far the most comfortable bag I've ever used. You can attach auxiliary bags to the belt, such as a lens-changing bag and a small bag to carry batteries and memory cards. For more information, visit this site: www.thinktankphoto. com/products/speed-freak-v2.aspx.

Using filters

If you were really into 35mm film photography, you had a camera bag full of goodies, including filters. Filters are great in digital photography, too. You use them to create special effects and manipulate the light coming into your camera. When you want to use a filter, you screw it into the accessory threads on the end of your lens. Here's a list of filters that are useful for photography:

- **Skylight filter:** A skylight filter slightly warms the colors in your image. Many photographers permanently affix a skylight filter to every lens they own because the filter also protects the lens.

- **Polarizing filter:** This filter deepens the blue hues in the sky and makes clouds look more prominent. It also reduces or eliminates glare, a useful

option if light is reflecting off the lake you're photographing. You rotate the outer ring of the polarizing filter until you get the effect you're after. Polarizing filters work best when you're facing 90 degrees from the sun.

✐ **Neutral density filters:** Neutral density filters come in different strengths and reduce the amount of light entering the camera, which enables you to shoot at lower f-stops in bright lighting conditions. A lower f-stop gives you a smaller depth of field. A smaller depth of field is ideal for certain aspects of nature photography, such as shooting a portrait of a majestic great blue heron. Neutral density filters are also useful when you're photographing waterfalls.

✐ **Graduated neutral density filters:** A graduated neutral density filter is useful when one part of your scene is brighter than the other. If you're photographing a scene with a sky full of puffy white clouds, the camera does its best to produce an acceptable image. However, the clouds probably won't have a lot of detail and will look brighter than they actually are. A graduated neutral density filter is dark at the top, which means less light reaches the top part of the sensor and gradually becomes clear in the middle of the filter. This gives you a realistic-looking scene with nice detail in the clouds.

There's also a reverse-graduated filter, which is clear at the top and dark in the middle. This is useful for photographing sunsets, where the camera (sans the filter) almost always renders the sun as an orange blob with absolutely no detail.

For more information on graduated neutral density filters, visit `www.singh-ray.com/grndgrads.html`. For more information on reverse graduated filters, visit `www.singh-ray.com/reversegrads.html`.

Lenses come with different accessory thread sizes. Purchase filters for the lens you own with the largest accessory thread size, and then purchase step-up rings that enable you to use the large filters on all of your lenses. A step-up ring has a small inner ring with male threads to attach to the lens and a larger outer ring with female threads into which you insert the filter. When you attach a step-up ring to a lens, and then add a filter, the standard lens cap won't fit, which means you'll have to take off the filter and step-up ring when you change lenses and put the lens back in the camera bag. To solve this problem, purchase a small filter pouch you can store inside your camera bag. Take off the filter and stow it in the pouch before you take the lens off the camera.

Steadying the camera with a tripod

Holding the camera steady and not shooting below a shutter speed that's the reciprocal of the focal length you're using results in a sharp image. For example, if you're using a lens with a focal length of 100mm, the reciprocal is 1/100, which means you should shoot with a shutter speed that is equal to or faster than 1/100 of a second. If you shoot with a digital SLR camera that has image stabilization (or use a lens with image stabilization), you can shoot a couple of stops slower. But when you're shooting in very low light conditions or shooting portraits with diffused window light, your only solutions are to crank up the ISO or put the camera on a tripod. A tripod is always the better solution, especially when you're shooting images with a sensor that is smaller than a frame of 35mm film. If you increase the ISO on a camera with a small sensor, you add digital noise to the image.

Here are some things to consider when purchasing a tripod:

- **How much weight will the tripod support?** The tripod needs to support the weight of your camera body and your heaviest lens. To be on the safe side, include a fudge factor of 50 percent. You never know when a manufacturer is being optimistic with data. The fudge factor will also accommodate a heavier camera if you upgrade or if you add a heavier lens to your digital photography arsenal.

- **How heavy is the tripod?** If you use the tripod at home only, weight isn't a factor. However, if you're going to be lugging it around on vacation, consider one of the low-weight tripods or consider a tripod like the Joby GorillaPod, which is versatile and lightweight. Its unique design lets you use it like a regular tripod or bend the legs to wrap the tripod around an object such as a tree limb or a pipe. (See Figure 2-7.) GorillaPods are also easy to fit in luggage when you go on vacation.

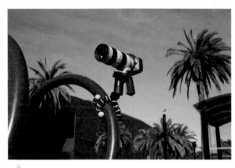

Figure 2-7: The Joby GorillaPod is an excellent alternative to a large cumbersome tripod.

- **Are you using the tripod outdoors?** If so, look for a tripod that has retractable rubber feet that reveal a sharp, stainless steel spike. Twist the rubber feet to reveal the spikes and then push the tripod legs into the ground. The spikes anchor the tripod. Note that some manufacturers have interchangeable tripod feet. You remove the rubber feet with a tool, such as a hex wrench, and then attach the spiked feet.

- **Does the tripod have a spirit level?** This device makes it possible for you to level the tripod, which means you'll get level horizon lines in your photos.

- **Does the tripod have a quick-release platform on top of the head?** This option is handy when you're attaching a camera to a tripod. Instead of attaching the camera to the head and the tripod, you attach the tripod to the platform — much easier to do.

- **What is the maximum extended length of the tripod?** Make sure it's tall enough for any scenario you're likely to encounter.

- **What is the folded length of the tripod?** This factor is important if you intend to travel with your tripod. If this is the case, make sure it can fit in your luggage.

- **Is it easy to lock and unlock the legs?** The better tripods have a twist lock or a lever.

TIP

Purchase a carrying case for your tripod. Sling the carrying case with the tripod over your shoulder when you're shooting on location and moving around. It's much easier than lugging the tripod around without a case. The alternative is to purchase a camera bag to which you can easily attach the tripod.

There are lots of tripod manufacturers. In fact, many tripod manufacturers are creating high-tech tripods made of lightweight materials. Such tripods

are an ideal, albeit expensive, alternative if you embrace a technique such as night photography that requires you to carry a tripod. Look at tripods and try the controls before you buy one. Many superstores have camera departments with tripods at reasonable prices.

Protecting the camera

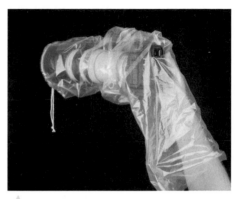

Figure 2-8: Protect your camera when the weather turns bad.

The camera case protects the camera when it's nestled safely inside your camera bag. But what happens when the weather turns bad and you still want to take pictures? Digital cameras have sensitive circuitry that should not get wet. Think oil and water. I used to protect my camera with a shower cap until I found a product that provides excellent protection for my camera and is also inexpensive. The Op/Tech Rainsleeve (see Figure 2-8) is made of heavy-duty plastic. It comes with a drawstring you use to snug the sleeve around the barrel of the lens you're using. It also has a hole over which you slip the viewfinder shield. The sleeve offers adequate protection. As of this writing, you can purchase a pack of two Rainsleeves for $5.99. For more information, visit www.outdoorphotogear.com/store/op-tech-rainsleeve-18.html.

Getting a comfortable camera strap

Figure 2-9: Purchase a comfortable camera strap.

The strap that comes with most cameras is very thin and has the camera manufacturer's name emblazoned on it in big bold letters. A thin camera strap digs into your neck and becomes quite uncomfortable if you have a camera around your neck for several hours. For comfort and convenience, consider purchasing a wide padded camera strap that will be comfortable when you carry your camera and a long telephoto lens. A company named BlackRapid has invented a unique camera strap that attaches to the tripod mount on the bottom of your camera. The strap slings over your left shoulder, which positions the camera by your side, ready for action. The strap takes the pressure off your neck and is more comfortable than conventional camera straps, especially when you're traipsing in the wilderness. The company has a model that is tailored

for a woman's physique (see Figure 2-9) and another model that has pockets for memory cards and other small accessories. For more information, visit www.blackrapid.com.

Cleaning the camera

Take care of your camera, and it will look like new even after years of use. Clean the camera body with a soft cloth. If the camera is ever exposed to salt spray, wet a soft cloth and wring it almost dry. Wipe it over the camera body, being careful not to dampen any electrical ports, the battery door, or the memory card door. If you have any embedded debris, gently brush the camera body with a soft toothbrush.

You should also clean your lenses on a regular basis. The first step in cleaning your lens is to blow off any loose debris with a blower. Then use a soft brush that is designed for lens cleaning to whisk off any additional particles. The last step is to wipe the lens with a microfiber cloth.

One other part of your dSLR camera needs attention: the sensor. Sensor dust is a fact of life because you take lenses off the camera. The short time that a lens is off the camera before replacing it with another leaves the sensor exposed to the elements. Dust can find its way to your sensor. Sensor dust shows up as black dots on your images. Most new digital cameras have built-in sensor cleaning, but that doesn't get all the dust out.

The only way to make sure your sensor is squeaky clean is to have it cleaned professionally or to use commercial products to clean your sensor. I've successfully used many of the products offered by VisibleDust (www.visibledust.com; see Figure 2-10). These products are not cheap, but they do keep the camera sensor clean.

Figure 2-10: Keep your camera sensor clean.
Image courtesy of VisibleDust

TIP Focus manually to the closest distance of which your lens is capable and then take a picture of a clear blue sky with your smallest aperture. Any dust will show up as dark spots on the image. Lots of dark spots means it's time to clean the sensor.

Choosing other accessories

When you buy your digital SLR, you get a camera, a battery, and a lens. That's enough to get you by when you're shooting close to home, but what happens when you take a daylong journey in search of lovely landscapes and animals to photograph? Or maybe you're going on vacation. Well, the battery charge dwindles as you photograph, and you fill up the memory card pretty

quickly. You also have to maintain your equipment. Here are some additional accessories you should consider:

- **An extra battery:** I always keep a spare battery fully charged in my camera bag for each camera. If you buy a third-party battery, make sure you aren't voiding your camera warranty by using it.

- **Extra memory cards:** Memory cards come in different capacities and different data transfer rates. High-speed memory cards decrease the amount of time it takes the memory card to accept the data from your camera. That means your camera's memory buffer won't fill up as quickly when you hold the shutter button to capture a sequence of images. High-speed memory cards are expensive, but well worth the money if you like to photograph sports or other genres of photography where you use continuous drive mode.

Some manufacturers include data recovery software with their high-speed cards. Data recovery software is handy if a card should ever become corrupt, which means you won't be able to download the images to the computer. The data recovery software may make it possible to recover the corrupt data.

- **A lens-cleaning brush:** A lens-cleaning brush has soft hairs that you use to whisk dust off the lens.

- **A lens-cleaning cloth:** A good microfiber lens-cleaning cloth is used to clean any smudges off the camera lens. Use the cloth after you use the brush.

- **A memory card holder:** When you have lots of memory cards, a memory card holder is a great way to keep everything organized. The holder I use has two sides. I put my empty cards on one side, which has a gray background. When I fill a card, I place it in the other side of the memory card holder, which has an orange background.

Choosing a Second Camera

If you own a digital SLR and a case full of lenses, you're probably reluctant to carry the camera with you at all times. Possibly, potential theft plays a role. After all, a lot of people out there would break into a car to steal an expensive camera. One solution is to purchase a cheaper second camera. To address this problem, I bought a sophisticated point-and-shoot camera that has many of the same features as my digital SLR. The same company that made my digital SLR built my point-and-shoot.

When you're shopping for a second camera, here are some things to consider:

- **Does the camera enable you to capture images in a RAW format that is supported by your image-editing application?** It isn't essential to capture your images in the RAW format, but this format gives you more flexibility when you process your images.

- **Is the camera menu similar to that of your digital SLR?** There's no sense in having to retrain yourself every time you pick up your second camera.

- **Does the camera take the same type of memory card as your primary camera?** This saves you the expense of purchasing different types of memory cards.

3

Mastering Your Equipment

Your digital camera is a mechanical marvel. When you first pick up a digital camera and look at all the dials and buttons, you may feel a bit intimidated. I know I was. And then I looked at the menus. Oh my. But I persevered and made the transition from film to digital. And quite frankly, I'm glad I did. If you're new to digital photography, this chapter is designed to flatten your learning curve. In this chapter, I show you some basic things about digital cameras, such as changing settings and changing lenses. I also show you how to flash your subjects, which, of course, is quite an illuminating subject. Another topic of discussion is choosing the right shooting mode for your subject. Yes, that's right; you're going to take the camera off automatic mode. Other topics of discussion are shooting blur-free pictures, using Live View, and shooting video with your digital camera. This chapter is not designed to be a replacement for your camera manual, but I guarantee it will be more interesting to read and will not put you to sleep.

Dials and Buttons and Modes, Oh My!

The shiny box with which you take pictures has lots of dials and buttons. Your first step is to get familiar with the lay of the land, so to speak. You need to know where the buttons and dials used to access camera features are. Then you need to understand what these dials and buttons do. I also discuss changing settings, using your camera menu, and so on.

Getting to know your camera

The quickest way to get great nature photographs is to know your camera like the back of your hand. If you have to think twice about which button to use to change a setting, you may lose a great picture. Let's face it: A majestic eagle will not stop in midair while you fiddle with your camera. I believe the easiest way to get familiar with a new camera is to use it. I always spend a few hours getting to know where the controls of the camera are. If I'm not familiar with what a control does, I pick up the camera manual. I refer to several controls in this chapter. I suggest you have your camera by your side when you read the following sections. Locate and use the control I mention. Depending on the control you use, you see the changes in your viewfinder. Buttons and dials are good things to know; they are your road map to changing to the right settings for compelling nature photographs.

Don't let your camera gather dust in the closet. Use it often, and you'll master the controls until the location of each control and what it is used for become second nature to you. When you transcend the technology of your camera, you can unleash your inner artist and create beautiful images.

Changing settings

Your camera has many settings. You have settings to change shooting mode, ISO settings, and so on. Most digital cameras have a dial that you use to change shooting modes and lots of other switches. Figure 3-1 shows the top and back of a Canon EOS 7D.

To capture great images of your world, you need to know how to change the following settings:

Figure 3-1: Use dials and switches to get the desired settings.

- ✔ **Shooting mode:** The default shooting mode for most cameras is Automatic. You may also have a P (Programmed) setting, which in essence is Automatic on steroids. If your camera has a P mode, the camera automatically sets both the shutter speed and aperture. You can change either setting to suit the scene you're shooting or to suit your artistic vision, and the camera changes the other setting for a correctly exposed image. I discuss the shooting modes for nature photography in upcoming sections. Most cameras have the shooting mode on a dial.

- ✔ **Shutter speed/f-stop:** With most cameras, these settings are located on the same dial. Which setting is functional depends on the shooting mode you choose. If you shoot in Shutter Priority mode, you change the

shutter speed to the desired setting. If you shoot in Aperture Priority mode, you choose the desired f-stop. If you shoot in Program or Manual mode, the settings appear on different dials or, on some cameras, as options on menus.

- **ISO setting:** The ISO setting determines how sensitive your camera is to light. When the light gets dim, you have to increase the ISO setting to get a blur-free picture without a tripod. You also need to increase the ISO setting when the shutter speed is too slow to stop action or when you need to use a smaller aperture for a greater depth of field. Some cameras use a combination of button and dial to change the ISO setting, and other cameras have a menu command to change ISO.

- **Auto-focus mode:** The auto-focus mode you use depends on whether you're photographing a stationary object or one in motion. Some cameras use a combination of a button and dial to change auto-focus mode; other cameras use a menu command.

- **Drive mode:** When you shoot stationary objects, you use One-Shot drive mode. When you shoot a sequence of images, you shoot in continuous mode. Some cameras have these options as buttons, while others use menu commands.

- **Exposure compensation:** Use this option to increase or decrease the exposure to suit the current lighting conditions. On most cameras, you use a button and dial to increase or decrease the exposure.

- **Flash exposure compensation:** Use this setting to increase or decrease the power of the built-in flash. On most cameras, this is a menu setting. Your camera may also have a feature that controls supported auxiliary flash units. If this is the case, you can increase or decrease the power of auxiliary flash units.

Your camera has other buttons and features that are not associated with picture-taking settings, but are useful.

- **Info button:** Press this button to cycle through the types of information that can be displayed on the LCD monitor with your pictures. The amount of information you can display varies depending on the manufacturer of your camera. You can display exposure settings, a histogram, and a histogram for each color channel, as well as different combinations of information. You can also display the number of images you've photographed or display nothing but the image.

- **LCD monitor:** Your LCD monitor isn't really a control, but it functions like Mission Central. The LCD monitor displays images and camera settings and is also integral when changing settings through your camera menu.

- **Viewfinder diopter:** If your camera has a viewfinder diopter, you use it to adjust the viewfinder to compensate for your vision. With most cameras, you move a dial until the focus points in the viewfinder are crystal clear. If you take pictures with your glasses on, make sure you wear them when you adjust the diopter.

Using your camera menu

You perform many tasks with the camera menu. The amount of tasks you perform with the camera menu depends on the camera you own. Canon camera owners can adjust many settings, such as ISO, with a combination of buttons and dials. Nikon camera owners must rely a bit more heavily on the camera menu to change settings. In fact, Nikon has a Shooting Menu as part of the camera menu. In addition to using the camera menu to change certain settings, you also use camera menus to change image format, quality, and auto-exposure bracketing. On the left side of Figure 3-2 is a Nikon camera menu; a Canon camera menu is shown on the right.

Figure 3-2: A tale of two camera menus.

Navigating your camera menu is like working with a computer program. In fact, your camera processor is like a little computer. The amount of menu settings depends on the complexity of your camera. You access the camera menu by pressing the Menu button on the back of your camera. You use buttons and dials to scroll through the menus. When you find the menu option you want to change, you press an OK or Set button to make the change. Some cameras also have a Function button that is used, in addition to the menu, to change camera settings.

Many cameras give you the option to create a custom menu. This option lets you keep your frequently used menu items on one menu for easy retrieval.

Changing lenses

If you have a digital SLR, you change lenses based on your artistic vision and the subject or scene you're photographing. Changing lenses is simple: You push a button and twist the lens to remove it from the camera, align the lens you're going to use with a dot on the camera body, and twist it until it locks into place. With a Canon camera, you twist the lens counterclockwise to remove it, and you twist it clockwise to lock it into place. The direction in which you twist a lens on a Nikon camera is clockwise to remove it and counterclockwise to lock it into place. When you change lenses, make sure you have

the new lens aligned perfectly. It will lock into position with a gentle twist of the wrist. It you have to force the lens, it is not aligned properly. If you force a lens that is not aligned properly, you can damage the lens and the camera body.

Always turn the camera off before you change lenses. If you don't, the current running through the sensor can set up a charge and act like a dust magnet. Never change lenses when it's windy or when you're in a dusty environment. When confronted with these challenges, go inside a car or building to change lenses.

Introducing Flash Photography

You may be wondering why flash photography is included in a book about nature photography. As a rule, you rely on natural lighting for nature photography. However, you can use on-camera flash or an auxiliary flash unit to augment natural lighting.

About on-camera flash

Most digital cameras come with an on-camera flash (see Figure 3-3). The flash unit pops up when needed. You can also enable on-camera flash when you need to add a bit of light to a scene. This is known as *fill flash*. The light from on-camera flash is harsh. If you are able to get close enough to an animal to use on-camera flash effectively, you'll end up with the equivalent of red-eye. I recommend avoiding any type of flash on wildlife because it can frighten them. However, adding a splash of light when photographing flowers can be useful.

Using auxiliary flash

Many digital point-and-shoot cameras and most digital SLR cameras have a *hot shoe,* which is a slot on

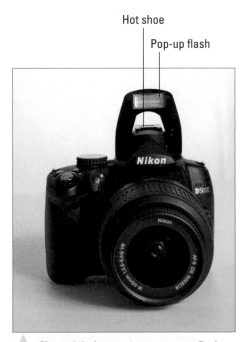

Hot shoe

Pop-up flash

Figure 3-3: An on-camera pop-up flash.

the top of the camera that will accept a flash unit, as shown in Figure 3-4. If the flash unit is recognized by the camera (for example, a Canon flash with a Canon camera, or a flash made by a third-party manufacturer that is designed

to communicate with a Canon camera), the camera communicates with the flash and automatically sets the flash exposure based on the ambient light and camera settings. The position of the auxiliary flash unit puts the light source above the camera, which results in better looking shadows than those created with a small on-camera flash. You can also bounce most auxiliary flash units off other surfaces, which diffuses the flash and results in a more pleasing light source.

If you have an advanced digital SLR that supports wireless flash, you have the power to control flash units that are not connected to your camera. In essence, the auxiliary flash unit acts as a *slave* to the camera flash. The sensor on the slave unit looks for the infrared beam from the on-camera flash as a signal to fire. You use the camera menu to control the power of the auxiliary flash unit. You can also control multiple flash units. For more information on using auxiliary flash units to augment natural light, see Chapter 5.

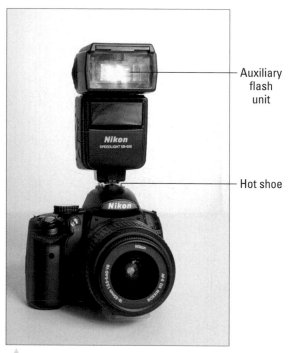

Auxiliary flash unit

Hot shoe

Figure 3-4: Using an auxiliary flash unit.

The biggest problem with on-camera or auxiliary flash is the size of the light source. A flash unit emits a pretty powerful beam of light, but it is very small and falls off quickly. Because the flash unit is small, the lighting is fairly harsh and creates garish knife-edge shadows. You can increase the relative size of the light source with a diffuser. As the name implies, the diffuser spreads out the light, making it appear as though the light originated from a large source. The sun is like your flash unit. In comparison to the objects on earth, it's a relatively small light source. Add some clouds, and the light is nicely diffused. Your flash and diffuser need to be fairly close to your source, just like the clouds are fairly close to the objects on earth when you compare the distance of the clouds to the distance of the sun. Figure 3-5 shows a couple of different diffusers made by LumiQuest (www. lumiquest.com). The camera on the left has a diffuser mounted on the pop-up flash unit; the camera on the right has a diffuser mounted on an auxiliary flash.

Figure 3-5: Using a flash diffuser.
Image courtesy of LumiQuest

Choosing the Right Shooting Mode

When you photograph nature, you have myriad subject matter. You have grand landscapes that stretch on forever, wildlife, and small objects like flowers and insects. The different modes of nature photography are like sub-genres. In a nutshell, you have a diverse array of subjects that fall under the nature photography umbrella. You've also got lots of combinations of shutter speed, aperture, and ISO you can use to yield a perfectly exposed image. Choosing the right shooting mode can be a challenge if you're new to nature photography. I discuss the shooting modes suitable for nature photography and suggest some settings in the upcoming sections.

Controlling depth of field with Aperture Priority mode

When you photograph landscapes, you want everything from the foreground to the most distant objects to be in sharp focus. When you photograph an animal, you want the animal, but not necessarily the objects in front of or behind the animal, to be sharp. When you consciously control what is sharp in your image from front to back, you control *depth of field*. You can control depth of field by switching to Aperture Priority mode and then choosing the desired f-stop. Choose a large aperture (small f-stop number) for a shallow depth of field, or a small aperture (large f-stop number) for a large depth of field. The focal length you choose also determines the depth of field. You get

a larger depth of field at a given f-stop when you shoot with a wide-angle focal length. You get a shallower depth of field at a given f-stop when you use a long focal length (telephoto lens). For more information about depth of field, see Chapter 1.

Photographing action with Shutter Priority mode

Nature photography is not all about shooting landscapes and flowers. Sometimes you photograph things in motion, such as birds in flight or animals on the move. When you photograph objects in motion, use Shutter Priority mode, which is listed as S (Shutter), or Tv (Time value) on other cameras. Your choice of shutter speed determines whether you create an artistic rendering of motion or freeze the action. Use a slow shutter speed to create an artistic rendition of motion and a fast shutter speed to freeze action. For more information on photographing action, see Chapter 1.

Shooting a Blur-Free Picture

When you press the shutter button, things are moving, and these moving things can prevent you from getting a crystal-clear picture. The movement of your finger pressing the shutter button causes slight movement of the camera. The motion of your body and your breathing are also transmitted to the camera. When you're using a telephoto lens, any operator motion is amplified. If you aren't shooting at a fast enough shutter speed, or you don't have image stabilization in either your lens or your camera, this motion results in an image that is not as sharp as it could be.

When you're shooting with a lens that does not have image stabilization and you're holding the camera by hand, the general rule is to use a shutter speed that is at least as fast as the reciprocal of the 35mm equivalent of the focal length you're using. It's pretty easy to do the math in your head. Just multiply the reciprocal of the focal length you're using by your focal length multiplier (see Chapter 2). For example, if the 35mm equivalent of the focal length is 1/80, the slowest shutter speed you can use while hand-holding the camera is 1/100 of a second. If your lens has image stabilization, you can probably use a shutter speed of 1/30 of a second, which is about two stops slower.

Your stance also has a lot to do with the sharpness of the image you get. Your body needs to be a stable platform for the camera. Good posture is important when you're taking a picture. Spread your feet about shoulder width apart and hold your elbows loosely at your side. Cradle the underside of the lens (as shown in Figure 3-6) and don't bend at the waist. If you need to change your vantage

Figure 3-6: Stabilize the camera with your body position.

point to a lower position, kneel, sit, or lie prone on the ground. When you've achieved a stable posture, press the shutter button halfway to achieve focus, compose the image, and then press the shutter button slowly as you exhale. If you jab the shutter button, or shoot as you inhale, you transmit vibration to the camera, and the resulting picture is not as sharp as it could be. Using this stance when you photograph is as close as you can get to a human tripod.

The alternative is to use a sturdy tripod (see Chapter 2). When you mount the camera on a tripod, use the spirit level to make sure the camera is level. Alternatively, you can use a two-axis level that mounts in your camera hot shoe. You can purchase a two-axis level from a well-equipped photography retailer for less than $30. You also use a tripod when taking pictures that require exposures that are several seconds long. One scenario in which you would use a very slow shutter speed is when you photograph a waterfall to render the water as a silky stream.

When you press the shutter button, you transmit a slight vibration to the tripod. That may result in a less than sharp picture when you're using a slow shutter speed. To stop the vibration from ruining your picture, use the camera self-timer at its shortest duration, which for cameras that are less than two years old is two seconds. The short delay between pressing the shutter button and shutter actuation gives the tripod and camera a chance to stabilize.

Using Live View Mode

Live View is an extremely useful feature. When you use Live View, the camera mirror locks up, and you see the scene on your LCD monitor instead of through the viewfinder. This gives you a larger canvas upon which to compose your images. When you shoot in Live View mode, you can hold the camera over your head or down low and compose the image through the camera LCD monitor. You can compose the image with the camera held higher or lower if your digital SLR has an LCD monitor that swivels. You also shoot video with Live View, a topic that is covered in the upcoming "Shooting Video with Your Digital Camera" section of this chapter.

Live View is not without its drawbacks:

- **Achieving focus can take longer when using Live View mode.** In fact, in low light and when shooting subjects without well-defined edges, you may not be able to achieve focus automatically. But if you do have to focus manually, it's easier to see if your subject is in focus on the camera LCD monitor.

- **Holding the camera away from your body to compose the shot with Live View gives the camera a less stable platform.** When you compose the scene with the viewfinder to your eye, you're able to hold the camera steady. Due to this fact, you have to shoot at a slightly higher shutter speed when you're using Live View. Exactly how much faster depends on how steady you are and whether you're taking the photograph before or after hiking five miles with a fully loaded backpack.

Reviewing Your Images

The beauty of digital photography is the fact that a photographer can quickly tell if he's got a good image. Almost immediately after you take a picture, it appears on the LCD monitor. This is your first clue as to whether you have a properly composed and properly exposed image. But the LCD monitor is not your only line of defense. Many cameras are equipped with a histogram that you can call up at will. This dynamic duo gives you lots of information. Of course, if you don't like what you see, you can take the picture over again and use exposure compensation to correct for the camera overexposing or underexposing the scene. I discuss using the LCD monitor and demystify the histogram in the following sections.

Using the LCD monitor

The LCD monitor is your friend. Use it to decide whether you've captured the image you envisioned. But the image isn't the only thing you can view on your LCD monitor. You can view shooting information and a histogram that you use to examine the exposure. Most digital cameras also give you the option to zoom in on one part of the image, display the zoomed-in portion, and then pan to different areas of the image. This helps you determine whether the important parts of the image are in focus or you need to trash the image and reshoot. Use the LCD monitor in conjunction with your histogram to determine whether you need to employ exposure compensation.

Many cameras have an option to display areas of an image that are blown out to pure white (and therefore contain no detail) as blinking highlights on the camera LCD monitor. Photographers affectionately call these *blinkies*. Being able to see blinkies is a good thing because blown-out highlights can ruin an image; luckily, you can correct the situation by using exposure compensation, which I discuss in a moment.

Cameras that were manufactured in the last two years have bright LCD monitors that are easy to see in bright sunlight. If you have an older camera, you may have to shade the monitor in order to get a good look at the displayed information. If you're handy, you can create a shade for the LCD monitor out of cardboard. If you're not handy, you can purchase a commercially made loupe for your LCD monitor. Hoodman (www.hoodmanusa.com) has a loupe that fits over the LCD monitor on a wide variety of digital cameras.

Using the histogram

Digital camera metering systems are wonderful, but sometimes they don't quite get it right when you're shooting under difficult lighting conditions, such as late afternoon or early dusk when cameras actually make a scene brighter than it should be. Another difficult lighting scenario is when you've got the sun in your image and the camera exposes the scene correctly, but the sun is overexposed. That's why most digital cameras give you the option of displaying a histogram (see Figure 3-7) alongside the image on your camera LCD monitor. A histogram is a wonderful thing: It's a graph — well, actually it looks more like a mountain — that shows the distribution of pixels from shadows to highlights.

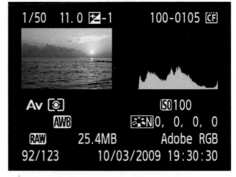

Figure 3-7: Using the histogram to gauge exposure.

After you take a picture, study the histogram to determine whether the image is properly exposed. The histogram can tell you whether the image was underexposed or overexposed. Notice the spike on the right side of the histogram in Figure 3-7. This indicates that all detail has been lost in some of the highlights. In the case of this image, the setting sun was too bright for the camera settings, even though I used exposure compensation to decrease the exposure by one stop. Your camera may have the option to display a single histogram or a histogram for the red, green, and blue channels, as shown in Figure 3-8. Figure 3-9 shows the same scene after adding additional exposure compensation and using a graduated neutral density filter.

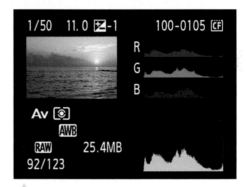

Figure 3-8: Your camera may have the option to display a histogram for each color channel.

The histogram is a tool. Use it wisely. When you're analyzing a scene that doesn't have any bright highlights, you may end up with a histogram that's relatively flat on the right side. When that happens, judge whether the image on the camera LCD monitor looks like the actual scene. If you rely on the histogram when you see a flat area in the highlights, and add exposure compensation, you may make the image brighter than the scene actually was.

Figure 3-9: Read the histogram and make in-camera adjustments to capture a good image.

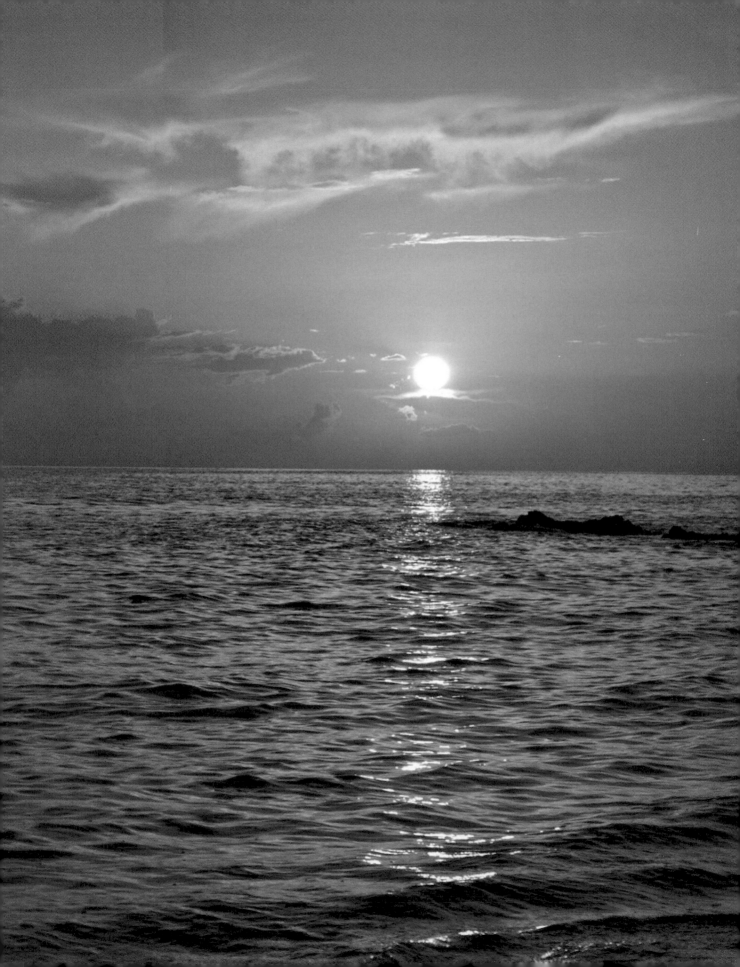

Banish the blinkies with exposure compensation

If your camera has the option to display a blinking warning on any part of the image that contains blown-out highlights, enable it. This feature tells you in an instant if your image is overexposed. If the image is overexposed, you use a feature known as *exposure compensation* to reduce the exposure of the image.

You also use exposure compensation if the image you see on your LCD monitor is too dark or if the histogram has a spike at the far left side of the scale. In this case, you would increase the exposure of the image. Exposure compensation is usually available in one-third EV increments.

 If your camera has the option to set up a custom-shooting mode, this can be very useful. For example, if you're into macro photography, you may find it helpful to use mirror lockup to prevent blurring caused by the mirror stopping after you press the shutter button. On most cameras, this is a menu option to which you have to navigate. Well, instead of navigating to the menu option every time you want to take a close-up photo of an insect or a flower, use the menu command and others as the basis for a custom-shooting mode. After setting up the custom-shooting mode, all you need to do is turn the shooting mode dial to the custom setting you created.

Improvising Your Way to a Great Photo

Necessity is the mother of invention. When you have a photograph you absolutely have to take, but don't have all the necessary gear, put that three pounds of gray matter you've been using as a hat rack into use and come up with a solution. In this section, I share a few solutions of my own.

Creating a makeshift reflector

Many photographers carry reflectors with them. A *reflector* is used to bounce light back into shadow areas when photographing objects like flowers. Portrait photographers also use reflectors to bounce light onto backlit subjects. But what do you do if you don't have a reflector? Or you do have one, but it's at home in a closet? Improvise! Here are a couple of things you can use to bounce light into the shadows:

 ✐ **A windshield sunshade:** These devices are handy because they're wide (as wide as the inside of a car windshield) and very reflective. They're typically silver on one side and gold on the other. Have a friend hold the sunshade and angle it until light bounces into the shadow areas of the object you're photographing. You can direct your friend while

you compose the scene through your viewfinder or LCD monitor. Use the silver side to bounce neutral-colored light into the shadows, or use the gold side to bounce warm light into the shadows.

- **A large, white shirt:** Ask a friend with a white shirt to move toward your subject, but out of frame. Have him move around until you see the shadows start to brighten.

- **A white sheet or blanket:** Have a friend place a white sheet on the ground near your subject in a position where it will bounce light back into the shadows.

Stabilizing the camera without a tripod

It's dusk. The billowing clouds are tinted in 20 hues ranging from purple to sky blue to pink. You have all the ingredients for a great shot except your tripod, which is in your closet gathering dust. (Don't you hate it when that happens? I know I do.) With a bit of ingenuity, you can still get a great shot. Here are some ways you can steady your camera without a tripod:

- **Place the camera near the edge of a table.** If you can see the tabletop in the viewfinder or LCD monitor, move the camera closer to the edge.

- **Hold the camera against a wall.** Use this technique when you rotate the camera 90 degrees *(Portrait mode)*.

- **Lean against a wall and spread your legs slightly.** This is known as "the human tripod." Press the shutter gently after you exhale.

- **Carry a small beanbag in your camera bag.** Place your camera on the beanbag and move it to achieve the desired composition. You can purchase beanbags at your local camera store.

- **Carry a baggie filled with uncooked rice in your camera bag.** (Cooked rice is messy and will spoil.) Place your camera on the bag and move it until you achieve the desired composition.

In addition to using one of these techniques, use your camera self-timer. This gives the camera a chance to stabilize from any vibration that occurs when you press the shutter button. Using the self-timer works great when you have the camera on a stable surface. It will also work if you handhold the camera and exhale when you press the shutter button and remain as steady as possible. These techniques are also great when you're on vacation and don't have the room to carry a tripod in your baggage.

Creating makeshift equipment

When you break a piece of equipment, need something that isn't available, or need something that's available but out of your budget, put your ingenuity to work and create what you need. Recently I needed something to

carry my Joby GorillaPod when I was traveling light, or as I call it, "going commando." I examined the GorillaPod and then went to the hardware store. I looked through the bins until I found some things I could assemble into a makeshift device to hang the GorillaPod from my smallest camera bag or hang it on a belt loop. See the result in Figure 3-10.

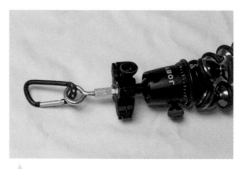

Figure 3-10: When you need equipment that isn't available, use your imagination.

Lens caps are easy to lose when you're on a photo shoot. I recently lost the lens cap for my Lensbaby Composer. I ordered a new one, but needed something to protect the lens before the new lens cap arrived. I looked through the kitchen cabinets and found a spice bottle that had a lid that was about the right size. I tried it, but it was a tad loose. I fixed the problem by cutting a rubber band and then attaching it to the circumference of the spice jar lid with Super Glue. The new one works so well that I use it full time and keep the factory cap in my camera bag for a spare.

Shooting Video with Your Digital Camera

Digital cameras can do it all these days. You can capture wonderful images of nature on your digital camera and shoot video of your favorite scenes as well. The quality of the video you can capture depends on the type of camera you own. If you own one of the latest digital SLRs, you may have the capability of capturing stunning high-definition video with a resolution of 1920 x 1080 pixels or 1280 x 720 pixels. If you own an older camera or a point-and-shoot camera, you may be able to capture video as well that is suitable for computer viewing or e-mail with a resolution of 320 x 240 pixels or 640 x 480 pixels. However, this is changing rapidly, and some high-end point-and-shoots are now available with high-definition video capabilities. The moving subject of video is covered in the upcoming sections.

Settings for shooting video with a digital SLR

The available video settings differ depending on the type of camera you own. Most digital point-and-shoot cameras have a movie mode. If you shoot video on a point-and-shoot digital camera, the only options you have are to determine the resolution of the video and perhaps the dimensions. However, if you own one of the new digital SLR cameras, you can adjust the exposure manually and creatively use depth of field when shooting your video. Specify

a large aperture (small f-stop number) when you want to use a shallow depth of field to draw attention to a specific object in the scene. Specify a small aperture (large f-stop number) when you want a large depth of field, such as when you're creating video of a beautiful landscape like Yosemite Valley. Your digital SLR may have the option to use manual settings to capture video or to specify the video frame rate. If you have one of the new all-singing, all-dancing digital SLRs, here are some video settings you should consider:

- **Manual shooting mode:** When you shoot in Manual mode, you use an indicator on the LCD monitor to set the shutter speed and aperture. When you manually set the exposure, you have complete control over depth of field. You may feel that you can accomplish this shooting in Aperture Priority mode, but it's important to shoot video with a shutter speed of about 1/50 of a second. This shutter speed works well with the frame rates offered on advanced digital SLR cameras to deliver silky smooth video.

- **Shutter speed:** Choose a shutter speed that's close to 1/50 of a second.

- **Aperture:** Choose a large aperture (small f-stop number) for a shallow depth of field, or choose a small aperture (large f-stop number) for a large depth of field.

- **ISO setting:** Choose an ISO setting that gives you the desired f-stop after dialing in a shutter speed of 1/50 of a second.

- **Frame rate:** Choose a frame rate of 24 fps for NTSC video or 25 fps for PAL video. These frame rates are identical to those used for video captured on film.

- **Focus:** Manually focus the camera on the important part of your scene. When you pan, your camera can't update the focus. If you're capturing video of a landscape, choose settings that give you a small aperture to ensure a large depth of field, and then focus about two-thirds of the way into the scene.

Tips for the aspiring videographer

You're shooting video with a digital camera, which would make you think you can walk with the camera and do all the things you can do while taking pictures with your camera. Unfortunately, this is not true. You have to put a little bit of thought into your video, especially if you plan on editing lots of clips to make a full-blown video in an application such as Adobe Premiere Elements. Here are some things to consider when shooting video clips:

- **Mount your camera on a tripod.** It's almost impossible to get steady video of any scene when you hand-hold the camera.

- **Don't walk with the camera.** If you walk and record video at the same time, the camera will bob up and down with every step you take. The end result is similar to being on a boat in a rolling sea. The effect on

anyone watching a video captured while you were walking with the camera will be the same. Professional videographers use a device called a *camera stabilizer,* or they mount the camera on a boom.

- **Pan at a moderate speed.** If your tripod has a pan head, you can pan the camera from side to side to capture the grand view in front of your camera as video. If you pan too quickly, your viewers won't be able to see the beauty of the scene. If you pan too slowly, you'll put your audience to sleep. Experiment until you find a panning speed that you can comfortably achieve and that looks good.

- **Pan at a constant speed.** If you start panning quickly and then slow down, the resulting video doesn't have smooth motion and looks very amateurish. Yes, you may be an amateur, but your video doesn't need to advertise that fact.

- **Zoom at a moderate speed.** If you zoom too quickly, your viewers may feel symptoms similar to motion sickness. If you zoom too slowly, they'll yawn and quickly lose interest.

- **Zoom at a steady speed.** When you zoom at a steady speed, your video looks more professional.

- **Leave three seconds before and after a clip.** This gives you room to create transitions when you edit the video in an application like Premiere Elements. The easiest way to do this is to push the record button and count 1001, 1002, 1003, and then start panning or zooming.

Useful accessories for shooting video

When you start shooting video with your digital SLR, you enter a brave new world. And that brave new world comes with goodies designed to make your life as an aspiring videographer for the Discovery Channel much easier. Here are some useful accessories:

- **UDMA (Ultra Direct Memory Access) memory card:** When you shoot video, you're capturing lots of frames per second. If you try to capture video with a standard memory card, you may end up dropping frames, which results in choppy motion. If you capture video with a UDMA video card, the memory card captures every frame your camera records. Memory cards are fairly inexpensive these days. A 16GB card records lots of video, and you can also record an impressive amount of stills before filling up the card. If your budget can afford it, get a couple of 16GB UDMA cards for your camera bag.

- **Steadicam:** This is a device with weights and balances that you wear. The device lets you walk with the camera and capture smooth video. Steadicams are expensive, but if you enter the words "homemade steadicam" in your favorite search engine, you'll find plans to create a homemade camera stabilizer that won't break the bank.

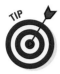

- **LCD monitor hood:** When you capture video, your monitor is your window to the world. Several manufacturers create monitor hoods with attached eyepieces that make it easy for you to see what you're recording even on a bright day.

- **A stable tripod:** When you shoot video, you pan the camera. You need a stable tripod that can support double the weight of your camera. This gives you a fudge factor to ensure the tripod stays firmly rooted to the ground while you're panning. A light tripod is a plus.

 Hang your camera bag from the hook in the middle of your tripod. The extra weight helps anchor the tripod.

- **Fluid ball head:** A fluid ball head replaces the standard head on your tripod. The fluid inside the head makes it possible for you to pan smoothly.

You can find lots of video accessories that are engineered for digital cameras at online camera retailers like Adorama and B&H Photo and Video.

Part II

Honing Your Skills

*L*andscape, nature, and wildlife photography is just like any other craft. You can do it, or you can excel at it. To excel at anything, you need a skill set, and you need to hone those skills until they become second nature.

In this part, I show you some rules of composition that can be broken once you learn them, some ways to get your mojo rising, and some ways to get inspired and develop a style.

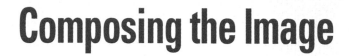

Composing the Image

*P*hotography is an art form. Good photographers don't settle for a simple snapshot of a scene. When a good photographer sees something worth photographing, he doesn't just randomly snap the shutter. He first figures out what the picture's going to portray, and then he puts the viewfinder to his eye and explores what's in the frame. If he doesn't like what he sees in the frame, he moves to a different position or he zooms in or out until what he sees in the viewfinder is close to what he sees in his mind's eye. Then he uses rules of composition to create a compelling photograph people will want to look at. That's what this chapter is all about — visualizing your image, arranging what's in the frame, and then using rules of composition to create an interesting photograph.

Visualizing Your Image

Before you take a picture, ask yourself what you're trying to portray. When you photograph a landscape on a bleak dreary day, perhaps you're trying to portray a certain mood. Or perhaps your goal is to portray the beauty of a place or your love of the place. Another mood you can portray is power and majesty such as when you photograph a bald eagle in flight with dinner gripped tightly in its talons. When you know why you're taking the picture, visualize the end result in your mind's eye. The image you envision may not be totally achievable in the camera. You may have to augment the image with filters in your image-editing application. Some people think this is cheating, but most of the great photographers manipulated their images in the darkroom. The difference is that our darkroom doesn't have any nasty-smelling chemicals or papers with potentially hazardous content. Our darkroom is totally digital. But your first step is knowing the story you want to tell with your photograph.

Master landscape photographer Ansel Adams was a proponent of visualization. He said he never released the shutter until he had a clear picture in his mind of the final image. If you adopt this technique, rather than pressing the shutter button in helter-skelter fashion taking lots of photos and then hoping for a few good ones, you'll add creativity to the equation and end up with better pictures as a result. Sure, you may end up taking quite a few photos of the scene or subject to get the image you want, but you're working with a goal in mind instead of relying on dumb luck to get a good picture. When you envision the photo in your mind, you'll know which settings to use, which lens to use, which vantage point to shoot the photo from, and so on. In the following sections, I discuss some things you should consider before you take a picture.

Less is more

As a photographer, you have choices. You choose which camera mode to shoot with, which lens to use, whether to have a large or shallow depth of field, and so on. You also choose what to include in the photograph and what to leave out. When you photograph any scene, you compose your image through the viewfinder or LCD monitor. Your job as a photographer is to arrange the elements in the frame into a pleasing composition that will result in a compelling image that people will want to look at. When you put the viewfinder to your eye, you distill everything in front of the camera into a tiny rectangle. The contents of the rectangle change when you zoom in or out, when you move to the right or left, when you crouch down, or when you view the scene from a higher vantage point.

Many photographers include too much information in their images. When people view a photograph with too much visual information, they aren't sure what to look at and they don't know why you took the photograph. When you compose your image, take a good look at what you see in the viewfinder and ask yourself if everything needs to be in your image. For example, when photographing a desert landscape, does the cactus in the right-hand corner of the viewfinder add anything to the image? If it doesn't, either zoom in or move to a different position until it's gone. On the other hand, if you determine that the cactus stays, is it in the best possible position to draw viewer interest? If not, move until it's in a position that's pleasing to you. If you like it, chances are others will too.

You can also diminish the appearance of elements within an image through use of focal length and aperture. Say you're shooting a picture of a deer in a state park. You want the deer to be the center of your attention, but you also want to include some of the background to give your viewer a sense of place. Of course, you don't want the background to be in sharp focus. That would distract the viewer's attention from your subject. Your solution: choose a focal length that will include both your subject and the background and a large aperture (small f-stop number) that will blur the background so it doesn't detract attention from your subject.

Zoom in to fine-tune what's in the viewfinder, removing elements from your composition until you've removed one too many and your story is no longer being told. Then recompose your picture to add the element back and take your picture. The practice of what to leave in and what to leave out of the picture becomes second nature with practice. Take lots of pictures.

Choosing a vantage point

Many photographers shoot all their pictures standing up. When you shoot your pictures standing up, the horizon tends to be smack dab in the middle of the picture, which does not necessarily result in the most compelling image.

A low vantage point is useful when you're photographing tall objects like majestic mountains (see Figure 4-1). A low vantage point is also useful when you're photographing tall trees like the sequoias in Muir Woods in California. You can achieve a low vantage point by dropping to one knee or by lying prone on the ground. If you choose the latter, pay careful attention to what's beneath you, and make sure you don't flatten something like a beautiful flower. Getting the photo is one thing, but preserving nature should always take precedence.

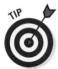

Dropping to one knee can be painful if you do it enough or if you kneel on something hard like a rock or the granite floor of a mountain. A small gardener's pad is easy to carry around and will save your knees from abuse.

Figure 4-1: Choose a low vantage point when you photograph something that's tall.

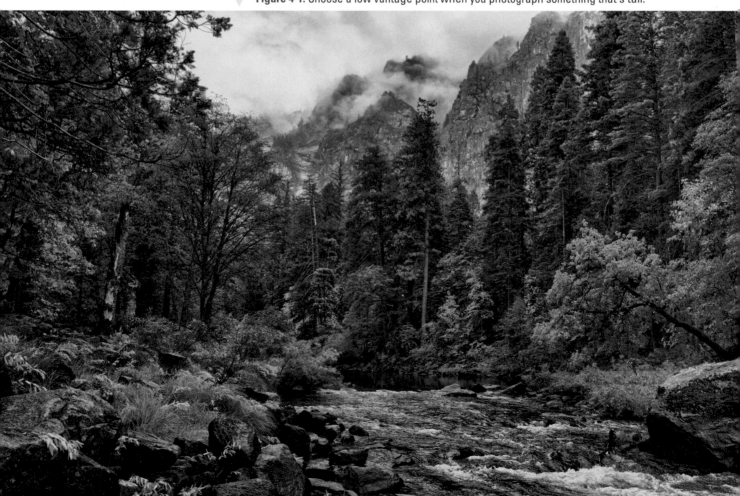

A high vantage point is useful when you're photographing valleys. Yosemite's Tunnel View (see Figure 4-2) places you above the floor of the valley, but well below the highest mountains. This vantage point gives you an idea of the grandeur and scale of the valley. If you photographed this from the floor of the valley, you'd still get a sense of scale, but the trees, not the mountains, would be the stars. Photographing from the valley floor would also require a shorter focal length to get the tops of the mountains in the picture.

When you're photographing a bird or animal, the best vantage point is at the level of the animal's eyes (see Figure 4-3). This can be a challenge if you're photographing wading birds, and virtually impossible when you're photographing a bird in its nest unless you can climb a neighboring tree.

Figure 4-2: Choose a high vantage point when photographing a valley.

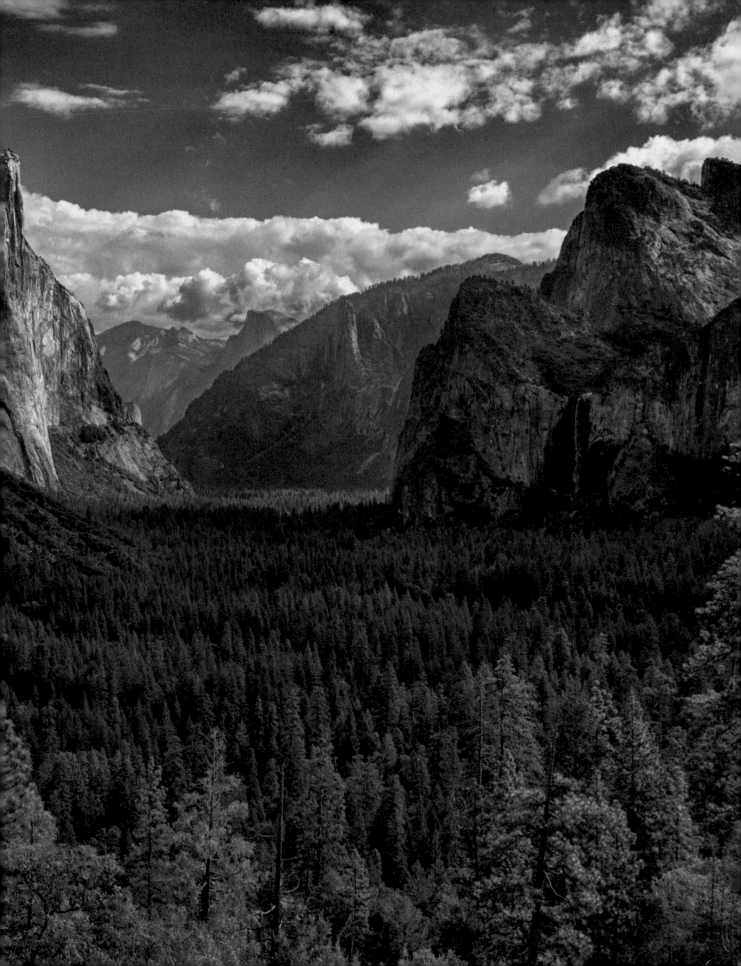

There are really no rules that are cast in stone about which vantage point will yield the best image for the scene you're photographing. A lot of it boils down to taking a lot of pictures. Experience and your personal style will come when you take an abundance of pictures. After a while, you'll instinctively know which vantage point to choose for a particular scene.

Defining the center of interest

The center of interest or focal point in a photo is the predominant feature in the image, the feature to which the viewer is first attracted. When you create a photograph of a landscape, look for a predominant feature to be your center of interest. For example, if you're photographing a landscape at sunset, the setting sun would be your center of interest. If you're photographing a bird or animal, the eye is almost always a safe bet for the center of interest.

It's up to you to determine what the center of interest in your photograph will be. The center of interest will be readily apparent in many of the scenes or things you photograph. With other objects or scenes, you'll have to do a bit of searching. Compose your image so that the center of interest is off to one side of the image, or compose the image according to the Rule of Thirds (see the section "Using the Rule of Thirds," later in this chapter).

No rule says you can't create many different renditions of a scene or object with different focal points.

You can also have multiple points of interest in an image. When you have multiple points of interest, they can act as visual stepping stones to direct the viewer's eye where you want it to go. Multiple points of interest can be creatures like birds sitting on pilings or objects like trees or flowers. When you photograph a scene with multiple focal points, be careful how many you include. If you have more than three focal points, you present too much information and run the risk of confusing the viewer. The best images are those with one or three focal points artistically located within the image. A photo with too many focal points is like a photo with no focal points; the viewer has no idea where to look.

You'll get a more interesting photograph with an odd number of focal points.

Landscape or portrait

Many photographers take pictures in *landscape format*. This is when the image is wider than it is tall. This is perfect for the majority of landscape photographs. However, when you photograph some scenes or objects, it makes sense to rotate the camera 90 degrees and create a picture that is taller than it is wide. This is known as *portrait format*. Rotate the camera

Figure 4-3: If possible, photograph animals at their eye level.

when you photograph an object or feature in a scene that is taller than it is wide. Perfect examples are subjects like a tall tree, a waterfall, a tall bird like a heron, or a majestic feature like El Capitan in Yosemite National Park (see Figure 4-4).

Make a conscious effort to examine what's in your viewfinder or on your LCD monitor before you take your picture. Slow down for a second and really look at what's in the viewfinder so you'll know whether landscape or portrait format makes sense for the picture you're about to take. If you take the effort now, soon it will become instinct. You'll automatically know which format, landscape or portrait, is best before you bring the camera to your eye.

When several tall objects are in a scene, it makes sense to photograph one or a few objects in portrait format, and then photograph the grand scene in landscape format.

Using the Rules of Composition

Nature is often chaotic. When you travel through a lush forest or craggy mountains, there is no sense of order. Strong wind causes trees to bend and become denuded on one side. Glaciers carve erratic valleys. Lightning fries a tree or causes a fire in part of the forest and temporarily changes the landscape. Animals often exhibit the same random nature, although many of them do line up in artistic patterns when traveling or migrating. Humans, on the other hand, don't relate well to chaos. We prefer some order in our lives and the way things are arranged. That's why we stack our dishes in cupboards and store our garden tools on racks. That's why it's important to have some sort of organization to your photograph, a path viewers can follow to make sense of nature's chaos.

If you don't bring some order to Mother Nature's chaos, you won't have interesting photographs. You bring order to the chaos when you compose your images. The following sections discuss composing photos. I show you how to use certain elements to bring order to the chaos and create a visually compelling image. As you become more proficient at photography, you'll use rules of composition instinctively. You'll also find that you use more than one rule when you compose a photograph. But of course rules are made to be broken, so I show you how to do that too.

Using the Rule of Thirds

You've probably seen a lot of pictures where the center of interest was smack dab in the middle of the frame. Picture a lone tree in a vast meadow. If you take the photograph with the tree aligned dead center in the middle of the frame, you have nothing but a snapshot. However, move the tree to

Figure 4-4: When you photograph a majestic object like El Capitan, rotate the camera 90 degrees.

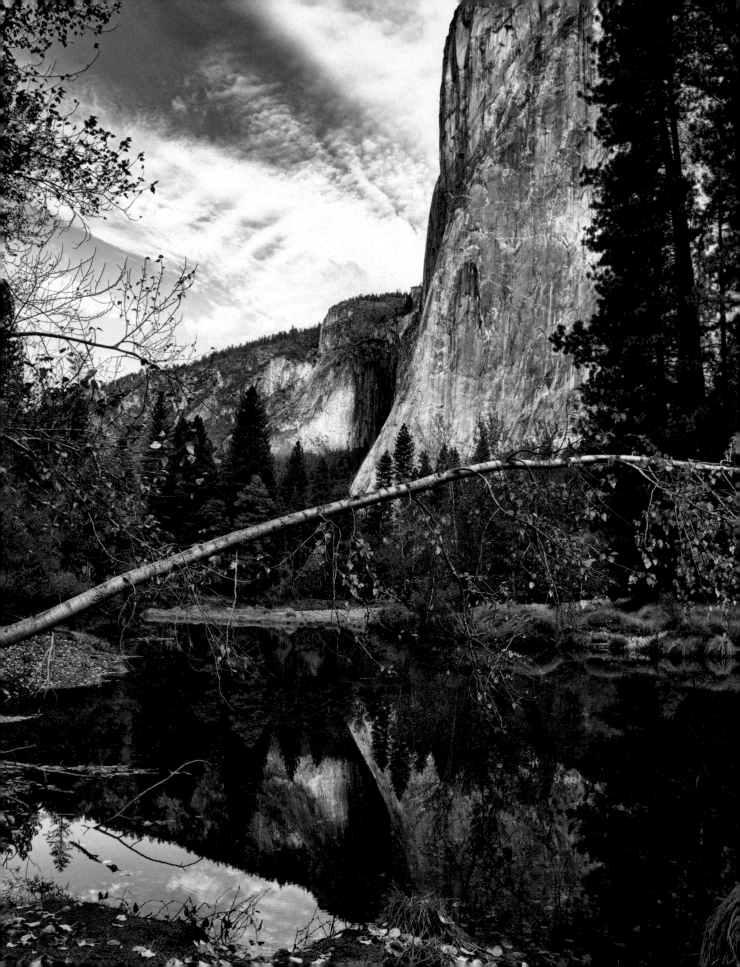

the side of the frame and you have a more interesting image. The tree is the visual anchor to which the eye is drawn. Great photographers have composed their images to draw viewers to the focal point since the beginning of photography. Of course, they probably got the idea from studying the works of great artists.

You can get precise and use the Rule of Thirds to position the center of interest in the frame. Imagine that your camera viewfinder is divided into three sections vertically and horizontally. A *power point* is where the borders of two sections intersect. Instead of placing your subject or center of interest in the middle of the frame, place it on a power point. Some digital cameras provide a grid in the viewfinder or on the LCD monitor that you can use to compose your images according to the Rule of Thirds. Figure 4-5 shows an image that has been composed using the Rule of Thirds. I also include a grid overlay for reference.

Using light to compose your image

The possible brightness values in the scenes you photograph range from dark shadows to bright highlights. When you photograph a scene, pay attention to the direction from which the light is coming. When an object interrupts the light, a shadow is created. Light and shadows are powerful

Figure 4-5: Using the Rule of Thirds to compose a photograph.

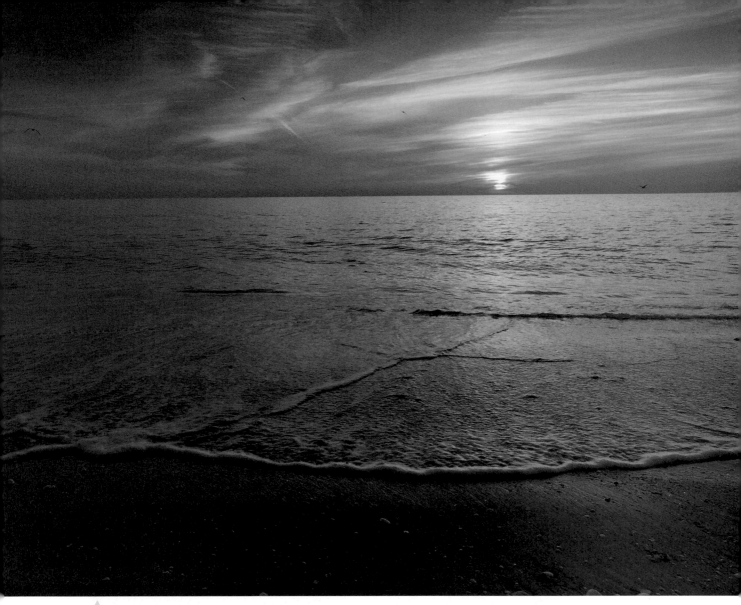

Figure 4-6: Use light to compose your images.

compositional elements. The human eye is naturally attracted to the brightest areas of a scene. You can use this to your advantage to create a compelling image. When you photograph a sunset, the sun is the brightest thing in the image. It's also your focal point. Using the Rule of Thirds, position the sun on a power point (see Figure 4-6). This will draw your viewer's eye to the most important part of your photograph.

WARNING! Brightness can also work against you when you take a photograph. Bright areas at the edge of the image give your viewer an escape route from your photograph. If you compose your photograph so that dark objects or areas are at the edges of the image, the darkness acts as a frame to keep your viewer's attention in the image.

Using color to compose your image

Color is another element you can use when composing your images. The human eye is drawn to warm colors like reds, yellows, and oranges before it recognizes cool colors like blues, cyans, and greens. The trick is to recognize the colors in the scene you're about to photograph and notice where they are. After you recognize the colors, it's time to arrange them in the viewfinder to lead your viewer's eye to where you want it to go. Use the bright colors as focal points and position them to lead your viewer through the image. The warm areas of the image are visual clues to the story you're telling.

This is a situation when you can combine rules. Position an object with a warm color on a power point according to the Rule of Thirds. Compose your photo so that the cool colors are at the edges of your image. This acts as a natural vignette to keep your viewer's eyes in the image (see Figure 4-7).

Color can also be used to convey mood. A photograph that is predominantly red and black portrays power or mystery. A photograph with greens and blues conveys a tranquil mood.

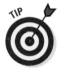

Avoid conflict; remember that the eye is drawn to warm colors before cool colors. When a bright area or warm color is not the center of interest in your image, recompose the image to move the bright area or warm color out of the frame.

Figure 4-7: Using color to compose your images.

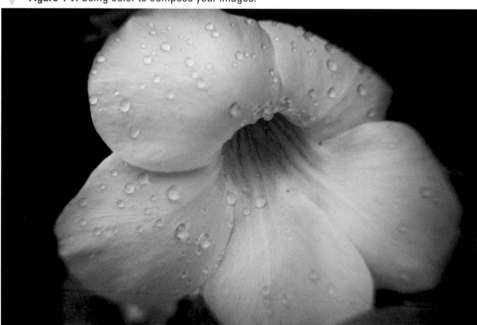

Composing the image with lines and curves

Nature has lots of lines. Tree trunks are vertical lines and wildflowers are horizontal lines. You also find diagonal lines in nature. Lines are a powerful element you can use when composing your photos. A line acts like an arrow, drawing your viewer to a specific part of your image.

Diagonal lines are more interesting than vertical and horizontal lines. When you compose a scene, look for a diagonal line that can be used to direct the viewer's eye. A diagonal in a corner of the frame is a natural lead-in to your image. Sometimes you can use diagonals in conjunction with verticals. For example, diagonal shadows from trees draw your viewer's eye to the trunks of the trees, which are vertical lines.

You can also use curves when composing your photos. A natural S-curve can be used to lead your viewer's eye through the image. You find curves on paths through forests, the spine of a mountain range, or the graceful curvature of a bird's neck. Use a curve to lead your viewer to the focal point of your image (see Figure 4-8). Get the most bang for your buck by placing your focal point on a power point according to the Rule of Thirds and have the curve lead the viewer to the focal point.

Figure 4-8: Use curves to compose your photographs.

Composing images when using a wide-angle lens

Taking a picture with a wide-angle lens nets a huge amount of real estate in the frame — sometimes too much real estate. When you review images photographed with a wide-angle lens on your camera LCD monitor, you may think you nailed the shot. However, viewing an image on your computer can help you determine if you have a lot of information in the image, yet nothing for your viewers to latch onto. When you photograph with a wide-angle lens, make sure you have something to draw the view-

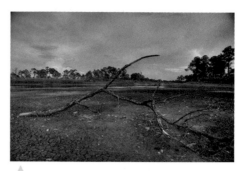

Figure 4-9: Composing images photographed with a wide-angle lens.

er's attention and make him spend some time with the image. If the features in the scene are all the same size, move around until you find something that will function as your center of interest. Then get close until the subject looms large in the final image. Compose the photo so that the center of interest is positioned a third of the way in from the left or right side of the image. You can also find a subject, such as this dead tree branch (see Figure 4-9), move in close, and then compose the image in such a manner that the curved wood draws the viewer through the image.

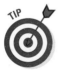

Check the edges of the frame: Some photographers make sure their subject is composed perfectly, but then they forget to look all around the viewfinder. If you're taking a picture of a beautiful landscape with bright foliage at the edge of the frame, this will distract your viewer's attention. You can rectify the problem by changing your vantage point.

Placing the horizon line

When you photograph a beautiful landscape or an animal, placement of the horizon line can make or break the image. If you place the horizon line in the center of the image, your viewer doesn't know which part of the image is the most important. You make that decision when you visualize the resulting photograph in your mind's eye. The placement of the horizon line is determined by which parts of the scene contain the visual information you think is the most important.

If you read the section on the Rule of Thirds, you know that you divide the scene into thirds vertically and horizontally. If the most important information is above the horizon, such as a scene with a beautiful cloudscape (see

Figure 4-10), place the horizon in the lower third of the image. Conversely, if the most important information is below the horizon line, such as a scene with a still lake with wonderful reflections, place the horizon line in the upper third of the image. If you pay attention to placement of the horizon line, the viewer knows where to look.

Using natural frames

You can use natural frames to draw the viewer into your image. Tall trees can frame a waterfall or sunset. In many cases, such as natural arch stone formations, the frame and the subject matter are one and the same. When you see an interesting subject or scene for a photograph, look around to see if anything nearby can serve as a frame. The frame should be darker than your subject matter and not powerful enough to distract from it. If you're photographing a sunset, the frame can be in silhouette. A frame can also be something like dark green leaves surrounding a colorful flower. You can find natural frames just about anywhere. Just look for them.

Figure 4-10: Placing the horizon line.

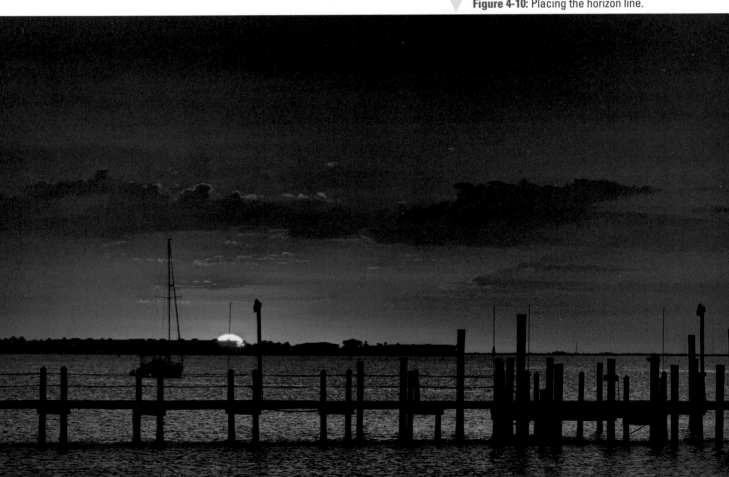

Using shapes and patterns

Every object has a readily identifiable shape. Palm fronds look like artistic spears, acorns are ovals, and so on. The object — or its shape — can be the subject of your photograph. Leaves, flowers, pebbles, and seashells have unique, intricate shapes. Sometimes, you get lucky and nature arranges shapes wonderfully; all you need to do is find the right vantage point to get a great photo. Other times, you have to help Mother Nature by creating an artistic arrangement of shapes. When you photograph shapes, make sure you have something to draw the viewer's attention. For example, if you photograph fall leaves, make sure some of them have color. Compose the photo so that the colorful leaves fall on a power point according to the Rule of Thirds.

Patterns can also be candidates for wonderful photographs. The wind creates a pattern in the sand as it blows across a dune. Trees in a forest may appear to be random, but if you shoot the photo from the right vantage point, they can form a pattern. Clouds are also a source for patterns. Small cumulus clouds often form patterns that look like the scales on a mackerel and are referred to as a "mackerel sky" (see Figure 4-11). The key to photographing

Figure 4-11: Look for patterns.

patterns is to not label things. If your goal is to take a picture of a pattern, don't think of aspen trees; look for patterns and then notice the vertical lines formed by the trunks of the trees. If you photograph the trees in the right light and from the right vantage point, you'll also have a pattern of diagonal shadows.

A break in a pattern can also be the source for an interesting photograph. For example, if you have trees lined up like cordwood with a small break followed by more trees lined up like cordwood, position the break a third of the way in from the left or right side of the image. The break will act like a magnet to draw your viewers to that part of the image and then drink in the whole image.

Using selective focus

If you use a lens with a large aperture (small f-stop value), you can then focus on one part of the scene; the rest of the scene will be soft, which means the rest of the scene may or may not be recognizable and will not distract from the focal point of your image. Use selective focus when you want to draw the viewer's attention to a specific part of the image. For example, if you're photographing a fence post in a field, use your largest aperture and then focus on the fence post. Everything in front of and behind the fence post will be a soft, out-of-focus blur (see Figure 4-12).

Breaking the Rules

Photography has many rules of composition, which I cover in previous sections. However, sometimes you can break the rules and create a more compelling photograph. When should you break the rules? The answer is simple: when you examine a scene through the viewfinder or LCD monitor and decide that you'll get a better photograph if you don't stick to the rules. For example, sometimes it makes sense to center your subject in an image (see Figure 4-13). But even though the bird is in the center of the photograph, your attention is drawn to its eye.

Other rules you can break:

- **Establish a level horizon line.** The majority of your nature photography images should have a level horizon line. But like all rules, you can break this one when the occasion presents itself, such as when you create a portrait of an animal. I remember photographing an alligator on a log, with the log running parallel to the bottom of the image. After reviewing the image on my LCD monitor, I decided to take another picture with the log and alligator on an angle from the lower-left corner of the image. It resulted in a more natural and interesting photograph.

- **Use a telephoto lens with a long focal length.** When you photograph a grand landscape, you almost always use a wide-angle lens. However, you can get some great shots if you use a telephoto lens with a focal length of 100mm or longer to zoom in and photograph details like the texture, pattern, or bark of the trunk of a sequoia tree.

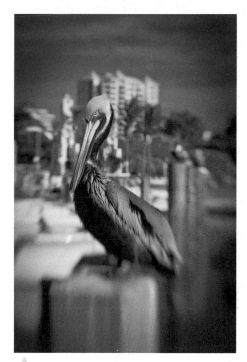

Figure 4-13: Breaking the rules can yield interesting images.

- **Shoot from an unorthodox vantage point.** Instead of sticking to the tried and true dogma of photographing your subjects at their eye level, experiment with shooting from an unusual vantage point. For example, photograph a bird from high above and make a noise so he'll look up at you. Or try the opposite and photograph a very tall animal like a giraffe from a low vantage point. Note that this technique works only with animals that are used to the presence of humans. Never try this with an animal in the wilderness.

- **Leave room for your subject to look into.** When you photograph an animal looking pensively into the distance, you generally leave some space for the animal to look into. For a different effect, zoom in tight, filling the frame with your subject's head. This is also known as an extreme close-up.

Figure 4-12: Use a large aperture and selectively focus on your center of interest.

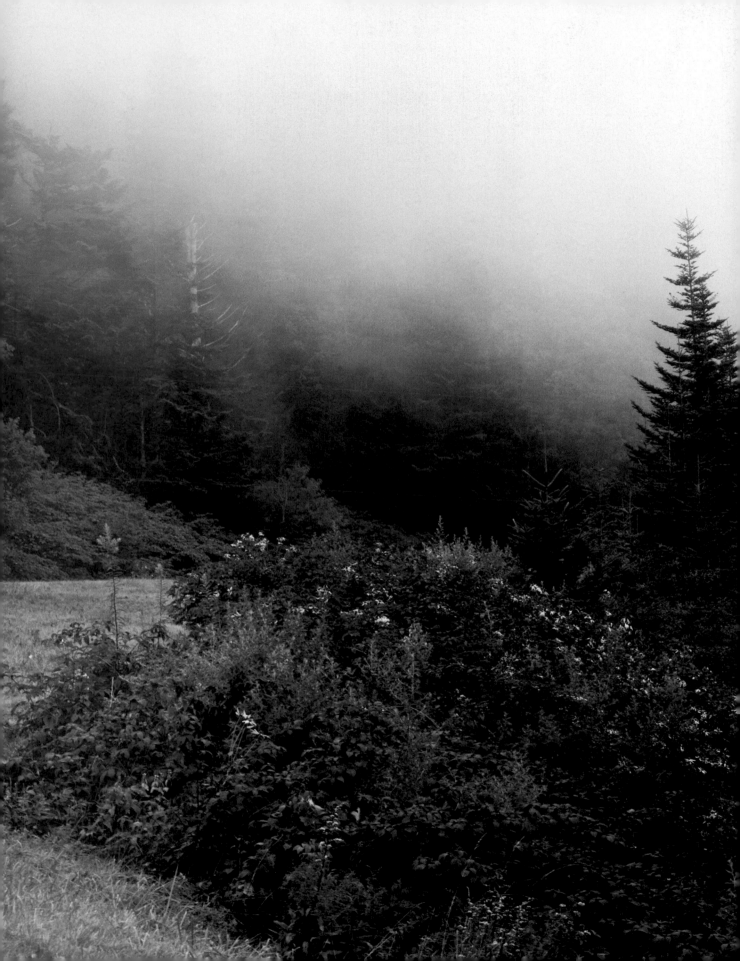

5

Mastering Shadow and Light

*Y*ou photograph three-dimensional objects, yet they're displayed on two-dimensional media. The only tools you have to show dimension and form are shadow and light, so landscape photographers need to master shadow and light to create compelling photos. The time of day you photograph nature has a huge impact on the resulting photos. The sunlight that reflects off the subjects you photograph has a unique character at different times of the day.

Depending on the part of the world in which you live, you may end up with many days without sunlight or have to deal with foggy conditions. Just because the sun isn't out doesn't mean you have to curtail your photography. Cloudy overcast days are wonderful times to take pictures of nature. Foggy days offer incredible opportunities as well.

In this chapter, I show you how to work with shadow and light. I also show you how to take photographs when the sun takes a holiday.

Shooting at the Right Time of Day

Sunlight has definite properties depending upon the time of day you photograph. Morning sunlight is soft and imbues objects with a soft golden glow. Late afternoon sunlight is a bit stronger, but also casts a wonderful golden glow. Midafternoon sunlight is a whole different kettle of fish. The sun is directly overhead and sends laser beams of harsh light directly on your subject, casting knife-edge shadows.

In the following sections, I show you the virtues of photographing early in the morning and late in the afternoon. I also discuss photographing during the brightest parts of the day, which is not ideal, but sometimes you have no other choice. The tips I present about photographing in harsh light will help you salvage a photo shoot that must be done during the middle of the day.

Capturing nature's beauty during Golden Hour

The first hour of light in the morning and the hour preceding sunset is known as "Golden Hour," which is also known as "Magic Hour." This is a great time of the day to photograph the beauty of nature. The contrast is less during this time of day, and the shadows are not as dark, or as stark, as they are during the middle of the day. If you don't have the sun in your picture, the dynamic range is less, which means you stand less of a chance of having blown-out (overexposed) highlights. Golden Hour light is warm and more diffuse because it travels through more atmosphere.

Photographers think of photographing the sunrise or sunset when they think of Golden Hour. But any type of nature photography looks great when you shoot in Golden Hour. Because of the softer shadows, late afternoon light is wonderful for photographing wildlife and birds. Just make sure that the sun is shining on your subjects. If your subjects are partly shaded, you'll be dealing with a wider dynamic range, and important details like one of the animal's eyes may be hidden.

Capturing the subtle hues of early morning light

Early morning is an exciting time to photograph. The soft light brings life to subtle details. A landscape looks more lively and lush when photographed early in the morning. For example, if you're photographing a meadow of swamp grass surrounded by tall trees, sunlight filters through the trees, speckling the grasses with fingers of light (see Figure 5-1).

When you shoot landscapes with the sun behind your back right after the sun rises, your camera exposure meter will think the scene needs to be brighter and will crank up the exposure. Review your photos as your

photo shoot progresses. If the image on your LCD monitor looks brighter than the scene before you, use exposure compensation to decrease the exposure. As the scene gets brighter, the camera will get closer to the correct exposure. If you set exposure compensation once and start shooting, you may wind up with pictures that are too bright. Review every image you shoot and adjust settings according to what you see on the camera LCD monitor.

In the early morning, the sun is low on the horizon. There generally is also some humidity in the air that disperses the light rays. The subjects you photograph in early morning are bathed in soft luminous light that is gold in color. The clouds pick up color as well and become puffy wads of pink and orange cotton candy.

After the sun rises, you can capture some wonderful silhouettes by shooting pictures where the sun is in the frame. You can also shoot into the sun and get some detail by hiding the sun behind a tree. If you're photographing on a humid morning and hide the sun behind a tree, the sun's rays will seem to fan out from behind the tree (see Figure 5-2).

The direction in which you point your camera during an early morning photo shoot depends on where the most beautiful scenery is. Sometimes you get the best of both worlds and can photograph an area that has beauty wherever you look. If you know the location, choose a vantage point that gives you good photographs when you shoot into the sun and away from the sun.

Before committing to an early morning photo shoot, visit the area when the sun is shining a day or two before your photo shoot. This gives you an idea of which areas of the scene will be illuminated as the sun gets higher in the sky. It will also give you an idea of where to set up shop, which objects of the landscape can be used as features, and so on. Checking out the area before the shoot beats getting there when it's dark and you're running on nothing but high-octane coffee.

Photographing nature in the late afternoon

As the day progresses, you can see the quality of the light change as the sun sinks lower in the sky. This is when the shadows start to get longer and the colors of the landscape get warmer. When you're an hour from sunset (Golden Hour), the quality of the light changes quickly. If you're on a photo walkabout and come upon a scene you like, take several pictures of it as the light changes.

Most photographers look toward the sun for their subject matter when photographing in the late afternoon. If you fall into this category, turn around and look at the wonderful golden light that falls on the landscape and subjects.

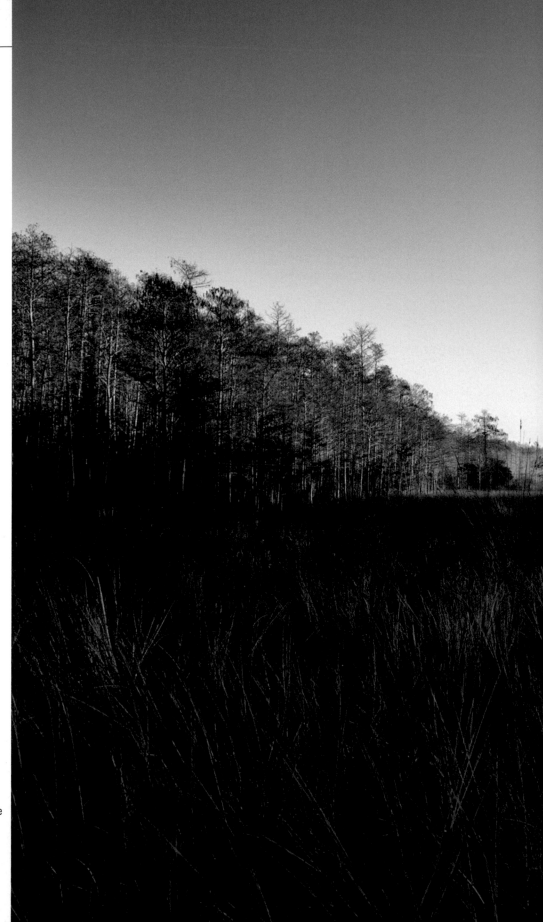

Figure 5-1: Capture subtle nuances of landscape when you photograph in the early morning.

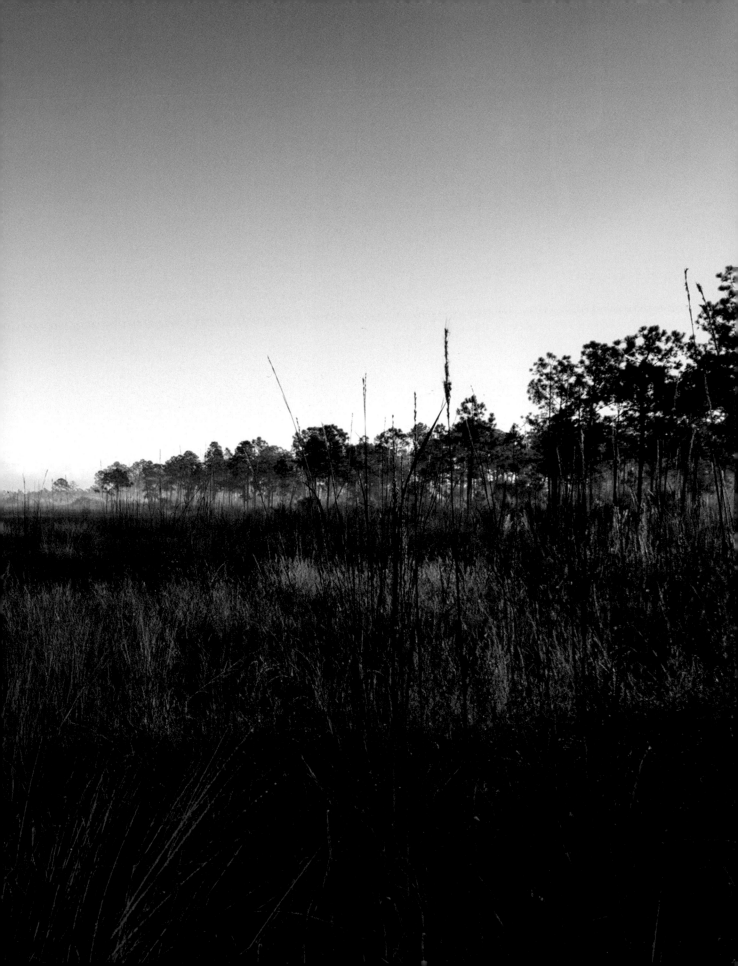

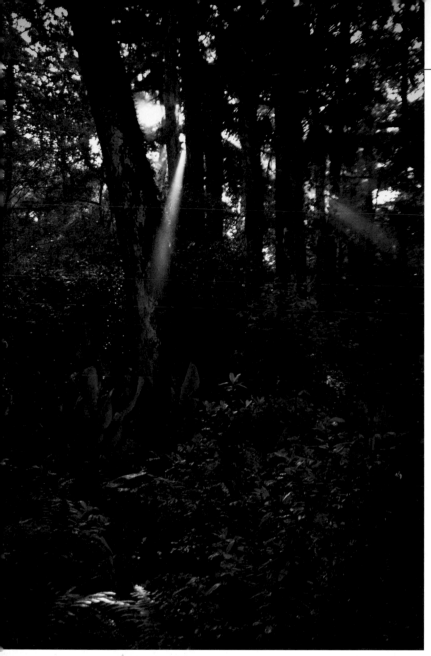

Figure 5-2: Early morning sunlight and high humidity are ingredients for great pictures.

Late afternoon sun is ideal for landscape photography. The long soft shadows add drama to your pictures. If you're photographing mountains, the warm colors bring life to the scene. If you use a wide-angle focal length with a small aperture and the sun is in your scene, the sun looks like a star. You see more spikes on the star when you shoot with a smaller aperture. When you shoot directly into the sun using a lens with a wide-angle focal length, the sun is small in relation to the rest of what's in your viewfinder. The sun will still be overexposed, but it won't be a glaring highlight.

Late afternoon sun is also great for creating silhouettes. Trees with graceful draping branches are wonderful subjects for silhouettes. If the trees are draped with moss, you can capture a dramatic picture. When your goal is to create a silhouette, use exposure compensation to ensure that the silhouettes are a rich dark black (see Figure 5-3). Start with –2/3 EV and review your image. If the silhouettes aren't dark enough, decrease the exposure even more. When you decrease the exposure, the colors of the sky become richly saturated. It's okay to radically underexpose an image when you're shooting a silhouette. When shooting a silhouette, make sure you don't have a prominent object in the background that is also in silhouette. This detracts the viewer's attention from your subject matter.

If clouds are in the sky, don't put your gear away after the sun sinks below the horizon. As long as the clouds don't go all the way to the horizon, the sun still illuminates the underside of them. The clouds will be orange right after the sun goes down. A minute or two later they turn deep pink and, about ten minutes after the sunset, they'll turn a deep purple. This is also a wonderful time to create photos with dramatic silhouettes.

When planning a photo shoot, it's a good idea to find out the exact time of the sunrise or sunset and the location of the sun at any time during the day. You can easily accomplish this task using an application called The Photographer's Ephemeris (TPE). The application is free for desktop computers and is available as a paid application for mobile devices like the iPhone and will become available at a later date for Android. The application enables you to plot the exact location of your photo shoot. Enter the date, and you can plot the path of the sun in relation to the area you're photographing.

Photographing nature at high noon

Bright afternoon sunlight is harsh and doesn't do a good job of modeling your subjects. However, sometimes you're forced to shoot in the middle of the day — such as when you're visiting a place and have no control over the time of day when you'll be at a vista that you'd like to photograph. If this is the case, you have two choices: Photograph the area or leave your camera in the camera bag. If you choose the former, you can use certain tricks to capture a decent photograph.

Figure 5-3: Create silhouettes when the sun is behind your subject.

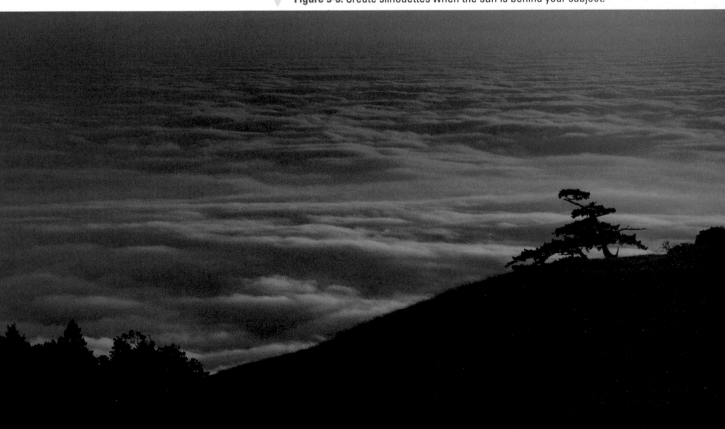

The best possible situation is midafternoon with broken clouds. When the sun ducks behind the clouds, they will diffuse the light, and you can still get good pictures. If you're lucky enough to have some clouds in the sky, you'll at least have some interest — and if there are enough clouds, some interesting shadows as well.

You can get good photographs of wildlife and birds in harsh light. The trick is to stalk the animals and photograph them when they perch in a tree or get out of the direct sunlight. If you shoot an animal or bird in direct sunlight in midafternoon, there will be almost no detail in the shadow areas because of the high-contrast light.

One option you have when photographing in the middle of the day is to take multiple exposures of the same scene with your camera on a tripod, and then convert the captures into HDR images (see Chapter 12). This works best if the sky has some clouds. An HDR image without clouds is like a juicy hamburger without French fries. It's just not right.

The high-contrast lighting of midafternoon is not the ideal situation for color photographs. However, high-contrast images are ideal candidates for conversion to black-and-white photographs (see Figure 5-4). Many image-editing applications give you the option to convert an image to black and white. Nik Silver Efex Pro 2 is a plug-in for Adobe Photoshop Lightroom, Adobe Photoshop, and Apple Aperture that converts color images to black and white. The application features several presets that you can tweak to create the look you want. It also has options that replicate popular black-and-white film. As of this writing, Nik Silver Efex Pro 2 retails for $199. For more information visit www.niksoftware.com/silverefexpro/usa/entry.php.

Figure 5-4: Convert midafternoon photos shot in harsh light to black and white.

Waiting for the light

If you don't have the right light for your photograph, wait. Things can change quickly, especially in the early morning or late afternoon. Light can make the difference between a mediocre photo and a WOW photo of a scene. If you're photographing in the afternoon when the light is harsh, but there are clouds in the sky, wait a few minutes until a cloud eclipses the sun. If it's a thick cloud, you'll have very nice lighting. If it's a thin cloud, the harsh light will be diffused to an extent, and you'll get a better photograph than you would have without the clouds. In addition to buffering the light, a cloud drifting by can add interest to a photo. Clouds can be used as compositional elements as well as light modifiers. Wait patiently until the cloud is in the right position to add interest to your photograph. The next time you arrive at a great scene but don't have the right light, wait. The following image shows the difference between bright afternoon sunlight (left) and afternoon sunlight an hour or so later with some clouds to add interest.

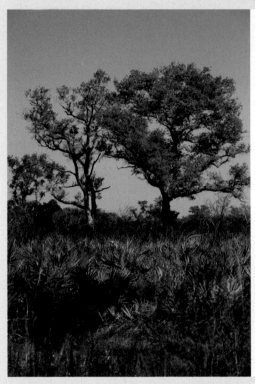 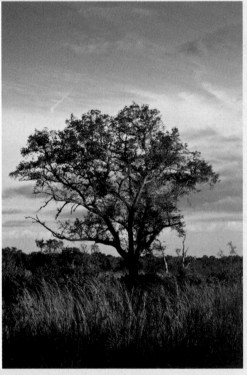

When you take a photo vacation, schedule your photography for early morning and late afternoon. Take care of trivial details like eating and being a tourist after your morning photo shoot and before your late afternoon photo shoot.

Shooting on a Cloudy or Foggy Day

When it's cloudy or foggy, you may think it's a good time to catch up on your reading or take care of those chores you've been putting off, like organizing your sock drawer. If you've never tried it before, the next time the clouds roll in or the air is full of mist, grab your gear and prepare to get some great pictures. I show you how to photograph in cloudy conditions and fog in the next sections.

Mastering nature's softbox

When a thick blanket of clouds blocks the sun, the light is wonderfully diffuse and there are virtually no shadows. This is flattering light for photographing landscapes and wildlife. When the clouds start forming, grab your camera gear and use the tips in this section to capture some wonderful photographs.

If the cloud layer is relatively thin, you'll be able to capture images with a relatively small aperture (large f-stop value). If the clouds are thick, you'll have to use a larger aperture (smaller f-stop value) or increase the ISO setting. Your other alternative is to place the camera on a tripod. When photographing landscapes on a cloudy day, you still want to use a fairly small aperture to ensure a large depth of field. If the light is very dim, you can get a decent depth of field with a wide-angle lens if you use an f-stop value of f/8.0. This beats increasing the ISO any day. You can increase depth of field by focusing on an object that is two-thirds of the way in your scene. When you focus partway into a scene, the background remains sharp because of the wide-angle lens and the relatively small aperture.

If the clouds are in conjunction with an incoming storm, you have all the ingredients for a compelling and powerful photograph. Use the brooding clouds as part of your composition. When you photograph a scene on a cloudy day with clouds that are drifting in and out of view, your camera may get a bit wonky when calculating the exposure. Look at the histogram to make sure you don't have any blown-out highlights. If you do, use exposure compensation to lower the exposure, and then take the picture again. If you photograph a scene that has subtle changes of tone in the clouds (see Figure 5-5), take three exposures and blend them using an HDR application (see Chapter 12).

When you take photographs on a cloudy day, use exposure compensation to decrease exposure by 1/3 EV (Exposure Value). This increases the saturation of the colors in the photograph.

Another tool that's useful on a cloudy day is a UV or polarizing filter. Either filter can help cut through any haze to make distant objects clearer. Another filter that's useful is a skylight filter, which also cuts through haze and warms the image slightly.

Cloudy days are also great for photographing wildlife. The soft shadowless light captures fine detail like beaks, feathers, and eyes. If you were to photograph a bird in bright afternoon sunlight, harsh shadows would hide some

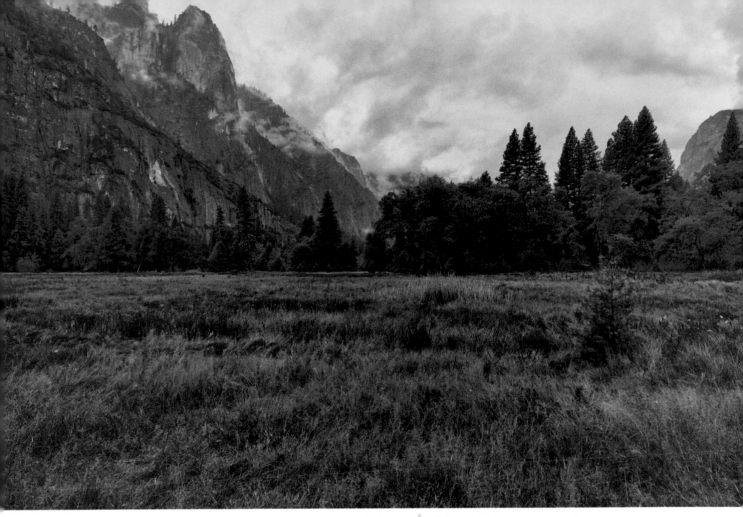

Figure 5-5: Photograph an approaching storm.

of the details that make your fine-feathered friend photogenic. The same rule holds for any wildlife. When your goal is to get photos of wildlife with good details, cloudy days are better than bright afternoon sun.

When you use filters on wide-angle lenses, you may see a vignette (dark area) at the edges of the image. This is because the angle of view is so wide that your camera actually captures part of the filter ring. The solution — albeit not a cheap one — is to purchase filters with a narrow ring. The other alternative is to remove the vignette in an image-editing application that has this feature.

Shooting nature in the mist

Fog is another interesting weather element to photograph, and to photograph in. The scenes you photograph blend into the fog. Details at the edge of visibility are soft and obscured (see Figure 5-6). Photographs taken in the fog convey a certain sense of mystery. What's beyond the fog?

Fog also reduces contrast, yet at the same time, the colors seem saturated. When you photograph in the fog, pay careful attention to your camera LCD monitor and your histogram. When you're photographing a scene with lots of fog, the image may be underexposed. If so, increase exposure by 2/3 or 1 EV.

If you've got sun peeking through, you may end up with a blown-out highlight where the sun is. With this scenario, the best thing to do is to recompose the image so that the sun is hidden behind a tree or change your vantage point so the sun is no longer visible. When the sun is just breaking through the clouds, you may end up with some blown-out highlights where the sun is shining on dew or moist leaves.

Misty mornings are also great times to shoot close-ups. Flowers will have pearls of water on them. Spider webs look very photogenic in the fog when photographed with a macro lens (see Figure 5-7).

Figure 5-6: Taking pictures in the fog.

Figure 5-7: Dewdrops on spider webs look like tiny pearls.

Fog is also a way to make a lake in the middle of a city look like it's in the wilderness. When you have thick fog, the opposite shoreline of the lake and all the buildings are hidden. Next time you wake up and see fog outside your window, grab your camera, head for the nearest lake, and shoot up a storm.

Photographing during Inclement Weather

Stormy weather can be a great time to capture incredible pictures of nature. Brooding clouds and beautiful landscapes are ingredients for compelling photographs. You can get great pictures during a storm or when it's clearing. Anyone who's ever seen Ansel Adams's "Clearing Storm" photograph can attest to the power that dramatic clouds add to an image. You can also get great pictures when the clouds are building before a storm (see Figure 5-8). In the upcoming sections, I offer some tips for getting great images in stormy weather.

Figure 5-8: Storm clouds add drama to your images.

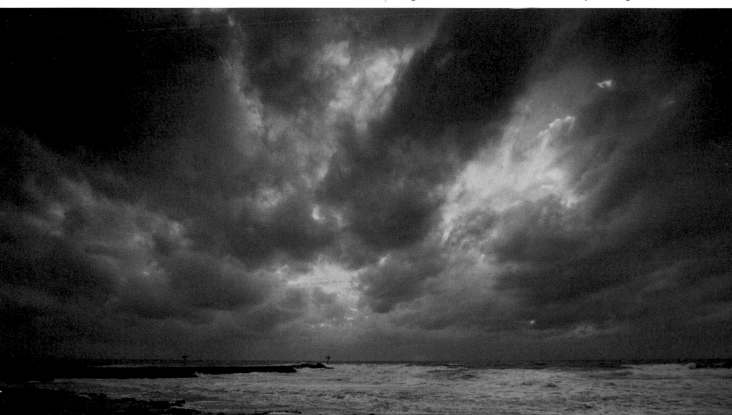

Protecting yourself and your gear

The first thing you need to worry about in stormy weather is your safety. In certain parts of the world, the weather can get ugly really quickly. What looks like a great photo opportunity can pose a threat for your safety. Here are some tips for protecting yourself in stormy weather:

- **Dress for the occasion.** If you're photographing in cold weather, wear warm clothing. In some areas, you'll have a chilly morning and then it will warm up in the afternoon. For this scenario, dress in layers. If you have a camera backpack with lots of room, store your jacket in a compartment when the temperature warms up. If you photograph in a climate where thunderstorms or rain showers occur frequently, carry a small plastic poncho in your camera bag.

- **Keep your hands warm.** There's nothing worse than trying to use camera controls when your hands feel like blocks of ice. If you photograph in a cold climate, purchase a pair of photographer's gloves. The tips of the thumb and forefinger of photographer's gloves flip back when you need bare fingers to use the camera controls and press the shutter button. When you're not taking pictures, flip the tips back to keep your fingers toasty warm.

- **Check the weather forecast.** If you're going out on a stormy day, check the weather forecast before you leave. If you go to a site like The Weather Channel (www.weather.com), enter your zip code to get a current forecast. You can also view a map that shows the storm clouds and click a button to show the predicted movement for the next several hours. If you own a smartphone, you can purchase an application (or get a free one) that will give you up-to-date weather conditions any place you have a signal.

- **Don't stray far from cover.** Weather conditions can change quickly. Make sure you can get to cover quickly if the weather looks like it is taking a turn for the worse.

Photographing in inclement weather requires common sense and stamina. After taking safeguards for your own safety, it's time to think about your gear:

- **Protect your camera.** Use a rain sleeve similar to the one shown in the section on equipment in Chapter 2. In lieu of a rain sleeve, carry a shower cap in your camera bag. Cut a hole for the lens and one for the viewfinder. Put a piece of packing tape on each side of the hole you cut for the viewfinder. It won't be crystal clear, but you will be able to compose your photos. Poke the camera lens through the large hole you cut in the shower cap and use a rubber band to fasten it securely.

- **Protect your camera bag.** Many camera bags have a built-in rain cover or a pouch you can use to cover the camera bag. In a pinch, you can use a large plastic bag to protect your camera bag. You can create a makeshift bag cover with a heavy plastic garbage bag. Cut slits for the camera bag strap. When you need to cover the camera bag, take the strap off, place the modified garbage bag over the camera bag, and then thread the strap through the holes you cut.

- **Change lenses cautiously.** Don't change lenses at all in windy weather unless you can get some shelter. The wind could blow dust or grit into your sensor.

- **Let your camera acclimate.** If you're going from a warm room into cold weather, protect your camera with a baggie. Condensate will form on the outside of the baggie. You can also leave your camera in the camera bag for several minutes until the cold penetrates the bag and acclimates your camera to the cold conditions. Reverse the procedure when you bring the camera indoors. Don't remove the memory card until the camera has acclimated to the warm conditions.

- **Keep your spare battery warm.** Batteries drain quickly in cold weather. Instead of keeping your spare battery in the camera bag, put it in your pocket.

Tips for rainy day photography

Photography is all about light and shadow. When you take a photograph, you literally create your composition with light. But the light during inclement weather is different than that of a sunny day. The former is soft and diffused, great light for photographing nature. But it can throw a curveball at your camera if you're not careful. Here are some tips for photographing during inclement weather:

- **Use image stabilization or a tripod.** You're dealing with low light conditions when you photograph in stormy weather, which requires slower shutter speeds. Use image stabilization if you're forced to shoot at slower shutter speeds. If you don't have image stabilization, stabilize your camera by mounting it on a tripod. Alternatively, try the next tip.

- **Choose a larger aperture.** When you photograph landscapes, you want a large depth of field, which means using a small aperture, but when you photograph in low light conditions, you have to compromise. Instead of shooting at f/16, stop down to f/8. You'll still get a decent depth of field at this setting.

- **Change the object on which you focus.** When you stop down, focus on an object two-thirds of the way into your scene. This will increase the depth of field in the foreground.

- **Have a well-defined center of interest.** This is a rule you should follow with all your photography, but it's even more important when the sky is gloomy and visibility is limited. The viewer needs something to latch onto.

- **Review all images.** Your camera may have difficulty metering a scene properly during inclement weather. In foggy conditions, the camera may underexpose the image. In stormy conditions, the camera may increase exposure and render an image that is brighter than the scene actually was when you took the photo. Make sure that what you see on the monitor is the same brightness as what you see in front of you. If it isn't, use the next tip.

- **Use exposure compensation.** Your camera may deliver an image that is brighter or darker than what you see before you. Use exposure compensation to increase exposure to brighten the image or decrease exposure to darken the image. Exposure compensation on most digital cameras can be done in one-third EV increments. After you change the exposure, take another picture and review it. If you have to increase exposure, don't go over the top and blow out highlights to pure white. Always review your camera histogram before you consider photographing another subject, and remember to reset the EV when the light gets brighter.

- **Take pictures from inside your vehicle.** If you're dealing with abysmal conditions but still see interesting photo opportunities, consider taking some pictures from inside your vehicle. You can roll the window down just long enough to take a picture. If you're photographing during a driving rainstorm, shoot through the window. If you do the latter, make sure your window is clean. If you shoot through a side window, press the camera to the glass to avoid any reflections.

- **Wait.** If the weather turns bad and you're forced to seek cover, do so, but wait a while for the weather to change. In some areas, the weather can go from good to bad back to good in a relatively short period of time.

Augmenting Natural Light

When at all possible, use natural light for your nature photos. However, sometimes Mother Nature throws up roadblocks like trees or other objects that block the sun. You may also find that you actually have too much sun, or the sun is shining directly on your subject and casting harsh shadows. When either scenario occurs, you have to augment natural light.

Diffusing light

When you see an object you want to photograph, like a lovely flower, but the light is directly overhead and casting knife-edge shadows, you have two options: Come back when the light is better or diffuse the light. If you choose the latter option and you're shooting with a buddy, you can create a makeshift diffuser by having your buddy hold a piece of cloth over the subject you're photographing. In fact, it's a good idea to carry a small piece of sheer fabric with you for situations like this. The sheer fabric diffuses the light just like an overhead cloud. Alternatively, you can purchase what is known as an all-in-one reflector that has gold, silver, white, and black reflector fabric as well as a fabric to diffuse the light. The black fabric is known as a *gobo,* which subtracts light from the side of the subject at which the reflector is pointed. Diffusing harsh light — also known as sucky light — can mean the difference between a bad photo and one that gains critical acclaim from your friends and fellow photographers.

Reflecting light toward your subject

When you photograph a small object, such as a flower that's shaded by another object, you can shed some light on your subject with a reflector. Commercial reflectors are available in a wide variety of sizes, but they are not always practical because of the sheer bulk. When you need to brighten shadow areas on an object you're photographing and you're with another photographer, have him hold a white object like a T-shirt and move it until it catches the available light and bounces it toward your subject. You'll be able to direct your buddy as you look at the scene through your viewfinder. If you aren't photographing with a buddy, you'll have to get inventive and place a white object in the right position to bounce light at your subject. A small piece of foam core or a car windshield sunshade works well as a makeshift reflector. If you do decide to purchase a commercial reflector, you can purchase a reflector as small as 12 inches, which is fine for bouncing light onto small objects like flowers. The next available size is 22 inches. Larger reflectors bounce more light at your subject but are not practical to carry in the field.

Using fill flash

Sometimes you need just a kiss of light to add a bit of life when photographing a subject such as a flower. The pop-up flash on your camera can be used to fill in shadows. It won't work, however, if you're very close to the object because the lens — especially a long lens — can actually cast a shadow. The shadow is cast on the subject, effectively defeating the purpose of fill flash.

An auxiliary flash unit that goes in the camera hot shoe is a better bet for fill flash. It's strong enough to send out a beam of light that won't be interrupted by a long lens. If your flash unit has exposure compensation, you can use this to add exactly the right amount of light to make the image pop. In many instances, you can decrease the amount of flash by just two-thirds EV and get a great image. Some digital SLRs have menus from which you can control the flash output.

Another technique you can try with an auxiliary flash unit — if the option is available — is to manually set the focal length. A flash unit matches the angle of the beam of light the unit emits to the angle of view of the lens. If you can manually set the focal length on the flash unit, you can send a beam of light that is narrower than the field of view of your lens. For example, if you're photographing a nearby object with a 50mm lens, you can set the flash to 80mm to send a pinpoint beam of light to the center of your subject, and create a natural vignette at the edges of the image.

Here's another trick you can do with a flash unit: When you photograph several flowers against a colorful background, use camera exposure compensation to decrease the exposure by 2/3 EV. Increase the camera flash exposure by 2/3 EV. The background will be richly saturated because the background is underexposed, and the flash causes the flower to be perfectly exposed (see Figure 5-9).

Dealing with backlit subjects

When the sun illuminates the back of your subject, it is backlit. When your camera meters for a backlit subject or object, it is much darker than the rest of the scene. You can deal with a backlit object in a couple of ways:

- **Use exposure compensation to increase the exposure.** This option brightens the entire image, which results in some of the image being overexposed. If the natural bright vignette is not a problem, this is an ideal solution.

- **Bounce some light toward your subject.** Use a makeshift or commercial reflector to bounce light toward your subject. This solution won't work if you're photographing an animal. The mere presence of the reflector will spook the animal.

Figure 5-9: Using exposure compensation and flash exposure compensation to saturate the background.

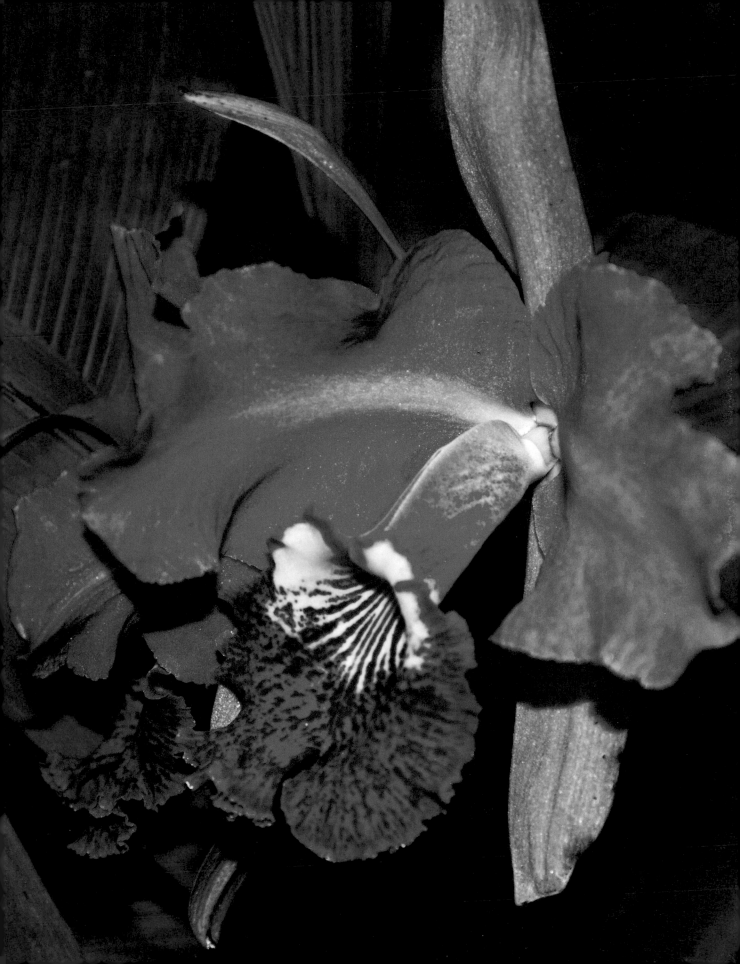

✒ **Use a Better Beamer on faraway subjects.** This device is a flash extender you can use with an auxiliary flash unit while using a telephoto lens. The Better Beamer has a Fresnel lens at the end of an extension, which magnifies the power of the flash and causes it to illuminate objects at greater distances. Bird photographers use it to photograph nesting birds. You can find a Better Beamer at many online photography retailers. Enter "Better Beamer" in the search box of your favorite search engine and choose your favorite.

✒ **Use exposure compensation to underexpose the image.** This option puts your subject in silhouette. When creating a silhouette, it's okay to underexpose the picture. Just make sure you have nothing in the background that is large and will also be a silhouette. You don't want it to compete with your subject for the viewer's attention.

Photographing Nature at Dusk

Dusk is the period between sunset and civil twilight. As soon as the sun goes down, many photographers pack their bags and head home. Those who do miss out on some prime opportunities for wonderful photographs of beautiful landscapes. If clouds are in the sky, the sun will illuminate the underside of the clouds for 10–15 minutes. This is a wonderful time to capture images of areas with calm water. The clouds cast a mirror reflection on the water. Sans any clouds, underexpose the image by 1/3 to 2/3 EV. This renders the landscape as a silhouette, and you see a tinge of color from the sun, which is below the horizon (see Figure 5-10).

When you photograph at dusk, your camera may deliver an image that is too bright. If this is the case, use exposure compensation until the image you see on your LCD monitor matches the scene in front of you.

Find the ideal exposure for the scene and then decrease the exposure by 1/3 EV to saturate the colors.

Photographing Nature at Twilight and Beyond

Civil twilight, the brightest phase of twilight, begins when the sun is 6 degrees below the horizon. Nautical twilight begins when the sun is 12 degrees below the horizon. The period between civil twilight and nautical twilight is known as the "Blue Hour" because the sky is a deep blue color. This is a wonderful time to take pictures of lovely landscapes. This light can also simplify a complex landscape because all shapes are rendered as silhouettes. The undersides of clouds also turn a rich blue-black color.

Figure 5-10: Photographing at dusk.

Tips for the twilight photographer

Photographing landscapes after dusk is not as easy as photographing during the day. The reason for the increased difficulty is dusk's low light, which means you'll have to increase the ISO setting, and many cameras are extremely noisy at high ISO settings. In short, you need your ducks in a row, even though ducks are probably sound asleep after the sun goes down. In any event, here are some tips for the aspiring twilight photographer:

- **Scout your shooting location.** Even if you know the place you plan to shoot like the back of your hand, the next time you shoot there, get into a twilight state of mind. Look at the features of the landscape and visualize what they'll look like as silhouettes. If you think a tree will look good as a silhouette, use it as a focal point in one of your images. You

also need to think of the background and make sure there are no large shapes that will compete with the object you've chosen as the focal point of your image.

✔ **Visualize.** As you check out a location that might be good for shooting at twilight, look for objects you can use to compose your images. Are there any strong lines that you can use to lead your viewer into the image? Remember that a diagonal line is more interesting than a vertical one. Also look for natural frames. If your subject is a large tree in a meadow, look for tall trees that you can use as a natural frame. When you compose your image, place the trees at the edges of the picture. The black shapes will prevent your viewers from leaving the picture and draw them to your center of interest.

✔ **Get your times right.** If your plan is to do a photo shoot beginning at dusk and into the twilight, know what time dusk begins. You can find this information online or by using an application like The Photographer's Ephemeris (www.thephotographersephemeris.com).

Leave plenty of time to get to your location and set up. An unexpected traffic jam when you have perfect conditions for photographing your desired subject is not good if you don't have a fudge factor. If you do leave in plenty of time and run into a traffic jam, you can do something else while you wait — such as visualize the great pictures you're going to get.

✔ **Look for reflective surfaces.** Clouds will reflect in bodies of water like lakes and rivers. If you have a still body of water, you have a mirror reflection of the sky and any objects on the horizon.

✔ **Use a tripod.** Your exposure times will be long. Cranking up the ISO in twilight will result in lots and lots of digital noise in the shadow areas of your image, which in many instances is the majority of the image. A long exposure time will increase noise as well, but not as bad as switching to an ISO high enough to hand-hold the camera. Another benefit of using a tripod is you can get the camera level.

✔ **Lock the mirror.** Before you fly into the twilight, make sure your camera mirror is in the upright and locked position. This applies only if you use a dSLR to take your pictures. When you take pictures at slow shutter speeds, the act of the mirror stopping transmits vibration to the camera, which results in an image that isn't as sharp as it could be.

If your camera has the option to save custom settings, create a custom setting to lock up the mirror. Add other settings such as switching to the Aperture Priority mode.

✔ **Use a cable release.** A cable release enables you to open the shutter without touching the camera (which can cause vibration resulting in a blurry image). Some cameras, such as Canon dSLRs, require a dedicated remote trigger. In lieu of a cable release, you can use the auto-timer

to delay the release of the shutter. This gives the camera a chance to stabilize from any vibration that occurs when you press the shutter button.

✓ **Carefully position the horizon line.** Don't place the horizon line in the middle of an image. Instead, place the horizon line where it will draw the viewer's attention to the most important objects in the photograph. Photographer David duChemin calls this "visual mass." If the most interesting parts of your photograph are above the horizon line, place the horizon line in the lower third of the image. If the most important parts of your image are below the horizon line, place the horizon line in the upper third of the image.

Photographing nature at night

At night all color is gone. You and your camera see shades of gray — that is, unless you use long exposures of several minutes. When you do this, you start to see color, and the black sky becomes blue. To photograph at night, shoot in Bulb (B) mode. This leaves the shutter open as long as the shutter button is pressed. You can use a cable release or a remote trigger to accomplish this. However, this can get tedious with long exposures that are several minutes in duration. If you enjoy photographing nature at night, consider investing in an *intervalometer,* a device that enables you to program the amount of time you want the shutter to remain open.

When you photograph a scene that will be rendered as a silhouette, you can get creative and use a flashlight to illuminate certain parts of the scene. This requires some experimentation on your part. The exposure will be a bit of a crapshoot, depending on the brightness of your flashlight and the amount of ambient light.

Long exposures drain batteries quickly. You can solve this problem if you have an AC adapter for your camera and available AC power.

Photographing a scene with the moon in the sky is tricky. The moon is much brighter than anything else. If you expose the scene for the landscape, the moon will be a bright blob in the sky. If you're photographing a mountain range, you can expose the image so that the moon is properly exposed. This will render the scenery as a silhouette. Done right, this can be the formula for a compelling photograph. Compose the image so that the moon is a focal point.

The alternative to photographing a landscape with the moon as a silhouette is to take multiple exposures of the image and blend them with HDR software (see Chapter 12).

Photographing star trails

At night when you keep the shutter open for 10 minutes or longer, the rotation of the earth becomes apparent in your image. The motion is readily apparent if you're photographing a landscape with no ambient light from civilization. The stars are rendered as long trails. To capture a compelling photograph of star trails requires an exposure that is longer than 30 minutes, and your camera must be mounted on a tripod. The settings for photographing star trails are above and beyond the scope of this book. They will depend on how bright the moon is. This type of photography will wreak havoc with your battery and can cause harm to your camera if the battery is exhausted during the exposure. When photographing star trails, consider making several 30-minute exposures and blending them in an application like Photoshop. When you change batteries, make sure you don't move the tripod or change any of the camera settings or lens focal length. In other words, be very careful when changing batteries if you're going to stitch several shots together. When you photograph star trails, you spend a lot of time waiting, but when you get it right, the results are well worth standing around while your camera captures the image.

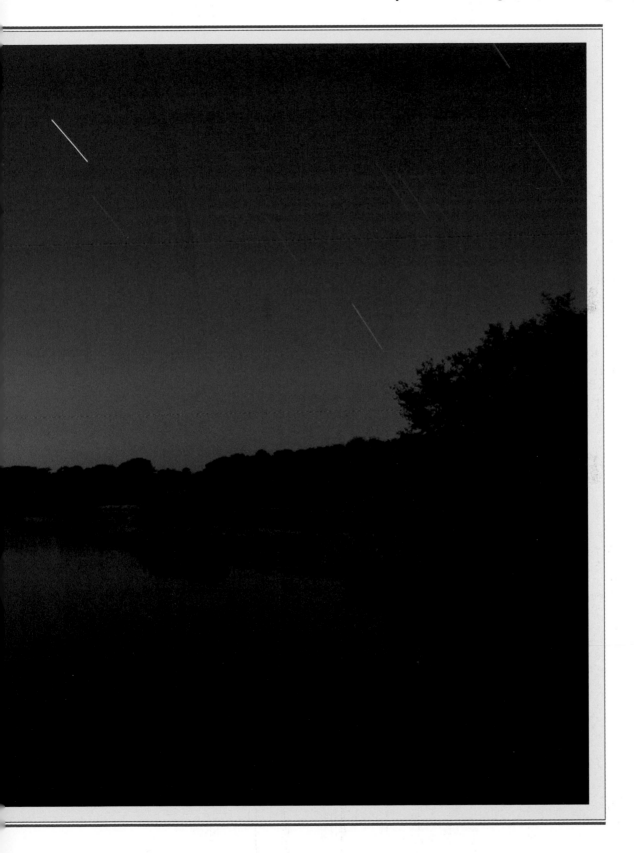

6

Creativity and the Nature Photographer

In Chapters 3, 4, and 5, I discuss rules of composition, camera options, and so on. Rules tend to imply rigid structure, but photography is very much a creative endeavor. You use state-of-the-art cameras that are technological miracles. When you're new to photography, you embrace technology and get familiar with your camera and photography. But to become an artist, you need to transcend technology. You transcend technology by knowing your camera and knowing how to create a technically perfect photograph. When that part of photography becomes second nature and your camera acts like a third eye, you're ready to get creative and transform your digital photography into something that's unique. In this chapter, I offer suggestions and exercises for becoming more creative.

Learning to See

People look, but they don't see. Beginning photographers look through the viewfinder or at the camera LCD monitor, but they don't really see the elements of a picture in the scene before them. Seeing is noticing everything that's in front of you and distilling it into a compelling image that people will want to spend some time looking at. The litmus test is when you show your

photography to other people. If they just take a casual glance at your photography, you've failed the test. If they say something like, "Wow, that's beautiful," you've passed the test. You may get a backhanded compliment like, "Wow, you must have a great camera." If you get a comment like that, smile and say, "It isn't the camera that composes and takes the picture, it's the photographer. My camera is merely a tool I use to express my vision." This may sound arrogant, but it's the truth.

When you photograph a beautiful place, your goal isn't to send the image to someone and say, "I was here." Your goal should be for someone looking at the picture to say, "I wish I was there." When you visit a beautiful landscape or see a colorful flower or an animal you want to take a picture of, it's time to dig deep and see what's in front of you. Here are some things to consider when you go on a photo shoot:

- **Set a high standard.** Approach each photo shoot with high expectations. Tell yourself you're going to get some great pictures, and don't cut your shooting time short. If you plan a photo shoot down to the minute because you have something to do or someplace to go right after the shoot, you add the pressure of time to the equation. Go shooting on a day when you have the luxury of time to devote to your photography without other constraints. Then you give yourself permission to keep shooting as long as things are interesting.

- **Be in the moment.** It's hard to be a photographer, see picture elements, and compose a great image when you're thinking about what you need to do after the photo shoot. If you think about what you have to do after the photo shoot, your mind won't be on your photography. Concentrate fully on your photography and you'll notice the beauty before you and see photographs before you put the camera to your eye.

- **See the big picture.** Notice everything. See the forest and the trees. You can equate this to looking at the area with a wide-angle lens.

- **See the details.** After you see the big picture, narrow your focus. Develop what photographer Jay Maisel calls "telephoto vision." When you see a splash of color or something that looks different, focus on the area and see if there's a picture there. Put the camera up to your eye and start moving around. Zoom in to fine-tune your vision.

- **See everything.** Don't forget to look down and up. You may find an interesting subject beneath your feet or in the treetops. That's right; the canopy of a forest can be a very interesting subject if you see an interesting pattern.

- **Take your time.** When you find an interesting area, milk it for all it's worth. Pick the low-hanging fruit first and then reach higher. Find an interesting way to photograph what you see, a way you've never photographed a scene like this before. Who knows? You may create a unique photograph of the area that nobody's ever taken before.

✏ **See the differences.** Nature doesn't have any set patterns or rhythms. But there is a certain order to things. Tree trunks are brown and leaves are green (or other vibrant colors, depending on the season and location). When you see something that's different, focus your attention on it. It could be an orchid hanging from a tree. The tawny brown shape you see in the distance could be a bobcat.

Feeding Your Muse for Inspiration

The photography bug is easy to catch. You take a couple of great pictures and you think you're ready to take on the world. But your enthusiasm quickly wanes when you realize you have a lot to learn and perhaps don't have a clue as to what it takes to create a great photograph of your favorite subjects. When you get discouraged, it's time to get inspired. And there are a few ways you can become inspired, as I show you in the upcoming sections.

Study the work of the masters

One of the best ways to learn photography is to look at photographs. Look at the photographs of the acknowledged masters in your genre of photography. I love landscape photography, so I study the work of Ansel Adams, David Muench, and Clyde Butcher. Galen Rowell has also made a mark in nature photography. When you're learning your chops, look at as many photographs as you can. You can find the work of your favorite photographers by entering their names in your favorite search engine.

Lately I've been converting lots of my color images to black and white. Before embarking on this adventure, I looked through my books of Ansel Adams's photography to get an idea of how he'd handle photography in the digital age. After experimenting with my photos, I've come to this conclusion: He'd embrace it and use his famous Zone System in conjunction with a program like Lightroom with the Nik Silver Efex Pro 2 plug-in. But Silver Efex Pro 2 does more than just convert images to black and white. You can emulate film grain from popular black-and-white films such as Kodak Plus-X and Tri-X, and many more. Figure 6-1 shows one of my photographs converted to black and white with Silver Efex Pro 2. For more information about Silver Efex Pro 2, visit www.niksoftware.com/silverefexpro.

When you study the work of a master, you see a pattern. His most famous photographs have a distinct style. If you've photographed any of the same places, compare your work to his. You'll probably see differences in the way the photo was composed, the vantage point he used, and perhaps the choice of focal lengths.

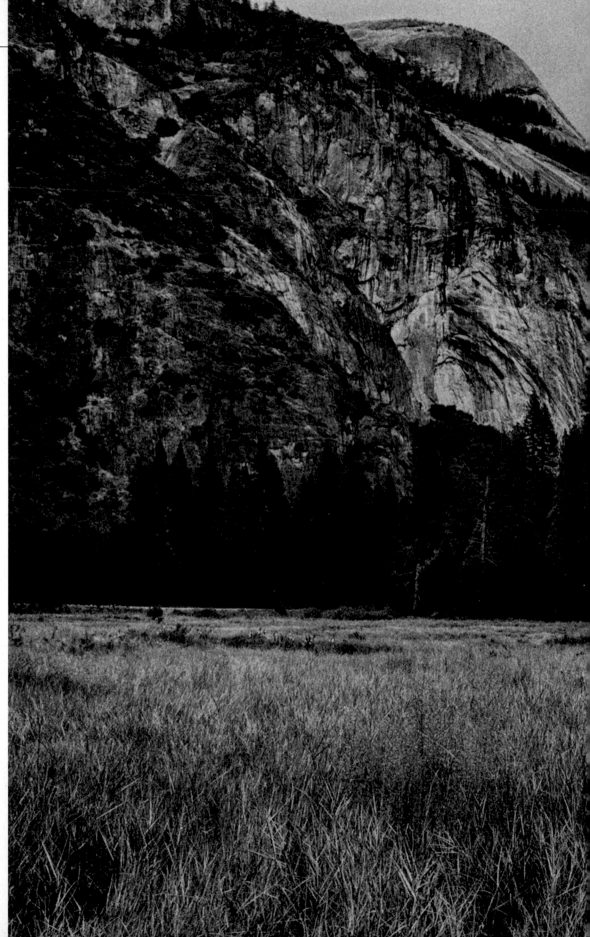

Figure 6-1:
Study the
work of other
photographers
to develop your
style.

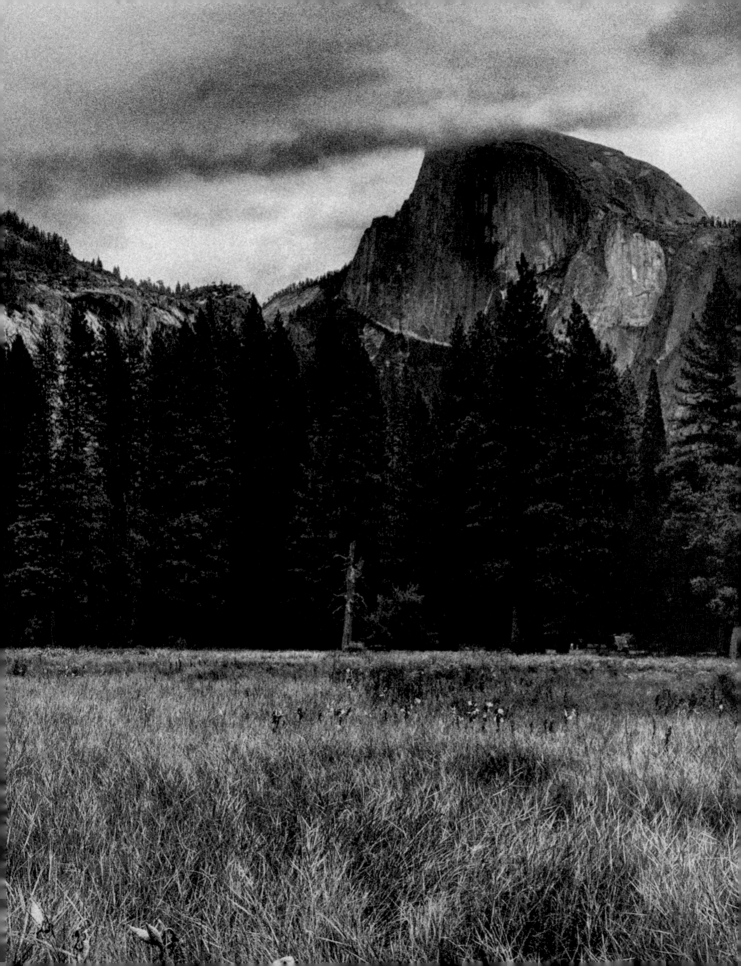

If your favorite photographer gained lots of notoriety, you may be able to find recorded interviews that give you an idea of how she captured her greatest images. YouTube is a great place to look for interviews and information about famous photographers.

Study the work of your peers

In addition to studying the masters, you can get inspiration and ideas by studying the work of your peers. There are lots of great websites that have photographs from photographers of varying skill levels, such as photo.net (www.photo.net), which has photographs from many different genres. When you look at photos from such sites, you'll see the settings and equipment the photographer used to capture the image. You can find lots of stunning work in online photo galleries. You also find some pretty lame excuses for photographs on these sites. You can learn from both.

When you see a bad photograph on a photography website, it will be one you won't want to look at very long. However, I advise that you figure out what it is you don't like about the photograph. Perhaps it was taken at the wrong time of day, or perhaps the photographer used the wrong focal length or the wrong settings. Be a bit of a detective and scope out the metadata (if listed) to see what lens and settings the photographer did use. Then be a critic and dissect the image to figure out what rule of composition wasn't used or could have been used. Perhaps the photographer could have chosen a better vantage point or been more careful when placing the horizon. After dissecting a couple of bad images, you know what not to do.

When you immerse yourself in photography created by established or aspiring professionals, you can gauge your own progress as a photographer and see how your work measures up.

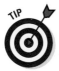

You can also find great examples of nature photography in magazines like *National Geographic* and *Outdoor Photographer* (www.outdoorphotographer.com). The latter also features how-to articles about nature and landscape photographers as well as columns from noted photographers.

Join an online community

Online communities are great places to strut your stuff and get feedback from other photographers. Join an active community like Flickr (www.flickr.com) or SmugMug (www.smugmug.com). After you join a community, start looking for photography you like. When you see something you like, leave a comment. Most photographers on community sites get encouraged when they get a positive comment. A positive comment about another

photographer's work piques her curiosity about your work. If you sprinkle enough comments around, you'll start getting feedback on your work. If the photographer is nearby, you may even strike up a friendship and go shooting together.

My girlfriend (Roxanne) and I belong to the SmugMug community. This site is wonderful and fully customizable. You can order prints of your work from the site and even sell your work. You can customize your pages as well. Our SmugMug page was customized to match our website (see Figure 6-2).

Developing Your Style

Figure 6-2: Display your work on a website like SmugMug.

After you study the work of the masters of nature photography and of your peers, it's time to put what you've learned to good use and start taking pictures. Don't take a few pictures every now and then; use your camera often. When you use your camera often, the technology of the camera, including the settings and lenses, becomes second nature, and you can start working on developing a style of your own.

If you're fortunate enough to live near an area that's been photographed by a master photographer you've studied, visit it. Go to the places where the photographer took some of his most famous photographs. When you arrive at the scene, see if you can find the vantage point from which the photograph was shot. See if you can take a photograph similar to that of the master you've been studying. This will give you a place to start. Now you can start experimenting to put your own spin on what your master has photographed. Experiment with different settings, different vantage points, and so on.

When you start getting prolific with your photography, your pictures will have a style similar to what you've been looking at. As you begin to experiment and stretch your personal envelope, gradually your photos begin to look different than those of your mentor and the other photographers who take pictures in the same areas you do. This is the beginning of your own style. This is when you hone your craft so the images you create are readily identifiable as yours.

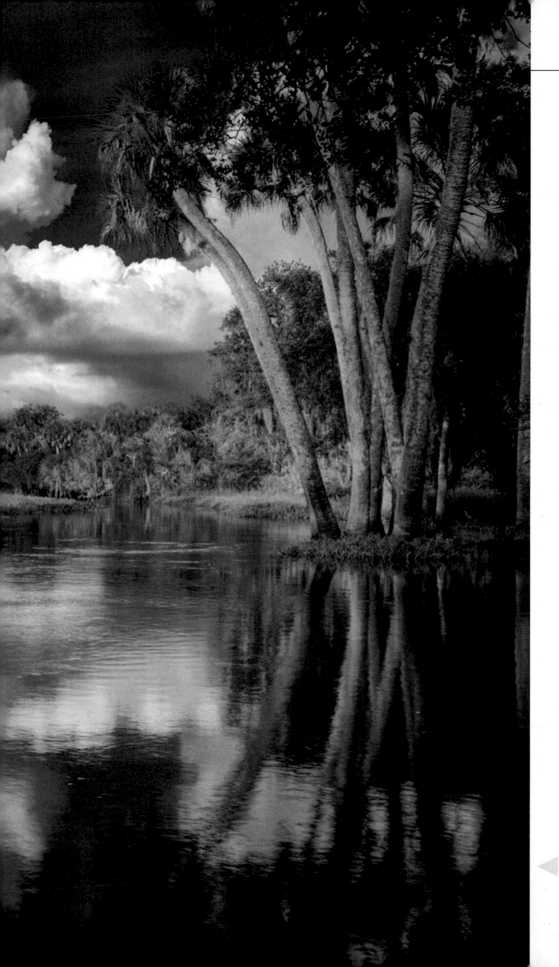

Figure 6-3: Your photography style changes over time.

Your style changes over time, even if you photograph the same things. You learn new techniques, get different equipment, and refine your photographic vision. During this period, continue studying the work of other photographers. Your changing style and unique vision vitalizes you and keeps you fresh.

When I moved two years ago, I had a vastly different area to photograph. I also started embracing the work of Clyde Butcher, known as the "Ansel Adams of the Everglades." Clyde happens to have a studio in my new home-town. My photography changed as a result of meeting Clyde, talking with him, and poring over his images. Now when I come upon a scene with a winding river and trees draped with Spanish moss, or a swampy meadow, I envision a black-and-white rendition of the scene (see Figure 6-3).

Convey a mood

Mood goes hand in hand with style. You can convey a mood with every photograph you take. Perhaps your goal is to create pictures that express the beauty of the area in which you live. Your photographs can show a calm, peaceful feeling when you capture images during Golden Hour. You can also create photographs that convey power when you photograph an area during stormy weather. Photograph an area on a cloudy day, and the image portrays a somber beauty.

You can portray a mood in many ways when you create a photograph. The most obvious method is to use light and shadow. A bright image conveys a bright, positive mood. An image with a lot of dark colors can give images a somber or even sinister mood. Color is another way you can portray a mood with your photography. Bright, warm colors signify joy and serenity. Bright colors like reds signify power. Pinks and pastel colors can portray romance or love. Conveying a mood also depends on how you assemble the elements in the frame to tell your story.

The subject you photograph can portray mood or emotion, too. Colorful flowers send a message of love and romance. An eagle or hawk is a powerful bird, and other birds are beautiful but at the same time comical. Even a small bird like a burrowing owl can look pretty fierce if you compose the image correctly (see Figure 6-4).

The composition you choose can make or break the photo when your goal is to portray emotion. Look at the elements in the viewfinder and judge whether the image tells the story you want to tell.

Choose a unique perspective

Many photographers take all their pictures from an upright position. You'll capture more interesting photographs if you choose a unique vantage point from which to photograph a scene. The vantage point for some photographs

Figure 6-4: Your subject sends a message to viewers.

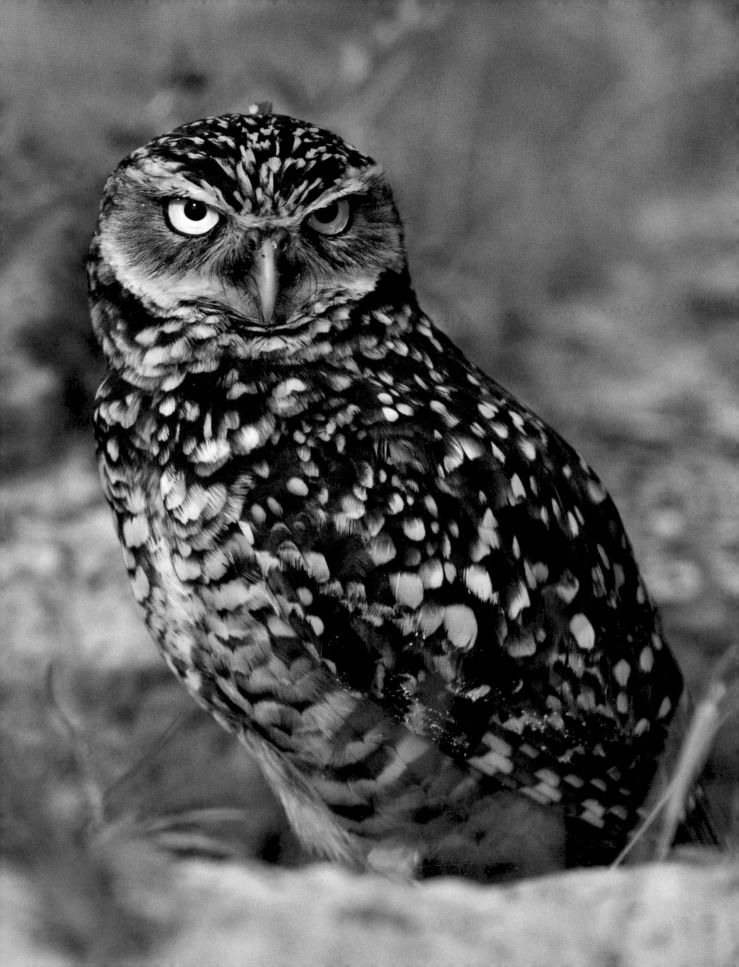

will be obvious, as outlined in the rules of composition I discuss in Chapter 4. When you aren't sure which vantage point to use for an image, take the easy shot first, then get creative.

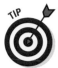

Dropping to one knee can be painful, especially on hard terrain. If you find that you frequently shoot from a low vantage point, pick up a gardener's kneeling pad. The pad is small enough to comfortably carry, will keep you from soiling the knee of a pant leg, and definitely is easier on your body.

Climbing to a higher vantage point and shooting down on a scene provides a perspective that often implies a sense of spaciousness and majesty when you're photographing a scene like Yosemite Valley, shown in Figure 6-5. This image was photographed from Washburn Point, which is approximately 3,000 feet above the floor of the valley.

Figure 6-5: Shoot from a unique vantage point.

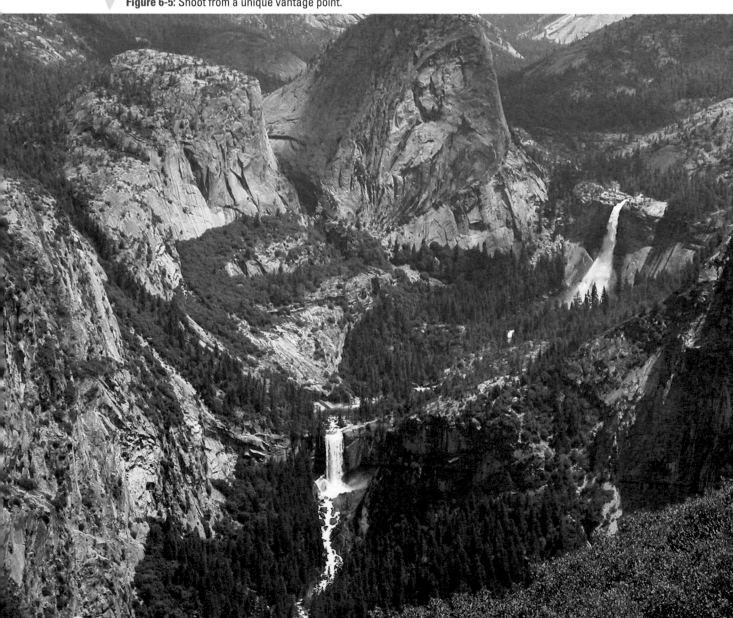

There's nothing that says you can't break a rule and tilt the camera on an angle. This won't work for every type of image, but can be used to create an abstract image of a tree, for example. Another option is to point the camera up when photographing a tree like a banyan.

Just Do It

Your camera does you absolutely no good if you keep it snug and secure in its case. The only way you gain your chops as a photographer is to take the advice of the Nike ads and "Just do it." Take your camera with you wherever you go and take lots of pictures. Take photographs on your way to work and on your way home from work. At many times of the year, this coincides with the Golden Hour. You may feel uncomfortable leaving an expensive camera in your car while you're at work (it may not be prudent, either!). If so, travel light; bring your camera and one lens and park it in your desk while you work.

If you have an occupation where you can't keep your camera secure while you work, consider investing in a point-and-shoot camera. You can take pictures on the way to work and on the way home and keep your camera hidden in your glove box while you work. The following sections give you some other ideas for honing your craft by doing.

Go on an "artist's date"

When I interviewed Joe McNally at Photoshop World, I asked him what advice he would give to photographers. His reply: "Take lots of pictures." To that I would add you have to photograph often. If you work a nine-to-five job, this may seem difficult. But with a bit of thought and planning, you can always find time to shoot. Leave for work a half-hour early and bring your camera with you. Shoot pictures on your way to work and shoot pictures on your way home. Set a specific time or times each week when you'll take pictures. Author Julia Cameron, in her book, *The Artist's Way,* refers to this as an "artist's date." Schedule a couple of hours each week when you do nothing but take pictures. When you go on your artist's date, go with a specific goal in mind. Visit a place you've photographed many times before, but photograph it in a different way, at a different time of day, or under varying weather conditions. You can also visit a place you've never photographed before and capture its essence with your photographs.

Another great time to use this technique is when you see a photograph and want to emulate it. Notice I say *emulate* and not *duplicate*. Put on your thinking cap and take your best guess at which equipment and settings the photographer used. Then grab only the gear you need (see the following "Go commando" section), travel to a location where you can photograph a similar subject, and then do your best to emulate the picture you like. After you emulate, spend more time at the scene and figure out how to put your own spin on it.

Go commando

Having lots of gear is a good thing, but some photographers have so much gear that they might never really master any particular piece of it, like a specific lens. When you want to learn how to use a specific piece of gear, such as a new lens, or master a specific technique, I advise that you *go commando*. When you go commando, you take just enough gear to master the technique you want to learn or only the lens with which you want to become more familiar. When you limit the amount of equipment you take, you learn how to get the most out of the gear you have on hand. You also learn to improvise to overcome any shortcoming of the equipment you have with you. For example, if you've just purchased a *prime* lens (a lens with one focal length), you have to learn the art of *foot zoom,* which means you have to move toward or away from your subject to get the composition you want.

You can combine going commando with an artist's date. In this instance, your goal is to master a technique or a new piece of gear. Use this technique a couple of times a month, and you'll master every piece of gear in your camera bag.

Go on a photo walkabout

Many photographers drive to an area, park their vehicle, shoot some pictures, and drive to another spot. Driving can be stressful, especially if a lot of people are visiting the area you want to photograph. You may think the areas in which you photograph nature are relatively secluded, but state parks can get extremely crowded at certain times of the year. The next time you feel the inspiration to go out and take some pictures, consider going on a photo walkabout. When you go on a photo walkabout, you park your vehicle in a central area and start walking. This is a great way to learn all about an area.

Before you go on your photo walkabout, do a little research. If you're visiting a state park, see if a trail map is available online. If you're visiting a popular national park like Yosemite, you may find a smartphone application that has a map of the hiking trails. Pick a trail that's compatible with your physical abilities. This is important if you aren't in tiptop shape and you're going on a walkabout in an area with severe elevation changes.

Go on your photo walkabout when the light is good. Early morning is a great time for a photo walkabout, especially in a place like Corkscrew Swamp Sanctuary (see Figure 6-6), where there may be early morning fog. When you go on your walkabout, allot plenty of time for a leisurely stroll. The walking is good exercise; plus, it becomes a meditation and you relax, which enables you to focus your attention on the beauty around you and capture every available photo opportunity.

A photo walkabout will help you get more familiar with an area. Photography is all about fun, and your photo walkabouts can be spontaneous or planned. A photo walkabout will also teach you to approach your photography in a more direct and purposeful manner.

You can go on a photo walkabout with a couple of friends or go solo. Both have their advantages, but sometimes it pays to go solo. When you go alone, you can concentrate on what you want to photograph, and you can stay out as long as you please. Going on a walkabout with other photographers is a useful exercise. Other photographers may see an area differently than you. You can feed off the other photographers, and they can feed off you. If you go with others, however, set up some ground rules, such as keeping the chatter to a minimum. A "Chatty Cathy" in the group can disrupt everyone's concentration, or in the case of photographing wildlife, scare off the subjects. Save the talking for when your walkabout is over and you meet in a coffee shop to compare notes and look at each other's photos.

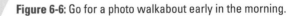
Figure 6-6: Go for a photo walkabout early in the morning.

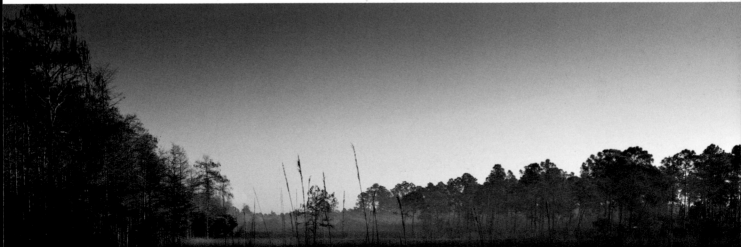

Self-assignments

Review your photography from time to time to get an idea of your strengths and weaknesses. As you learn new skills, your photography becomes better; when you think you're perfect, you've reached a plateau as a photographer. Determine which areas of your photography need work. Consider the following as you review each of your images:

- Does your composition lead the viewer's eye through the image?
- Does the image have a well-defined center of interest?
- Is the center of interest positioned to draw attention to it?
- Are there "escape routes" — such as bright areas at the edge of the frame — where the viewer can leave the image?
- Is the horizon line placed to draw attention to the dominating subject of the image? Or is it smack dab in the middle of the photograph?
- Is the image properly exposed?
- Was the image photographed in good light?
- If you didn't photograph the image, would you spend time looking at it?

Armed with this information, create an assignment and a time to do it. For example, if you like to photograph birds and your photographs of birds in flight need improvement, go to a place where you've sighted lots of birds in flight and photograph them for an hour or two. When you go on a self-assignment, shoot with the goal of improving your photography and review your work to see how you're progressing.

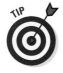

You can also do a self-assignment to enhance your creativity as a photographer. Flip through the dictionary and pick a random word and then attempt to show the word in photographs. I don't mean to literally take pictures of the word. For example, you could create an assignment based on "blue" and interpret it in a way that's meaningful for you. You could take pictures of blue flowers, water, or animals with expressions that look like they have a case of the blues. This exercise stretches the envelope a bit and makes you look for subjects in a different way.

You can turn a self-assignment into an ongoing theme. For example, you could photograph the textures of nature: Take photographs of leaves, close-ups of tree bark, ice crystals, and so on. Another example would be to capture autumn's colors (see Figure 6-7). This is another way to increase your comfort zone and think about nature photography in a different way.

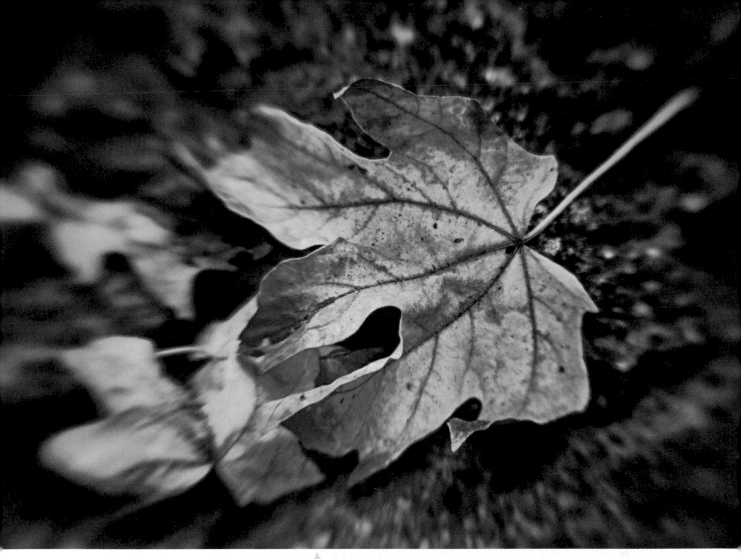

▲ **Figure 6-7:** Challenge yourself to create pictures based on a theme.

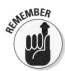

When you schedule time to consciously focus on a specific area of photography, you get better. And like Vince Lombardi used to say, "Practice does not make perfect. Only perfect practice makes perfect." When you go on a self-assignment, consciously focus on making the best pictures you can. To that I would add to not stray from the task at hand.

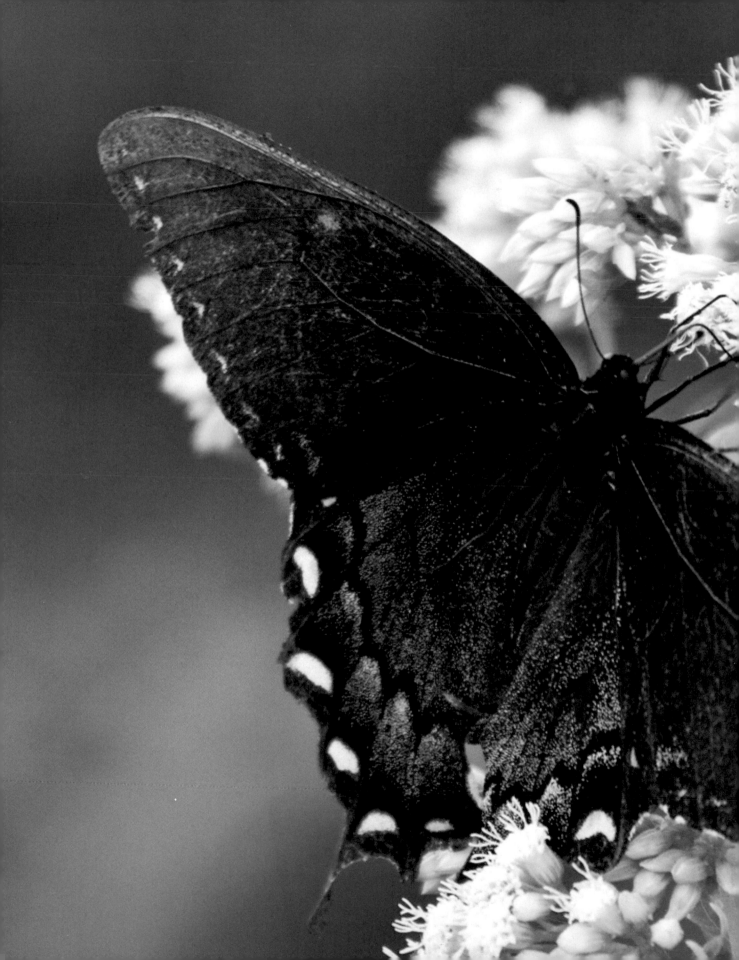

Part III

Photographing Nature

*T*he world is your oyster — or at least the world in which you are at the moment, with a camera in your hand and something interesting to photograph. If you fancy photographing birds, deer, alligator, moose, insects, or flowers, this part's for you.

As if that wasn't enough, in this part I introduce you to nature photography with the Lensbaby Composer.

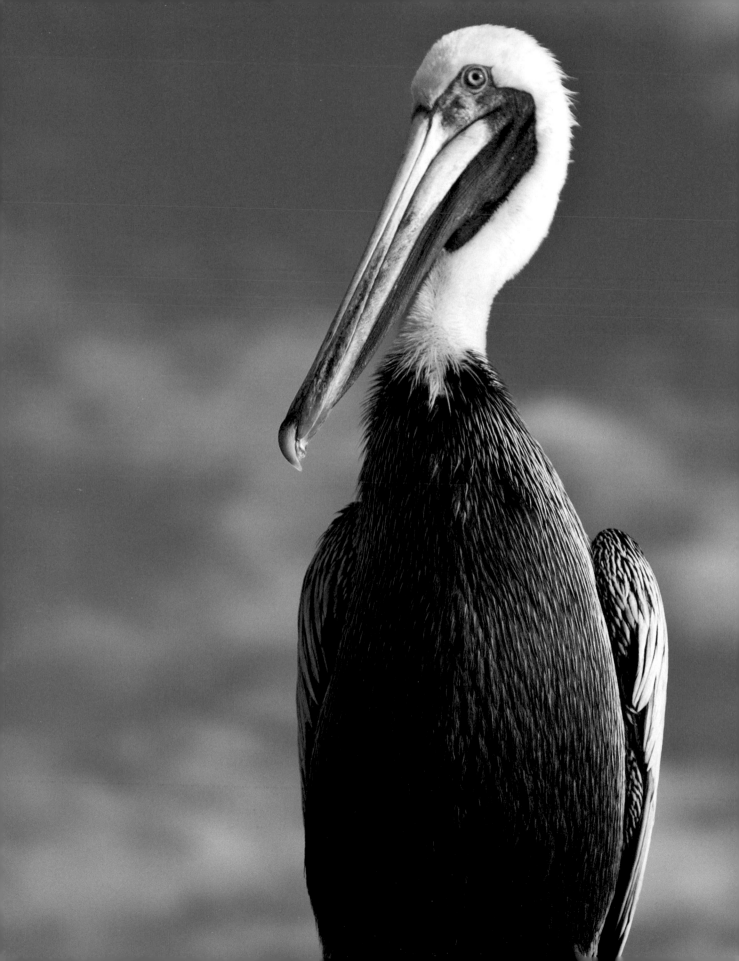

7

Birds

Birds are everywhere. You find them flying through your backyard, at the beach, and even in busy cities. Avid bird photographers welcome the opportunity to pursue their passion, whether it is photographing small birds, wading birds, or majestic birds like bald eagles. Photographing birds requires knowledge, skill, and practice. It also requires patience and planning. You need to learn something about your subjects' daily habits in order to know where to find them and when they'll be most active. In addition to knowing about your subjects, you also need to know what equipment to use and what techniques to employ to capture great bird images with your digital camera. In this chapter, I show you how to photograph small birds, wading birds, and birds of prey.

What You Need to Know Before Capturing Great Photos of Birds

The best way to get great photographs of any birds is to study them. When you take the guesswork out of your photography, you'll spend more time shooting and less time driving to places where you think birds *might* be. This list gives you ideas of where and how to research habits of birds and where to find them in your area:

▸ **The local chapter of the Audubon Society (www.audubon.org/):** Enter your zip code in the text box in the Audubon Near You section of the Audubon Society home page. You may also find that your local camera club has avid bird photographers as members.

▸ **Magazines:** You can also find information in magazines like *Outdoor Photographer*.

- **Your portable device or iPhone:** You can purchase Audubon field guide applications for the iPhone, iPod, iPad, or Android at this website: www. audubonguides.com/index.html. iBird (www.ibirdexplorer.com) is another popular application for the iPhone, iPad, iPod, or Android.

- **A good resource book:** Go to a website like Amazon.com and search for the name of your state, followed by birds. In many instances, you'll see a couple of books. For most states, you'll find a guide entitled *Field Guide to Birds of [Name of a State].* Authoritative ornithology books tell you the migration habits, mating season, and other valuable information for a species of bird.

 The *National Audubon Society Field Guide to North American Birds* is an excellent resource. The book contains pictures of birds and information about each species, and it lists the geographic range of each species presented. The book comes in two versions: one for eastern North America and one for western North America.

- **Online resources:** You can find lots of information about wading birds online. Look at local Audubon Society websites. Try doing a search for "Wading Birds" preceded by the name of your state.

 Knowing the sounds a bird makes will make it easier for you to locate it and get the picture. Find a plethora of information about birds as well as hear recordings of the sounds they make at www.whatbird.com.

- **A mentor or shooting buddy:** No matter what kind of photography you're into, you can find a mentor in a camera club or befriend a photographer who's shooting in the same area as you are. Most photographers are friendly and gladly share information — about techniques and hotspots for getting great photos — with their fellow photographers.

Getting the right equipment for photographing birds

Bird photography is very rewarding. However, it can be quite challenging to get good photographs of birds when you don't have the right stuff. The best solution for photographing birds is a good digital SLR camera. If you're considering purchasing a camera specifically for photographing birds, a digital SLR with a sensor that is smaller than a 35mm frame of film is ideal. The focal length multiplier of these cameras gets you close to the action. For example, a 200mm lens on a Canon EOS 7D has the 35mm equivalent focal length of 320mm. Get the longest lens you can afford. A focal length of 200mm may be ideal for photographing large wading birds like great blue herons, but to photograph birds like bald eagles or red-shouldered hawks, you need a focal length of at least 400mm.

If you can't afford a long lens, consider buying a good quality tele-extender. A 2X tele-extender doubles the focal length of any lens. Unfortunately, it also doubles the largest aperture of the lens, which means a 200mm f/4.0 lens with a 2X tele-extender becomes a 400mm f/8.0 lens. To ensure a sharp picture with a long lens, or with a lens with a tele-extender, consider purchasing a good tripod. Long telephoto lenses don't come cheap, but you can find some reasonably priced lenses that get the job done, such as the Tamron 200–500mm

f/5–6.3 Di LD IF Autofocus Lens (see Figure 7-1). It's a long lens, but it's relatively easy to handhold and comes with a built-in tripod mount. As of this writing, the lens retails for less than $1,000.

Figure 7-1: Photographing birds requires a long lens.
Photo courtesy of Tamron

Creating a makeshift bird blind

If you're serious about photographing birds, you need a bird blind. A *bird blind* is a manmade structure that blends in with the surroundings and gives you a place to hide while waiting for birds to show up so you can photograph them. The photographer or birdwatcher stays in the bird blind and watches or photographs the birds when they come into view.

You can easily create a makeshift bird blind using a brown or green bedsheet. Use a clothesline and some clothespins to fasten the sheet to trees. It's also a good idea to put something like a sheet of plastic or an old poncho on the ground before fastening the sheet to the trees. Fasten a couple of twigs with some leaves attached to the bedsheet. Cut a hole for your camera to poke through, climb inside, and wait. If you're real adventurous, purchase some camouflage material and use it instead of a bedsheet.

Small Birds

Small birds range in size from a bird that would comfortably fit into the palm of your hand to a bird that is about nine inches tall. You find everything in this category from small finches to burrowing owls. Small birds are often colorful, active, and fun to watch and photograph. Witness the antics of a woodpecker, the sound of a mockingbird imitating a hawk, or a catbird perched in its catbird seat and then photograph it. You can photograph small birds in your backyard or in the wilderness.

Taking pictures of birds at a bird feeder

If you like bird photography, you can do so in the comfort of your backyard. All you need is a bird feeder, some bird feed, and a bit of patience. You can get stunning pictures of cardinals, blue jays, and hummingbirds. Here are some tips to get great pictures of birds at your bird feeder:

- **Place a squirrel-proof bird feeder in a convenient place.** Bird feed is expensive, so there's no sense in feeding the neighborhood squirrels. You can find squirrel-proof bird feeders by entering "squirrel-proof bird feeder" in your favorite search engine.

 When you position the bird feeder, consider the direction of the sun. You want the birds to be illuminated by early morning or late afternoon sun shining directly at them, not by harsh overhead light found in the middle of the day. If you shoot birds in the middle of the day, the sun

casts knife-edge shadows on the birds, which results in unsatisfactory images. Of course, the alternative is to hang the bird feeder in a tree that shades it at all hours of the day. This will require a slightly higher ISO to compensate for the shady conditions.

✏ **Keep the feeder filled.** The birds will find the feeder after you put it out. As long as you keep it filled, they'll keep coming back.

✏ **Let the birds acclimate to your presence.** After birds have been stopping by for a while, find a place where you can sit and watch the action. The distance from the place where you sit to the bird feeder should be within reach of your longest telephoto lens. The birds will let you get only so close before they fly away. With a telephoto lens, you'll be able to zoom in fairly tight on your subject.

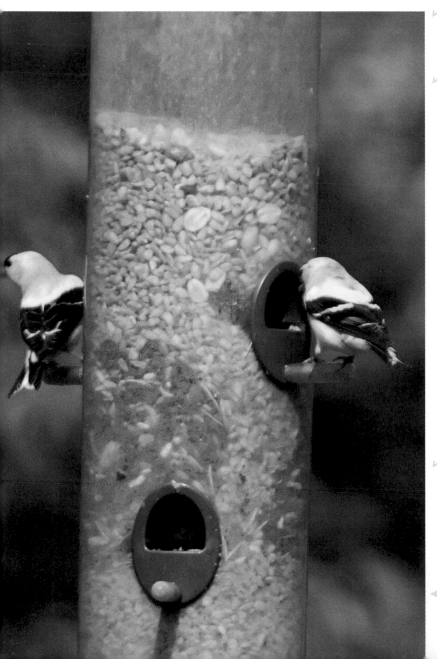

✏ **Use a shutter speed of 1/250 of a second.** That will ensure that you get sharp pictures of the birds while they're feeding.

✏ **Use a faster shutter speed to freeze the motion of hummingbird wings.** Try a shutter speed of 1/1000 of a second. Alternatively, you can stick with a shutter speed of 1/250 of a second, which will freeze the hummingbird, but the wings will be blurry. This will show viewers that the bird's wings were flapping rapidly when you captured the image.

Hummingbirds require special feeders that contain a mixture of sugar water. Hummingbirds are remarkably tame. You can place a hummingbird feeder very close to your house and photograph them through a squeaky clean window. When you photograph from inside a house, the birds may appear a bit dark. If this is the case, use exposure compensation to brighten the image.

✏ **Use a large aperture of f/4.0 to f/5.6.** The large aperture will give you a shallow depth of field and render objects like your neighbor's laundry hanging out to dry as an out-of-focus blur (see Figure 7-2).

◀ **Figure 7-2:** Photographing small birds at a feeder.

- **Switch to continuous focus mode.** When you're photographing a bird that's flitting from one part of a bird feeder to another, the camera will update focus as the bird moves.

- **Use image stabilization if your camera or lens has it.**

- **Use a tripod.** A tripod steadies the camera. Even with a fast shutter speed, any operator movement can result in an image that isn't tack sharp. If you use a tripod, disable image stabilization.

Photographing small birds in the wild

Birds come in all shapes and sizes. The smaller fine-feathered friends can be very interesting subjects for photography. You find small birds in many places. The best place to photograph them is in their natural habitat. For example, this catbird was photographed in Corkscrew Swamp (see Figure 7-3).

Figure 7-3: Photographing small birds in their natural habitats.

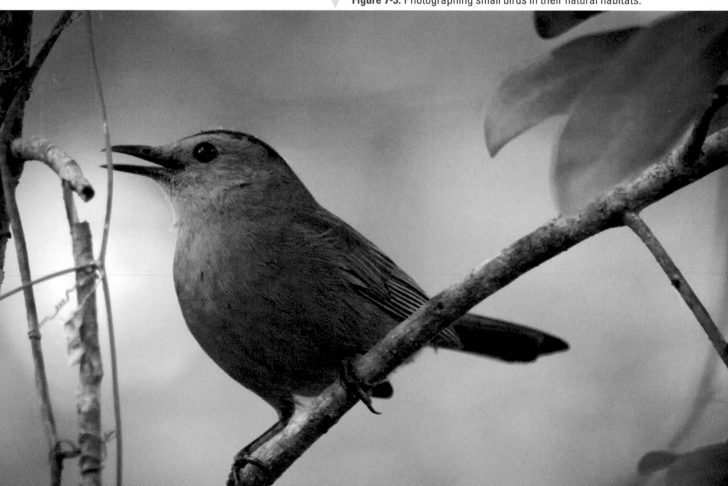

Here are some tips for photographing small birds in the wild:

- **Observe and learn the habits of your subjects.** If you're visiting a state park, you can find out a lot by talking with a park ranger. Ask her what area of the park you're likely to find a particular species of bird and find out when they're most active.

- **Disable the beep that occurs when your camera achieves focus.** The beep may frighten the bird you're trying to photograph. You can disable the beep on most cameras using a menu option.

- **Design your approach based on the species you're photographing.** If you're photographing nesting birds or protected species like burrowing owls, respect your subject. Photograph them, but don't get too close. If you get too close to nesting birds, they may abandon the nest. The only cure for not scaring birds is investing in a longer lens. The focal length depends on the species you're photographing. As mentioned earlier in this chapter, a focal length of 200mm is ideal for large wading birds, but you'll need at least a 400mm lens to photograph shy birds or birds of prey.

 If the birds start fidgeting or squawking, you're too close.

- **Listen.** If you know the song the bird you want to photograph sings, you can start looking for where the bird is when she sings. You can learn bird sounds and other information about birds at www.whatbird.com.

- **Use natural cover.** When you find an area that's frequented by the type of bird you want to photograph, find an area where you can set up shop. Trees or bushes can be a good place to hide. Make sure the distance from your hiding place to the birds you want to photograph is within range of your longest telephoto lens, and make sure that your hiding place is not the home to some other animal that could be potentially harmful, such as a snake.

- **With a photographer buddy, take turns driving through an area where small birds are frequently sighted.** When your friend drives, you can look ahead and notice anything that's different. Small birds will light on fence posts, barbed wire, and low tree branches. When you see a bird, tell your friend to stop. After your buddy makes one pass through the park, switch places so she has a chance to photograph, too.

- **Change your camera to Aperture Priority mode and choose an aperture of f/4.0 to f/6.3.** This gives you a limited depth of field that draws your viewers' attention to the bird.

- **Focus on the eye of the bird that is closest to the camera.** If the eye nearest the camera is in focus, the entire picture appears sharp because viewers will be drawn to the eye before they look at anything else in the photo. If the eye is out of focus, the entire image appears to be out of focus.

- **Switch to Continuous Auto-Focus mode to photograph birds on the move.** When you choose this mode, the camera updates focus as the bird moves.

✔ **Switch to Continuous Drive mode.** In this mode, the camera captures images as long as you have the shutter button fully depressed. This is another way to hedge your bets when photographing active birds.

Bird Portraits

Birds are photogenic. Eagles are majestic, herons are stately, sandhill cranes are gangly birds that are the Curly Howards of the bird kingdom. I'll probably catch some flack from sandhill crane lovers over that comment, but one look at their antics and you can't help but grin. And the whooping sound they make as they fly . . . At any rate, I rest my case on sandhill cranes.

Some birds are just naturally born hams. They'll stay put until you're almost within touching distance. Birds that are used to the presence of humans, and occasionally get a handout, such as pelicans, will stare you right in the eye as you take their picture (see Figure 7-4).

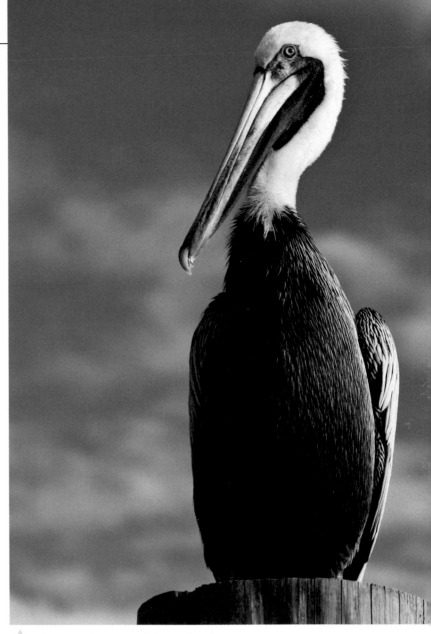

▲ Figure 7-4: Creating a bird portrait.

Tips for capturing bird portraits

Some birds make it difficult for you to get a portrait. Some stay hidden in trees, and some are quite skittish. But when a bird stays put out of curiosity

or doesn't feel intimidated by the silly human with the goofy third eye, you have a golden opportunity to capture great pictures. Here are some tips for capturing great portraits of birds:

- **Use a long focal length of at least 150mm.** A zoom telephoto lens with a range of 70–200mm is ideal. This lets you zoom in tight on your feathered friend.

- **Switch to Aperture Priority mode and choose a medium aperture with an f-stop of f/7.1.** This ensures that you have sufficient depth of field to see every detail of the bird's face but to still render the background as an out-of-focus blur with a telephoto lens.

- **Switch to an ISO setting that yields a shutter speed that is the reciprocal of the 35mm equivalent of the focal length you're using to photograph the bird, even if the camera is mounted on a tripod.** If the bird makes the slightest movement, or you make the slightest movement and you're shooting at a slower shutter speed, the bird will be blurry.

- **Enable image stabilization if your camera or lens has this feature.** If your camera is mounted on a tripod, image stabilization is not necessary, and may actually be counter productive.

- **Switch to Continuous Auto-Focus mode.** In this mode, the camera automatically updates focus if the bird moves.

- **Switch to Continuous Drive mode.** In the event the bird decides to fly away, you can capture a sequence of images as it leaves the cuckoo's nest.

- **Switch to a single auto-focus point and achieve focus on the eye that is closest to the camera.** If the eye nearest the viewer isn't in sharp focus, the entire image appears to be out of focus.

- **If possible, photograph birds on an overcast day, or when the bird is in the shade.** Harsh overhead light is not flattering for any type of picture.

- **Choose times of day when the light is softer and more diffused.** If you're photographing birds in broad daylight, capture your images in the early morning or late afternoon.

- **If you do photograph the bird straight on in broad daylight, make sure the front of the bird is illuminated.** If the light hits the bird on an angle, part of its head, including an eye, will be in shadow.

- **If you're photographing the side of the bird's head in broad daylight, make sure the side of its head is completely illuminated.** If the light is coming from a different angle, parts of its head may be in shadow.

 You can shed some light on your subjects with an auxiliary flash unit and a product called Better Beamer, which is available for several flash units (www.bhphotovideo.com/c/search?Ntt=VISUALECHOES&N=0). The device uses a Fresnel lens to magnify the flash to illuminate distant subjects like birds in trees. The Better Beamer is designed to work with lenses that have a focal length of 300mm or longer.

Silhouette bird portraits

You can capture a stunning silhouette portrait of a bird. Many birds, such as herons, egrets, and pelicans, have distinct shapes and are perfect candidates for silhouette portraits. For this type of portrait, you want the sun low in the sky and behind the bird. Here's how you get good silhouette portrait:

1. **Decrease the exposure by –2 EV using exposure compensation.**

 The camera will attempt to expose the area of the scene upon which you lock exposure at mid-tone. This is exactly the opposite of what you want. Your goal is a nice dark saturated background that will render the bird as a rich black.

2. **Switch to a single auto-focus point, point the camera at the bird, and press the shutter button halfway to achieve focus.**

3. **Take the picture.**

4. **Review the image.**

 If the bird isn't a dark black, and the background doesn't have richly saturated color, decrease the exposure even more and take another picture. You may have to go as far as –3 EV to get an image you're satisfied with.

Wading Birds

If you live near a lake, river, stream, or the ocean, you have a wonderful opportunity to photograph wading birds. The type of bird you find depends on the area in which you live. In Florida, we typically see great blue herons, great egrets, snowy egrets, black crowned night herons, and yellow crowned night herons. We also see anhinga, cormorants, and roseate spoonbills. The type of bird is also determined by whether you're photographing in a body of water that is fresh water, brackish water, or salt water. You may also see birds of prey like eagles, hawks, and osprey circling overhead, ready to pounce on a fish for a meal in the area. The diversity makes this type of photography exciting.

Understanding the habits of wading birds

After you read about the habits of wading birds and/or study them online (as I describe in the "What You Need to Know Before Capturing Great Photos of Birds" section, earlier in this chapter), the next best thing is to observe them. Go to an area where, based on your research, wading birds hang out. Bring your camera! As you photograph the birds, note their behavior. See how close you can get to the birds before they fly away. Experience is always the best teacher.

If your research tells you that you're likely to find birds in a nearby state park, visit the park. Before you embark on your birding safari, ask the park rangers for information. This can save you a tremendous amount of time. You'll learn where the birds are. You can also ask the park rangers if any dangerous animals inhabit the same area. Nothing beats being prepared and informed.

If you live in a state where anhingas live, you're in luck. Anhingas don't have waterproof wings. Their wings have to dry before these amazing birds can fly away (see Figure 7-5).

Tips and settings

Wading birds are interesting subjects for nature photographers. They have tall spindly legs like stilts that keep their bodies high above the waters in which they fish. They also have pointy beaks that they use like harpoons to impale their dinner prior to eating it. They're also very stealthy. Watching a heron stalk its dinner is an amazing sight. With camera in hand, you can capture this magic. Here are some tips for photographing wading birds:

- **Get to the bird's level.** This often means lying prone. For your safety and protection, consider draping a cheap poncho on the ground before you become one with the ground. This protects you against moist ground, things that crawl, and so on.

 Never lie down in thick brush, even with a poncho. The last thing you want to do is disturb a venomous snake in the grass that may be looking for a meal. If you're photographing in a park or wildlife management area, check with a park ranger for information about potentially harmful animals or snakes that inhabit the same area as the birds you want to photograph.

- **Disable the beep that sounds when your camera achieves focus.** The sound may scare the bird and cause it to fly away before you get your shot. Most cameras give you the option to disable the beep from the camera menu.

- **Wait.** Wading birds literally drop in and start feeding. If nothing's happening, wait a few minutes and some subjects may fly in.

- **Find a spot where you aren't in the bird's direct line of sight.** If the bird can see you and your equipment, it's more likely to depart the area. If you stay behind trees or at a fair distance from the bird with your trusty telephoto lens, the bird is more likely to continue its activities.

- **Look for wading birds asleep during the day.** You can find them perched in trees or mangroves during the day. At dusk they come out to feed.

⌐ **Go to where the wading birds find their fish dinner.** Wading birds are fishermen. They're active at the same time the fish are active, they fish in shallow water, and — obviously — they go where the fish are. This means you'll find them close to shore at feeding time or perched on a branch or rock near the shoreline. And because fish congregate underneath the docks, this is an excellent area to photograph wading birds. Find an isolated dock off the beaten path where other people won't spook the birds you're photographing.

Some wading birds like ibis can be found in neighborhoods near the coast. I've seen flocks of ibis grubbing for worms in my backyard during rainy season. If you have the good fortune to live in a neighborhood where wading birds have been seen, have a camera ready at all times. You never know when a photo opportunity will literally pop up just outside your window. When wading birds show up in an unusual locale, take pictures immediately. They're just passing through and you may not see them there again.

⌐ **Photograph wading birds in Shutter Priority mode, using a shutter speed of 1/250 of a second or faster.** The relatively fast shutter speed freezes the motion of the bird as it dives for its prey.

⌐ **Shoot in Continuous Focus mode and switch to a single auto-focus point.** Birds move when feeding. After you press the shutter button halfway to achieve focus, the camera updates focus as the bird moves. The single auto-focus point gives you the capability to focus with laser precision. Focus on the bird's eye.

⌐ **Use a long focal length to photograph wading birds that are feeding.** The long focal length lets you zoom in from a distance without spooking the bird.

⌐ **Shoot at an ISO setting that yields an aperture with an f-stop of f/7.1 or f/8.0.** Coupled with a long focal length, this gives you an adequate depth of field to render all the details on the bird, yet the background is still a soft blur.

⌐ **Shoot in Continuous Drive mode.** This enables you to capture an image when the bird is in peak motions. When the bird starts doing something interesting, press the shutter button and hold it down to capture a sequence of images. If you're patient and lucky, you'll capture one or more images of the bird spearing its prey and then eating it (see Figure 7-6).

⌐ **Wait a few seconds after a bird stops feeding.** When the water stills, turn your camera 90 degrees and then take a picture of the bird and its reflection in the calm water.

Birds are inquisitive and they will put things in their beaks that they shouldn't. Don't leave an empty bottle or bottle caps. These can prove deadly to birds. If you bring any type of food or drinks with you, keep your litter with you.

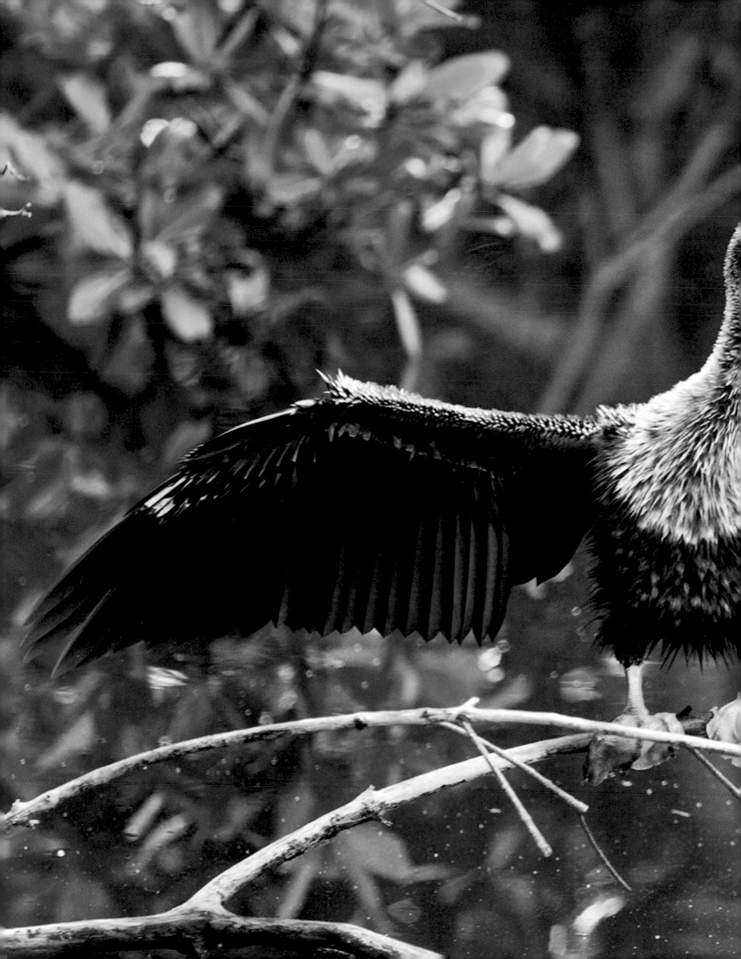

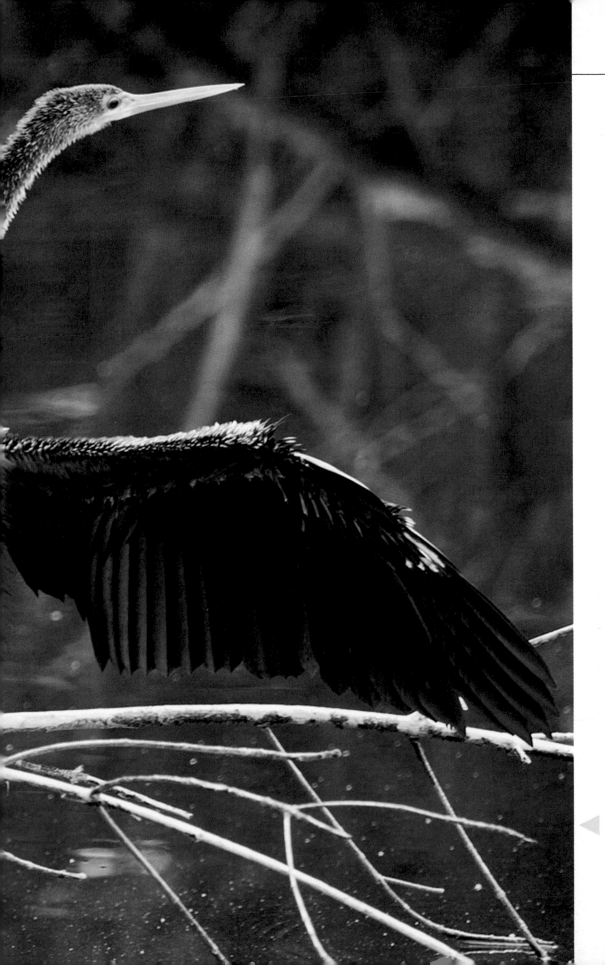

Figure 7-5:
Photographing
birds that are
native to a
specific area.

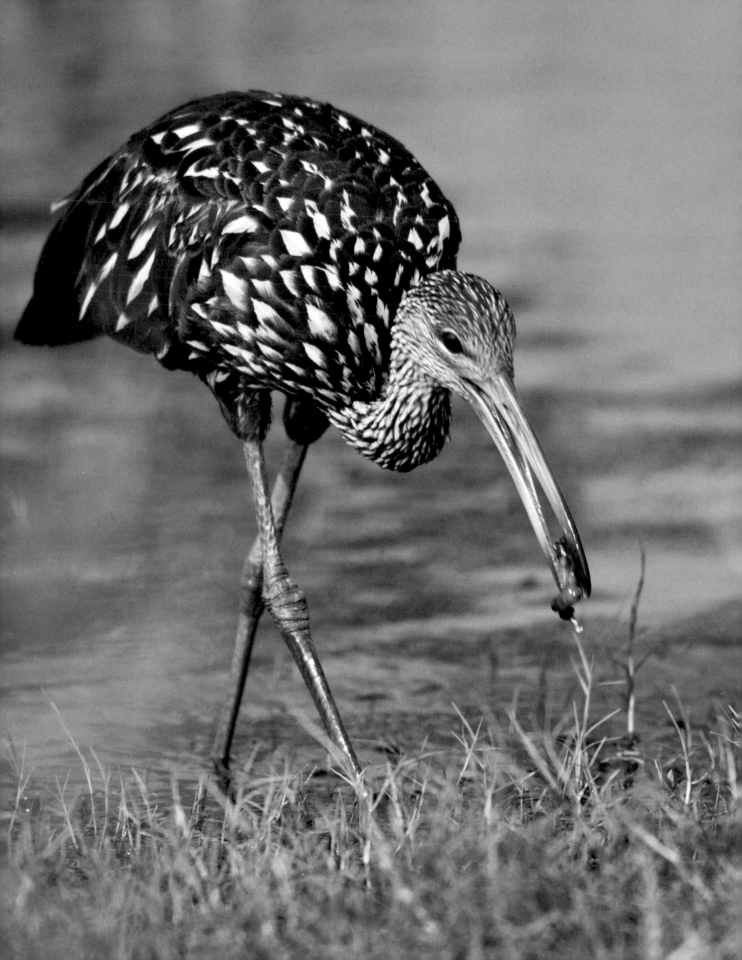

Birds of Prey

Birds of prey like hawks, eagles (see Figure 7-7), and kestrels are sleek, fast-flying birds that feed on small animals, snakes, fish, and rodents. Birds of prey can be found in surprising places. Depending on where you live, you may find birds of prey in your neighborhood. I often hear and see red-shouldered hawks where I live.

Learning the habits of birds of prey

You'll be better prepared to photograph birds of prey if you know where to find them and know something about their lifestyles. You can find this information in books or through your local Audubon Society. You can also do an online search to find out about birds of prey in your area. At the risk of being redundant, I'll stop here. If you haven't read it already, you'll find more information about learning the habits of birds in the "Understanding the Habits of Wading Birds" section of this chapter. Use the same technique to learn the habits of birds of prey.

Tips and settings

You'll find birds of prey where you least expect them. During the day, they may be high in the sky, circling overhead. You also find birds of prey in many of the same places you photograph landscapes. As you're riding through a park, look for differences in the landscape and listen for the cry of the bird you want to photograph. Birds have unique songs. With a bit of experience, you'll be able to differentiate the cry of a hawk, osprey, or eagle. When you hear the cry of the bird you want to photograph, figure out the direction from which the sound is coming. Birds often call to their mates. A female eagle will call to her mate when she wants a break from nest sitting.

As a reminder, you can find out lots of information from photographers in your area and your local chapter of the Audubon Society. Believe it or not, one of the birding hotspots where I live is the local landfill. Many species of birds, including eagles, visit this location. I often spot them in the trees on the border of the landfill and on top of the utility poles.

Figure 7-6: A limpkin eating its dinner.

Figure 7-7: Birds of prey are fascinating subjects.

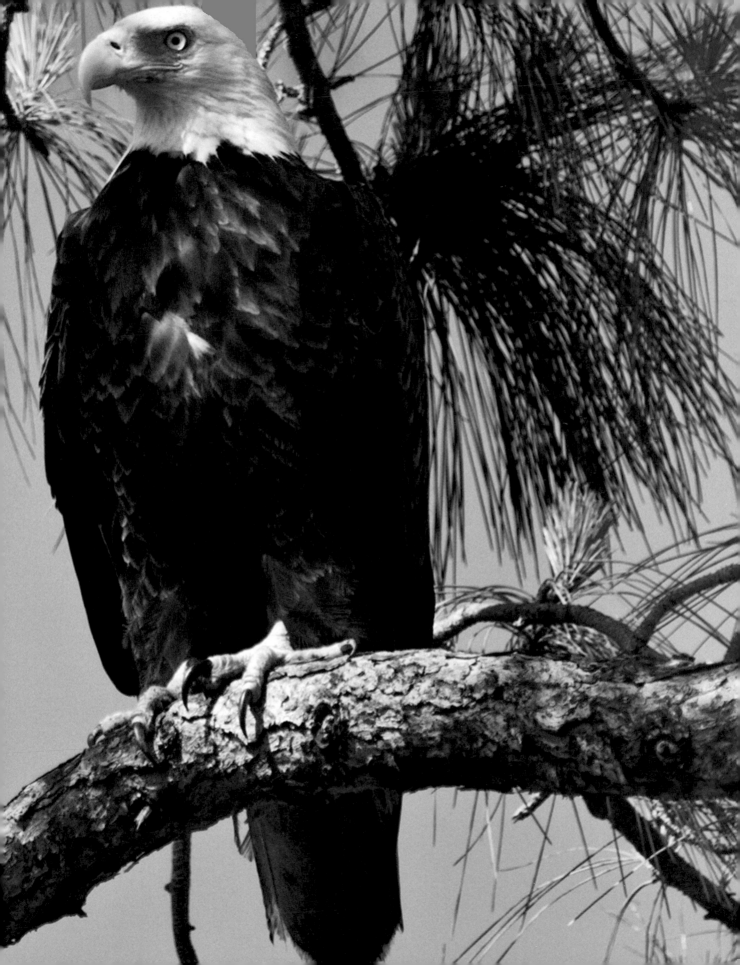

Here are some tips and settings to use when photographing birds of prey:

- **Listen for the bird's distinct cry.** You can find information about birds of prey and the sounds they make or hear recordings of the sounds they make at www.whatbird.com/. You can also purchase field guides for the Android, iPhone, iPod, or iPad from www.audubonguides.com/index.html.

- **Look for differences in the trees.** Bald eagles have a distinct white crown that you can easily spot if you're looking in the right direction. Instead of rushing helter-skelter when you don't see a bird, slow down, or stay in one spot and continually scan the area around you.

- **Use the longest telephoto lens you have.** Birds of prey perch high in trees and fly high in the sky. In a photographer's perfect world, you could get close enough to photograph birds of prey with a 150mm lens, but the truth of the matter is you'll need a lens with a focal length of at least 400mm to get decent shots of birds of prey.

- **Use Aperture Priority mode if you're shooting stationary birds.** Switch to an f-stop of f/8.0. Combined with a long telephoto lens, this gives you a very shallow depth of field to render the background as a soft out-of-focus blur.

- **Switch to a single auto-focus point and, if possible, focus on the eye closest to the camera.** If the eye closest to the camera is not in focus, viewers assume the entire image is out of focus.

- **Switch to Continuous Auto-Focus mode.** If the bird moves after you achieve focus, the camera automatically updates.

- **Switch to Continuous Drive mode.** Doing so will enable you to capture a sequence of images when the bird moves or flies away.

Birds in the Nest

Life goes on. Birds are egg bearers and build nests to hatch and raise their chicks. Birds propagate the species in areas where they can find materials and a sheltered area for building nests and tending to the eggs during the gestation period. These areas are known as rookeries and are a great place to capture compelling images of birds. If you've never photographed large birds in a nest and I've piqued your curiosity, do an online search for "rookeries" in your state. If you're lucky enough to have a rookery within driving distance, you're in for a treat. At a rookery, you get an opportunity to see bird family units. You can follow the process from week to week as the birds build their nest and protect the eggs from predators, and then observe the chicks after they hatch (see Figure 7-8). I'm fortunate enough to have a rookery that's just a five-minute drive from my house.

Figure 7-8: Mother and child reunion.

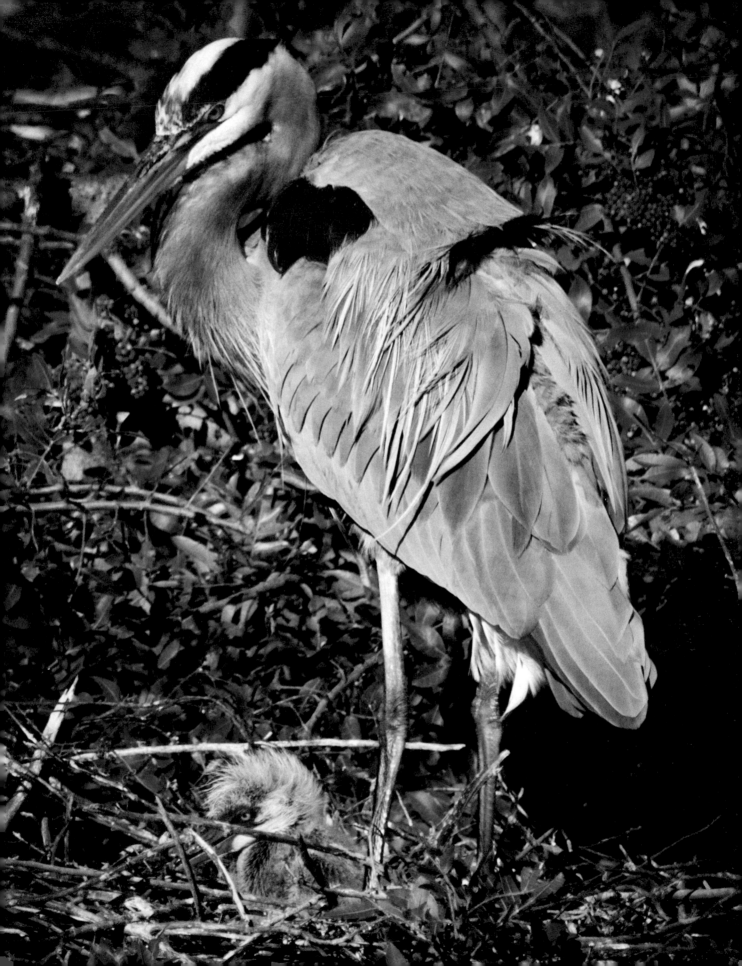

A rookery may be home to many species of birds. Birds of a feather congregate together. Different species congregate in different areas of a rookery. Rookeries are like bird condominiums. Here are some techniques for photographing birds in a rookery:

- **Scout the rookery's location a day or two before you get ready to photograph the birds.** Notice where the nests are and the direction from which the sun is shining. This will also tell you the best time to photograph the birds.

- **Photograph the birds at the beginning of the mating season when they're setting up their nests.** The males will fly to the shoreline and pick up twigs and branches. They hand off the building materials to their mates and the nest is built. You'll also get some great photos when the birds repair their nests.

- **Stick around into the late afternoon when the birds often return en masse from the day's activities.** You'll get great pictures even if the birds are backlit.

- **Use a long telephoto with a focal length of 400mm or a medium telephoto with a focal length of 200 with 2X tele-extender.** If you can afford a longer lens, you'll be able to get even closer. Shy away from mirror reflex lenses. The low price point makes them look attractive, but the image quality leaves a lot to be desired.

- **Mount your camera on a tripod.** When you photograph birds in a nest, the slightest camera movement results in a blurry image.

- **Disable image stabilization if your camera is mounted on a tripod; otherwise, use it to ensure a sharp image.**

- **Switch to a single auto-focus point and focus on the bird's eye that is closest to the camera.** If the eyes are not in focus, the viewer thinks the entire image is out of focus.

- **Arrive early and set up before the birds wake up.** This often means getting there before the sun rises.

- **Watch for other birds stalking the area for an easy meal of chicks.** Birds are fiercely protective of their chicks; you may have the opportunity to photograph a bird defending its nest.

Birds in Flight

Birds in flight are great subjects for nature photographers. When you're photographing a bird in the nest or at rest, the bird may soon take off in search of food or to pick up building material for a nest. This type of opportunity is the best of both worlds: You get to photograph birds at rest, at work, and in flight. Photographing birds in flight takes practice and anticipation (see Figure 7-9).

Tips and settings

When you get to an area where birds congregate, get ready to photograph birds in flight. Here are some tips and camera settings for getting great images of birds:

- **Use exposure compensation if needed.** If you're photographing a bird that is flying overhead, the underside of the bird may be dark. If so, use exposure compensation to increase the exposure. The resulting image may have blown-out highlights in the sky behind the bird, but the bird will be properly exposed.

- **Use the longest telephoto lens you have.** It's difficult to get close to a flying bird. You'll need at least a 400mm focal length to get close enough to get a good picture. You can get by with a 200mm telephoto lens and a 2X tele-extender.

Figure 7-9: Photographing birds in flight.

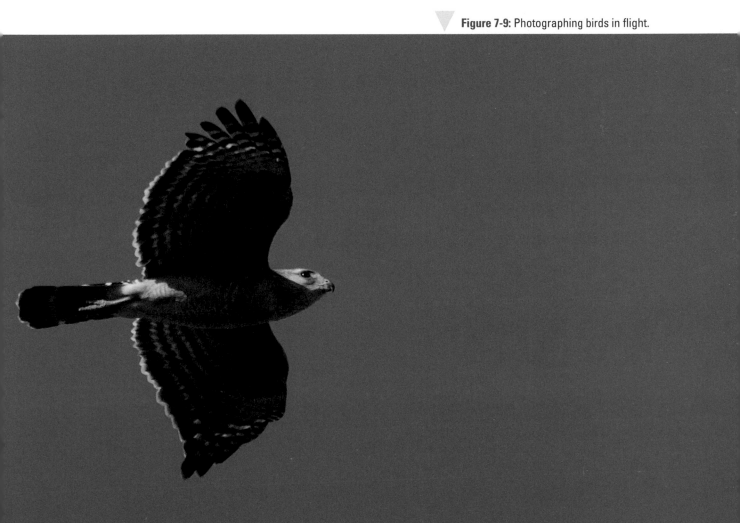

- **Shoot in Shutter Priority mode and use a shutter speed of at least 1/1000 of a second or faster.** The fast shutter speed freezes the motion of the bird.

- **Switch to Continuous Auto-Focus mode.** In this mode, your camera updates focus as the bird flies closer to or farther away from you.

- **Switch to Continuous Drive mode.** When shooting in this mode, the camera captures images as long as you have the shutter button fully pressed. You can capture a sequence of images as a bird takes off and lands, or you can capture a series of images of the bird in flight.

- **Use image stabilization to compensate for any movement when your arms get tired after tracking birds with a long telephoto lens.** You'll find image stabilization especially beneficial when you're doing a lot of shooting.

- **If possible, leave more room in front of the bird than behind the bird.** This gives viewers an idea that the bird is going somewhere.

- **Anticipate the bird's movement.** Birds often lighten their load just before taking off.

Panning to capture birds in flight

When you photograph birds in flight, you have another option. You can take a photograph in which the bird is sharp and in focus, but the background is blurred. This type of photograph shows the artistry of a bird in motion. To photograph a bird in flight and depict the beauty of motion, follow these steps:

1. **Switch to Continuous Auto-Focus mode.**

 This enables your camera to continually focus on your subject as it moves closer to or farther from you.

 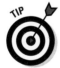

 Enable image stabilization if your camera or lens has this feature. This stabilizes the motion of the camera as you pan with your subject, which yields a sharper image.

2. **Switch to Shutter Priority mode and choose a shutter speed of 1/80 second.**

 You may have to use a slightly higher shutter speed if you're using a focal length that is the 35mm equivalent of 200mm or greater.

3. **Spread your legs slightly and move your elbows to the side of your body.**

 If you're using a digital SLR, cradle the barrel or the lens with your left hand and position your right forefinger over the shutter button. This helps stabilize the camera as you pan with your subject.

4. **Pivot from the waist toward the direction from which your subject will be coming.**

5. **When your subject comes into view, press the shutter button halfway to achieve focus.**

6. **Pan the camera with the bird to keep it in frame.**

 When you photograph an object in motion, it's a good idea to have more space in front of the object than behind it. This shows your viewer the direction in which your subject is traveling.

7. **Press the shutter button all the way when your subject is in the desired position and follow through.**

 If you stop panning when you press the shutter, your subject won't be sharp.

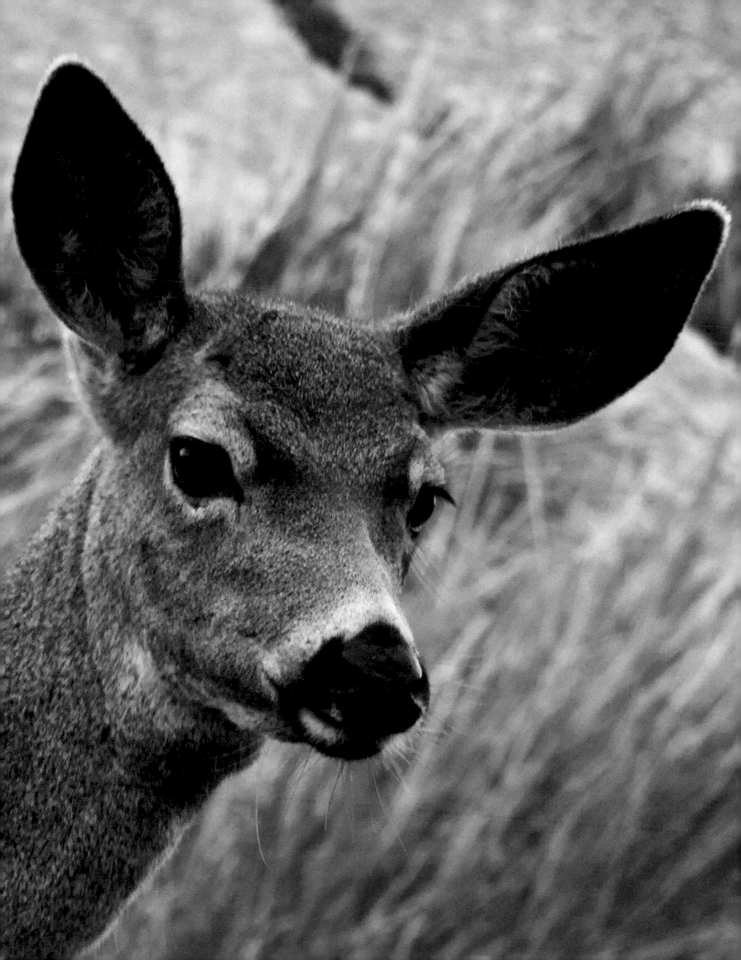

8

Animals

*P*hotographing animals is exciting. Photographing wild animals is similar to hunting, yet your prey survives to live another day. When you photograph wild animals, you need to know something about the species you're photographing. You need to know where they live, when they feed, when they mate, and what type of equipment and settings to use when you photograph these beautiful animals. So if you're ready to go on safari with your camera, read on.

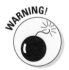

You also need to know what to do to protect the photographer — that would be you — and the wildlife you're photographing to prevent harm from coming to either of you.

Animals in State Parks and Wildlife Reserves

State parks and wildlife preserves are wonderful places that national and local governing agencies had the foresight to protect for future generations to enjoy. In these places, animals get to roam in their native habitats with only minimal intrusion from man. When you visit one of these areas, you get to see what the area looked like before man intruded and littered the land

with condominiums, high-rise buildings, and shopping malls. State parks and wildlife preserves are wonderful places to visit and wonderful places to capture compelling photographs of wildlife.

State parks offer different amenities. Some state parks have miles of paved roads, which make it relatively easy to find your way around. Other parks are relatively secluded; you drive in, park, and pick a hiking trail, and then go off in search of wildlife to photograph. In my opinion, the best state parks and wildlife reserves are those that have a combination of paved roads and paths. If you're lucky, you may see the occasional animal while you're driving on the paved roads, but they'll be in the distance — probably out of reach to all but the longest lens. When you hike a trail that leads into the wilderness, you stand a better chance of finding wildlife that you can photograph with a moderate telephoto lens with a focal length that is the 35mm equivalent of 300mm. The farther along the trail you go, the more likely you are to find wildlife.

You also find wildlife near bodies of water. If the state park or wildlife reserve has a river or lake, you can find animals like the turtles shown in Figure 8-1 congregating for a meal.

Figure 8-1: Turtles waiting for dinner to swim by.

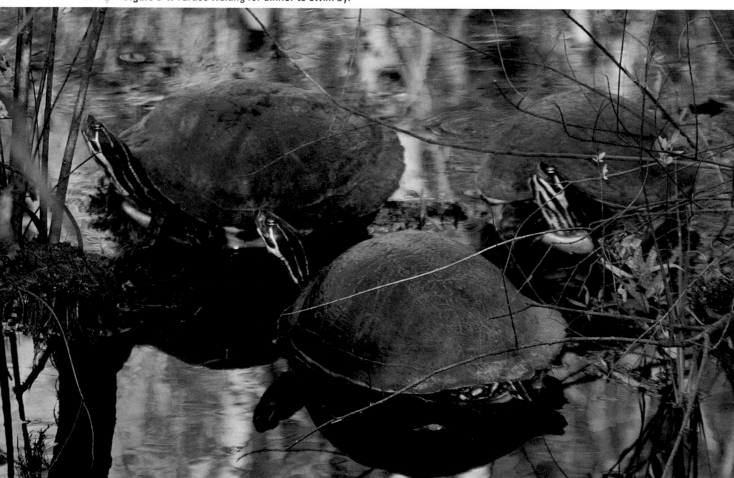

Finding places to photograph wildlife

Every state in the country has lots of state parks. The trick is to find the best ones that are near your home. This task is not as daunting as it may seem. You can find information about state parks and wildlife preserves in several places. Here are five suggestions to get you started:

- **Perform an Internet search.** Google the phrase "State Park" preceded by the name of your state, county, or town.

- **Join a local camera club.** Local camera clubs know all the hot spots for any type of photography in the local area.

- **Check with the local chapter of the Audubon Society.** Your local Audubon Society will be a wealth of information about wildlife and nature in your area.

- **Perform a search at a photography site such as Flickr.** Type in the name of your town or the nearest large town. Look at the photos that are displayed as a result of your search. When you see a photo that has wildlife you'd like to photograph, click it and look at the information included with the photograph. Flickr also gives you the option to search using tags, which gives you lots of photos to look at. For example, if you type in "wildlife" followed by the name of your town, the search returns photos with those tags.

- **"Friend" a wildlife photographer.** This can be done on a photography site or a social media site such as Facebook or Twitter. Photographers are pretty meticulous about recording information with their photographs, so you may find a couple of places to shoot based on the photos that turn up from your search. On many photography-sharing sites, you can request to be a contact or "friend" of the photographer. Choose this option and comment on the photographer's images. Photographers love to get feedback on their images and usually respond to the feedback. You may be able to pursue the online friendship further and get information about local wildlife photography hot spots.

Finding your subjects

After you find local areas in which to photograph wildlife, you need to find the wildlife, such as the deer shown in Figure 8-2. Sometimes you get lucky and find a spot that is loaded with wildlife. In other parks, you have to search for wildlife. In my experience, the latter is more likely to be the case.

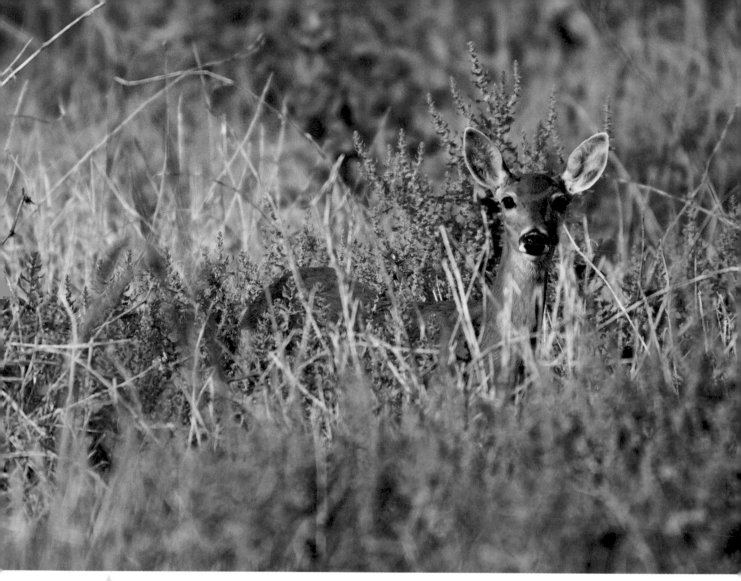

Figure 8-2: You have to go into nature to find nature.

Here are six things you can do to find wildlife when visiting a state park:

- **Ask a park ranger.** The easiest way to learn about the wildlife in a state park is to ask someone who knows the park intimately. An experienced ranger who has been in the park for at least a year can tell you what types of wildlife you can find there and what time of day they're most active.

- **Ask a photographer.** If you see a photographer with a camera bag and a digital SLR, you've probably found someone who is more than just a casual photographer. If you're in a public place and there are other people present, ask the photographer for some information. The worst thing he can do is ignore you, but chances are he'll share some information with you.

✒ **Look for telltale signs that animals have been around.** If you're on a trail, look for footprints in the dirt.

If you notice a smell similar to an uncleaned cage at a zoo, you've found an area that an animal has marked as its territory. I once stumbled upon a bobcat's lair. The bobcat didn't take kindly to the presence of my photography buddy and me. She snarled to let us know we were in her territory. We noticed the smell after we made an orderly retreat.

✒ **Listen.** If you know the sounds the animal makes, stop and listen. Sometimes you can hear the animal's footsteps as it disturbs the underbrush. Other animals, like bobcats and panthers, can walk through the woods without making a sound the human ear can capture.

✒ **Look for differences in the landscape.** The trick is to look for something that doesn't belong. If you see a swatch of tan in a forest, you've probably located an animal.

✒ **Listen for the animal's distinctive voice.** If you've done your research, you can identify your subject by its distinctive voice.

Learning your subjects' habits

In order to photograph a particular animal, you must know the habits of the species. You need to know where the animals you want to photograph live, what times they are active, the places they frequent at different times of the day, and so on. Without this knowledge, wildlife photography is a huge . . . uh . . . shot in the dark, and sometimes impossible — you can't photograph pika in Florida because they thrive in the cold and live at high altitudes.

The easiest way to learn the habits of a species is to do some research (note that several tactics that work for finding where to shoot also apply to learning your subjects' habits):

✒ **Go online.** You can do lots of research online by typing the name of the species in your favorite search engine. You'll come up with lots of results. This information, however, is to be digested with several grains of salt, especially if the website design is amateurish. If you find information from an official looking site, and the result is near the top of the search results, you can feel confident that the site has good information.

✒ **Talk to other people.** For more information about a species, you can ask photographers you know, rangers of parks where the species have been sighted, or members of local camera clubs. If you're lucky, a photographer may act as a mentor and ask you to go out shooting with him. If you get an invitation like this, be like Grasshopper and soak up everything your master has to show you.

When you do go out on a shoot with someone who knows more than you do, ask questions, but don't interrupt your mentor when he's setting up a picture. Sit back and watch. Ask questions when your photography teacher takes a break. And don't be a "Chatty Cathy." Nothing interrupts a photographer who's on a mission worse than banter about anything but photography.

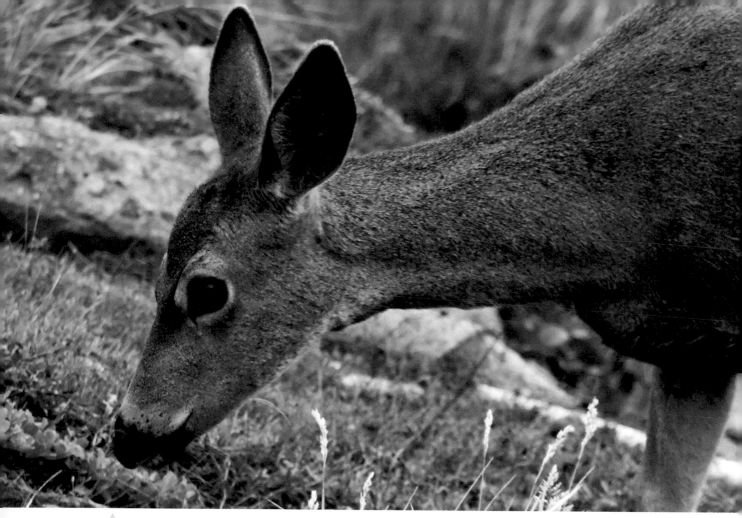

Figure 8-3: Get as close as possible and zoom in.

- **Study the animals.** When you're researching the animals you want to photograph, learn these things:

 - How to identify the paw prints they leave
 - What time of day the animals feed

 You can get interesting close-ups of animals feeding, as shown in Figure 8-3.

 - When the animals' mating season is and when they give birth
 - Sounds the animals make

 When the animal sounds off, you know it's time for action. You should also know the sound your prey makes when it is angry or feels threatened.

- **Read a book.** If you live in North America, Peterson's *Field Guide to Mammals of North America*, Fourth Edition, by Fiona Reid is a good resource. The book is authoritative, yet small enough to carry when you go on a photo shoot.

Camera Settings for the Wildlife Photographer

When you photograph animals, if you spend time fiddling with camera controls, you lose the shot. Make sure your camera is ready before you see an animal you want to photograph. Then it's a simple matter of raising the camera to your eye and taking the picture. Here are settings to use when photographing wildlife:

- **Camera shooting mode:** Choose Aperture Priority mode when photographing animals at rest or Shutter Priority mode for animals on the move. These controls are on your camera dial. If you know your camera well, you can switch gears quickly and change camera modes if resting animals move and vice versa.

- **ISO setting:** Choose the lowest ISO setting for the available light.

- **Auto-focus point:** When photographing wildlife, choose a single auto-focus point in the center of the frame. A single auto-focus point enables you to pinpoint your focus on the animal. This is especially important if you're photographing close-ups of an animal, in which case you focus on the eye closest to the camera.

- **Drive mode:** Choose Continuous Drive mode. This enables you to squeeze off several shots in succession, which can make the difference between getting a great shot and capturing a ho-hum image. For example, if you photograph a great blue heron feeding her offspring, press the shutter button when the feeding begins and you'll get a lovely sequence of images.

- **Tripod:** Mounting your camera on a tripod ensures you'll get a sharp image. While this is not practical for shooting animals in motion, it works very well if you happen upon a herd of deer grazing in the wilderness.

Tips and Tricks for Photographing in Parks

You may think photographing animals in parks would be easy to do. However, many parks are huge, sprawling over miles and miles of real estate. This means timid animals can more easily hide far from the beaten path trodden by the humans who invade their territory. When you run into animals when you're hiking, in most cases, they'll be quite timid. Of course, there's the other side of the coin when you encounter an animal that is definitely hostile or aggressive. You'll find photo opportunities while hiking, but in some parks, because animals are used to seeing vehicles, you stand a better chance of getting good photographs of wildlife from your car. Here are other things to keep in mind:

✎ **Disable any camera sounds.** This includes the default beep that notifies you when focus has been achieved. The noise may spook the animal you're trying to photograph.

✎ **Use equipment that blends into the surroundings.** A brown, black, or khaki camera bag is a good choice. Black lenses also blend into the surrounding better than light-colored lenses. If you own a light-colored lens, purchase a camouflage skin that protects it and makes the lens less conspicuous. A black tripod is preferable over a silver one.

✎ **Visit the park when the animals you want to photograph are most active.** Many animals rest in the heat of the day and become active in the late afternoon. If your research didn't tell you when the animals are most active, ask a park ranger. And if your research did tell you when the animals are most active, it's still a good idea to talk to an experienced park ranger! She can tell whether or not the information is accurate.

✎ **Many animals can be photographed from park roads.** When you plan to photograph from inside a vehicle, make sure your gear is ready. Choose an ISO setting that's appropriate for lighting conditions. When you see an animal you want to photograph, quietly pull to the side of the road, compose your picture, and take the shot. When you plan to shoot from a vehicle, leave the windows open so you're ready for action. The sound of the window opening may also spook the animal you're trying to photograph. Rest the camera lens on the door frame or partially open window for added stability. If you rest the camera on your vehicle, turn the engine off so the vibrations don't blur the pictures you take.

If you're really ambitious, you can purchase camouflage netting and size it to your passenger window. Cut a hole through the screen for your lens.

If you photograph wildlife from a vehicle with another photographer, be a good buddy. Switch places so you each get equal shooting time. One photographer concentrates on driving and the other photographer keeps her eyes peeled for wildlife.

✎ **If you hike in search of your prey, wear clothing that helps you blend into the surroundings.** The animals you want to photograph will sense your presence, but blending in makes you less conspicuous.

Do not photograph wildlife in an area frequented by hunters during hunting season.

✎ **When you're hiking and you see an animal you want to photograph, squat down and slowly approach the animal, with your camera ready for action.** Don't walk straight toward the animal; meander as though you're doing something else.

Do not attempt to sneak up on potentially dangerous animals like bears and alligators.

If you do photograph in areas that are inhabited by dangerous animals, consider carrying a portable boat horn with you. The shrill sound can be used to scare off animals that may cause you harm.

- **Don't make any sudden moves.** Your actions should be slow, deliberate, and non-threatening.

- **Don't make eye contact with the animal.** When you feel you're close enough to get a picture, take it so you have one in the bank. Then move closer.

- **Move when the animal isn't looking at you.** If the animal makes eye contact, squat and then fiddle with your camera, or do something else non-threatening. Look away from the animal. Don't make eye contact when the animal spots you; otherwise, she may bolt. Use your peripheral vision to keep tabs on your subject. When your subject breaks eye contact, take one picture and then move closer.

- **When you move, pick your path carefully.** Don't walk over any dead or otherwise crunchy leaves or step on downed tree branches. Animals have acute hearing. Any unusual or loud noises alert your subject that you're on the move (then the animal will be, too!).

- **Move with the sun at your back if possible.** This prevents you from having to deal with a backlit subject.

- **Don't block the animal's escape route.** Some animals run for thick cover when trying to escape; others run uphill. If you've done your research and know the habits of the animal, you'll know which way they'll move when they feel threatened. If you block the escape route, you may put yourself in danger.

- **Watch the animal for visual clues.** Animals will give you a clue when they're ready to move. Some animals will twitch nervously, while others will look in the direction they're going to move. When you sense the animal is ready to move, act quickly and take some pictures.

Portraits of Animals

You can create wonderful pictures of animals by zooming in and taking a picture of the animal's head and shoulders. This type of picture is similar to a portrait of a person. You want the animal to be in sharp focus, against a background that is out of focus and doesn't compete with your subject. Creating a portrait of an animal requires patience and practice, just like any other form of photography. Here are 13 tips to get you pointed in the right direction.

- **Switch to Aperture Priority mode** and choose a large aperture (small f-stop value). This gives you a shallow depth of field.

- **Use a long focal length and zoom in close.** The focal length you use depends on your subject and how threatened the animal feels by your presence. If you're serious about photographing portraits of small or reclusive animals, invest in a long lens with a focal length that is the 35mm equivalent of 400mm or longer. A good tele-extender (1.4X or 2X) gets you even closer.

- **Use the stealth techniques** described in the preceding section when you set up the shot. Make sure the sun is at your back so the subject is not backlit.

- **Switch to spot metering mode** and position the auto-focus point over a middle tone if the subject is backlit. Lock exposure on that point and compose your picture. You'll blow out the highlights to pure white, but you'll get your portrait. The alternative is to underexpose the image and create a silhouette portrait of your subject.

- **Focus on your subject's eyes.** If one eye is closer to the camera than the other (in other words, the animal is not facing you head-on), focus on the eye closest to the camera. When you shoot a portrait with a shallow depth of field, it's important to have the eyes in sharp focus.

- **Choose the background carefully.** You need a background that contrasts well with your subject's colors. This may involve choosing a different vantage point.

- **Give your subject a place to look into** if you photograph a profile of your subject.

- **Don't center your subject.** Place your subject to one side of the frame and use the slope of your subject's neck to lead viewers into the picture.

- **Watch for hot spots or glare** in the background that could divert your viewers' attention from your subject. The human eye is drawn toward bright objects.

- **Take the picture from your subject's level.** If possible, position yourself eye to eye with your subject.

- **Make sure your shutter speed is at least 1/250 of a second.** This will compensate for any motion caused by the wind. You may have to increase your ISO level to achieve this shutter speed on a dreary day.

- **Frame your subject, if possible.** You can do this by including some out-of-focus objects in the background that are darker than your subject. Tree trunks make good frames.

- **Include some elements to place your subject.** This gives your viewers a sense of location. For example, if you're photographing a deer in the mountains, include some of the grass the animal feeds on and some of the rocks in the background. This gives viewers an idea of the harsh environment in which the animal lives. If possible, these elements should be reasonably sharp so the viewer can identify them (see Figure 8-4).

Sometimes a straight animal portrait isn't possible. However, you can get interesting close-ups of animals feeding, as I discuss earlier, in the section "Learning your subjects' habits" (refer to Figure 8-3). If you see an animal feeding, be very quiet. Get as close as possible, zoom in, and then take the picture. This is another time when it's important to include some of the background to give viewers visual clues to the animal's location.

The preceding tips seem like a pretty difficult set of parameters to follow with every wildlife portrait you take. You won't be able to achieve everything on the list, but if you do as many as you can, you exponentially increase your chances of getting a compelling image. The most important rule is to get your subject's eyes in sharp focus.

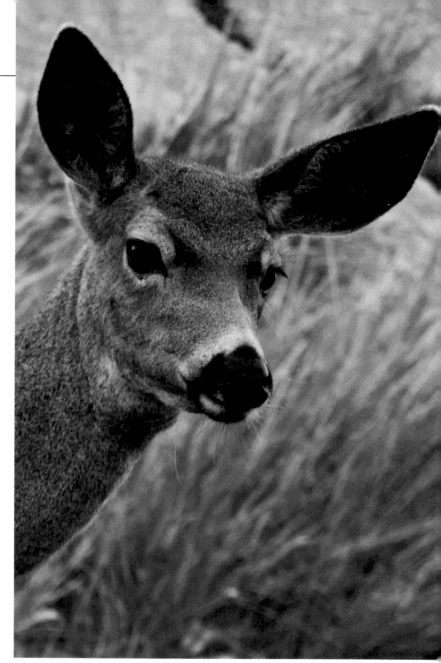

▲ **Figure 8-4:** Say cheese.

Animals in Motion

Animals don't stay in one place very long, at least not when they're out in the open. Animals constantly migrate from one place to another during the course of a day. Sometimes they move very slowly, such as when they're grazing. At other times, they may move swiftly, such as when they've been startled by a predator. And if the predator takes up chase, he'll be moving very fast as well. You have two ways to approach action photography with animals. You can freeze the action or create an artistic depiction of the animal's motion.

To freeze the animal's motion:

- **Shoot in Shutter Priority mode** using a shutter speed of at least 1/250 of a second if you're panning with the subject — faster if you're not panning and the subject is coming toward you.

- **Switch to Continuous Auto-Focus mode.** In this mode, the camera continually updates focus as the animal moves closer to or farther away from you.

- **Switch to Continuous Drive mode.** In this mode, the camera continues taking pictures as long as the shutter button is fully pressed. This gives you a sequence of images, which enables you to capture some frames where the animal is at peak motion with legs fully extended.

- **Pan with the animal.** If the animal is traveling from your left to your right or vice versa, pan with it. When the animal comes into frame, press the shutter button halfway to achieve focus, pan smoothly by pivoting at the waist, and then press the shutter button (see Figure 8-5).

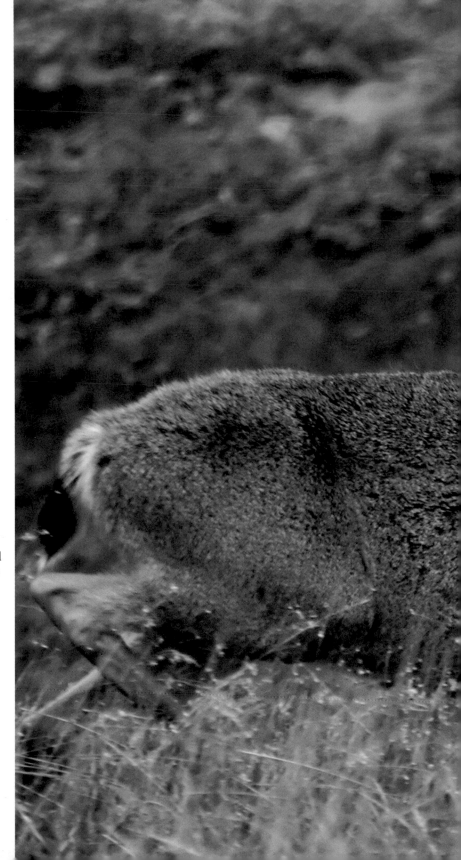

Figure 8-5: Pan smoothly with the animal as it moves.

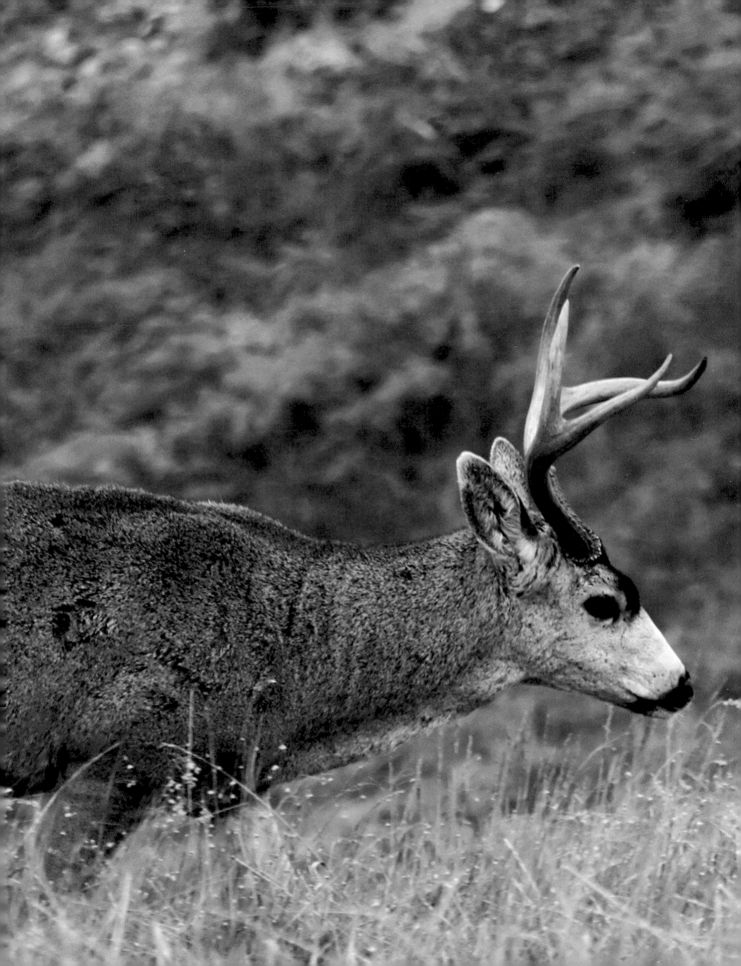

✔ **Follow through.** Keep panning even after you press the shutter button. If you stop panning when you press the shutter button, the image won't be as sharp as it could be.

✔ **Leave more room in front of the animal.** This gives your viewers a sense that the animal is going somewhere (see Figure 8-6).

To create an artistic photo of an animal in motion, use the same technique, with the exception of the shutter speed. Choose a shutter speed that's 1/15 of a second or slower. If you pan steadily, the animal's head will be relatively sharp, but the legs will be a blur of motion. If your lens has horizontal image stabilization, enable it. This compensates for any up-and-down motion when panning with the animal.

Figure 8-6: Where are you going, deer?

Dangerous Animals

Animals like deer and turtles are not usually a threat to man unless severely provoked. However, other animals are predators and can definitely pose a threat to a photographer. Alligators, bears, bobcats, and panthers, to name a few, are animals that you must photograph with extreme caution. Here are eight essential tips to keep in mind when you encounter a potentially dangerous animal you'd like to photograph:

- **Keep your distance.** The only way to photograph a dangerous animal is from a distance. Get as close as you safely can, and then use your longest telephoto lens. Remember that if you have a camera that captures lots of megapixels, you can do a bit of judicious cropping to remove extraneous background and still have enough pixels to get a good 8 x 10 print.

- **Stay downwind.** Animals have a keen sense of smell. If you're upwind from the animal, it will sense your presence. You have a much better chance of not being on the animal's radar if you're downwind.

- **Stay behind cover.** Stay in a place where you can photograph the animal but the animal cannot see you. Good research will tell you where the animals congregate and what time they congregate there. Arrive ahead of time and find a hiding place that is downwind from the animal.

- **Don't try to entice the animal.** Even many dangerous animals will have respect for someone as large as a human adult. However, if you try to entice the animal with food, or otherwise antagonize it, all bets are off. Besides, it's illegal to interact with dangerous animals in most states.

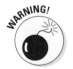

Some nature photography books suggest using peanut butter to entice animals, but this is not permitted in state parks. Another problem is that the scent stays on your fingers and in your clothes, which alerts animals to your presence. Bears in particular have a keen sense of smell. Being a "Bear Magnet" is not a good thing!

- **Always travel with a buddy.** A pair of humans is more intimidating than one. You and your buddy can watch each other's back.

- **Have an escape route.** When you decide to photograph dangerous animals, scout out the location before you set up and have an escape route that gives you quick access to safe grounds or a shelter. If a dangerous animal intimidates you, don't take time to break down a tripod. Take an orderly retreat to your haven and come back for your gear later. Camera gear can be replaced. Your life can't.

✏ **Photograph dangerous animals when they're feeding.** If you're lucky, you may find a place from which you can safely photograph animals feeding (see Figure 8-7). To get these types of pictures requires a bit of luck and a long telephoto lens.

✏ **Photograph a sequence of images.** Shoot in continuous drive mode when you find animals doing something interesting. Press the shutter button when the animal becomes active and capture a sequence of images (see Figure 8-8).

Figure 8-7: Photographing dangerous animals.

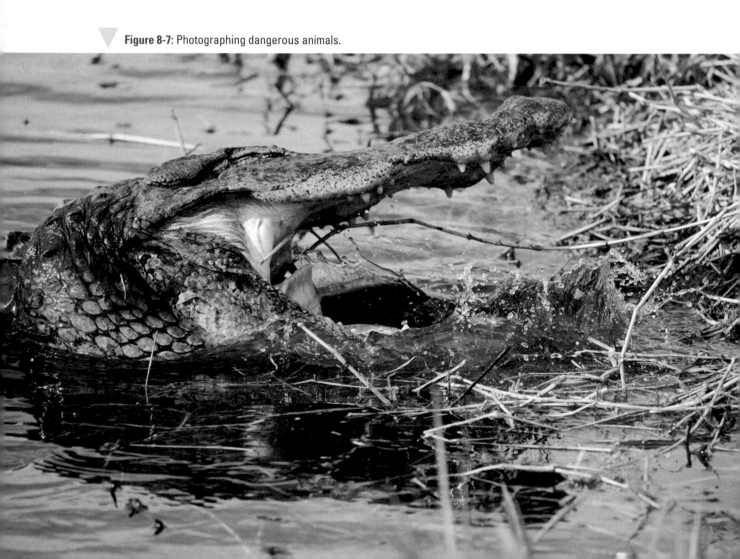

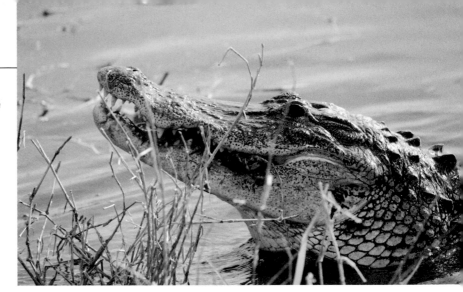

Figure 8-8: Photographing a sequence of interesting action.

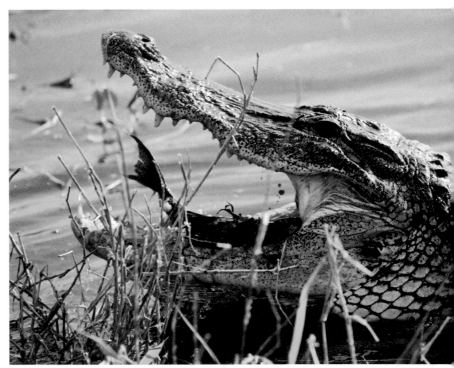

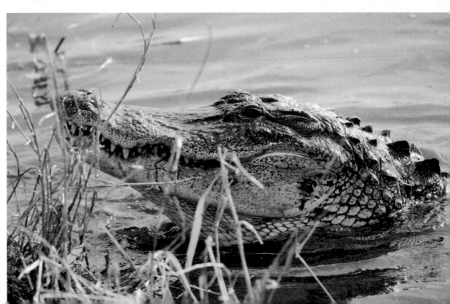

Taking Proper Precautions to Keep Both Animal and Photographer Safe

When photographers go into the wilderness in search of beauty and wildlife for that perfect photograph, it can and should be enjoyable, rewarding, and free of stress. It should also be a stress-free experience for the animals in the confines of that environment. Before you venture into the wild and wooly area in which you want to photograph wildlife and nature, consider the following:

- **Don't venture off the beaten path.** If you venture off park trails, or into underbrush, you run the risk of disturbing vegetation or blooming flowers. It's never a good idea to walk through dense underbrush; you may get exposed to poison ivy or disturb a poisonous snake. You may also come in contact with ticks and lice that may carry Lyme disease.

- **Be alert.** As you walk along the trail, be alert for any serendipitous photo opportunities, and also be alert for any situations that may put you in danger.

- **Use all your senses.** You use your eyes to see photo opportunities, but you engage your other senses as well. Listen for any unusual noises, like an animal growling. Animals are usually fearful of humans, but if you venture near the territory of a mama and her cubs, the mother will usually defend her cubs to the death. You'll get a warning first. When you hear it, make an orderly exit out of the animal's territory. Animals will also mark their territory. If you smell something that resembles a lion's cage in need of cleaning, get out of the area.

- **Beware of animals that are accustomed to humans.** In some parks, animals have become accustomed to humans. In many parks like Yosemite, bears are used to human presence and will break into cars or tents if they smell food. In many Florida state parks, alligators are used to seeing humans and can become quite bold.

 I once witnessed an alligator racing to shore to fight a cast net fisherman for his catch. The fisherman realized it was futile to resist so he let the alligator steal his fish. Had he not, he would have been in serious danger: The alligator was almost nine feet long and very well fed.

- **Don't feed the animals.** It's illegal to feed animals in every state park that I'm aware of. People think animals are cute, and so they toss them a slice of bread. What they don't realize is that they could be putting themselves in serious danger by what seems to be an innocent act. But when you feed animals, they lose their fear of humans. Ever hear of stories where bears or raccoons have ransacked a campsite? They're usually looking for food and may not be afraid of humans because they've been fed before. (Feeding wild animals also hurts the animals because they can learn to be dependent on humans rather than use their own natural hunting skills. Yes, it happens!)

- **Beware of animals that might have rabies.** Animals with rabies often exhibit strange behavior — such as stumbling, falling, or attacking inanimate objects — and have been known to come up to people.

If an animal that could be a carrier of rabies bites a person and the animal is not caught (for testing), the inflicted person is in for a painful series of injections. Rabies cannot be cured after symptoms appear and will result in death.

- **Get a weather forecast.** Never venture into the wilderness when storms are in the area. A sudden cloudburst can cause flooding conditions.

- **Scan the horizon.** Before you embark on a hike down a long trail, scan the horizon to see what's going on. Sometimes the weather forecasters get it wrong and a storm may be brewing. You may also see smoke on the horizon, which could designate a forest fire or a controlled burn. If you see storm clouds or smoke, note which way the wind is blowing and decide whether it's more prudent to hike somewhere else or go back home.

- **Get information from park rangers.** Park rangers know what's going on inside their parks. They can tell you if there's a controlled burn or if a trail you plan on traversing is flooded out.

- **Let someone know where you're going.** Tell a friend or relative where you're going and what time you expect to return. Make sure you call when you return so they don't call out the cavalry if it isn't needed.

- **Carry a mobile phone.** A mobile phone can save your life if you run into a predicament while you're out in the wilderness. If you're going to an area where there are no cellular towers, consider renting a satellite phone, especially if you're going to be hiking deep into the wilderness.

- **Be well hydrated.** Drink plenty of water before and during your photo shoot.

- **Bring provisions.** If you're going on a long hike, bring a bottle or two of water and some fruit or an energy bar.

- **Pack a small first-aid kit.** Carry a small first-aid kit with bandages and anything else that might be useful. If you're traveling into an area where you may encounter venomous snakes, bring a snake bite kit.

- **Wear suitable clothing.** If you're hiking in the woods, it's a good idea to wear long pants, even on a hot summer day. A long-sleeve shirt will protect your arms from low-hanging branches. Consider wearing a hat if you're hiking on a sunny day. If you're hiking in an area where there may be ticks, tuck your pants legs into your socks.

- **Protect your body.** Slather your face with sunscreen and protect any other exposed parts of your body. Getting sunburned on your neck and ears is not fun.

- **Use mosquito repellent.** Mosquitoes can carry nasty diseases. If you're venturing into an area where you may find mosquitoes, use mosquito repellent, or use one of the small fans that attaches to your belt or camera bag and sends out a fog of mosquito repellent.

- **Bring a compass.** If you're traveling way off the beaten path, a compass will help you find your way back home. There are also applications for mobile phones that act like GPS devices. As long as you have cellular service, the application keeps track of where you've been.

- **Mark the trail.** And I don't mean drop bread crumbs. That would be counter to earlier advice to not feed wild animals! If you take a fork in the trail (and no, I don't mean the kind with tines), tie a piece of cloth to a tree so you'll know which way to turn when you return.

9

Flowers and Insects

Nature takes many forms and sizes. Landscapes are big and don't move. Animals are smaller, and they do move. Birds are smaller yet, and they fly. Then you have really small creatures that either move very slowly (some do fly) or are rooted in the earth. In this chapter, I concentrate on the latter, nature's smallest inhabitants. This is the wonderful world of macro photography, or getting small. In addition to covering macro photography, I also discuss photographing nature's patterns. The final part of this chapter deals with a creative tool that nature photographers everywhere are embracing: the Lensbaby line of creative optics.

Wildflowers

The earth renews itself during the spring, recovering from the change of seasons. The dull brown monotone landscape becomes green, and colorful wildflowers dot the landscape (see Figure 9-1). This is a great time to get your camera and capture some wonderful images of nature. In some areas, you find wildflowers everywhere: in the woods, by streams, and even in natural storm water ditches. You also find wildflowers in mountainous regions. In the following sections, I share some techniques with you for photographing wildflowers.

Figure 9-1: Wildflowers dot the landscape in spring and summer.

Choosing the right equipment and camera settings

Some types of photography require special equipment. Flower photography falls into that category. For flower photography, you need these things:

✐ **The right camera and lens:** The best type of camera for flower photography is a digital SLR with a telephoto lens that focuses close. Many telephoto lenses have a macro mode, which enables you to get very close to the object you want to photograph. A dedicated macro lens with a focal length of 60mm or 90mm is the best choice, but a macro lens can be expensive. Using a good macro lens, you can create life-size (1:1 magnification) images of small objects like flowers.

✐ **A sturdy, lightweight tripod:** Carbon fiber tripods are wonderful, but they are a bit expensive. If you can't afford a carbon fiber tripod, get the lightest aluminum tripod your budget allows. Your tripod needs to be sturdy enough to support double the weight of your camera and heaviest lens. This gives you a bit of a fudge factor. If you purchase a tripod that supports only a bit more weight than your camera and heaviest lens, it won't be very stable. A stiff wind can also wreak havoc on a flimsy tripod. The legs will vibrate, which can cause images to be less sharp than they should be. For flower photography, you also want a tripod with these features:

 • *Collapses to a short height.* This enables you to get a low vantage point and photograph at the same level as flowers that are low to the ground.

 • *A reversible column,* which enables you to get the camera even lower to the ground.

 • *A spirit level.* Alternatively, you can purchase a small dual axis level that fits in your camera hot shoe.

 • *Interchangeable feet.* When you photograph in dirt, switch to the foot that looks like a spike so the tripod digs into the terrain.

When you photograph flowers, shoot in Aperture Priority mode. This enables you to control your depth of field. When you're shooting lots of wildflowers, you have two options: You can create a photograph where every flower is in sharp focus or where the flowers in front of the scene are in focus and the rest of the image is a dreamy blur (see Figure 9-2). To create the first type of photograph, use a small aperture and focus one-third to halfway into the field of wildflowers. This ensures that the entire field of flowers will be in focus. Create a dreamy look by shooting with a large aperture (small f-stop number). Focus on the flowers nearest the camera, and the distant flowers will be a creamy blur.

Figure 9-2: A field of wildflowers is a joy forever.

Shoot at the lowest ISO setting possible that yields a shutter speed of at least 1/200 of a second. I know what you're thinking: Why the fast shutter speed? Well, there are two reasons. First, when you photograph close-ups of flowers (see the "Photographing close-ups of flowers" section later in this chapter), any camera movement is magnified when you zoom in tightly. Second, if you're photographing flowers on a windy day, the fast shutter speed will freeze the motion of the flowers swaying in the breeze.

Photographing wildflowers in perfect light

Photography is all about finding the right light, and flower photography is no exception. You may think the perfect light for photographing wildflowers is the Golden Hour. That is a good time to photograph any subject, but the best light for photographing flowers is even shade or an overcast day. The scenario is slightly different when you're photographing a single flower. I show you the perfect light for photographing a solitary flower in the "Photographing close-ups of flowers" section of this chapter.

Finding the perfect vantage point

Finding the perfect vantage point for photographing flowers can be tricky. Most flowers are fairly low to the ground, which means that you need to get low and grovel with the flowers. If you shoot from a high vantage point, you don't capture the subtle details of the flowers. When photographing a field of wildflowers, you want to position your camera a few inches above the flowers and aim your camera into them. Your goal is to capture an image that shows the depth of the field of flowers. Even if you choose to go with a shallow depth of field, it's still a good idea to show that you're photographing lots of flowers and not just a single row of flowers.

Here's where a good tripod comes in handy. Lower the tripod so that it's just above the field of wildflowers and point the camera down. Where you aim and how high above the flowers you position the camera depend on the depth of the field of flowers. If the flowers are deep enough, you can create an image in which the flowers seem to go on forever. This type of image works well with either a large depth of field or a shallow depth of field.

Getting Small with Macro Photography

Photographing a single flower is an art unto itself (see Figure 9-3). This is similar to portrait photography. If you live in a temperate climate, you can find flowers just about anywhere in the spring and summer months. You find flowers in botanical gardens, in planters on windowsills of shops, and even in the most unexpected places, like drainage ditches. I show you the art of flower macro photography in the upcoming sections.

Photographing close-ups of flowers

When you photograph close-ups of flowers, you need a telephoto lens, with a short focusing distance, or a true macro lens. This enables you to zoom in tightly and capture the flower and a bit of background or to zoom in tighter to create a picture of the delicate parts of a flower: the stem, the petals, or the stamen. Here are six tips for photographing close-ups of flowers:

- **Set your camera on the same plane as the flower.** When you're photographing an extreme close-up of anything, you're dealing with a limited depth of field. If the camera is slightly tilted, parts of the flower will appear out of focus.

- **Shoot in Aperture Priority mode** using an aperture with an f-stop of f/8. If you choose a larger aperture (smaller f-stop value), the back of the flower will be out of focus.

✓ **Photograph a perfect specimen.** Let's face it; even a good photograph of a wilted flower won't garner rave reviews.

✓ **Photograph the flower against a contrasting background.** In most cases, you get your best results when you photograph a flower against a dark background. Even a dark colored flower looks best against a darker background.

✓ **Choose an ISO setting** that yields a shutter speed of 1/250 of a second when choosing an aperture of f/8. The fast shutter speed helps freeze action on a windy day and also compensates for any camera movement. Use a fast shutter speed even when you place your camera on a tripod.

✓ **Photograph flowers on an overcast day or in even shade.** This helps control the dynamic range (variation from light to dark tones) and yields more saturated colors.

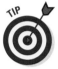

Carry a small 12-inch diffuser with you if you're forced to photograph flowers in bright light. The diffuser folds into a 4-inch circle that fits easily in most camera bags. Take the diffuser out of its case to extend it to its full diameter and hold it over the flower — instant shade.

Figure 9-3: Photographing a single flower.

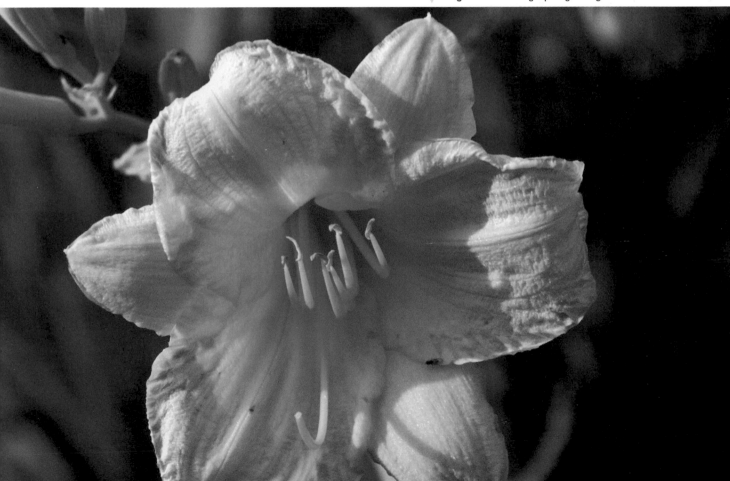

Adding a kiss of light

Sometimes you need to add a kiss of light to a flower photograph. A little bit of light can go a long way toward warming up an otherwise sterile picture. You can add some light to a photograph of a flower in the following ways:

- **Use a small handheld reflector to bounce light into a flower.** Purchase a small, 12-inch, two-sided reflector that is silver on one side and gold on the other. The silver side doesn't alter the color of the light. The gold side warms the light, giving it a golden hue like the light you get during Magic Hour. If you're photographing with a friend, ask your buddy to hold the reflector and rotate it until light splashes on the flower.

- **Use your auxiliary flash to add a splash of light to the image.** This cannot be done effectively with an on-camera flash unit. When you're photographing close-ups of a flower, the lens causes a shadow to appear on your subject. An auxiliary flash is higher and the beam of light doesn't strike the lens in such a way that a shadow is formed. You'll get even better results if you use a diffuser on your flash, such as the one from LumiQuest (www.lumiquest.com) in

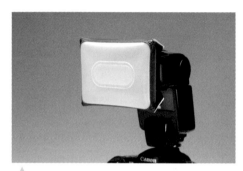

Figure 9-4: Diffuse the light of your auxiliary flash unit.

Image courtesy of LumiQuest

Figure 9-4. This increases the size of the light source and creates a more diffuse light.

TIP

If your auxiliary flash unit is equipped with exposure compensation, you can control the amount of flash that reaches your subject. Use this feature to decrease the amount of light that hits your subject.

- **Use your auxiliary flash off camera.** Many cameras give you the option of triggering a supported auxiliary flash unit from a camera menu control. If your camera has this feature, the camera automatically meters the exposure, including the light generated by the flash unit. Your camera may also have the capability to control the amount of flash output using flash exposure compensation. When you use the flash unit off camera, you can control the direction from which the kiss of light is coming. You should also diffuse the output using a light modifier. LumiQuest (www. lumiquest.com) makes products that diffuse the light from a flash unit. Most of their products are fairly small and will fit in a camera bag.

Small Insects

If the thought of photographing small insects bugs you (see Figure 9-5), you're reading the right section. Insects can be interesting subjects for photographers. They're colorful, have intricate shapes, and are some of nature's smallest citizens. For example, caterpillars are often fuzzy, have lots of legs, and are colorful. Then they change into majestic butterflies or moths. The insects you photograph range from small slug-like creatures that move at a snail's pace to butterflies that flit from flower to flower at a fairly rapid pace. In the following sections, I show you what you need to photograph insects and how to do it.

Figure 9-5: Does macro photography bug you?

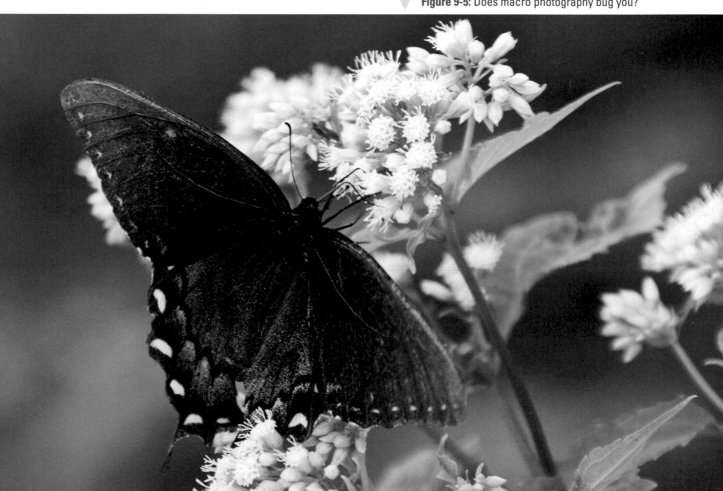

Choosing the right equipment and camera settings

Photographing insects does require some specialized equipment and settings:

- **A telephoto lens with a macro mode** gets you close to your subject. A dedicated macro lens with a focal length of 100mm or longer is a good choice. Insects may move if you physically get too close, so the long focal length lets you get close in a different way.

- **A good tripod** is a useful accessory if you're photographing insects that crawl on flowers. The tripod stabilizes the camera and prevents any camera shake from blurring the image.

- **Shoot in Aperture Priority mode** if you photograph slow-moving insects such as caterpillars or spiders in their webs. Aperture Priority mode enables you to control your depth of field. When you're up close and personal with insects, use a medium aperture with an f-stop value of f/7.1. This gives you enough depth of field to see all the details on the insect yet render the background as an out-of-focus blur.

- **Shoot in Shutter Priority mode** if you photograph insects that fly, such as butterflies and dragonflies. For butterflies, choose a shutter speed of 1/250 of a second. If you're photographing insects like dragonflies and you want to freeze the motion of their wings, choose a shutter speed of 1/2000 of a second or faster.

- **Choose an ISO that yields an f-stop of 7.1** if you shoot fast-moving insects. This combination enables you to capture detail while keeping the background softly out of focus. You should also switch to continuous auto-focus and choose continuous shooting mode. When you shoot in continuous auto-focus mode, the camera updates focus as the insect moves toward or away from the camera. Continuous shooting mode also enables you to capture a sequence of images of the insect in action.

 If you see a butterfly opening and closing its wings, press the shutter button and capture a sequence of images. Combine them in an image-editing application like Photoshop Elements to create an animation.

- **Choose an ISO setting** that yields a shutter speed that is the reciprocal of the 35mm equivalent of the focal length you are using to photograph moving insects. If your camera has image stabilization, this is a plus.

Photographing potentially dangerous insects

If you like to photograph insects, you might be inclined to photograph potentially dangerous bugs like bees or spiders, such as black widows or brown recluse spiders. It's a good idea to keep your distance from any spider (see Figure 9-6). The photographs can be compelling, but the outcome can be very unpleasant if you anger or threaten the insect.

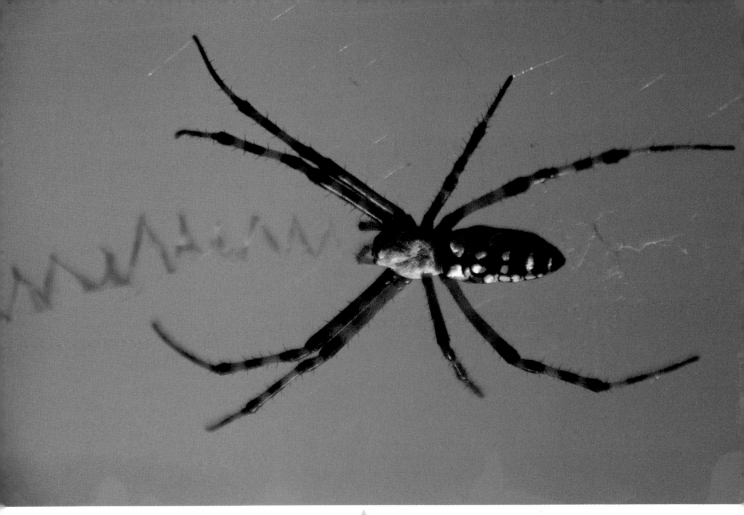

▲ **Figure 9-6:** Do you like to photograph spiders and snakes?

Here are five tips to ensure your safety when photographing potentially dangerous creepy-crawlies:

- **Use a tripod to stabilize the camera.** This gives you the option of distancing yourself from the insect.

- **Set up your shot when the insect is not there.** This is an educated guess on your part. If you've seen insects in a particular spot before, set your camera up and hope for the best.

- **Use a remote switch to trigger the shutter.** With a remote switch, you can stand far enough from the insect to be out of harm's way.

- **Switch to manual focus.** Pre-focus the camera on the place where you think the insect will show up.

- **Choose a fairly small aperture.** Choose an f-stop of f/11. This gives you enough depth of field to still have the insect in focus if it doesn't land exactly where you pre-focused.

Nature's Patterns

Landscape photographers tend to look at wide expanses of nature and photograph majestic vistas like the Grand Canyon or Yosemite Valley. When focusing on these wonderful scenes, photographers miss some of the smaller elements of the landscape. For example, Yosemite has iconic objects like Half Dome, El Capitan, and Bridal Veil Falls. But it also has small groupings of boulders and streams. Getting even closer, you see scattered pebbles or a stream that is diverted into several small waterfalls when it cascades over small rocks (see Figure 9-7).

Figure 9-7: Nature provides several photo-worthy patterns.

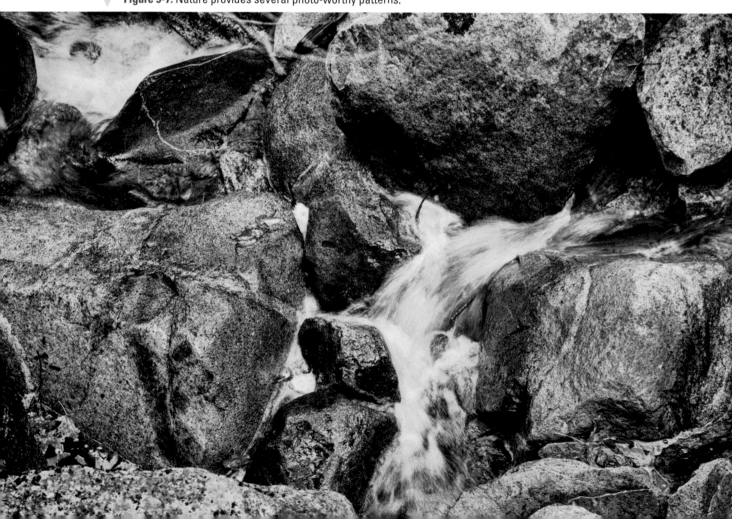

Finding patterns

Patterns are everywhere. You literally have to see the trees instead of the forest. Then you have to see the branches instead of the trees. Then you need to see the leaves instead of the branches. In other words, you need to switch from wide-angle mode to telephoto mode. Look closely and then look a little closer. When you're walking on a forest path, look down and you may see an artistic arrangement of fallen leaves (see Figure 9-8).

Setting up the camera

Light is everything in photography. When you photograph intricate details of nature, the image will be ruined if you shoot in harsh light. Photograph objects like leaves, vines, and other details during the early morning or late afternoon. This gives you nice warm light that is flattering and more diffuse than harsh overhead light. Cloudy days are also great times to photograph details. The soft diffuse light gives you wonderful color.

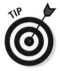

Another great time to photograph details is after a rainstorm or on a foggy morning when your subject is dappled with little pearls of moisture. Carry a small mister with you. When you want to add moisture to a flower, just spritz and you've got instant dew. Don't do this during the heat of the day as you may kill or injure the flower.

Here are seven other tips for photographing details:

- **Shoot in Aperture Priority mode** and choose a relatively large aperture (small f-stop value). This gives you a limited depth of field, which renders any distracting details in front of or behind your subject as a soft out-of-focus blur. If you're photographing something like a tangle of vines, or any subject that has some depth, stop down to about f/7.1 and focus about one-third of the way into the subject. This gives you a slightly larger depth of field to ensure your subject is in focus from front to back.

- **Use a focal length that is the 35mm equivalent of 100mm or longer.** This gets you close to your subject without distorting it. It also gives you a shallower depth of field than a wide-angle lens does.

- **Switch to a single auto-focus point.** This gives you precise control over the point where focus is achieved. When you're photographing details, focus is critical.

- **Choose the lowest ISO setting** that yields a shutter speed that is the reciprocal of the 35mm equivalent of the focal length you're using to photograph your subject.

- **Use image stabilization** if your camera or lens has this option. This option is useful when you're photographing small details because any camera movement can result in a blurry image.

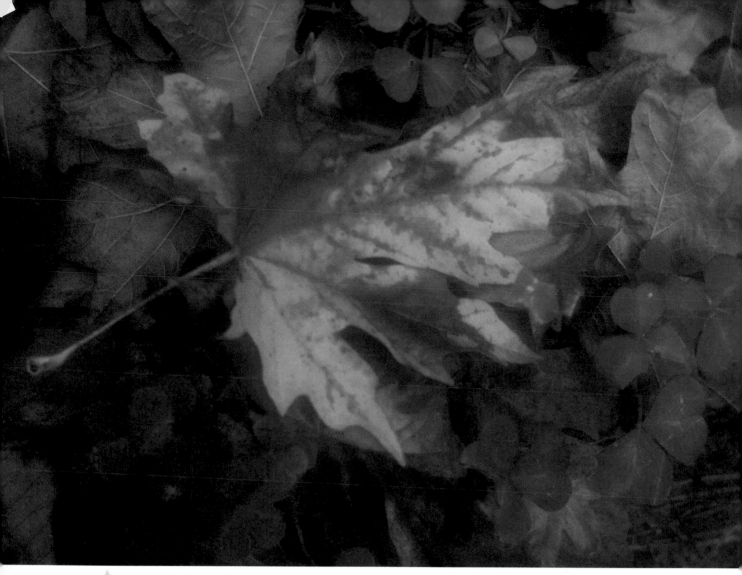

▲ **Figure 9-8:** Interesting patterns are everywhere.

✏ **Photograph a subject against a contrasting background.** You won't get enough contrast for a good image if you photograph green leaves on green grass. However, red flower petals against green grass do give you good contrast. Also be careful that you don't have any bright areas in the background. Bright spectral highlights wreak havoc with an image, especially when those highlights appear in the corner of an image. A bright area in the corner of an image gives your viewers an escape route.

✏ **Carry a shear cloth or a small handheld diffuser** with you, and have a friend hold it over the object you want to photograph if you are forced to photograph in bright light. This diffuses the harsh light, making it look like you photographed the image on a cloudy day.

Capturing a compelling picture of patterns

Now that you know what settings and equipment to use to photograph nature's details, it's time to find some and take some pictures. Here are 12 tips you can use to get great photos of patterns:

- **Switch your personal vision to telephoto mode.** Zoom in and look past the obvious.

- **Sometimes the shadow of a pattern is more interesting than the pattern.**

- **Look up, down, to both sides, and behind you.**

- **Take multiple shots of the same pattern.** When you find an interesting pattern, take one picture from the most obvious vantage point, then move around, explore other vantage points, and take more pictures.

- **Photograph a pattern, and then move closer to discover another pattern.** For example, if you photograph an interesting pattern of tree trunks, you'll probably find additional patterns, such as the tree bark or the pile of leaves between the trees.

- **Don't be afraid to rearrange what Mother Nature has served up.** There's nothing wrong with moving things like stones or leaves that are scattered on the ground to create a more artistic pattern. Just make sure you don't trample anything, including nearby flowers or insects.

- **Augment the patterns.** For example, if you find an interesting pile of seashells on the beach, take a stick and draw a line in the sand to draw your viewer into the picture.

Another way to augment the pattern is to add a star-like pattern. Compose the image so that the sun is partially hidden behind a tree. Choose a small aperture (large f-stop value) so a starburst pattern appears around the sun.

- **Zoom out.** If a pattern has interesting things going on in the background, such as animal footprints, zoom out to include them and tell a different story.

- **Look for juxtaposition between nature and manmade objects.** Sand drifting through a fence on a beach creates interesting patterns.

- **Find patterns where you least expect to see them.** A gentle wave rippling as it comes to shore makes an interesting photograph. So does the foam it creates when it makes landfall.

- **Animals can create patterns.** Birds flying in formation make interesting photographs. So do birds lined up on the shoreline as they feed in the early morning.

- **Look where the sun shines.** Leaves can create interesting patterns where the sun dapples through them. You can also find interesting patterns where the sun breaks through the clouds and creates "God Beams" (see Figure 9-9).

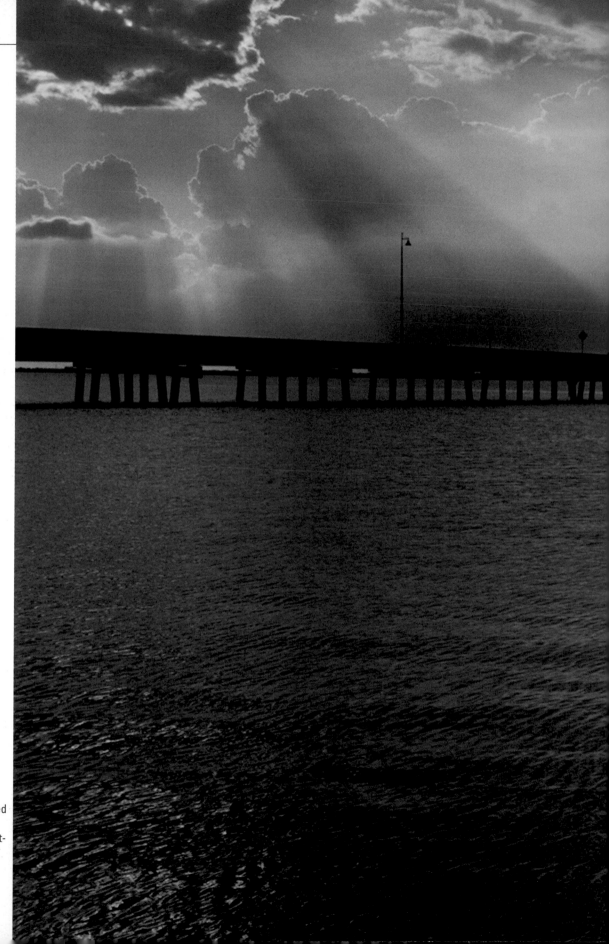

Figure 9-9:
Sunlight diffused through clouds creates interest-ing patterns.

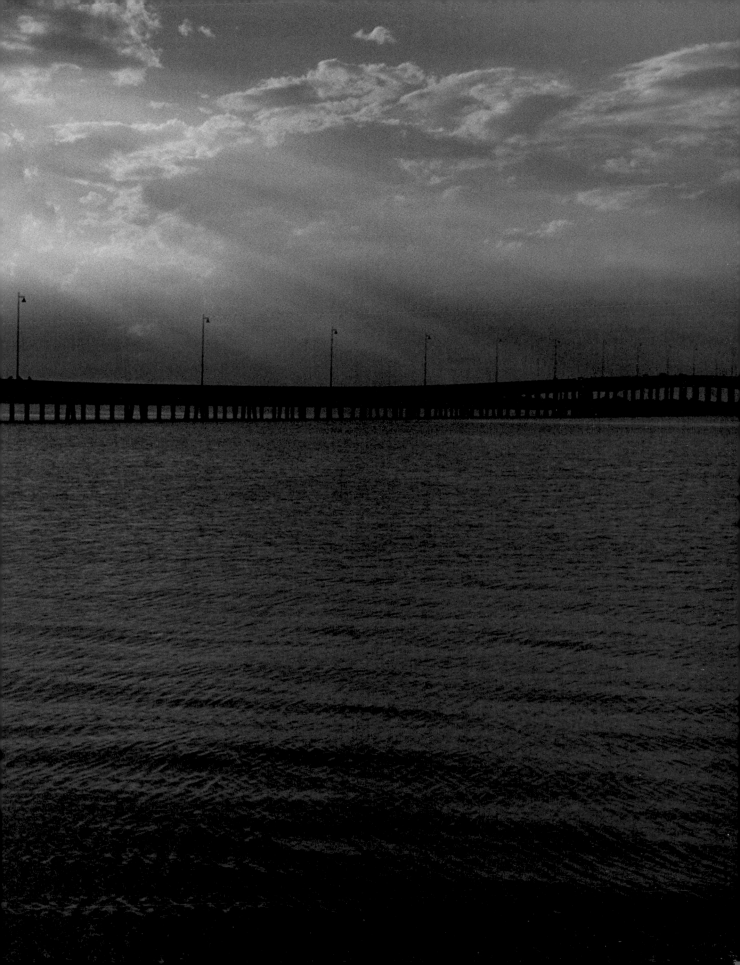

Romancing the Blur with the Lensbaby

The Lensbaby is a tool that creative photographers use to capture images with a sweet spot of focus in one part of the image that gradually goes out of focus at the edge of the frame. The photographer has full control over how large the sweet spot is and where it appears in the final image. Images created with the Lensbaby have a dreamy, artistic look that can be used to good effect when photographing nature, especially flowers.

The Lensbaby is the brainchild of Craig Strong, a wedding and journalistic photographer. He used Holga and Diana cameras to get soft, dreamy photographs when he used film. Then came digital, which, as we all know, changed everything. Craig longed to duplicate the look of the simple Holga and Diana cameras with his digital camera. When he couldn't find a commercially available lens to replicate this look, he decided to make his own. He started out with a Nikon mount, a simple optic, and some vacuum cleaner hose. He refined it until he had a commercially viable product. The lens has undergone several iterations since it was introduced in 2004. Now Lensbaby offers a full product line complete with interchangeable optics and a pro lens. In the following sections, I introduce you to Lensbaby photography. ***Warning:*** It's positively addictive. But I mean that in a good way: You can use it to create wonderful images.

Introducing the Lensbaby Composer and Composer Pro

The first Lensbaby had a steep learning curve. Actually, it was like a juggling act. You pulled on the outer ring of the lens to focus, and then tilted it to one side to change where the sweet spot of focus appeared in the image. It took a lot of getting used to, but I personally loved the Muse and got some great images with it. Then Lensbaby introduced the Composer (see Figure 9-10). Think of it as *Lensbaby For Dummies* (with my irreverent apologies to Wiley!). It was still manual focus, and you had to manually change the aperture disc to change the size of the sweet

Figure 9-10: The Lensbaby Composer.

spot of focus — but you could focus the lens by twisting the outer barrel. And it was also much easier to tilt the lens to change the sweet spot of focus. To this day, it remains the most popular lens that Lensbaby offers. But that may soon change.

Lensbaby introduced the Composer Pro in April 2011. This black beauty gives the photographer more precise control when focusing and when tilting

the lens to change the sweet spot of focus (see Figure 9-11). It retails for $299 with the Double Optic and $399 with the Sweet 35 optic.

The Lensbaby Composer and Composer Pro feature interchangeable optics that range from a soft, dreamy look to a tack-sharp sweet spot of focus. Lensbaby optics are covered in the next section.

Figure 9-11: The Lensbaby Composer Pro.

Using Lensbaby optics

The Lensbaby Optic Swap system makes it possible for you to change the look and feel of your images by changing the optic. With the exception of the Sweet 35 optic, which was introduced in March 2011, you use the Optic Swap Tool, which is also the cover for the optic case. Align the tool with the notches in the optic and turn counterclockwise to remove the optic. Reverse the procedure to remove the optic prior to installing a different optic. Install the Sweet 35 optic by aligning it with a dot on the lens body, and then twisting it into the locked position. To remove the Sweet 35, push the lens into the lens body, and then turn to release it.

The other factor is the size of the sweet spot, which is controlled by the aperture. A large aperture (small f-stop value) nets a small sweet spot of focus. The sweet spot of focus gets larger when you use a smaller aperture (larger f-stop value). Every optic except the Pinhole/Zone Plate and the Sweet 35 uses a magnetic aperture disc. To remove an aperture disc, you touch the Aperture Disc tool (which also doubles as a storage device for the aperture disc) to the disc currently in the optic and remove it. Drop the desired aperture disc into the lens optic, and it develops a magnetic attraction. To change the aperture on the Sweet 35, rotate the barrel and align the desired f-stop number with the dot on the lens body.

The Lensbaby line has several optics (see Figure 9-12).

Following are five optics I commonly use for nature photography:

Figure 9-12: The Lensbaby line includes a wide variety of optics.

- **Double Glass optic:** This is the sharpest optic available for a Lensbaby. The lens offers a tack-sharp sweet spot of focus. This optic is great when you're photographing landscapes or waterfalls. The landscape is readily identifiable, but the image has a dreamy painterly look to it. The lens has a focal length that is the 35mm equivalent of 50mm.

- **Single Glass optic:** This optic has a single piece of glass. It's not as sharp as the Double Glass optic. This optic works well when you're photographing flowers. The lens has a focal length that is the 35mm equivalent of 50mm.

- **Soft Focus optic:** The optic yields an image with evenly soft focus. This optic is also useful when photographing flowers (see Figure 9-13) or trees. The lens has a focal length that is the 35mm equivalent of 50mm.

- **Fisheye optic:** This optic gives you a very wide view. When mounted on a full-frame camera, it has a dark vignette around the edges, just like the fish-eye optic your uncle may have used on his 35mm camera. The lens gives the traditional barrel distortion. Use this lens when you're photographing caricatures of nature. The lens has a focal length that is the 35mm equivalent of 12mm.

- **Sweet 35 optic:** This is the first Lensbaby optic with an adjustable aperture, just like a traditional camera lens, that has 12 blades. You can change the size of the sweet spot of focus by turning the barrel of the optic to the desired f-stop value. This optic has an aperture range from f/2.5 to f/22. The lens has a focal length that is the 35mm equivalent of 35mm. The Sweet 35 works well for many photographic situations, including photographing flowers (see Figure 9-14).

Lensbaby also offers a Pinhole/Zone Plate optic that yields an image that's identical to the old Pinhole cameras. You may also want to try the Plastic optic, which gives you a dreamy, ethereal image. The Plastic optic works best when photographing on an overcast day or in even shade. Images photographed with the Plastic optic, which is uncoated, have wonderfully saturated colors.

Using Lensbaby accessories

Lensbaby offers an impressive line of accessories that increase the range of images you can capture with the brand's optics. The company also offers a carrying case in which you can put your Lensbaby stuff. Here are the most popular Lensbaby accessories for nature photographers:

- **Super Wide Angle:** This extension converts the standard 50mm Lensbaby optics to the 35mm equivalent of 21mm. The extension also lets you focus as close as 2.75 inches. The extension screws into the Lensbaby optic's 37mm accessory threads. If you use this extension on a full-frame camera, and tilt the lens body, you will experience some vignetting. You will experience no vignetting if you use this attachment with the Lensbaby Scout body, which does not bend.

- **Wide Angle:** This extension converts the standard 50mm Lensbaby optics to the 35mm equivalent of 30mm.

- **Telephoto:** This extension converts the standard 50mm Lensbaby optic to the 35mm equivalent of 80mm.

- **Step-up Adapter:** The step-up adapter gives you the option of adding 52mm filters to Lensbaby optics. It also doubles as a lens hood, preventing lens flare.

- **Macro Kit:** This accessory has two extensions: a +4 macro filter and a +10 macro filter. You can stack these extensions to get very close to your subject. These are great for photographing insects and small flowers.

Figure 9-13: The Soft Focus optic is great for photographing flowers.

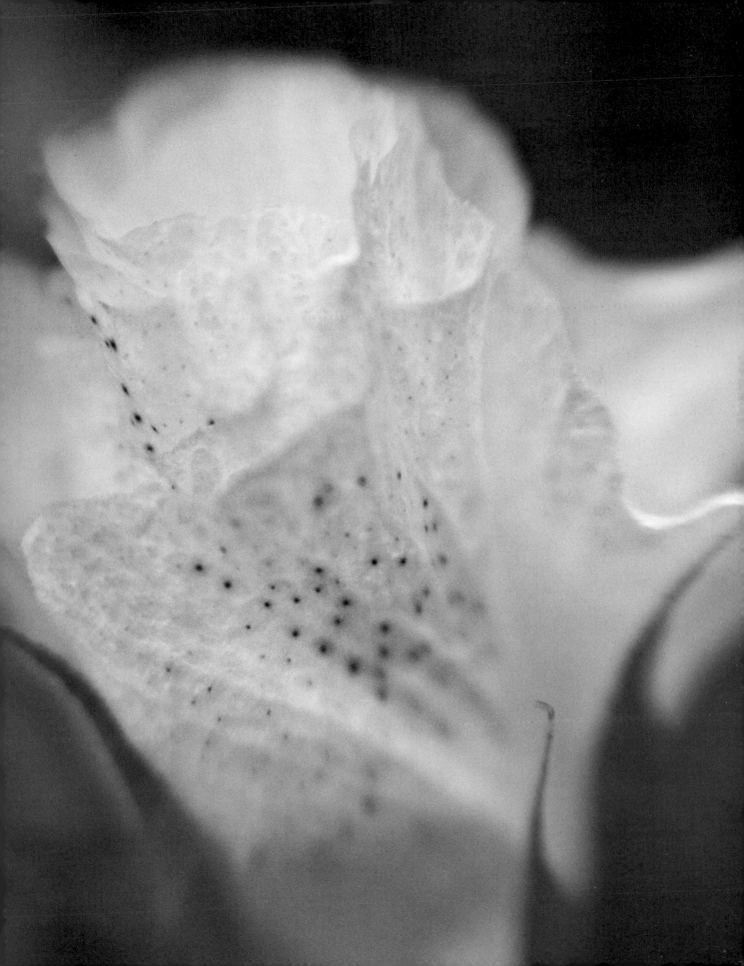

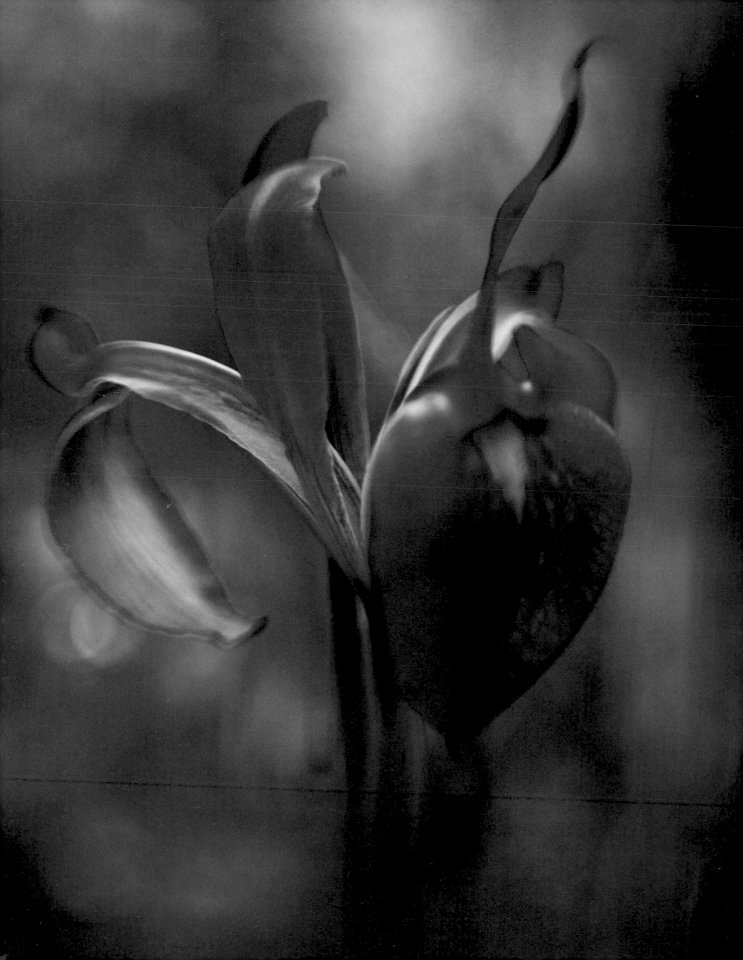

Setting up your camera for Lensbaby

Lensbaby does not make an auto-focus lens, which means your all-singing, all-dancing camera will be as blind as a bat. You'll have to manually focus the lens to get an image that has a sharp sweet spot of focus. And if you don't have something in focus, no one will want to look at your image, no matter how cool you think it looks.

Because you have to manually focus a Lensbaby, the trick to getting good photos with the lens is having a viewfinder that is adjusted for your eyesight. Most cameras have a diopter adjustment that you use to fine-tune the viewfinder, which ensures you'll be able to manually focus and have a crystal-clear sweet spot of focus. To adjust your camera for a Lensbaby, follow these steps:

1. **Switch to a single auto-focus point.**

2. **Put a lens other than the Lensbaby on your camera.**

3. **Point the camera at a blank wall and turn the diopter adjustment until the auto-focus point is sharp and clear.**

 On most digital SLRs, the diopter adjustment is a small knob beside the viewfinder. Your viewfinder is now adjusted to your eyesight, and you'll get a sharp sweet spot of focus when you manually focus your Lensbaby.

Using the Lensbaby

When you look at the Lensbaby Composer for the first time, you may frown and wonder what it's all about. Nothing on the lens is automatic. You have to set your shot. But after the initial fumbling, you start to get the knack of it and use the lens more frequently. In a nutshell, here's how you use the Lensbaby Composer:

1. **Put the lens on your camera.**

 When you change lenses, always power off the camera. A sensor with current is a dust magnet. Make sure you change lens optics in a relatively dust-free environment. That's right, you can't change lenses in the Sahara Desert during a dust storm.

2. **Switch to Aperture Priority mode if you own a Canon camera, or manual shooting mode if you own a Nikon.**

 A Canon camera will meter and automatically set exposure when you shoot in Aperture Priority mode. When you use a Nikon camera, you have to manually adjust the shutter speed to yield a properly exposed image.

3. **Point your camera at the subject that you want to photograph.**

4. **Twist the focusing dial until the center of the viewfinder is in clear focus.**

5. **Take the picture.**

Figure 9-14: Photographing flowers with the Sweet 35 optic.

6. **Review the image on your LCD monitor.**

> The Lensbaby is a different breed of cat. Your camera may underexpose or overexpose the image, depending on the lighting conditions. If either scenario occurs, you'll see it on the LCD monitor or on your histogram. Use exposure compensation to increase or decrease the exposure and rectify the problem.

You'll notice I didn't mention moving the sweet spot of focus. I suggest you get used to focusing the camera with the sweet spot set in the center of the image. After you get some good images, you can experiment with moving the sweet spot of focus. To move the sweet spot of focus, loosen the locking ring at the rear of the lens and then move the outer part of the lens to move the sweet spot. After you move the sweet spot to a different part of the frame, twist the focusing ring until that part of the image is in focus.

Lensbaby photography tips and tricks

The Lensbaby is positively addictive. When you start getting good photos, you get inspired to stretch the envelope and take more. But the Lensbaby Composer has a bit of a learning curve. Here are ten tips that your friendly author learned the hard way:

- **Begin your Lensbaby explorations with the Double optic using the f/4.0 aperture disc.** Doing so makes it easier to learn how to use the Lensbaby and get sharp images. After you master shooting with the Double optic and the f/4.0 aperture disc, you're ready to try other optics and apertures.

- **Don't tilt the Lensbaby until you've successfully taken lots of images using the preceding tip.**

- **When learning how to use the Sweet 35 optic, shoot at f/5.6 or f/8.** The bigger sweet spot helps you learn how to focus accurately with the optic.

- **When shooting with the macro filters, use either the f/5.6 or f/8 aperture disc.** This extends your depth of field, which is woefully shallow once you add the macro filters to the Lensbaby.

- **When shooting with the wide-angle, super wide-angle, or telephoto extensions, look at the sides of the frame.** If you tilt the lens too much, you'll see the edge of the extension in the frame. This problem is more noticeable with a full-frame camera.

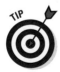

Lensbaby makes a lens called Scout that doesn't bend. The lens ships with the Fisheye optic, but you can use any Lensbaby optic in the Scout. This lens body is ideal for photographers who own full-frame cameras. With the Scout, you don't get any vignetting because you can't tilt the lens. As of this writing, the Scout retails for $180.

- **When photographing close-ups on a windy day, focus your camera at a point in the middle of the arc in which your subject in swinging, switch the camera to continuous drive mode, and press the shutter button.** Capture four or five images. Chances are one or two of them will be in focus.

- **When using the macro filters, switch to Live View if your camera is so equipped.** The bigger screen makes it easier to accurately focus on your subject. Live View is also handy when you're shooting with a small aperture.

- **Stack the telephoto extension with the macro filters to zoom in.** Using this techniques enables you to photograph a potentially dangerous subject — such as the bee in Figure 9-15 — from a safe distance.

- **Use the Step-up adapter with a 52mm polarizing filter when shooting landscapes.** The polarizing filter darkens the blue parts of the sky when the camera is pointed 90 degrees from the sun.

- **Use the Step-up adapter with a 52mm neutral density filter when you want a slower shutter speed to photograph subjects like waterfalls.** The neutral density filter decreases the amount of light reaching the sensor.

Figure 9-15: The Lensbaby Composer with the telephoto extension puts you safely up-close-and-personal with dangerous bugs.

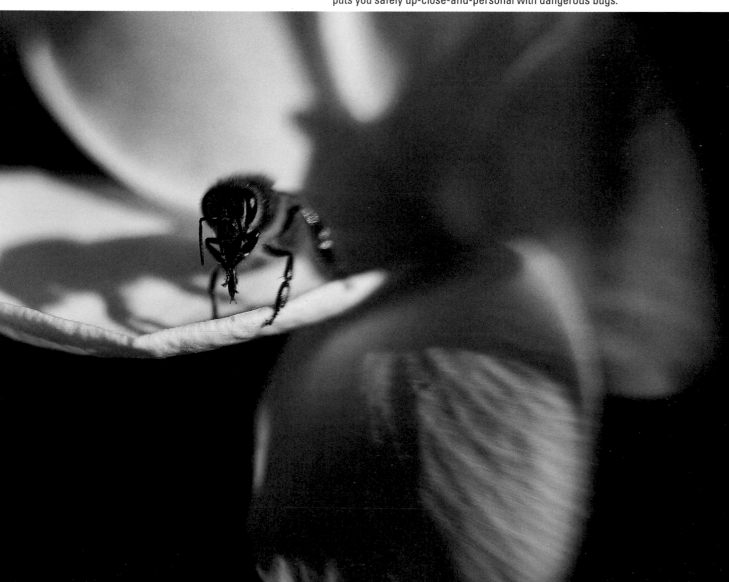

Part IV
Photographing Landscapes

*V*ast landscapes like Yosemite have long inspired photographers. You may have a landscape like Yosemite near your home, or perhaps you live near a river or the ocean, or you will travel to such places and want to capture great images of these great things with your digital camera.

In this part, I show you how to photograph landscapes in the right light, which settings to use, and so on. I also show you how to get great sunset and sunrise programs. You can also take a dip in the shallow end of the HDR and panorama pool in this part.

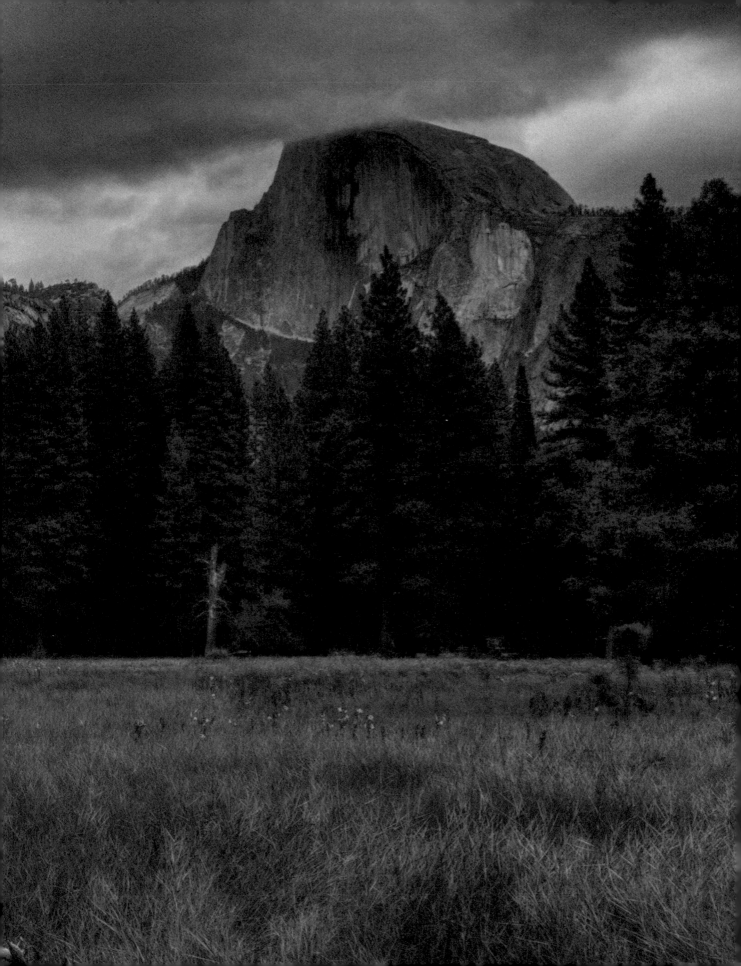

10

The Land, Rivers, and Oceans

The land, sea, rivers, streams, and swamps are great subjects for the nature photographer. Great landscapes are within driving distance of most major cities. You can also find rivers and streams near most major cities. Mountains and oceans are different stories. Mountains range from rolling hills that are the foothills of major mountain ranges to sharp craggy peaks. With your digital camera, you can capture compelling photos of the land and sea. You can even create abstract images of the land and sea with your digital SLR. In this chapter, I discuss photographing the land and sea. I show you tips and tidbits as well as settings.

Forests

Forests are wonderful places. The canopy of leaves shields the light from the forest floor, giving you cool conditions in winter but hot conditions in summer, especially after a rainstorm. Forests are all over the world. In some areas you find tall pine and cypress trees at the edge of a grassy meadow (see Figure 10-1).

You face a different set of challenges when you photograph a forest. Whether you're inside the forest or photographing a forest from a plain or meadow, you're photographing a monotone world. In spring and summer, forests are a sea of green.

In many climates, trees — with the exception of evergreens — lose their leaves in the fall, and the forest becomes a sea of tree skeletons. In colder climates, trees like poplars and maples are denuded in winter, and evergreens may have a heavy dusting of snow.

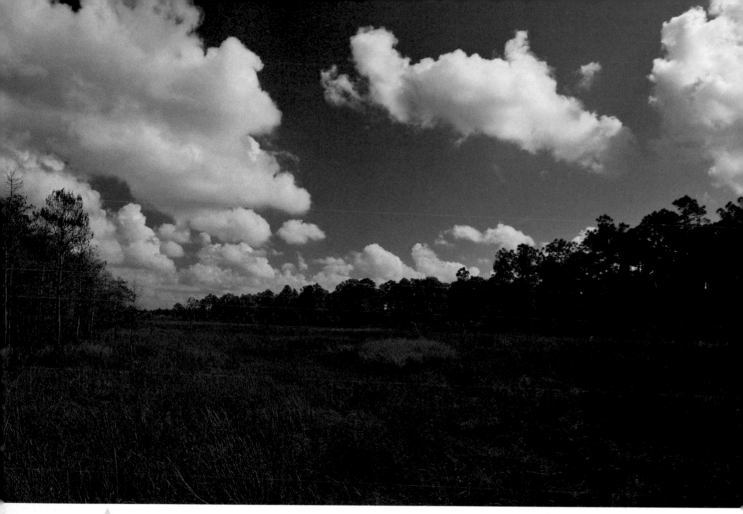

▲ **Figure 10-1:** A meadow, forest, and clouds are wonderful subjects for a nature photographer.

It's up to the photographer to find a center of interest in a forest of trees that are essentially carbon copies of one another. In the upcoming sections, I show you how to create interesting photographs of forests and the trees within.

Finding interest in a monotone world

Every landscape photographer's goal is to take a picture that captures the true essence and beauty of a place. When your subject is essentially monotone, in this case a lovely shade of green, this can be a difficult task. Even a forest of aspens changing colors in fall can be monotonous if you aren't on your toes. When you have so many objects that look the same, you have to be creative to take an interesting photograph. The following list highlights what to look for in a forest:

- **Differences:** As you walk through the forest, you'll see lots of trees. The challenge: they all look similar. A solution: look for a different species of tree or a tree that is shaped differently and use it as your focal point. You can also use a tree that's taller than its brethren for a great center of interest, or photograph a sapling growing in the shade of a larger tree.

- **Patches of color:** When leaves are changing color in autumn, look for one tree that is transitioning either ahead of or behind the other trees. Compose your photo to draw viewers to that tree. If you're photographing an evergreen forest, look for a tree that isn't an evergreen.

- **Patterns of shadow and light:** When the sun shines through the trees, a patchwork quilt of dappled shadows appears on the ground. If you're photographing early in the morning or late in the afternoon, compose the image so that the sun is behind a tree that is in the picture. Choose a small aperture (large f-stop value) so the sun appears as a starburst. If you get a little lens flare, not to worry: This can add an artistic touch to the image (see Figure 10-2).

- **Patterns:** Tree trunks form a strong vertical pattern, which can be the basis for a good image. Another alternative is to zoom in and take a picture of just tree trunks. You can also find patterns on the tree bark. For a tree bark pattern, zoom in tight, or put a macro lens on your camera, get close, and then take one more step.

- **Breaks in patterns:** A break in a pattern can be a compelling focal point for any image. For example, if you have a break in a dense thicket of trees followed by another dense thicket of trees, compose your image in a manner that leads viewers to the break in the pattern.

Figure 10-2: A splash of light adds interest to an image.

- **Diagonal lines:** A diagonal line carries more power than a vertical or horizontal line. Lines are everywhere. A tree trunk is typically a vertical line (keep reading), and in many cases, the horizon is a horizontal line. Find a diagonal line, such as a path cutting through the woods or a tree that is bent because of constant exposure to the wind. Use this diagonal line as a focal point in your image or as a way to draw your viewers to the focal point in the image.

- **Curves:** Curves are more interesting than straight lines. Nature provides curves everywhere: a bend in the river or a weirdly shaped tree, for instance. Use the curve to draw the viewer's eye to the most important part of your image.

These are a few things you can use to create interesting photographs in a forest. The key is to keenly observe everything as you stroll through the forest. Look in front of you, look up, look down, and then look where you've already been.

Photographing the forest

Sometimes you literally cannot see the forest for the trees. In order to get good photographs of a forest, you must notice the forest as an entity. To get a great picture of a forest, look for the elements mentioned in the preceding section. When you see the elements for a compelling picture fall into place, it's time to think about composition, settings, and so on. Here are six things to consider when photographing a forest:

- **Choose a high vantage point.** If you're photographing a forest in the middle of a mountain range or one that's nestled in a valley, photograph the forest from a high vantage point.

- **Choose a low vantage point.** If you're walking down a meandering path in a forest and the elements for a great picture appear before you, consider crouching down to photograph the forest from a low vantage point. From this position, you capture the majesty and grandeur of the forest.

- **Pick the appropriate format.** You should almost always photograph a forest in landscape format (the picture is wider than it is tall) with the camera level with the horizon.

- **Use a wide-angle focal length.** To capture the big picture, use a wide-angle focal length, 28mm or wider. Note that if you photograph a forest with a focal length less than 28mm from a distance, you'll have to include something rather prominent in the foreground to capture the interest of the viewer — such as a large bush, rock, or tree. If you don't, the picture will be confusing to viewers because they don't have a visual anchor to latch onto.

- **Choose the right settings.** Use the lowest possible ISO setting to minimize noise. Choose a small aperture with an f-stop value between f/11 and the camera's smallest aperture. If you're shooting in dim lighting

conditions, the small aperture yields a slow shutter speed, sometimes too slow to handhold the camera. If this is the case, bump the ISO slightly, but try not to exceed an ISO setting of 800.

↳ **Use a tripod.** If you want clear, sharp pictures, consider carrying a tripod with you. You may think tripods are a nuisance to carry around, but mounting your camera on a tripod guarantees you get a sharp picture.

Photographing the trees in the forest

If you're more interested in seeing the trees and not the whole forest, this section is for you. There are hundreds of different species of trees. Each species has a different look or personality, if you will. Redwoods are tall, majestic giants. Weeping willows have silhouettes like graceful Spanish dancers. Bristlecone pines look like giant bonsai trees (see Figure 10-3).

To bring out the personality of a tree requires thought, keen observation skills, and careful composition. Here are four things to consider when photographing trees:

↳ **Find interesting shapes.** Many photographers try to photograph a species of tree such as a palm tree. Instead of photographing a palm tree or a bristlecone, look a little deeper and see the unique shapes of trees and other elements in the forest. When you find a shape that interests you, use the rest of the tips in this section to create a compelling photograph.

↳ **Choose the proper focal length.** When you photograph a tree or a group of trees, you create a nature portrait. Zoom in until you see only the tree or trees that truly create your beautiful nature portrait.

↳ **Pick the proper vantage point.** Many photographers photograph a tree from eye level. You can create a unique and more interesting photograph if you climb a nearby hill to photograph a tree from a higher vantage point or hike downhill to photograph a tree from a lower vantage point.

↳ **Shoot in portrait mode.** In most instances, trees are taller than they are wide. When this is the case, rotate the camera 90 degrees. The only exception to this rule is when you're photographing a group of trees, or a tree like a weeping willow or banyan that is wider than it is tall.

The Beauty of a Mountain Range

Mountains have captured the interest of adventurous souls since the beginning of time. Many people climb them and others photograph them. Some mountain ranges, like the Sierra Nevada, have tall and craggy peaks. Other mountain ranges, like the Catskills, are gently undulating hills with a few peaks. Then there are ranges like the Smoky Mountains, offering a combination of both. Every mountain range has a unique character. Seek to portray it in your photographs.

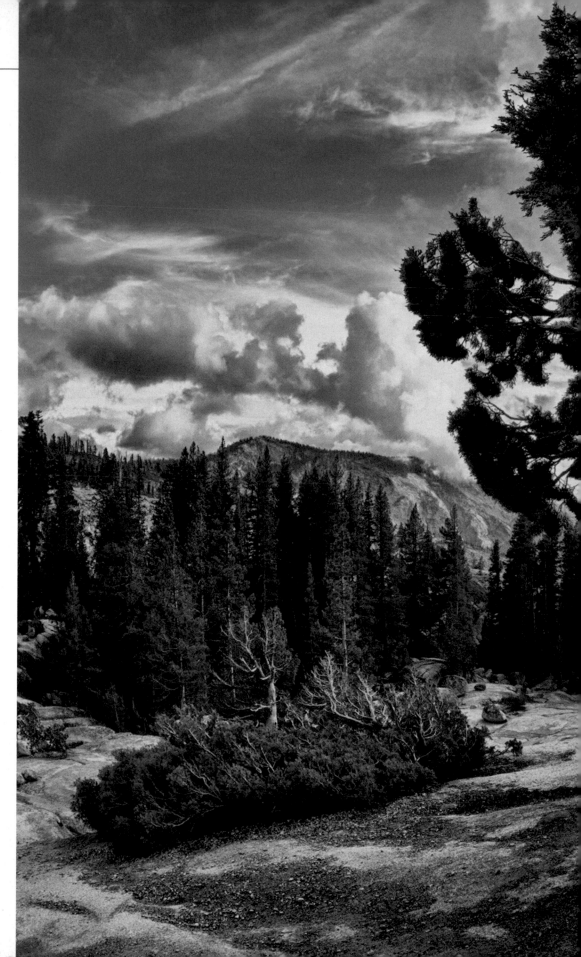

Figure 10-3:
Find a tree with an interesting shape.

Some mountain ranges give you a wide variety of subjects. The Smoky Mountains include waterfalls, rivers, lots of trees, and wildflowers. An area like Yosemite National Park also gives you a well-rounded venue for photography subjects. You can capture images of trees, waterfalls, and animals in the valley or venture into the High Sierra and capture wonderful pictures of mirror-smooth lakes with reflections of mountains and the sky (see Figure 10-4).

Mountain ranges like the Rockies give you even more subjects to photograph. When you get past 12,000 feet, there are no trees. You see lofty peaks, ice-cold lakes, animals that have evolved to live in a cold, harsh environment, and vegetation that can survive cold temperatures and little moisture. This region is known as *tundra*. When you photograph tundra regions, your high vantage point gives you the luxury of photographing nearby mountains from eye level or pointing your camera down to photograph the beauty of a valley carved by a glacier.

If you live near a mountain range or are vacationing near one, go there with an open mind. See the beauty and capture it with your digital camera. In the following sections, I show you how to capture great pictures of a mountain range.

Choosing the proper focal length and camera settings

As with any other form of photography, you need to have the right equipment and the right settings to get fabulous mountain range photos. In this section, I show you which focal length range will yield great photos of mountain ranges. I also discuss camera settings and other helpful goodies. When you visit a mountain range, set up your camera as follows:

- **Focal length:** The focal length you use depends on how close you get to the mountain range. Assuming you're actually in the mountain range, you'll use a wide-angle focal length with a 35mm equivalent of 28mm or wider. This range gives you the power to capture a large landscape in one picture.

 When you use a wide-angle focal length, you capture a lot of information in a single photograph — perhaps too much information for your viewer to get a clear idea of what you're photographing. Make sure you have a definitive center of interest, or something large in the foreground to draw your viewer into the picture.

- **Shooting mode:** Use Aperture Priority mode to control depth of field.

- **Aperture:** Choose an aperture with an f-stop value of f/11 to f/16. This gives you a large depth of field. The resulting photograph shows detail from the foreground to as far as the eye can see.

- **ISO setting:** Use the lowest ISO setting for the current light conditions that will yield a shutter speed of at least 1/30 of a second when using a lens with a 35mm equivalent focal length of 28mm. If your camera or lens has image stabilization, you can take pictures with a shutter speed as low as 1/15 of a second when using a lens with a 28mm focal length. If you're shooting on a cloudy day, you may have to bump the ISO setting to achieve a shutter speed of 1/30 of a second. Don't exceed 800 ISO (full-frame camera) or ISO 400 (for cameras with a sensor smaller than a full frame of 35mm film), or you'll get noisy images.

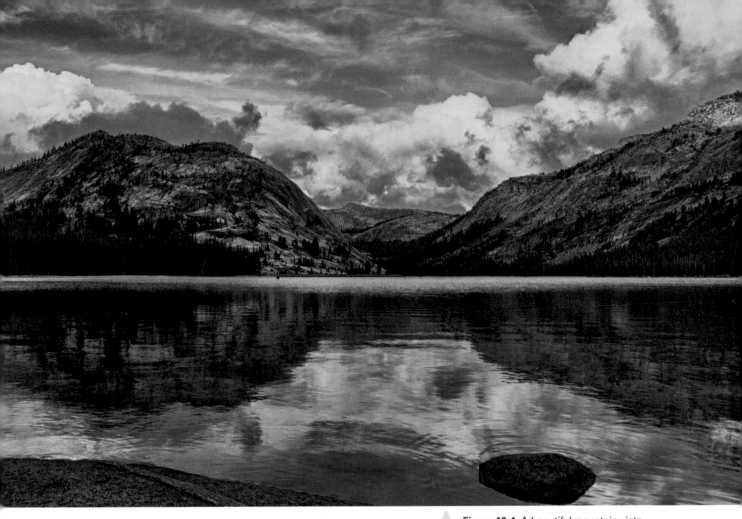

Figure 10-4: A beautiful mountain vista.

TIP

If the light gets dim and you don't have a tripod to steady the camera, open the aperture to f/8.0 and focus two-thirds of the way into the scene. This will yield an acceptable depth of field, and everything in the photograph will be sharp enough to show excellent detail.

Tripod: A tripod with a spirit level is an excellent accessory when you're capturing landscape images. The tripod keeps the camera steady, which is an asset in any lighting scenario. When light conditions conspire against you and yield a shutter speed that is too slow to handhold the camera, the tripod ensures you'll get a sharp image. When using a tripod, use a cable release or remote trigger to actuate the shutter. This prevents a blurry image that can occur from vibration that is transmitted to the camera when you press the shutter button. If you use a tripod with a camera or lens that has image stabilization, disable it before mounting your camera on the tripod. Image stabilization can be counterproductive when you have your camera on a tripod.

TIP

In lieu of a cable release, use the camera self-timer and set it for its shortest duration. The vibrations dissipate during the slight delay from the time you press the shutter button to the time the shutter opens.

Mirror lock-up: This is a handy option when you photograph from a tripod. Use this in conjunction with a cable release or self-timer countdown. The mirror locks up when the shutter is actuated. This prevents any vibration from blurring the image when the mirror stops. Check your camera's menu to see if it has the mirror lock-up option.

✏ **Polarizing filter:** A polarizing filter darkens a blue sky, which makes any clouds pop out in sharp relief. Polarizing filters yield the best results when the camera is aimed 90 degrees from the sun.

✏ **Graduated neutral density filter:** This filter is useful when you photograph a mountain scene and the sun is in your picture. The dynamic range of brightness from dark shadows to the radiant sun is more than your camera can capture. A graduated neutral density filter darkens the top of the image, and the image gradually becomes clear in the middle of the filter. You can get a round filter that screws into the accessory threads on the front of your lens. However, you have more control if you purchase a square filter and a filter holder. A square filter enables you to precisely align the middle of the filter with the horizon line.

When using a graduated neutral density filter, choose a larger aperture (smaller f-stop value) so that the blend line in the middle of the filter is not noticeable in your image.

Finding a center of interest

To create a great image of a mountain range, you need to find a center of interest, just like with any other photograph. You also need to direct the viewer's eye to your center of interest. Mountain ranges are vast compilations of peaks and valleys. Here are seven tips to find a center of interest for your mountain scenes:

✏ **Use a tree as your center of interest.** If you're photographing a mountain range from a valley, use a tree as your center of interest, as shown in this image of Half Dome from Cook's Meadow (see Figure 10-5).

✏ **Look for a recognizable peak.** Many mountain ranges have signature peaks. In Rocky Mountain National Park, Longs Peak is recognizable because it's been photographed so frequently. Yosemite has El Capitan, Cloud's Rest, and Half Dome. Compose your image in such a manner that the recognizable mountaintop is the center of interest.

✏ **Look for an unusual rock formation or prominent peak.** If the mountain range doesn't have a signature peak, look for an interesting-looking mountain peak or graceful rock formation to use as your center of interest.

✏ **Wait for the clouds.** Clouds can make an otherwise dull image look interesting. If you photograph a scene with clouds, use your polarizing filter. Remember that a polarizing filter has the best results when you aim the camera 90 degrees from the sun.

✏ **Find a winding mountain road or path to direct your viewer's eye.** It can be the path in front of you or a path that comes in from the side of your picture. Move around until the path is in a position to draw your viewer into the scene.

✏ **Draw the viewer to your center of interest with diagonal lines.** The lines can be tree shadows, a fallen tree, a path — see the line with your mind's eye. The diagonal line can also be the side of a mountain.

✏ **Use curves to lead the viewer to the most important part of an image.** A path, a river, an unusual grouping of trees — nature throws curves at you from every angle (and I mean that in a good, creative way!).

Finding the perfect vantage point

When you find a vista that you want to photograph, assess the scene and find a center of interest. Walk around the scene, looking for an ideal vantage point. The ideal vantage point depends on what you're taking a picture of. As you move around, you see different possibilities, and then a picture starts to take shape in your mind's eye. Here are five suggestions for vantage points when photographing mountain ranges.

- If the mountains rise high above you, photograph the scene from a low vantage point and place the horizon line in the lower third of the frame. This vantage point gives your viewers a sense of how high the mountains are.

- If you're using diagonals to draw your viewer's attention to the center of interest, choose a vantage point that places the diagonal at one of the corners of the frame.

- If you're using a path to draw your viewers into the image, crouch low or lie down on the ground for a snail's-eye view. Let the path fill the bottom of the frame from edge to edge.

- If you're high in the mountains and you have a lovely cloudscape, climb a little higher and shoot straight ahead to place the horizon line in the

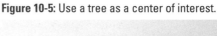

Figure 10-5: Use a tree as a center of interest.

lower third of the image. This gives your viewers the sense that you're high in the mountains.

⬚ Another alternative for when you're high in the mountains is to point the camera down into a valley. This also gives your viewers the message that you're at a high altitude.

Rivers, Lakes, and Swamps

Rivers and streams flow from a high point, eventually emptying into an ocean. A river can be raging when snow is melting, or it can be placid at the end of summer. If you live or photograph in cold country, the river or stream may be partially or totally frozen during the winter. Rivers have their own beauty. Tall trees or grasslands often border a gently meandering river (see Figure 10-6). Other rivers carve deep canyons and are surrounded by huge granite rocks and maybe a few trees. Rivers can swell to fill (or overrun!) their banks during rainy season, but at other times of the year, they can resemble a beach. Rivers are sanctuaries for wildlife: Alligators, wading birds, spawning fish, or bears may be catching their dinner. If you live near a river, visit it at different times of the year to capture its full diversity.

Figure 10-6: Photograph a river where it changes direction.

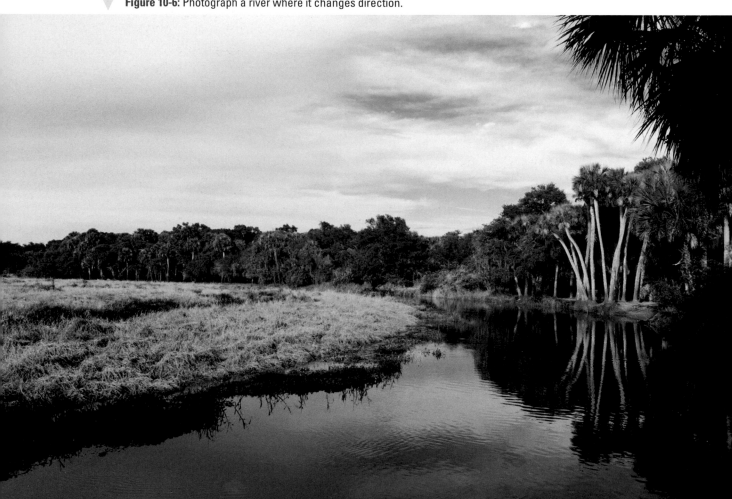

Here are five details to consider when photographing a river:

- **Shoot in Aperture Priority mode and choose the smallest aperture possible.** When you photograph a scenic river, you want every subtle detail to be in focus.

- **Fill the frame with the river in the foreground.** If that isn't possible, get as much of the river in the frame as you can.

- **Shoot from a low vantage point.** Crouch down when shooting a river from ground level. This vantage point gives your viewers a scene of space and scale.

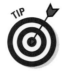

If you don't like to crouch low and your camera has Live View, enable it and compose your image using the camera LCD monitor. Remember that you can't hold the camera as steady when you're using Live View because the camera is in front of you. Increase your shutter speed slightly to offset any operator movement. A hot-shoe level is also useful to ensure the camera is parallel to the horizon.

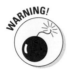

Many rivers are home to alligators. If you know there are alligators in the river, don't stand too close to the edge. Alligators are very quick. Normally they're wary of humans, but they have been known to be quite aggressive during mating season. It's always better to err on the side of caution.

- **Photograph the river from a unique vantage point.** Unless you have interesting scenery surrounding the river, or you are photographing a raging river, find a bend in the river and use the curve as a compositional element.

- **If possible, place the horizon line in the upper third of the image so the river is the main element in your picture.** If you can't achieve this composition, make sure the river is more than half of the image.

Capturing the beauty of water in motion

When a river starts on a mountain and comes to a cliff, a waterfall occurs. Cascading water is exciting to watch and photograph. Waterfalls run the gamut from thundering waterfalls that fall several hundred feet or more to small waterfalls in a river or stream. Raging rivers also make beautiful photographs. Surging white water rapids, briny mist, and cascading spray are all the elements you need for a great picture. Here are eight tips to consider when photographing water in motion:

- **Use a shutter speed of 1/15 of a second or slower.** A slow shutter speed renders moving water as a silky white blur.

- **Use a low ISO setting.** A low ISO setting gives you a relatively small aperture, which ensures a large depth of field.

- **Use a tripod.** When you use a slow shutter speed, stabilize the camera to get a sharp picture.

- **Use a neutral density filter in bright light.** In bright light, you won't be able to use a slow shutter speed and get a properly exposed image. A neutral density filter cuts down on the amount of light reaching the sensor, which means you can get a properly exposed image using a slow shutter speed.

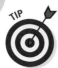

If you use neutral density filters on a regular basis, consider purchasing a variable neutral density filter. This is actually two filters in one. You rotate the outer ring to dial in the strength of the filter.

- **Use a fast shutter speed when you want to freeze the motion of a raging river.** You can also use a fast shutter speed when you want to show the details of a waterfall. You may have to increase the ISO setting when using a fast shutter speed to achieve a large depth of field, which requires a small aperture. Don't increase the ISO too high or you'll end up with a noisy image; use a tripod instead.

- **When you compose the image, position the horizon line in the lower third of the image.** It's also a good idea to place the waterfall to one side of the image.

- **Rotate the camera 90 degrees when photographing a waterfall.** This is known as *portrait format*. Rotate the camera 90 degrees any time you photograph a subject that is taller than it is wide. The only possible exception to this rule would be a waterfall like Niagara Falls that is actually wider than it is tall.

- **Take a picture downstream from a waterfall.** You'll often find wonderful details when you venture a couple of hundred feet downriver from a waterfall, such as this image that was photographed a few hundred feet from Bridal Veil Falls (see Figure 10-7).

Figure 10-7: Interesting details abound downstream from a waterfall.

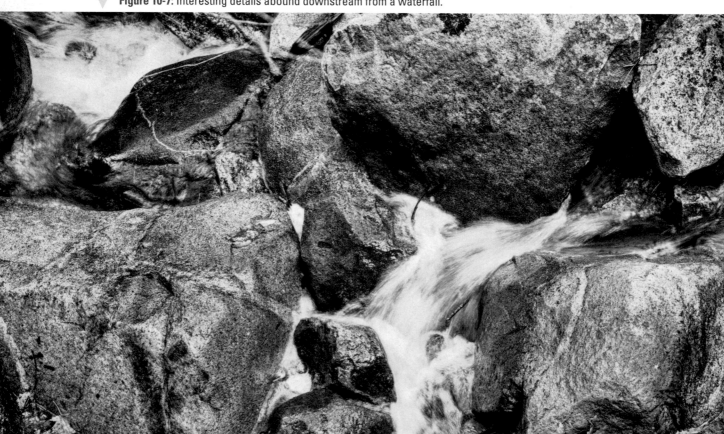

Photographing a serene lake or swamp

Still water is an interesting subject for a photographer. Lakes can be shallow bodies of water with vegetation on the shorelines, or they can be mountain lakes that were carved out by glaciers. A healthy lake teems with fish. Where you find fish, you'll find other wildlife that dines on said fish.

Swamps are literally rivers with grass (see Figure 10-8). The Florida Everglades is a shallow body of water brimming with fish and wildlife. In some areas, you'll find lakes that are swamp-like in appearance, shallow bodies of water with delicate grass in the shallow water. A true swamp may be dry at certain times of the year or when the area encounters drought conditions. You can get information about a swamp you want to photograph by entering the name of the swamp in your favorite search engine.

Lakes and swamps are places of serene beauty. Armed with your digital camera and a bit of knowledge, you can capture compelling photographs of a swamp. Photographing the area on a regular basis and following the information here will get you started. Here are eight helpful tips:

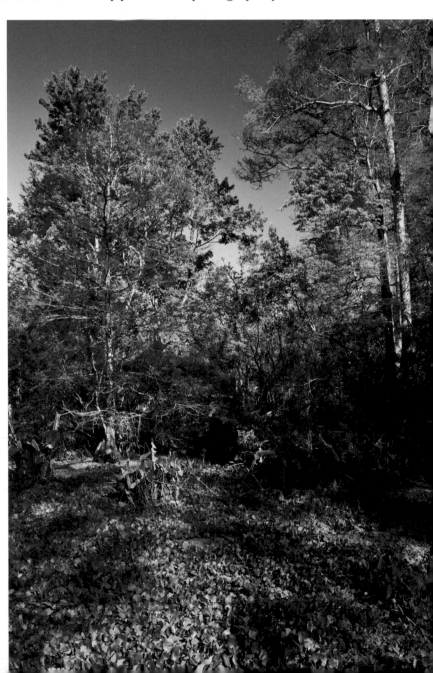

- **Use a wide-angle lens.** Capturing a panoramic view of a lake or swamp requires a wide-angle lens with a focal length that is the 35mm equivalent of 28mm or wider. When you photograph a vast landscape with a wide-angle lens, remember to include something in the foreground to draw your viewers into the photograph.

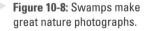

Figure 10-8: Swamps make great nature photographs.

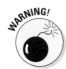

✔ **Use Aperture Priority mode.** Choose a small aperture with an f-stop value of f/16.

Many photographers like to use the smallest aperture on a zoom lens to photograph landscapes. However, many lenses are a bit soft at either extreme of the aperture range. If you shoot wide open (the largest aperture, smallest f-stop value) or stop down to the smallest aperture (largest f-stop value), the image may be a bit soft, especially around the edges.

✔ **Use the lowest possible ISO setting.** Photographing in bright light enables you to use your lowest ISO setting and a small aperture and still have a relatively fast shutter speed. However, when you photograph on a cloudy or stormy day, you have to increase the ISO to achieve a fast enough shutter speed for a blur-free photo. Use an ISO setting no greater than 800 on a camera with a full-frame sensor, or use an ISO no higher than 400 if you have a camera with a sensor that is smaller than a frame of 35mm film. Exceeding the suggested ISO settings may result in an unacceptable amount of noise in the image. The alternative to a high ISO setting is to use a smaller aperture with an f-stop of f/8.0. When you use a smaller aperture, focus two-thirds of the way into the scene. It will render an image that will be sharp from foreground to background.

✔ **Include the shoreline in your photograph.** A photograph of water and the opposite shoreline won't be interesting. Back up and include the shoreline on your side of the water in your picture.

✔ **Include a center of interest in the photo.** A picture of a wide expanse of water is, quite frankly, boring. Look for something in the foreground or perhaps an island in the middle of the body of water, and use it as a center of interest. If you're photographing a swamp, scope out a tree that looks different than the adjacent trees. A splash of color also makes an interesting center of interest. Rays of sun breaking through the trees can also be used as a center of interest.

✔ **Place the horizon line in the right spot.** If you place the horizon line in the center of the image, your viewers won't know what to look at. When a body of water is your center of interest, place the horizon line in the upper third of the image. To do this, you have to shoot from a low vantage point.

✔ **Include wildlife.** A picture of a lake with a swan gracefully swimming is more interesting than a photo of just the lake.

✔ **Wait for the light.** Shoot pictures of the lake early in the morning or late in the afternoon when the light is soft and diffuse, casting wonderful golden hues on the landscape. A cloudy or foggy day is another great time to photograph a lake.

The Mighty Ocean

Oceans are great subjects for nature photographers. Jimmy Buffet sings, "Mother, mother ocean, I have heard you call" to start his song, "A Pirate Looks at Forty." And the ocean does beckon those who seek adventure — and photographers who seek interesting pictures. Oceans have personalities and whims. They can be calm and placid one day, and the next day they can turn into a raging turmoil of crashing waves and foamy surf. If you're fortunate enough to live near an ocean, you have incredible photographic opportunities. In the upcoming sections, I discuss techniques for creating interesting pictures of the ocean.

Finding the perfect beach

Unless you're out at sea on a sailboat or yacht, your photos will include some land in them. In my humble opinion, the best pictures of the ocean include a beach. But the beach has to be interesting. If all you have is the ocean with a patch of sand in the foreground, you have a yawner that won't hold anybody's attention for long. Instead, look for unique, unusual features on the beach. They add interest to images. Also use the following recommended settings, which are much like those described in the preceding section:

- **Use a wide-angle lens.** To capture the beauty of a pristine beach and the ocean, use a wide-angle lens with a focal length that is the 35mm equivalent of 28mm or wider.

- **Use Aperture Priority mode.** Choose a small aperture with an f-stop value of f/16.

- **Use the lowest possible ISO setting.** Use the lowest possible ISO setting to achieve a shutter speed that is the reciprocal of the 35mm equivalent of the focal length you're using to take the picture. If nature gangs up on you with low light, increase the ISO, but don't exceed ISO 800, if you own a full-frame digital SLR, or ISO 400, if you own a digital SLR with a sensor that is smaller than the frame of a 35mm film negative.

- **Include objects in the foreground.** Look for something on the beach to draw the viewer into the image. An egret or great blue heron can serve as a focal point or a compositional element to lead the viewer's eye. A patch of sea oats or other vegetation can also serve as a great point of interest.

- **Use rocks to compose an image of the ocean.** Look for a series of rocks starting on the beach and ending up in the ocean. As long as the tips of the rocks are exposed, they act as stepping-stones into your image. If the surf is up, the rocks will kick up spray when the waves hit them.

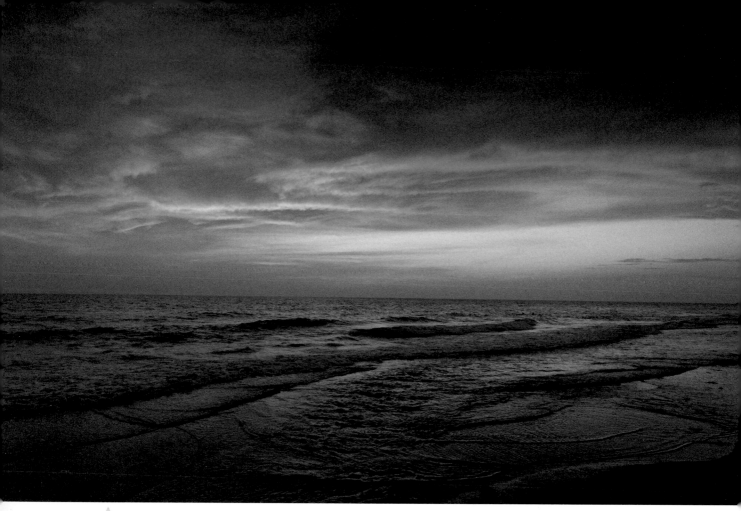

Figure 10-9: Interesting foregrounds invite your viewers into your photo.

- **Concentrate on the surf line.** When the ocean meets the shore, the motion of the ocean is eventually compressed into a wave. The height of the wave depends on weather and other conditions. The spot where the wave starts to crest can be used as a point of interest to direct the viewer's eye. If you don't have huge waves, you will have a nice line of foam when the wave spills onto the shoreline (see Figure 10-9).

- **Add interest with clouds.** The type of clouds you get depends on the time of year you photograph the beach. In Florida, we get towering thunderheads in summer and high cirrus clouds at other times of the year. In winter, we often get high cirrocumulus clouds, which is sometimes referred to as a *mackerel sky*.

- **Position the horizon line appropriately.** The placement of the horizon line contributes to the success (or lack thereof) of your image. When you photograph the ocean, place the horizon in the upper third of the image. If, however, the clouds are more interesting than the ocean, place the horizon line in the lower third of the image to let your viewers know the clouds are the most important part of your image.

Portraying the motion of the ocean

Tides rise and fall; waves crest and crash upon the shore. The ocean is in constant motion. There are two schools of thought regarding waves. The first is to use a high shutter speed to freeze the motion of a cresting wave and any spray. Other photographers like to use a slow shutter speed. The following paragraphs address each scenario.

To freeze the motion of a wave, you need to use a shutter speed of at least 1/250 of a second. If you zoom in on a wave, you have to use an even faster shutter speed, perhaps as fast as 1/1000 of a second. You should also use a small aperture of f/11 to ensure a large depth of field. Shooting in low light conditions forces you to increase the ISO setting, which may cause a noise problem.

To artistically portray the power of waves in motion (see Figure 10-10), use a slow shutter speed longer than one second. This renders the water in silky patterns. When you use a shutter speed that's several seconds long, you get an even more artistic result. To achieve a long shutter speed, choose your lowest ISO setting, and then choose the smallest aperture on your lens. If you're photographing in bright light, you may have to use a neutral density filter to reduce the amount of light reaching the sensor, which decreases the shutter speed. You will have to use a tripod or some other method of supporting the camera when you photograph waves with a slow shutter speed.

Capturing abstract images of cresting waves

There's another way you can capture interesting images of waves. A technique known as *wave panning* creates a very abstract, almost painterly, image of a cresting wave (see Figure 10-11). You can also do wave panning on large lakes when the wind kicks up vigorous wave action. Wave panning can be done anywhere, but heavy seas offer the best images. The technique also involves a bit of timing and coordination. You get the best results when you're adjacent to the waves at a location such as a jetty or low-lying pier. When you're at the ocean and want to try wave panning, follow these steps:

1. **Choose your lowest ISO setting and switch to Aperture Priority mode.**

2. **Choose the smallest aperture (largest f-stop value) for your lens.**

 Make sure the resulting shutter speed is at least one second in duration. If it isn't, add a neutral density filter to reduce the amount of light reaching the sensor.

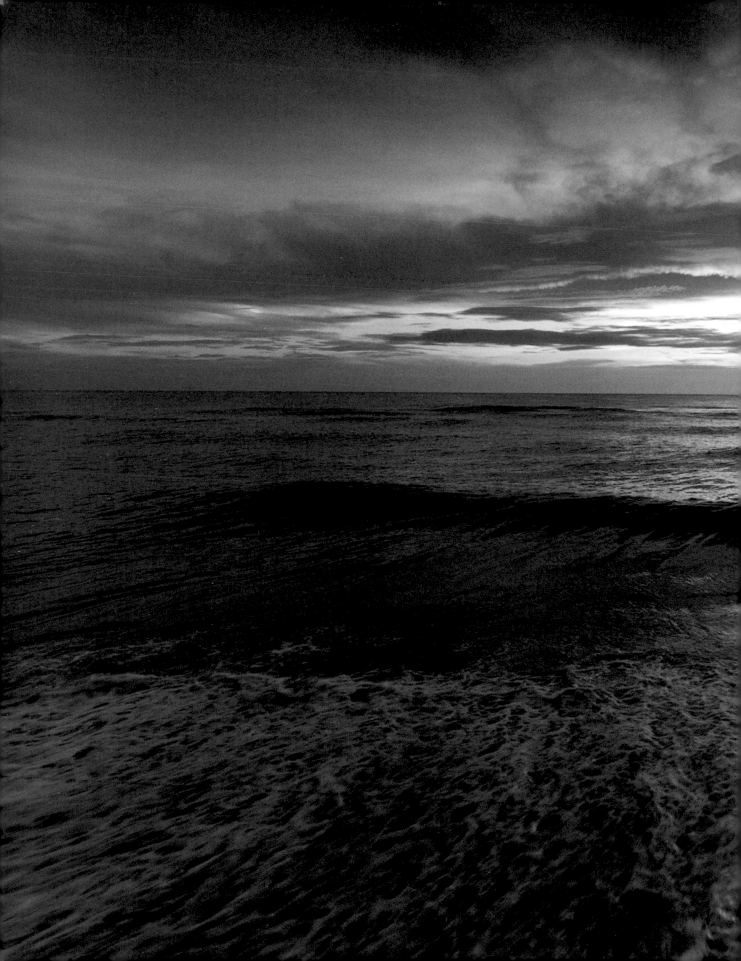

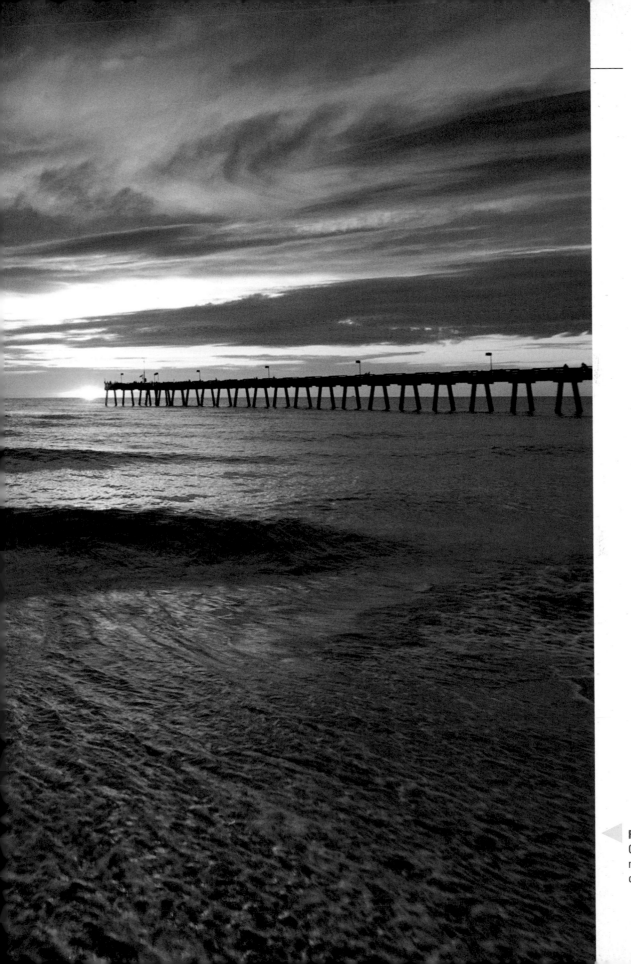

Figure 10-10: Capture the motion of the ocean.

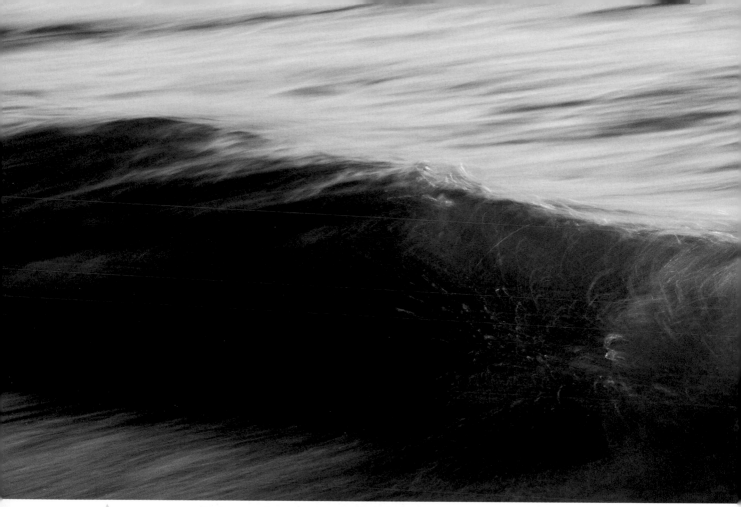

△ **Figure 10-11:** Artistically depicting ocean waves.

3. **Cradle the underside of the lens with your left hand, brace your elbows against your ribs, and spread your feet shoulder-width apart for stability.**

4. **When you see a wave racing to shore, bring the viewfinder to your eye and zoom in.**

 Your goal is to capture an image of the cresting wave and a bit of the ocean in front of and behind the wave.

5. **Rotate from the hip, press the shutter button fully, and then pan smoothly to follow the motion of the wave.**

Nature's Reflections

When you have a still body of water, you have a mirror-like surface that reflects the beauty of nature. The quality of the reflection depends on your vantage point and whether the water is perfectly still. You'll also get better reflections if you shoot during "Golden Hour" or on an overcast day. Harsh overhead light and pretty reflections are like oil and vinegar; they don't mix. Large lakes on windless days and slow-moving rivers are excellent sources for mirror reflections. You can also capture reflections of nature in puddles after a rainstorm. If you're photographing wading birds in still water, you have another opportunity to get a picture with a mirror reflection of your subject. The possibilities are limited only by your imagination. In the following sections, I share tips for photographing reflections.

Photographing still water that runs deep

When you arrive at a beautiful lake or large river, look around and notice what is reflected in the water. The reflection, not the actual objects being reflected, will be your subject. Therefore, you have to carefully compose your picture. If you do it right, you capture a compelling image that your viewers will take more than a casual glance at. Here are several tips for photographing reflections:

- **Place the sun at your back.** If you shoot into the sun, the reflection will be too dark.

- **Shoot in Aperture Priority mode** and choose a small aperture of f/11 or smaller (larger f-stop value). This ensures a large depth of field.

- **Focus on the reflection.** This ensures that the reflection is in sharp focus. The rest of the scene will be in focus as well because you're using a small aperture.

If you have a polarizing filter on your camera and have it dialed in for photographing clouds in the sky, you'll minimize reflections or eliminate them altogether. Rotate the outer ring of the polarizer until the reflection is revealed in all its glory. Remember that you get the best effects from a polarizer if you aim your camera 90 degrees from the sun.

✒ **Place the horizon line for maximum effect.** Placement of the horizon line determines the focal point of your image. You have three choices:

- *Place the horizon line in the upper third of the image.* This draws the viewer's attention to the reflection.

- *Place the horizon line in the center of the image.* When you choose this treatment, you give equal importance to the scenery and the reflection.

- *Photograph only the reflection.* When you choose this treatment, the horizon line isn't in the picture, and your viewer sees only the reflection.

✒ **Toss a stone in the water.** When you toss a stone in a still pond, a concentric pattern of ripples appears and breaks up the reflection.

Photographing reflections after a rainstorm

If you live in an arid climate or are photographing an area during a dry season of the year, rivers and lakes may be partially dry. This can all change when a spring shower suddenly appears. The parched land can't absorb the water quickly enough, and puddles form. After the rain stops, puddles turn into mirror-smooth surfaces upon which the surrounding scenery is reflected. When you photograph reflections of nature in puddles, keep these four tips in mind:

✒ **Use a telephoto lens** and zoom in tightly on the puddle.

✒ **Use the lowest ISO setting** possible to ensure a noise-free image.

✒ **Shoot in Aperture Priority mode** and use a small aperture (large f-stop value) for maximum depth of field.

✒ **Mount the camera on a tripod.** When you're zoomed in tightly on an object, the slightest movement can result in a blurry image.

Nature's Details

When you're photographing a beautiful place, it's easy to become overwhelmed and not notice everything, especially when you're photographing a place for the first and perhaps only time. Photographers need to be aware of everything around them, including the smallest details (see Figure 10-12). Here are four tips for getting great photographs of nature's details:

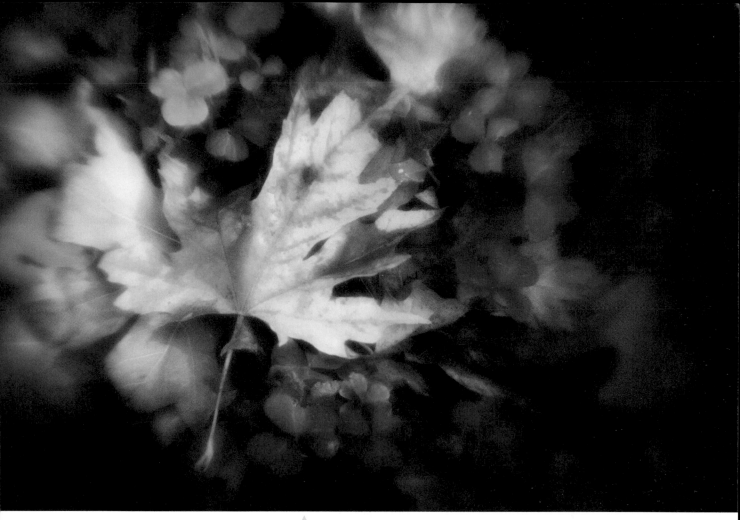

Figure 10-12: Nature's details make incredible photography subjects.

- ✓ **Look up.** Forests and swamps abound with wonderful details and patterns in the canopy. You also find intricate patterns of light and shadow on the trees.

- ✓ **Look down.** Find interesting objects like leaves blown on the ground, intricate patterns of tree roots, or small insects and animals.

- ✓ **Move closer and switch to a macro lens.** Tree bark, foliage, and vines make great subjects.

When you photograph with a macro lens and think you're close enough for a picture, take it and then move one step closer. The difference will surprise you.

- ✓ **Look for things that are different.** When you're strolling through a forest, you may notice things like spider webs, wildflowers sprouting beside a tree root, or a butterfly flitting from flower to flower. When you see subjects like these, switch to your macro lens and go in for a closer look.

In-Camera Abstracts

You can get interesting in-camera abstract photos with subjects that have patterns, such as a row of trees, tree barks, palm fronds, and so on. This technique involves controlled motion of the camera while shooting at a slow shutter speed. To create an in-camera abstract image, follow these steps:

1. **Choose your lowest ISO setting.**

2. **Shoot in Aperture Priority mode and choose your smallest aperture.**

 You may have to use a neutral density filter if you're shooting in bright conditions. For this technique to work, you need a shutter speed of 1 or 2 seconds.

3. **Find a subject with an interesting pattern, such as closely spaced tree trunks.**

4. **Push the shutter button halfway to achieve focus.**

5. **Press the shutter button and slowly move the camera. If you're photographing a vertical pattern, move the camera up. If you're photographing a horizontal pattern, move the camera left or right.**

 The resulting image has a soft painterly look to it (Claude Monet, eat your heart out!). See Figure 10-13.

Black-and-White Photos

Ansel Adams captured wonderful images of Yosemite using black-and-white film. Your camera captures color images, but that doesn't mean you can't follow in Ansel's footsteps and create black-and-white photos (see Figure 10-14). The only difference is that you have to convert your photos to black and white in your digital darkroom.

In Photoshop Elements, you can convert an image to grayscale, but you don't have the control needed to get the rich blacks like those seen in Ansel Adams's photographs. You can get closer using an application like Aperture, Adobe Photoshop Lightroom, or Adobe Photoshop. You also can use third-party plug-ins to convert your color images to black and white. Here are two of them:

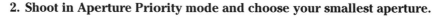

Figure 10-13: Capturing in-camera abstract images of nature.

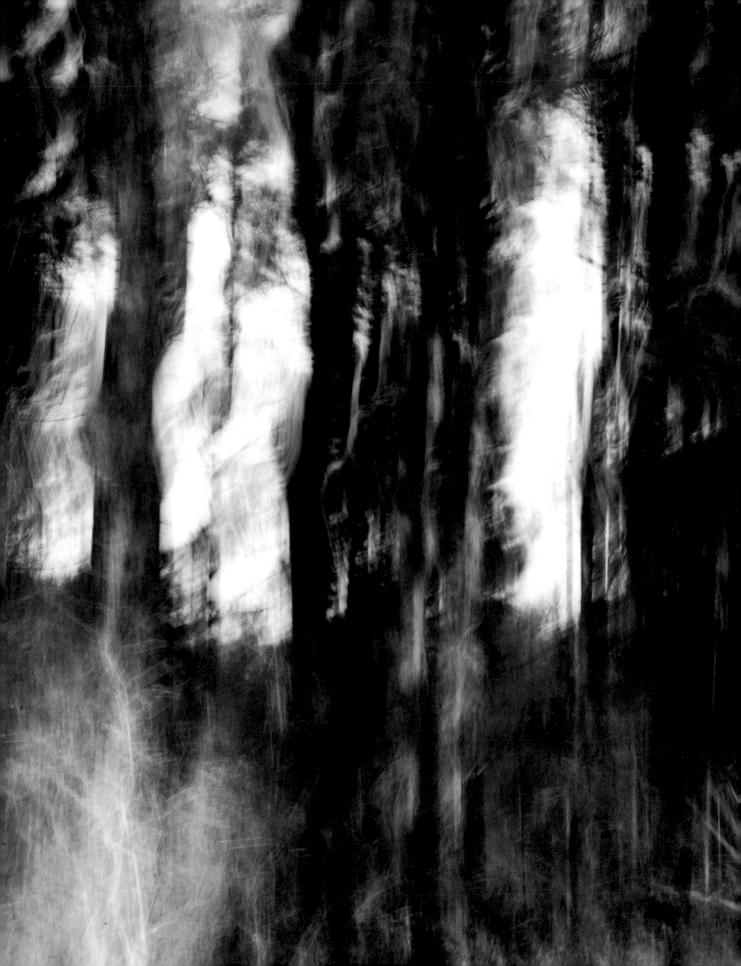

- ✔ Alien Skin has a plug-in called Exposure 3 that you use to emulate color and black-and-white film. Exposure 3 (you can find more info at `www.alienskin.com/exposure/index.aspx`) works in conjunction with Photoshop Elements 7 and later, Photoshop CS3 and later, and Lightroom 2 and later. The plug-in retails for $249.

- ✔ Nik Software has a plug-in called Silver Efex Pro 2 (more info at `www.niksoftware.com/silverefexpro/usa/entry.php`) that works with Apple Aperture 2.14 and later, Adobe Photoshop Lightroom 2.6 and later, Adobe Photoshop Elements 6 and later, and Adobe Photoshop CS3 and later. Silver Efex Pro 2 has U Point technology that enables you to make localized adjustments to control brightness, contrast, and structure. Silver Efex Pro 2 retails for $199.95.

Figure 10-14: Nature's beauty looks great in black and white.

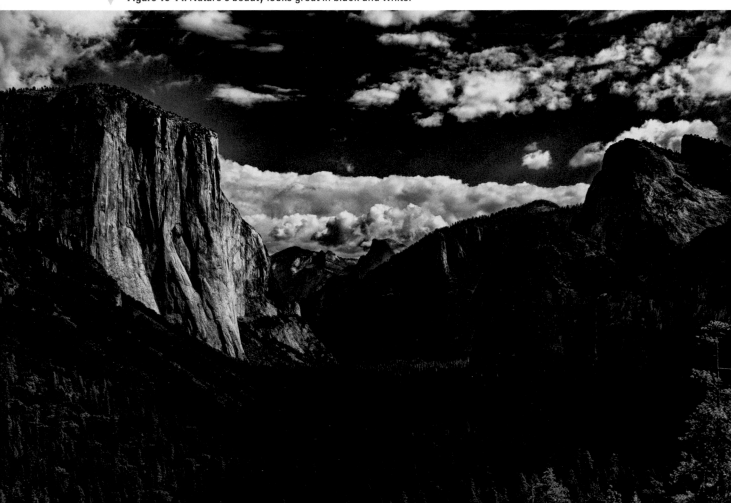

If you want to follow in the footsteps of Ansel Adams and create compelling black-and-white photos when you process your images, keep the following in mind:

- **Photograph scenes with lots of contrast.** A landscape with a blue sky and billowing thunderheads is ideal for conversion to black and white.

- **Place the horizon line in the lower third of the image** when photographing a scene with a beautiful cloudscape.

- **Use a polarizing filter** with the camera facing 90 degrees from the sun. This maximizes the darkening effect of the filter. Rotate the outer ring of the filter until the sky is a deep blue and the clouds pop out in contrast.

- **Underexpose the image by 1/3 EV.** This will give you an image with darker shadows, which look great when converted to black and white.

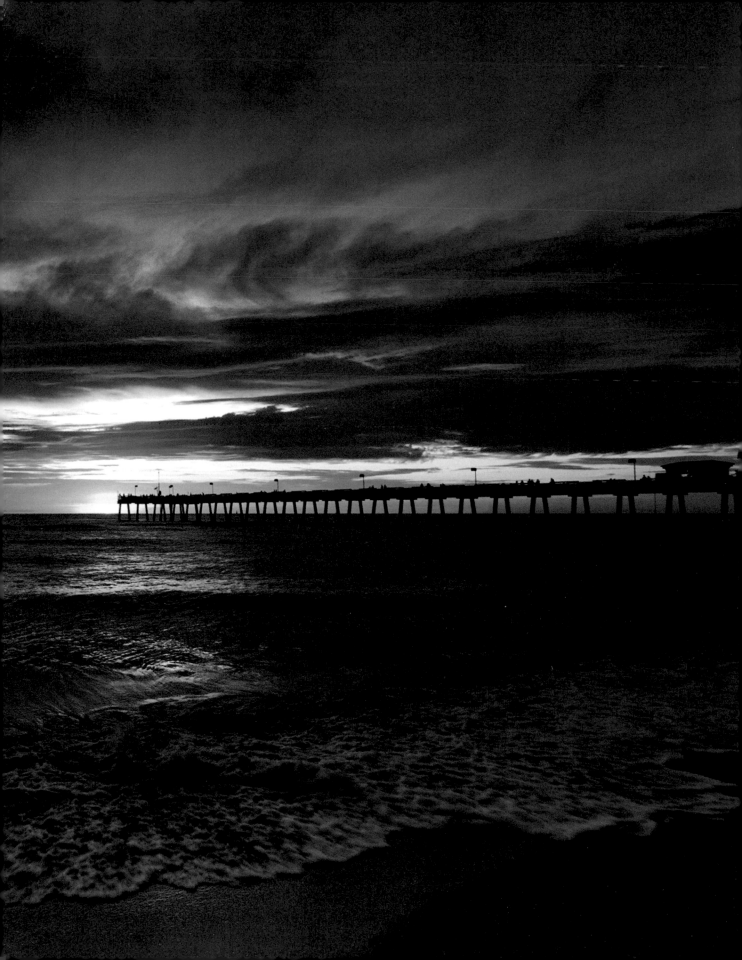

11

Sunrise and Sunset

Sunrise and sunset are great times to shoot pictures. The sun casts a golden hue on landscapes and seascapes. Add some clouds and you have the recipe for great pictures. However, if you want to get decent photos of the sunrise and sunset, you need to do more than just point the camera at the sun and then take a picture. Your camera is easily fooled when you point it at a bright source of light like the sun. The picture on your camera LCD monitor may look a lot brighter than the scene in front of you. This is when you need to know your camera intimately, including which settings to use and how to compensate for what the camera thinks are the proper settings. If you're ready to master your camera and shoot awesome photos of the sunrise and sunset where you live or where you vacation, read on.

The Sunrise

Sunrise is a glorious time that signifies the birth of a new day. You capture wonderful images just before the sun comes up and as it peeks over the horizon. You can also capture wonderful photographs of the landscape for an hour or so after the sun rises. After that, it's time for a second (or in my case, fourth) cup of coffee and breakfast. The following sections shed light on the wonderful art of capturing great photographs at sunrise.

The ingredients for a great sunrise photo

If you do your job as a photographer the right way, you don't take a picture — you create a photograph. When you create anything, you assemble given elements, add your creative spin, and then create your masterpiece. A sunrise photograph is no exception. It is known that the sun will rise at a certain time on a given day. But other factors, such as the weather, are wild cards. Here are six things you can do to hedge your bets:

✏ **Know the exact time the sun rises and the exact time it will illuminate the landscape.** You can find out the exact time of the sunrise by conducting an Internet search. Sometimes your local broadcast news reports it during the weather portion of the program, too. The time the sun rises and the time it will start illuminating the landscape depend on the altitude of the place you're photographing and the surrounding terrain. If you're in a forest, the sun will take a while to poke over the tops of the trees. Before that occurs, you'll see patches of light poking through the trees, casting brilliant rays of light on the landscape.

If you're in a valley surrounded by mountains, the sun will have to crest the mountain before you can start taking photos. If clouds are hovering above the mountains, you can start taking pictures as soon as the clouds are illuminated. If you're not blessed with clouds, then wait patiently until the valley is flooded with glorious golden sunlight. Then start taking lots of pictures.

✏ **Shoot the sunrise rising over a beautiful landscape.** This requires a bit of thought. You need to know the direction from which the sun rises and how it illuminates the landscape. The only way to know this is to visit a place a day or two before you plan to shoot the sunrise.

If you're going on a photo vacation, look at the work of other photographers who have photographed the area in which you'll be taking pictures. Many photographers and photo-sharing sites post the metadata for images. This information tells you exactly when the photograph was taken. All you need to do is be in the same place at the same time of year to capture a photograph with the sun rising over the landscape. Of course, put your own spin on it to capture your unique photograph.

When I visited Yosemite, I knew I wanted to capture a photograph of the sun's first rays hitting El Capitan. I did my research before my visit, and asked photographers at the Ansel Adams Gallery for enlightenment. They told me the ideal place. I woke up one morning and waited patiently. I was rewarded with the opportunity to take a breathtaking photograph (see Figure 11-1).

On many photo-sharing sites like Flickr and SmugMug, you can post a comment about a photo that piques your curiosity. You can include a query in your comment to the photographer to find out more about the location. Many photographers on photo-sharing sites are happy to share information with fellow photographers.

✏ **Location is everything.** You can get to the most beautiful location in the world and still not get a great photograph. The difference of a hundred yards or a quarter of a mile can make all the difference between a great picture and an average picture. This is where your knowledge of the area or your research of that area comes into play. When you get to a great location, move around until you find the ideal vantage point. Take the "cliché" pictures first and then dig deeper to create unique photographs.

Pay careful attention to what you see in the viewfinder. Landscapes don't move so you can take a few seconds to figure out exactly what needs to be in your photograph to create a more interesting image.

✏ **A layer of clouds will enhance your image.** The sun will illuminate the underside of the clouds before it rises above the horizon. This is why I always advise arriving at least half an hour before sunrise.

✏ **Water features will enhance your picture.** If you're photographing a location where the sun rises over a lake or the ocean, the sun will cast a

wonderful reflection on the water. When you photograph a scene with the sun reflecting on the water, you may have to use exposure compensation to reduce the exposure if the reflections are too bright. If your camera has the highlight warning, enable it when shooting sunrises; areas of blown-out highlights will appear as blinking overlays on your camera LCD monitor. When you see the "blinkies," dial the exposure down by 1/3 to 2/3 EV until you banish the blinkies.

- **Compose your image properly.** If the sun is in your picture, compose the picture so that the sun is on the left or right side of the image about one-third of the way from the edge. The placement of the horizon line depends on the scenery. If you have a ho-hum landscape but a wonderful layer of clouds, place the horizon line in the lower third of the image. If you're photographing the sun rising over a body of water, place the horizon line in the upper third of the image to draw the viewer's attention to the water. When you compose an image properly, your viewers know where to look and what the focal point of your image is.

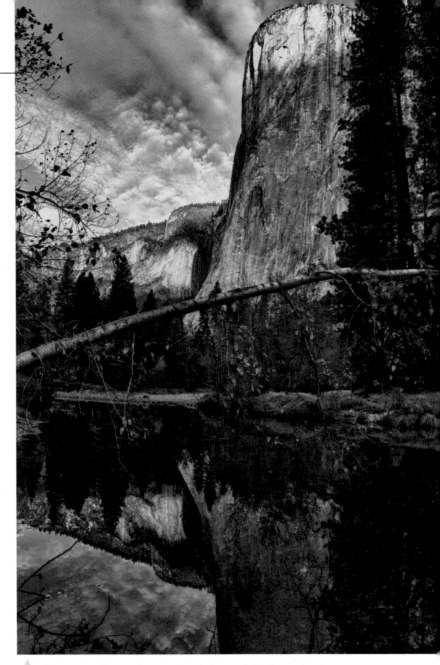

Figure 11-1: Do your research and then wait for the sun to rise.

Setting up for the perfect sunrise photo shoot

If you're going to photograph landscapes in the morning, arrive at your destination at least half an hour before the sun rises. If clouds are in the sky, point

your camera away from the area where the sun will rise and start taking pictures immediately. A few minutes before the sun actually rises, it illuminates the clouds with wonderfully warm colors. Things will change rapidly as it gets closer to sunrise. The colors on the clouds can change within a few seconds. The landscape will be in silhouette until the sun actually rises. As long as you have beautiful light on the clouds, shoot up a storm. When the landscape is in silhouette, use exposure compensation to underexpose the image by 1/3 to 2/3 EV. This will saturate the colors and make the clouds pop.

Keep a small flashlight in your camera bag. This makes it easier to get around when you arrive at a scene before the sun comes up. It also makes it easier to set up your camera and tripod if you're using one.

When you photograph the landscape before sunrise, look toward the area from which the sun will rise. At first you'll see a faint glimmer on the horizon. Take a couple of pictures and then turn around and take more pictures of the landscape and clouds. Keep changing your viewpoint and use the rules of composition to position the elements in your scene.

Shooting into the sun

Start shooting into the sun when it peeks above the horizon. When you photograph a landscape at sunrise, the quality of the light and the colors changes almost by the second. Shoot lots of frames and shoot them from different vantage points. Use the rules of composition as outlined in Chapter 4 and pay careful attention to where you place the horizon line. Don't get so carried away with the beauty of the sunrise that you forget that your goal is to capture compelling photographs of the sunrise — photos that people will spend some time viewing.

If you photograph a sunrise and shoot directly into the sun, your camera will try to outfox your best efforts. Be alert and stay one step ahead of your camera. Getting a great photograph of the sunrise requires the proper focal length, shooting mode, and more. The following list will get you pointed in the right direction:

- **Focal length:** When you're photographing a beautiful landscape with a rising sun, choose a wide-angle focal length between 24mm and 35mm. The sun will be relatively small in the image, but you'll capture the beauty of the landscape and any clouds that are in the scene. In addition, the camera won't have to compensate for quite as wide a dynamic range because the sun is a tiny pinpoint of light.

- **ISO:** Choose the lowest possible ISO setting for the available ambient light. This ensures a noise-free image. If you have to increase the ISO setting, don't exceed ISO 400, if your camera sensor is not full frame, or ISO 800, if your camera has a full-frame sensor.

- **Shooting mode:** Use Aperture Priority mode when you photograph a sunrise with a beautiful landscape. This gives you complete control over the depth of field.

- **Aperture:** Choose the smallest possible aperture that yields a shutter speed of 1/50 of a second. If your lens has image stabilization, you can get by with a shutter speed of 1/30 of a second, or perhaps 1/15 of a second if you have a very steady hand. You should use an aperture with

an f-stop value of f/11 or higher. When you dial in a higher f-stop value, you get a smaller aperture and a greater depth of field. If you shoot at the largest recommended aperture and your shutter speed dips too low, the alternative is to increase the ISO setting. Don't increase the ISO setting beyond 400, or 800 if you have a camera with a full-frame sensor, especially if the scene has lots of shadow areas.

- **Tripod:** A tripod is optional but ensures that you get a sharper image. You'll also need a tripod if you're photographing the scenery before the sun rises.

- **Exposure compensation:** When you photograph a sunrise, your camera will think the scene needs to be brighter and will crank up the exposure. The sun may be bright, but you also get dark areas in your scene. To keep one step ahead of your camera, review your photos as your photo shoot progresses. If the image on your LCD monitor looks brighter than the scene before you, use exposure compensation to decrease the exposure.

- **Reverse graduated neutral density filter:** This filter is darkest at the middle and gradually becomes clear at the top. This filter balances the bright light of the sun with the shadows, bringing the dynamic range into something your digital camera can manage.

Shooting away from the sun

Shooting away from the sun poses the same challenges as shooting into it. Use the same settings as outlined in the preceding section, with one exception: Don't use the reverse graduated neutral density filter. When you shoot away from the sun, you're taking advantage of the spectacular light you get during Golden Hour, which is one hour after sunrise and one hour before sunset (see Figure 11-2).

When photographing colorful landscapes during Golden Hour, use exposure compensation to reduce exposure by 1/3 EV to saturate colors. The image will pop!

Taking pictures after the sun rises

You have roughly an hour of beautiful golden light after the sun rises. Yup, that's why it's called Golden Hour. As the sun gets higher, you'll have more even lighting, and your camera won't need to capture the huge dynamic range from shadows to highlights as it does when you shoot at sunrise. You'll notice that the image your camera captures looks more like the scene before you. Therefore, you won't have to rely on exposure compensation. I advise that you review each picture immediately after you take it to make sure it's acceptable. Review the histogram as well. Reviewing your images tells you when you can disable or reduce exposure compensation.

When the light starts embracing the land, move around and take lots of pictures from different vantage points. This is a perfect time to use all your nature photography skills. You can photograph the landscape, flowers, birds, and wildlife. Birds and wildlife get active in the morning as they search for the first meal of the day.

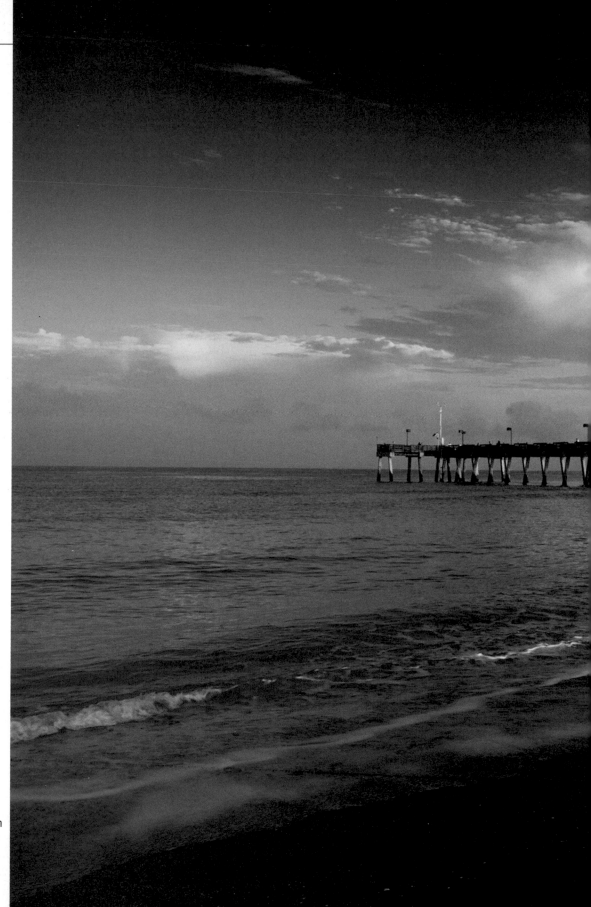

Figure 11-2:
Shoot away from
the sun during
Golden Hour.

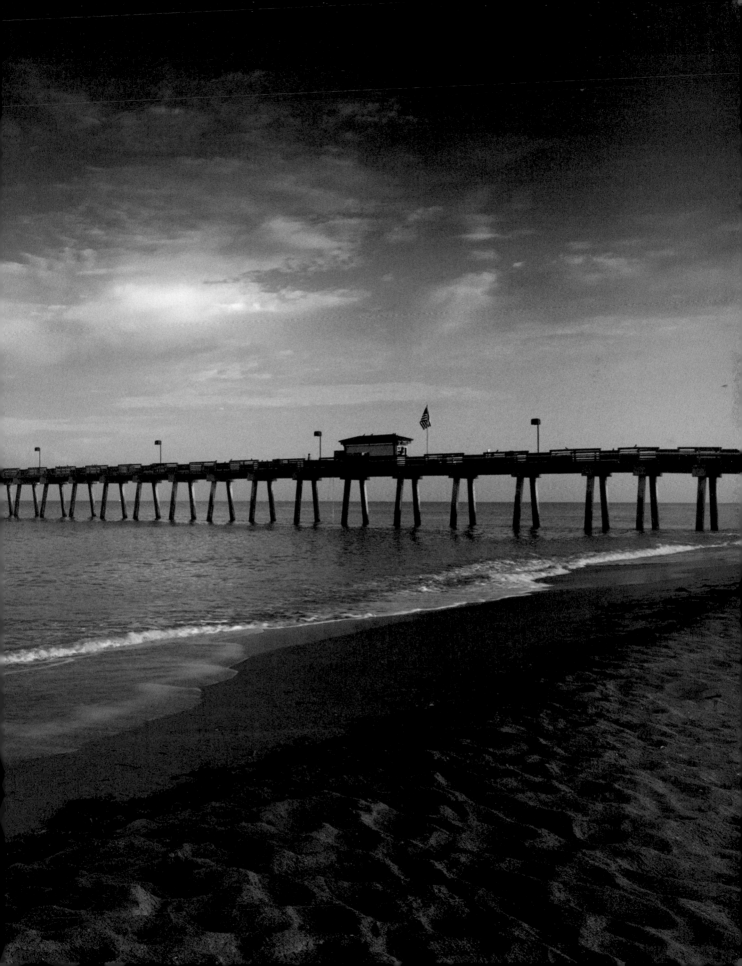

The Sunset

Sunrise and sunset are the proverbial bookends of a day — hopefully, a day filled with photographic adventures. Sunset gives you the same wonderful light you get in the morning, only the scenario is reversed. You get the wonderful light at the end of the day, then the sun dips below the horizon and any clouds in the area are bathed with giddy hues of orange, pink, and purple.

Setting up for the perfect sunset shoot

At sunset, you have about 75 minutes of beautiful light for photography. To have as much time as possible for the actual shoot, do your preparations ahead of time:

- **Know the exact time the sun sets and when it will stop shining on the landscape.** Find out what time the sun sets by performing an Internet search or watching the weather section of your local broadcast news. If you're photographing in the mountains and you're below the peaks, the sun stops illuminating the landscape before it actually sinks below the horizon. The distance below the peak behind which the sun sets determines when the area you're in will be in shadow. If you're shooting in a forest, the sun dips below the highest trees a few minutes before it sinks below the horizon. You can get dramatic shots of the sun shining through the trees. You'll have long shadows as well.

 Several programs are available that can calculate when the sunset will occur and when the sun will stop shining. One is called The Photographer's Ephemeris (www.photoephemeris.com). It's a free desktop application, or you can purchase an application for a mobile device.

- **Choose a great landscape for your sunset shot.** Pick a landscape with character. Beaches are great spots to shoot sunsets, but any landscape can be a good location. You'll need interesting elements in the location to draw your viewers in.

- **Choose the right location.** You can go to the most beautiful location in the world and still not get a great photograph. Moving to a different vantage point can make all the difference between a great picture and an average picture. This is where your knowledge of the area or your research of an area you're going to visit will come into play.

- **Shoot your sunset on a day when clouds are in the sky.** If you photograph the sunset in a place where you live, you'll know the weather patterns and can predict whether you'll have the ingredients for a great sunset picture. Ansel Adams could predict if it would be worth photographing the sunset in Yosemite by looking west half an hour before sunset. You need to become that intimate with the landscape where you live.

- **Use water features to enhance your picture.** If you're photographing a location where the sun sets over a lake or the ocean, the sun will cast wonderful reflections (see Figure 11-3). If the water is choppy, the pattern of the waves catches the reflections. If the water is like glass, you capture an image with a wonderful swatch of golden color.

▶ **Figure 11-3:** Who can resist a sunset over the ocean?

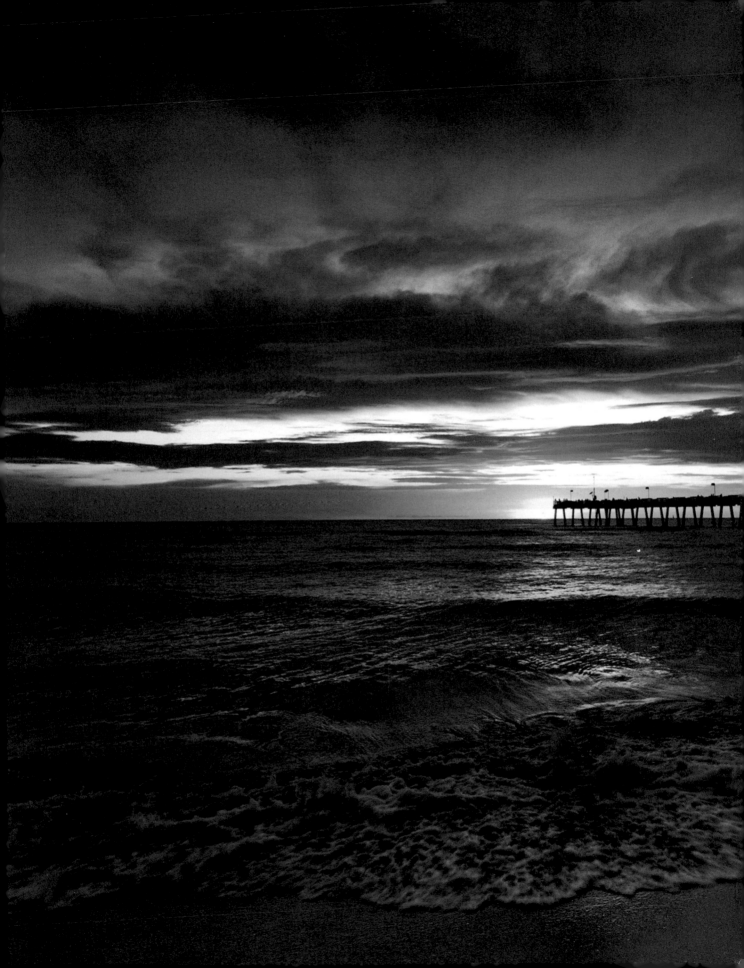

✔ **Compose your image properly.** The sun is an integral part of a sunset photograph. Placing the sun in the center of the image results in a boring photograph. Instead, compose the picture so that the sun is on the left or right side of the image about one-third of the way from the edge. The placement of the horizon line depends on the scenery. If you have a mundane landscape with a wonderful layer of clouds, place the horizon line in the lower third of the image. If you're photographing the sun setting over a mountain range, place the horizon line in the upper third of the image.

Shooting into the sun

Sunset is a wonderful time of the day to take photographs. Sunset is the other Golden Hour. The quality of light is very similar to sunrise's Golden Hour. Whether you shoot the sunrise or sunset depends on the area in which you live and the landscape features you have. The sun setting over the ocean is an ideal scenario for a great photograph. Of course, the luckiest nature photographers live near the west coast of Florida or the west coast of the United States. Another alternative is visiting any place where the sun sets over the ocean (see Figure 11-4).

When you shoot a sunset, the camera has a hard time metering for the wide dynamic range. The sun is the brightest part of the scene, much brighter than any other object you'll include in a photograph. A sunset scene also has dark shadows. Your camera will meter for the average, and the sun will be a blown-out blob of yellow or orange color. The rest of the scene will probably be too bright as well. Compensate by using exposure compensation to reduce the exposure until what you see on the camera LCD monitor matches the scene you see before you. Or you can use the HDR techniques outlined in Chapter 12.

Photographing a sunset is exciting. The light changes by the minute (or even second) as the sun sinks lower on the horizon. And some of the best images happen just before the sun sinks below the horizon, especially if you have calm water and wonderful billowing clouds (see Figure 11-5).

In order to capture the best possible photo, you need to use the right equipment and settings. The following list, similar to the previous list for shooting sunrise photos, will get you pointed in the right direction:

✔ **Focal length:** When you're photographing a compelling landscape at sunset, choose a wide-angle focal length between 24mm and 35mm. The sun will be relatively small in the image, but you'll capture the beauty

of the landscape and any clouds in the area. In addition, your camera doesn't have to compensate for a wide dynamic range because the sun is a very small part of the image.

For something different, try photographing the sunset with a telephoto lens. The sun will be much larger in your image, and other parts of the scene will be compressed, making them appear closer to the camera and each other than they really are.

Never look directly at the sun through your camera lens, because this can damage your vision. If your camera has Live View, enable it and compose the scene using your LCD monitor. If you use Live View, don't use it any longer than you have to. Prolonged exposure to the sun can damage the camera sensor, especially when you use a telephoto lens.

- **Shooting mode:** Use Aperture Priority mode when you photograph a landscape at sunset to gain total control over the depth of field.

- **ISO:** Choose the lowest possible ISO setting for the available light. If you have lots of clouds in the sky, you may have to increase the ISO setting, even when photographing a sunset. The alternative is to mount your camera on a tripod.

- **Aperture:** Choose a small aperture with an f-stop value of f/16 or higher (smaller aperture). This gives you a large depth of field. You can get by with a shutter speed of 1/30 of a second if your camera has image stabilization. If you shoot at the smallest recommended aperture and your shutter speed dips too low, the alternative is to increase the ISO setting. Don't increase the ISO setting beyond 400, or 800 if your camera has a full-frame sensor, especially if the scene has lots of shadow areas.

- **Tripod:** A tripod is optional but ensures that you get a sharper image.

- **Exposure compensation:** When you photograph a scene as the sun is setting, your camera will meter the scene and crank up the exposure to create an image that is brighter than it should be. The sun may be bright, but your scene also has dark areas. In order to keep one step ahead of your camera, review each photo immediately after you take it. If the image on your LCD monitor is brighter than the scene before you, use exposure compensation to decrease the exposure.

- **Reverse graduated neutral density filter:** This filter makes the dynamic range more manageable for your camera by making the horizon darker. This filter is darkest at the middle and gradually becomes clear at the top.

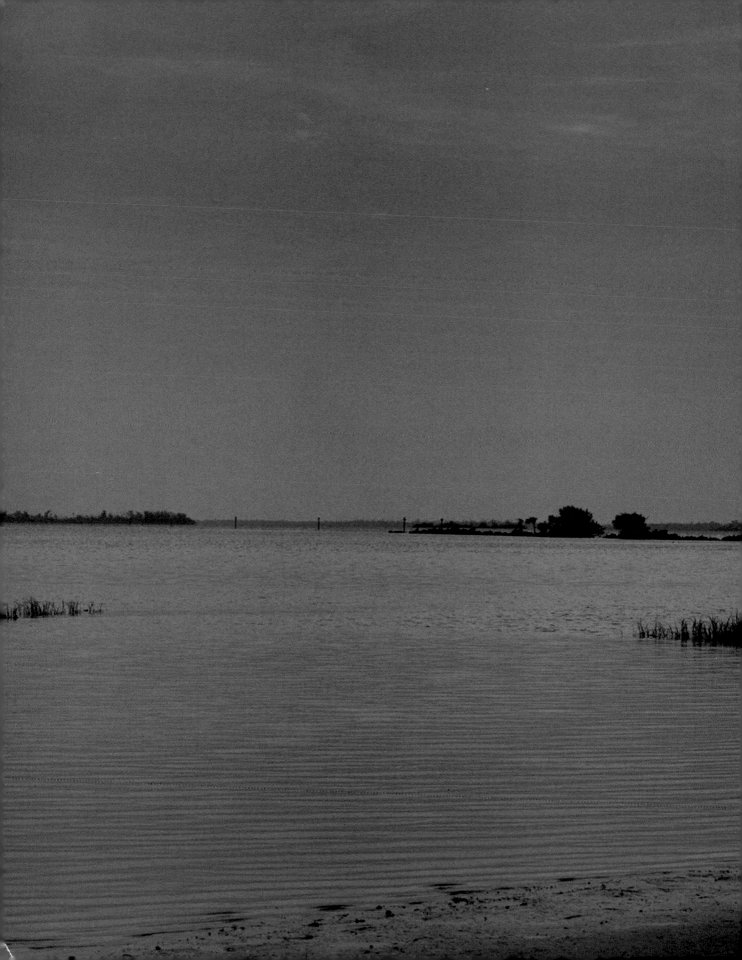

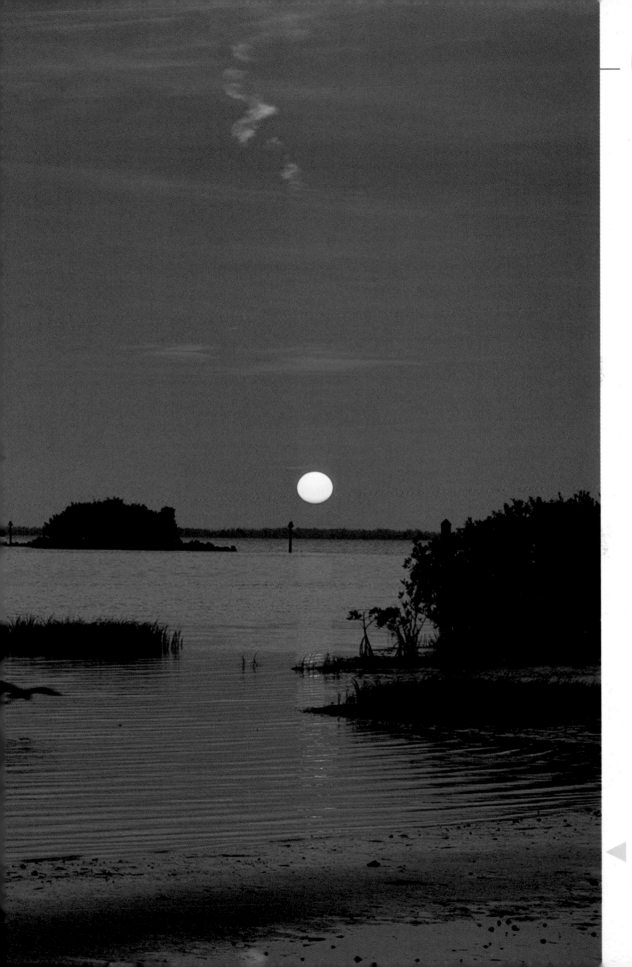

Figure 11-4:
Shooting
into the sun.

Figure 11-5:
Clouds and
calm water
are ingredients
for wonderful
sunset images.

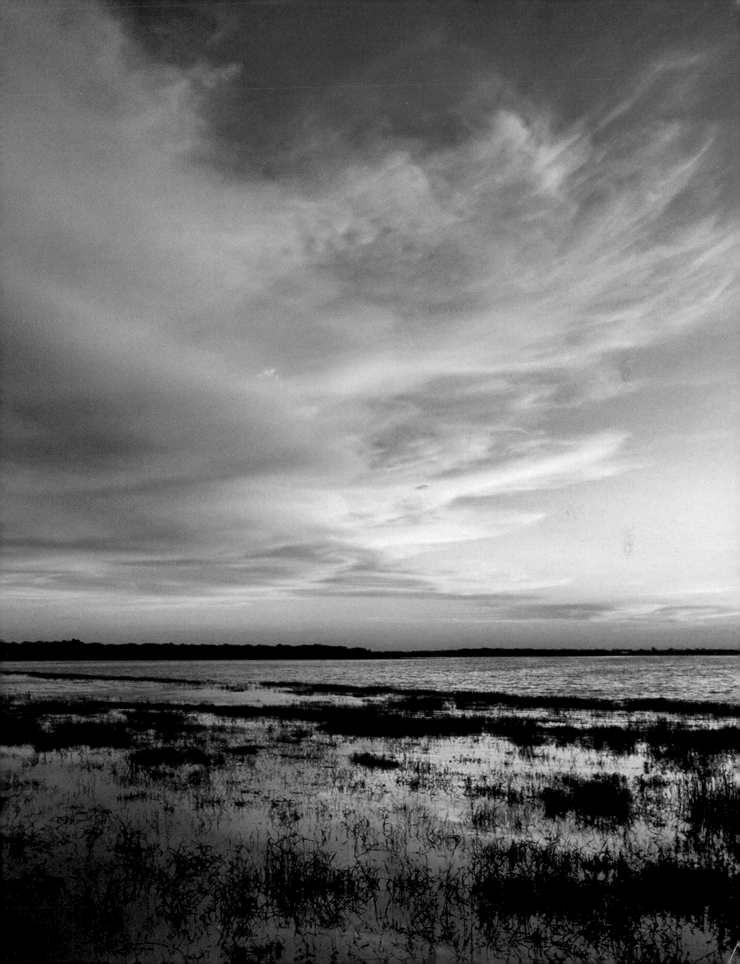

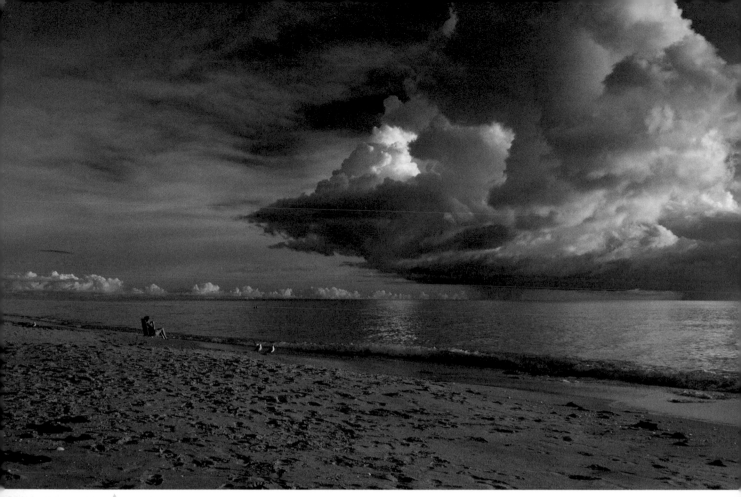

▲ **Figure 11-6:** A polarizing filter enhances the color of the sky.

Shooting away from the sun

When you arrive at the place from which you're going to photograph the sunset, the sun will probably still be fairly high in the sky. Use this time to capture beautiful images by pointing your camera away from the sun. You'll be rewarded with a landscape that is bathed in warm color — color that enhances the scenery.

To photograph Golden Hour with the sun at your back, use the same camera settings, with one exception: Skip the reverse neutral density graduated filter. If a sky is full of clouds, you can intensify the blue with a polarizing filter. Note that you get your best results with a polarizing filter when your camera is pointed 90 degrees from the sun (see Figure 11-6).

Beyond the flash of green

The mystical *flash of green* occurs right as the sun dips below the horizon — it's the official sunset time. If clouds hover in the sky, don't pack up your gear when the sun goes down. As long as the clouds don't go all the way to the horizon, you still have 15 to 20 minutes' worth of picture-taking opportunities. The sun reflects on the underside of the clouds. As the sun sinks lower, the colors become more intense. Wait patiently and take pictures when you see the color start to intensify. The amount of ambient light decreases fairly quickly, and your camera thinks the scene needs to be brighter than it actually is. Don't let the camera ruin your pictures. Review each image on your LCD monitor, and if necessary use exposure compensation to decrease the exposure. You may have to decrease the exposure a couple of times until all the color is gone from the clouds.

You may also experience a phenomenon known as *alpenglow,* a band of red light on the horizon directly opposite the direction in which the sun sets. This occurs when the sun reflects off the underside of clouds and illuminates prominent features of the landscape. Alpenglow is easier to see when you're in the mountains. The reflections bathe the mountaintops in red light (see Figure 11-7).

Figure 11-7: Photograph the mountains after the sun goes down.

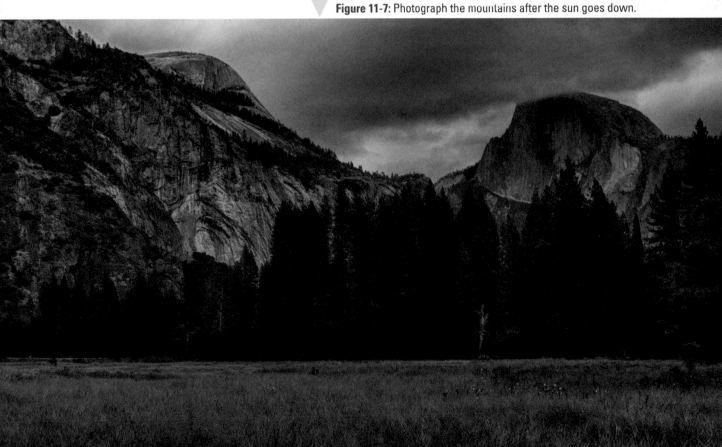

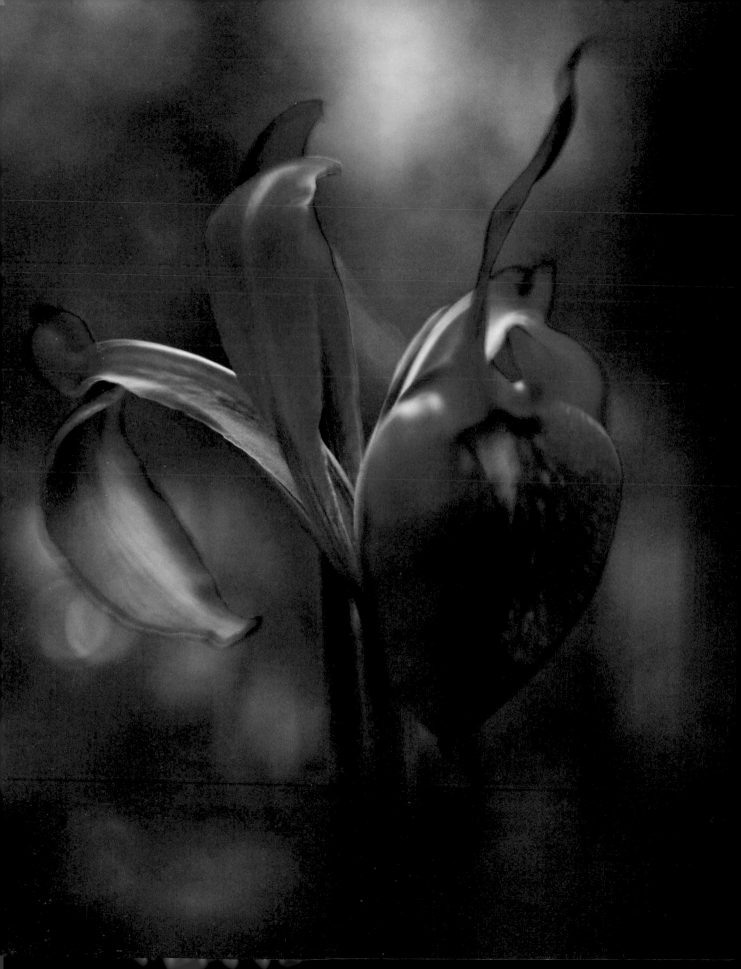

12

HDR Landscapes

*T*he human eye can see a wider range of brightness than your digital camera is capable of capturing. This shortcoming in your camera is readily apparent when you photograph a sunset or any scene that has very bright objects and dark objects. For example, a photograph of the Grand Canyon taken late in the afternoon will have shadow areas in which you can't see any detail. Do you give up? You don't have to: A method known as *high-definition range (HDR) photography* enables you to create images that have a wider range of colors and tonality.

HDR photography involves taking multiple exposures of the same scene and then using software to merge them. You may have been disappointed with HDR images you've seen in the past. Some HDR images look overworked and like they were crudely drawn pictures with crayons instead of photographs, which happens when the photographer doesn't use the HDR software correctly.

A true HDR image captures all the beauty of the scene in a realistic manner. In this chapter, I show you how to capture HDR images and merge them using software. I also introduce you to the magic of panoramas. A panorama captures a huge amount of real estate in one image. In essence, to create a panorama, you capture several images with your digital camera and then merge the separate images in a software application to create the final piece. I show you how to shoot the images and then stitch them together in Adobe Photoshop Elements 9.

Understanding HDR Photography

HDR photography is used to create an image with beautiful lifelike colors and a wide dynamic range of tonality from the darkest shadow to the brightest object in a scene. When you take an HDR photograph, like the one in Figure 12-1, you actually take three or more pictures at different settings. You can usually get by with three images unless you have a very wide dynamic range. One image is as the camera meters it, another image is underexposed, and the last image is overexposed. The underexposed image picks up details in the bright areas of the scene, and the overexposed image picks up details in the dark areas of the scene. Figure 12-2 shows three exposures ready to be merged in an HDR application. The range of tonality you're trying to capture determines the amount by which you underexpose or overexpose each image. The images are merged together using one of the software applications described in the next section. The end result is an image with a full range of tonality from light to dark (see Figure 12-1).

About HDR software

In my humble opinion, the HDR market has only two real contenders:

- **Photomatix by HDRsoft:** Available at www.hdrsoft.com as stand-alone software and as a plug-in for Adobe Photoshop Lightroom, Adobe Photoshop (versions CS2 through CS5), and Apple Aperture. Photomatix does a good job in creating HDR images, but it's not intuitive, as there are lots of controls that may or may not make sense to you. As of this writing, Photomatix Pro retails for $99.

- **HDR Efex Pro by Nik Software:** Available as a plug-in for Adobe Photoshop (versions C4 and CS5 64-bit), Adobe Photoshop Lightroom (versions 2.6 through 3.0, 32-bit and 64-bit), and Apple Aperture (versions 2.14 through 3.0, 32-bit and 64-bit). The application, which is available at www.niksoftware.com/hdrefexpro/usa/entry.php, features thumbnails that show each preset. You can tweak a preset to get the look you want and then save the preset for future use. As of this writing, HDR Efex Pro sells for $159.95.

Photoshop CS5 does have built-in HDR toning. However, I find that Nik's application is the most intuitive and is also the easiest to learn.

Shooting the images for your HDR photo

Creating images to merge into HDR isn't rocket science, but you do have to follow a logical sequence and use some specific tools. The images you merge using HDR software need to be perfectly aligned. You also have to create three different exposures to merge into an HDR photo, like the ones shown in Figure 12-2.

The logistics may sound complicated, but it's actually very easy if you take advantage of some camera automation. To create images to merge into an HDR photo, follow these steps:

1. **Choose your lowest ISO setting.**

 This may result in slow shutter speeds, which will cause some problems if leaves, tree branches, or objects like flags are swaying in the breeze.

2. **Choose Auto-Exposure Bracketing (sometimes listed as AEB) from your camera menu.**

 When you choose Auto-Exposure Bracketing, you can choose how much the exposure changes for the images you plan to merge to HDR. Most cameras let you bracket only three exposures. As a rule, bracket the exposures by 2 EV, which will give you one image at −2 EV, one at the exposure as metered by the camera, and one image at +2 EV.

3. **Set your camera to Aperture Priority mode.**

 When you photograph in Aperture Priority mode, the shutter speed changes when the camera brackets the exposures.

 When you shoot HDR images, never set the camera to Shutter Priority mode. When the camera brackets for the different exposures, the f-stop changes, which gives you a slightly different depth of field for each image. That, in turn, yields undesirable results when merged in an HDR application. If an object has a dynamic range of tones from dark shadow to bright light, when the images are merged in the HDR application, part of the object is in sharp focus and the rest is not.

4. **Enable your camera's time-delay function and choose the lowest duration.**

 When you enable Auto-Exposure Bracketing, your camera takes three exposures in succession. (If you don't enable the time delay, you must press the shutter button three times.) An added bonus is the fact that the delay stabilizes the camera from any vibration that might have occurred when you pressed the shutter button, which is especially useful if you're shooting in low lighting conditions.

5. **Mount your camera on a tripod.**

 Most HDR applications attempt to align images, but it's best to have all images pin-registered, which means the camera is in exactly the same position for each exposure.

That's the basic setup. Now all you need to do is find a scene you'd like to create an HDR image of, compose the shot, and fire away.

To keep your sequence of bracketed images organized, take one picture with the lens cap on (or put your hand in front of the lens) between each sequence. This creates a black image that serves as your visual reference for the next sequence of bracketed images.

Figure 12-1:
Create an
HDR image
to capture the
full tonal range
in a scene.

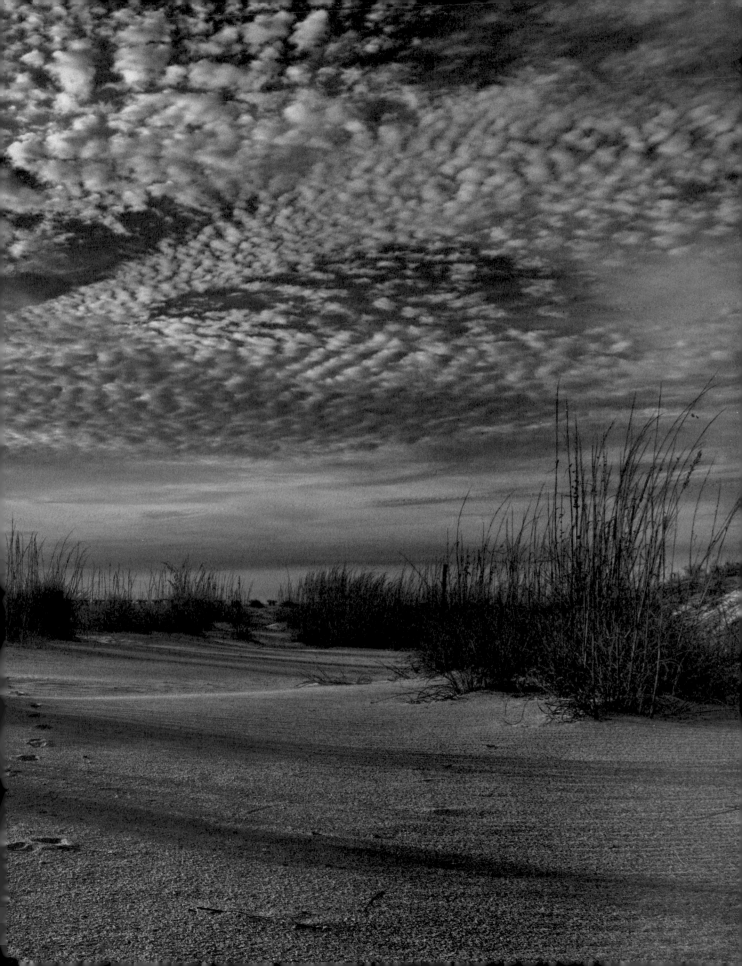

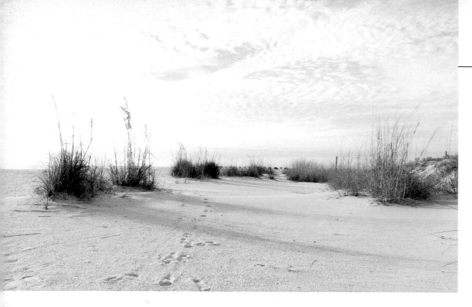

Creating an HDR image

Photoshop Elements 9 is an amazing application. You can use it to merge multiple exposures into a surprisingly realistic HDR image, as shown in Figure 12-3.

If you don't have Photoshop or Lightroom coupled with Photomatix or HDR Efex Pro, you can get a good HDR image by merging exposures in Photoshop Elements. To merge exposures in Photoshop Elements, follow these steps on the computer on which you installed the HDR software:

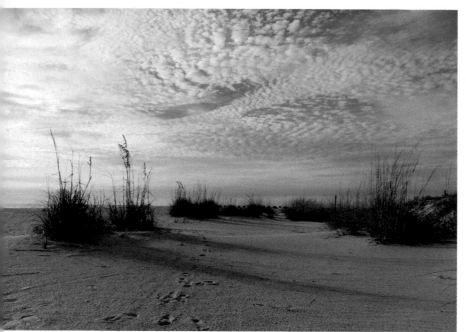

1. **Choose File⇨Open.**

 The Open dialog box appears.

2. **Select the images you created with bracketed exposures.**

 Photoshop Elements can merge exposures for a minimum of two images and a maximum of ten images.

3. **Open the images.**

 The images appear in the project bin.

Figure 12-2: You combine three exposures to create an HDR image.

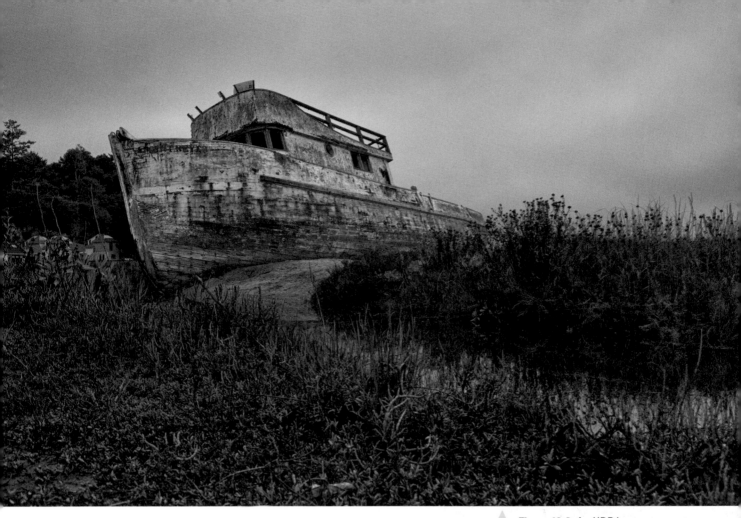

Figure 12-3: An HDR image.

4. **Select the images and then choose File⇨New⇨Photomerge Exposure Merge (see Figure 12-4).**

 The Photomerge Exposure dialog box appears with a message telling you Photoshop Elements is examining the images. This process may take a while. After the images are analyzed, you see the final image in a window.

5. **Accept the default Smart Blending option, or click Simple Blending.**

 The default option lets you tweak the final image. Simple Blending blends the image, and you have no control. The following steps are based on Smart Blending. But hey, if you're in a hurry,

Figure 12-4: Merging exposures with Elements' Photomerge Exposure command.

give Simple Blending a shot. You can always select Smart Blending if you don't like the results you get.

6. **Drag the Highlights slider right to brighten highlight details or left to darken them.**

7. **Drag the Shadows slider right to brighten shadows or left to darken them.**

8. **Drag the Saturation slider right to add more saturation to the colors or left to desaturate them.**

 If you drag the slider all the way to the left, you have a black-and-white — grayscale for you purists — image.

9. **Click Done.**

 Photoshop Elements blends the images. The time this takes depends on the speed of your computer. After the blending is complete, your HDR image appears in the main window and the project bin.

10. **Choose File⇨Save As and follow the prompts to save the image in the desired file format.**

Capturing Your Grand Vision with a Panorama

Landscapes that go on for miles and miles and miles deserve special treatment. Instead of creating a landscape image with the standard digital photography 4:3 aspect ratio, go really wide and create a panorama. When you create a panorama, you must use specific settings. You also need to mount your camera on a tripod. To create a panorama, take several pictures and use an application to stitch them together. The resulting image (see my panorama in Figure 12-5) is a stunning representation of the landscape you photographed. In the following sections, I show you how to capture images for your panorama and stitch them together using Photoshop Elements.

Capturing the images for your panorama

The images you capture for your panorama need to be squeaky clean. You need to mount your camera on a tripod and rotate the head exactly 90 degrees so that the camera is in a vertical position. This enables you to create images that will properly stitch together. Your tripod probably has a level. If not, you can purchase an inexpensive bubble level that attaches to your camera hot shoe. When you shoot panoramas, use a lens with a focal length that is the 35mm equivalent of 50mm. If you try to create a panorama with a wide-angle focal length, the inherent distortion makes it impossible to get a realistic panorama. To create images for your panorama, follow these steps:

1. **Switch to Aperture Priority mode.**

 Aperture Priority mode gives you precise control over depth of field.

2. **Choose an f-stop of f/11 or larger (smaller aperture).**

 A small aperture gives you a huge depth of field, which is just what you need when you're creating a panorama.

3. **Manually set the white balance.**

 Choose the white balance that matches the lighting conditions for the scene you're photographing. If you let the camera automatically set white balance, the camera may change it slightly between each capture, which will cause problems when you stitch the images together. Refer to your camera manual for information on manually setting the white balance.

4. **Mount your camera on a tripod and use the tripod controls to rotate the camera 90 degrees.**

 Photoshop Elements does a good job of stitching images into a panorama. The images in Figure 12-5 were captured from a camera not mounted on a tripod. If you left your tripod at home and feel the urge to shoot a panorama, follow the steps in this section. Just remember to rotate the camera 90 degrees and overlap the images by at least 30 percent.

5. **Rotate the tripod controls until the camera faces the center of the scene.**

6. **Press the shutter button halfway and make a note of the shutter speed.**

7. **Rotate the camera to the leftmost part of the scene you're photographing and note the shutter speed.**

 If the shutter speed is significantly slower than the shutter speed in the middle of the scene, you'll have to reduce the shutter speed by 2/3 of a stop (two speeds slower). If there's only a small difference, reduce the shutter speed by 1/3 of a stop (one speed slower).

8. **Switch to manual exposure and then switch to the shutter speed noted in the preceding step.**

9. **Rotate the camera to the leftmost side of the scene you're photographing and take your first picture.**

10. **Rotate the tripod so that the next image overlaps the first by about 30 degrees.**

 The details on the left side of the second image will overlap the details on the right side of the preceding image.

11. **Take a picture.**

12. **Repeat Steps 10 and 11 to take two or three additional images.**

13. **Stitch the images together.**

 Refer to the next section to stitch the images together in Photoshop Elements 9.

Put your hand in front of the lens and take one (blank/black) picture before you create a sequence of panorama images. Take another blank picture with your hand in front of the lens after you take the last shot of a sequence of panorama images. This shows you which images to stitch together. This is useful when you're shooting several sequences of panorama images.

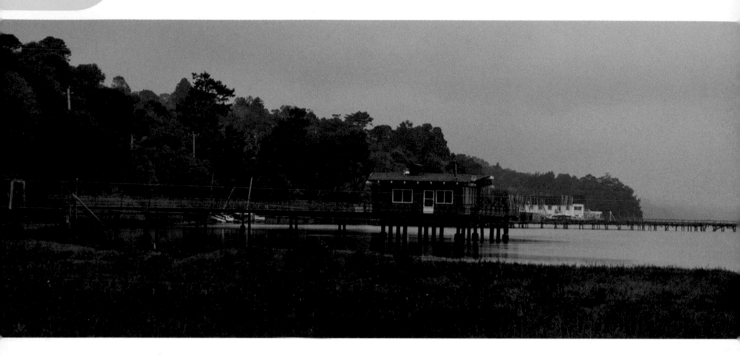

Stitching the panorama in Photoshop Elements

After you take images for a panorama, you stitch them together to make a single image. Many newer cameras have stitching software as part of the package. If your camera doesn't have stitching software, or you're looking for a different solution, consider using Photoshop Elements Photomerge Panorama. To stitch images using Photoshop Elements Photomerge Panorama, follow these steps:

1. **Choose File⇨New⇨Photomerge Panorama.**

 The Photomerge dialog box appears, as shown in Figure 12-6.

2. **Click Browse.**

 The Open dialog box appears.

3. **Navigate to the images you photographed for your panorama and open them.**

 The filenames appear in the Photomerge dialog box.

4. **Choose a layout.**

 Accept the default Auto layout if you photographed your images as outlined in the preceding section.

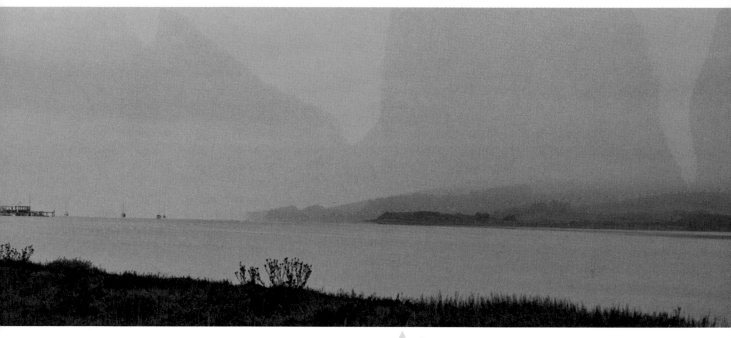

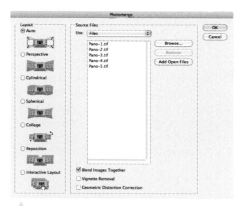

Figure 12-5: Create a picture-perfect panorama.

5. Accept the default Blend Images Together option and choose any additional options.

The Vignette Removal option is handy if the lens you used to photograph panoramas produced a dark corner at the edge of each image. This option removes the dark corner before merging the images together. Geometric Distortion Correction is not needed if you photograph the images for your panorama with a lens that is the 35mm equivalent of 50mm.

Figure 12-6: Merging panorama images using Photoshop Elements.

6. Click OK.

Photoshop Elements merges the images together, the Photomerge dialog closes, and the stitched image appears in the Photoshop Elements main window. This takes a while even on a fast computer. After the image appears, Photoshop Elements displays the Clean Edges dialog box.

7. Accept the default option to fill in the edges of your panorama.

This option tidies up the image and fills in any blank spaces at the edge of the panorama. Alternatively, you can choose No and crop the image to the desired size.

Part V

The Part of Tens

*E*ach chapter in the time-honored Part of Tens contains ten sections (more or less) highlighting quick and dirty information that didn't quite fit elsewhere in the book. This part has a chapter that tells you how to organize and share your photos and perform some quick edits. I also include a chapter about troubleshooting common landscape and nature photography problems.

In the final chapter, I dissect ten of my favorite images and tell you a little bit about what inspired me to take the picture, what settings I used, and other pertinent details.

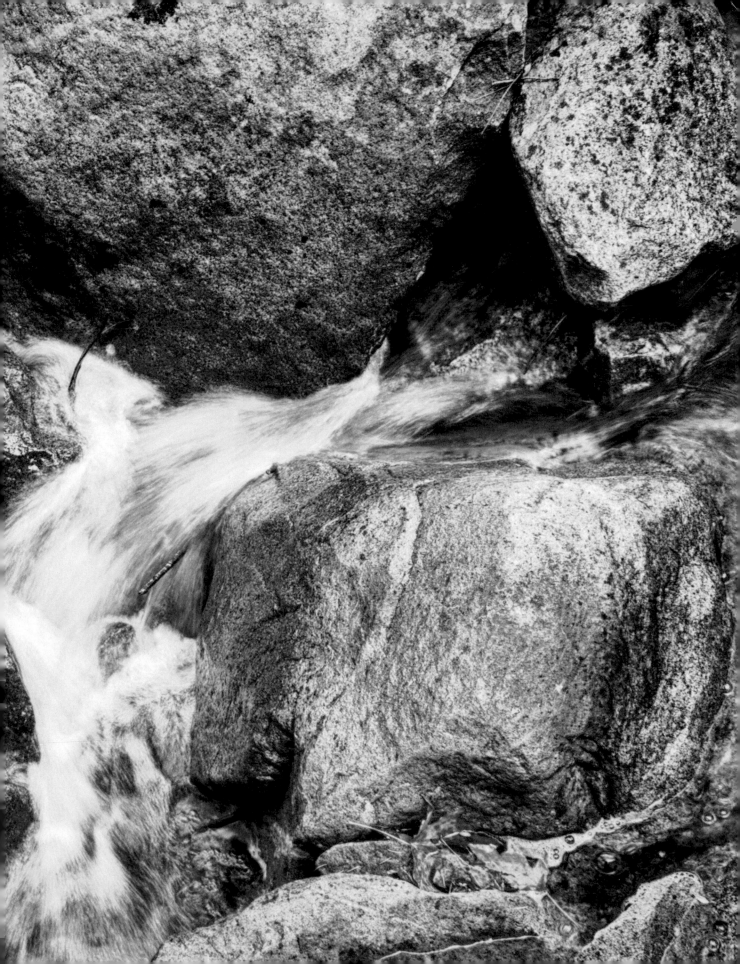

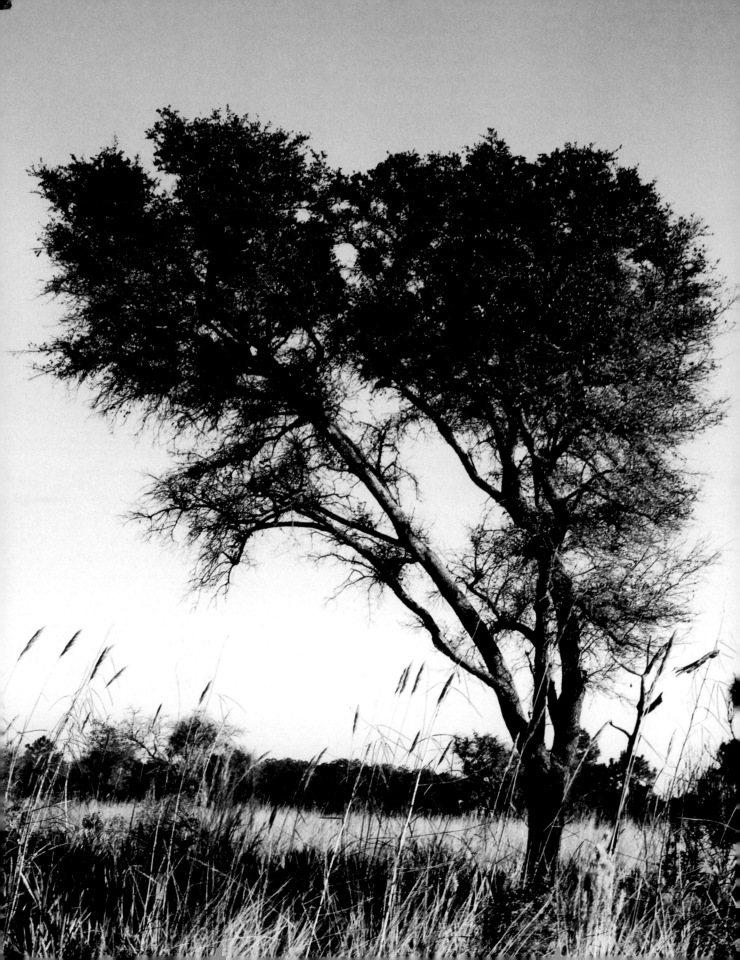

13

Ten (Plus One) Ways to Process and Share Your Images

*P*hotographs of nature are a thing of beauty and a joy forever. But they'll never be a joy as long as they're held captive on your camera memory card. The first step is to get the images into your computer and organize them. The images you capture with your camera generally need a bit of work, so after you download images, the next step is to edit and enhance your images. Once your images are squeaky clean, you're ready to share them with a few close friends or the world.

In this chapter, I show you how to do all that and more. But first I detail a post-shoot ritual I recommend you do habitually.

The editing and organizing sections of this chapter are based on Photoshop Elements 9, a photographer's best friend if its big brother, Photoshop CS5, is not in the budget. As of this writing, Photoshop Elements 9 is available for Windows and Macintosh computers and retails for $99.95.

Establishing a Post-Shoot Ritual

You've returned from a great photo shoot with a couple of memory cards filled with images. Now it's time to get your images into the computer and think about your next photo shoot. If that's all you do, you're heading down the highway to disaster. After a photo shoot, there are several things you should do before the next time you use your camera. Here's what I suggest you do after every shoot:

1. **Download the images to your computer.**

 After you download the images to your computer, you should give them a meaningful name and add keywords. This does take a bit of time but makes it much easier to find your images after you download a few hundred — or a few thousand — to your computer. Refer to your image-editing application for more information on renaming images and creating keywords. If you don't have an image-editing program, consider getting Adobe Photoshop Elements 9 (www.adobe.com/products/photoshopel), which is an excellent program for organizing and editing images.

2. **After downloading your images as described in the next section, back them up to an external hard drive.**

 This is extra work, but it prevents the loss of your valuable images if the hard drive on your computer ever decides to go belly-up on you. External hard drives are quite inexpensive these days. If you religiously back up your work and your system hard drive crashes in the future, your images are safe and sound on your external hard drive. If you don't have an external hard drive, back up your images to CDs or DVDs. Most CDs and DVDs last only about 5 years. To safeguard your backed up images, purchase archival CDs or DVDs. These cost more but have a life expectancy of about 35 years. Another alternative is to investigate backing up images online. Google "online backup".

3. **Clean your camera.**

 Follow the manufacturer's instructions for cleaning the camera body. Clean your lenses with a soft brush and a lens-cleaning cloth. You can find these accessories at your local camera store.

4. **Return your camera settings to their default states.**

 Check all settings. For example, if you change your white balance setting to cope with tungsten light and forget to set it back, you'll end up with blue pictures the next time you shoot in bright sunlight. Make sure to change your ISO setting back to its lowest value as well.

5. **Format your memory cards.**

 If you start shooting with a partially full card, you'll end up mixing images from two photo shoots. If you're dealing with a minimal number of memory cards, you can run out of room before you expect to. And this always happens at the worst possible time.

 Always format your cards in the camera. Remember, though, that formatting your card deletes everything on the card.

6. **If necessary, recharge your camera battery.**

Look at the battery life in your LCD monitor. If it's close to being exhausted, recharge it. Some people recharge their battery after every shoot. It's great to start a shoot with a full battery, but your camera battery has a limited number of charges. I advise purchasing at least one extra battery and keeping the spare fully charged and with you when you're shooting.

Swap batteries at regular intervals to make sure your batteries have equal recharging performance. Many newer cameras have intelligent batteries that tell you how many shutter actuations have occurred since the last recharge and also show you the recharging performance of the battery.

Downloading Images to Your Computer

After you finish a photo shoot, your first task is to get your images into your computer. Your camera probably has a USB port and cable you can use to download your images. This method uses camera battery power and is also fairly slow. You'll get images into your computer faster if you use a card reader. There are lots of card readers on the market, and many of them support multiple memory card formats. Purchase one that matches your memory card type. If you download copious amounts of images, consider purchasing one of the FireWire card readers; they're much faster. The following steps show you how to download images using a card reader with a Macintosh operating system:

1. **Connect your card reader to the computer.**

 Figure 13-1 shows a SanDisk card reader attached to a laptop computer.

2. **Launch Photoshop Elements.**

 When you launch Photoshop Elements for the first time, a Welcome screen appears. This is useful if you're new to Photoshop Elements or have upgraded from a previous version of the software.

Figure 13-1: Using a card reader to download images.
Photo courtesy of SanDisk

3. **Insert a card into the reader.**

4. **Choose Organize.**

 The Photoshop Elements Organizer appears.

5. **Choose File⇨Get Photos and Videos⇨From Camera or Card Reader.**

 The Elements Organizer – Photo Downloader dialog appears (see Figure 13-2).

6. **Specify these settings:**

- *Location:* Click the Choose button and navigate to the desired location where you want to save your photos. I advise that you set up a main folder on your hard drive for all your digital images, and then create subfolders for specific years. For example, I named my main image folder Digital Images. I then set up subfolders for each year.

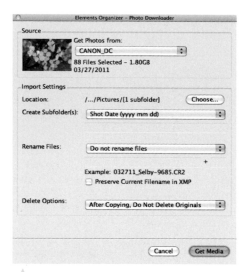

Figure 13-2: Downloading images to your computer.

- *Create Subfolder(s):* The default option is the Shot Date. This is a good way to keep your images organized. However, I recommend you go one step further and choose the Custom Name option from the drop-down menu. When you do this, a text field appears beneath the first drop-down menu, enabling you to specify a new name. I name my folders with the date of the shoot, followed by the place I photographed. For example, if I photograph in Myakka River State Park on August 15, 2011, I name the folder 081511_Myakka. This keeps the folders organized by date and makes it easy to locate a specific folder of images.

- *Rename Files:* The default option doesn't rename files. If you select this option, your camera will use a default naming option that isn't user friendly; it will name all your files with an acronym like IMG or DSC, followed by a four-digit number. If you want to stay organized, choose one of the renaming options from the drop-down menu. My favorite is Shot Date (yy mm dd) + Custom Name. I use the name of the place I photographed for the custom name. Choosing this option will give you image names like 081511_Myakka_ followed by a four-digit number.

- *Preserve Current Filename in XMP:* This option records the current filename (the default name from your camera) as metadata in an XMP file. *Metadata* is data from your camera, such as the date the image was shot, the focal length, shutter speed, and so on. This information is automatically generated by your camera along with the filename according to the naming convention used by your camera manufacturer. An *XMP file* is a small data file that records this information. It is stored in the same folder in which the image is saved. When the image is opened, Photoshop Elements reads the metadata from the XMP file.

- *Delete Options:* Choose one of the options from the drop-down menu. The default option doesn't delete the originals. There's also an option to verify and delete originals, which verifies that the images have downloaded properly. However, I recommend that you stick with the default option and format your cards in the camera after downloading them. Your camera is better equipped to optimally format your memory cards for future use.

7. **Click Get Media.**

 Photoshop Elements downloads the images. A progress bar appears as the images are downloading. After the images have downloaded, Photoshop Elements displays the Files Successfully Copied dialog, which prompts you to show only new files in the Media Browser. Choose Yes to display only new files or No to display all files. I suggest you select Yes. You can easily find old files as outlined in upcoming sections. If you always choose the same option, you can prevent the dialog from appearing again by clicking the Always Take This Action check box before choosing Yes or No.

8. **Click Yes or No.**

 Photoshop Elements imports the files into the Media Browser and displays them as thumbnails. One last dialog appears. It tells you that the only files displayed in the main window are those just imported. Choose Don't Show Again and you'll never see this dialog again. Click OK to close the dialog.

 You can perform other tasks when downloading photos by clicking the Advanced Dialog button. In the Advanced section of the Elements Organizer dialog, you can specify which images to include in the download, rotate images, fix red-eye, apply copyright information, and so on. For more information on the Advanced options, check out *Photoshop Elements 9 For Dummies,* by Barbara Obermeier and Ted Padova (John Wiley & Sons, Inc.).

Organizing Your Images

After you download images into the Organizer, you can perform other steps to organize your images even further. You can rank your images, add keywords to your images, select images to add to an album, and much more. In the upcoming sections, I show you how to get your ducks in a row.

Ranking images

If you've imported lots of pictures, it's hard to know which ones to edit. You can make things easy on yourself by ranking your imported images so that the fine distinctions between images become more obvious.

I generally make three passes. In the first pass, I give the best images a three-star rating. Then I click the icon below the image thumbnails to filter the images and show photos with three-star and higher ratings. To do this, click the third star icon and then choose 3-Stars and Higher from the drop-down menu. On the next pass, I give the best of those images a four-star rating. On the final pass, I filter the images to show only four-star ratings and higher. The images I'm going to edit get a five-star rating.

The following steps show you how to separate the wheat from the chaff and select a group of candidates you want to edit:

1. **Drag the slider to increase the size of the thumbnails.**

 You find the slider at the top of the Organizer above the thumbnails. The default view of the Organizer shows the imported images as thumbnails — very small thumbnails. At this size, you can't see the rating stars or the minute details in each image. I prefer to see the whole image (see Figure 13-3). You can quickly do this by double-clicking an image. Alternatively, you can click the blue square to the right of the thumbnail size slider.

Figure 13-3: Increase magnification to get a better look at your images.

2. **Rank the first image.**

 You can rank an image by clicking one of the stars beneath the image or by pressing the number on your keyboard. You can give images rankings between 1 and 5, with 1 being the worst image and 5 being the best.

3. **Navigate to and rank the next image.**

 If you're viewing individual thumbnails, click the desired thumbnail and then rank it. You can also click a star under any thumbnail to rank it. However, it's hard to get a good look at an image without magnifying it. To view an image at full magnification, double-click it and then use the right arrow key to navigate to the next image.

4. **Continue ranking images until you've ranked everything from the shoot.**

After ranking images, you can filter them by clicking a star to the upper right of the images. You can also choose a viewing option from the drop-down menu. The default option is to view images of a certain rank and higher. You can choose to view only images with that rank or images that are the chosen rank and lower.

Adding keywords to images

Keywords keep you organized, especially when you want to find images. I add keywords to all images, regardless of their rank. You never know when you can use a three-star image you normally wouldn't edit as part of a collage. Keywords make it easy to find images. For example, if you take photos of Yosemite National Park, you could use *Yosemite* as your keyword. When you have hundreds of images of Yosemite National Park spread over the course of several months or years, stored in different folders, the keyword will make it easy for you to locate all those pictures.

Photoshop Elements has some keyword categories built in. This is a book about nature and landscape photography; therefore, your primary concern will be the Places category. Add your own keywords to the Places category, and apply them to images by following these steps:

1. **On the Keyword Tags panel, click the keyword category under which you want to create the keyword.**

 Don't click the space next to the keyword. That's used to find images with that keyword.

2. **Click the green plus sign (+).**

 The Keyword drop-down menu appears (see Figure 13-4).

Figure 13-4: Add a keyword to a group.

3. **Choose New Keyword Tag from the drop-down menu.**

 This opens the Create Keyword Tag dialog (see Figure 13-5).

4. **Enter the keyword text in the Name field.**

 We're landscape and nature photographers. The name of the place in which the photograph was taken is logical. If the photos in your shoot are birds, the name of the bird would be the keyword for this batch of photos.

5. **Click OK.**

Figure 13-5: Create a new keyword.

 The new keyword is added to the group, with a question mark for an icon. The icon changes as soon as you apply the keyword to an image.

6. **Continue adding keywords as needed.**

To add a keyword to one or more images, follow these steps:

1. **In the Organizer, select the images to which you want to apply the keyword.**

 You can select a single image or multiple images. To select contiguous images, Shift+click the first and last images. To select noncontiguous images, ⌘+click (Macintosh) or Ctrl+click (Windows) each image to which you want to apply the keyword.

2. **Drag the keyword over the selected images.**

 The keyword tag is applied to the selected images, and the keyword tag icon changes to the last picture to which the keyword was applied. Each image to which a keyword is applied has a triangular yellow icon in the lower-right corner of its thumbnail. Pause your cursor over the icon to see which keyword(s) have been applied to the image.

3. **Continue applying keywords as needed.**

 That's right; you can apply multiple keywords to an image. For example, you might want to further refine your keywords by adding the name of the object you photographed or where the image was photographed. For example, if you photograph a purple iris flower, you could add *purple iris* as another keyword.

To find images to which a keyword has been applied, follow these steps:

1. **On the Keyword Tags panel, click the down arrow to the left of the parent keyword category.**

 This expands the category and displays all keywords assigned to the category.

2. **Click the blank square to the left of the keyword.**

 All images with that keyword are displayed.

Choose Display⇨Date View to view images by date. In this mode, a calendar is displayed with the latest date.

Editing Your Images with Photoshop Elements

Your digital camera does a great job of capturing images. But like their film counterparts, digital images generally need a bit of work. Photoshop Elements is your digital darkroom. This application can do marvelous things for images that aren't quite up to snuff. You can also use the application to enhance images and add special effects using filters. The program has so much to offer that I can only skim the surface here. If you want a full-course serving of Photoshop Elements 9, consider purchasing *Photoshop Elements 9 For Dummies.*

Photoshop Elements 9 has three ways you can edit images:

- **The Edit Quick mode:** This is ideal for tasks like removing red-eye, removing a color cast, adjusting white balance, and sharpening an image. The Edit Quick option is great when you need to make only minimal changes on an image.

- **The Full Photo Edit:** If you want the "Full Monty," use the Full Photo Edit workspace. In the Full Photo Edit workspace, you can also work with layers.

- **The Guided Edit:** This workspace leads you by the hand from start to finish of the editing process.

A full-course serving of all editing workspaces is beyond the scope of this book. In the next section, I show you how to use the Edit Quick workspace.

When you need a quick, cursory edit, the place to take your images is the Edit Quick workspace. In this workspace, you can use automatic adjustments and then tweak them manually.

To edit an image in the Edit Quick workspace, follow these steps:

1. **Launch the Photoshop Elements Organizer.**

 Your most recent import is displayed. To find other images, switch the Date view by choosing Date View from the Display drop-down menu in the upper-right corner of the Organize workspace, and then find the shoot you want to edit by navigating the calendars. In Date View, you can view in Date, Month, or Year calendar format.

2. **Select the image you want to edit.**

3. **Choose Edit Quick from the Fix drop-down menu.**

 If you're opening an image that was captured using your camera's native RAW format, the Adobe Camera Raw dialog appears. A detailed description of how to process images in Adobe Camera Raw is beyond the scope of this book.

4. **Choose an option from the View drop-down menu.**

 I prefer to work with the Before and After (Horizontal) view mode for a landscape format image (see Figure 13-6). This provides an accurate representation of the changes being applied to an image. The Edit Quick workspace is similar to the Full Edit workspace, but you have fewer tools with which to work. Many of the menu commands are dimmed out, which means you can access them only in Full Edit mode. The panel on the right side of the interface is the home for the Edit Quick options.

5. **Implement one or all of the following quick fixes:**

 • *Smart Fix:* Click the Auto button to apply general corrections for color balance. This fix also enhances shadows and highlights, if needed. You can also drag the slider to manually apply Smart Fix. Use this option if you don't get the desired results. You can also click the grid to the left of the Amount slider to reveal thumbnails of the image, with different amounts of Smart Fix applied. Pause your cursor over a thumbnail, and the image changes. Click the thumbnail to apply the change.

 • *Lighting:* Click the Levels Auto button to automatically adjust the shadows and highlights to improve the image. Click the Contrast Auto button to automatically improve image contrast. If the changes are not to your liking, you can manually adjust the lighting by dragging the Shadows, Highlights, or Midtone sliders. Click the check mark to apply your edits.

 • *Color:* Click the Color Auto button to automatically adjust the color tones in the image. If you aren't happy with the results, drag the Saturation slider to the right to increase image saturation, or drag it to the left to decrease saturation. However, when you change saturation, you change all colors and hues. If you increase saturation, you end up with unrealistic skin tones if there are any people in the image you're editing. You can also change the hues in the image by dragging the Hue slider. Drag the slider left to change the hues to a bluish color, or drag it right to change the hues to a greenish color. This is a global correction and not ideal for all images. Click the check mark to apply your edits.

Figure 13-6: Editing an image in the Edit Quick workspace.

- *Balance:* This setting adjusts the white balance of the image. Drag the temperature slider left to cool the colors in the image, or drag it right to warm the colors. When you cool the colors, they have more of a bluish cast; when you warm the colors in the image, they have an orange cast. Drag the Tint slider left to add more magenta to the colors or right to add more cyan to the colors. Click the check mark to apply your edits.

- *Sharpness:* Drag the slider to the right to sharpen the image. Don't overdo sharpening. If you start to see artifacts around the edges, you've gone too far. In most instances, clicking Auto does a fine job of sharpening images.

If you're new to image editing, choose Guided Photo Edit from the Fix drop-down menu. This opens the image in the Guided Photo Edit workspace, where you can choose the task you want to complete from a list.

If you need to perform only a simple edit, click the Fix button to reveal buttons that perform tasks such as Auto Smart Fix, Auto Color, and so on.

Resizing and Cropping Your Images

Your camera has a set size and resolution for the images it captures. The size depends on the resolution of the camera in megapixels. You can use Photoshop Elements to resize your images prior to exporting them for e-mail, posting them on a website, or creating prints. To do so, specify the image size and resolution. You can also crop your images to a specific aspect ratio or a specific size. The following sections tell you everything you need to know about resizing and cropping images but were afraid to ask.

Understanding image size and resolution

Your camera has a maximum dimension and a set resolution at which it captures images. You can change the size and resolution using your camera menu. However, unless you're using images for the web, I recommend you capture images at your camera's maximum size and resolution. The maximum size and resolution for my Canon EOS 5D Mark II is 5616 x 3744 pixels with a resolution of 240 pixels per inch (ppi). That equates to a print size of 23.4 x 15.6 inches. To get the maximum print size for your camera, divide the dimension in pixels by the resolution.

Resizing images

You can resize images to a specific size. Resizing is also known as *resampling*. You can resample images to a smaller size with no loss of fidelity. However, if you try to increase the size of an image, you're asking the image-editing application to redraw pixels, which causes image degradation. To resize images, follow these steps:

1. **Open the image you want to resize in either the Edit Quick or the Full Edit workspace.**

2. **Choose Image➪Resize➪ Image Size.**

 This opens the Image Size dialog (see Figure 13-7).

3. **In the Document Size section, enter the desired resolution.**

 You'll get your best results on most printers if you specify a resolution of 300 pixels per inch.

Figure 13-7: Resizing an image.

4. **Enter the desired size in either the Width or Height text box.**

 As long as you accept the default option to Constrain Proportions, Photoshop Elements supplies the other value. If you don't accept the Constrain Proportions option, your image will be distorted.

5. **Choose an option from the Resample Image drop-down list.**

 Bicubic is always the best when you're resampling to a smaller size.

6. **Click OK.**

 Photoshop Elements resizes the image.

You can also change the image size by changing resolution. Deselect the Resample Image option and enter the desired resolution. If you enter a smaller resolution, the document size (print size) becomes larger. If you enter a higher resolution, the document size becomes smaller.

Cropping images

You can crop images to remove unwanted items, such as too much background or other distracting elements. You can also crop an image to a specific size and resolution. To crop an image, follow these steps:

1. **Launch the Photoshop Elements Organizer and choose the image you want to crop.**

2. **From the Fix drop-down menu, choose Full Photo Edit or Edit Quick.**

 Your choice depends on how much work you need to do to the image. If all you want to do is crop the image and apply minimal edits, choose Edit Quick.

3. **Select the Crop tool.**

4. **Choose an option from the Aspect Ratio drop-down menu on the Option bar.**

 The default option is No Restriction, which lets you crop the image to any aspect ratio. You can also choose to crop the image while maintaining the aspect ratio of the image by choosing the Use Photo Ratio option or by choosing one of the preset sizes, such as 4 x 6. Alternatively, you can enter the desired dimensions in the Width and Height text fields.

5. **Enter the desired image resolution in the Resolution field.**

 If you're cropping images for the web, enter **96** or **72** pixels per inch. If you're cropping an image for print, specify **300** pixels per inch or the resolution specified by the printing service you're using.

6. **Drag inside the image to specify the crop area.**

 The crop area is signified by a border of dotted lines and eight handles (see Figure 13-8). The handles are used to resize the area to which the image is cropped.

7. **Adjust the size of the crop rectangle.**

 Drag the corner handles to resize the width and height at the same time. Drag the handle in the middle of the top or bottom of the crop rectangle to change the height, or drag the handle in the middle of the right or left side of the crop handle to change the width. If you're cropping your image to a size or aspect ratio, dragging any handle changes the size of the rectangle proportionately.

8. **Click inside the crop rectangle and drag to change its position.**

9. **When the crop rectangle is the desired size, click the green check mark below the lower-right corner of the rectangle to crop the image.**

 You can also click the red circle with the diagonal slash to remove the crop rectangle and leave your image unchanged.

10. **Save your work.**

 When you make changes to an image, I advise you to use the Save As command and save the image with a different filename in order to preserve the original.

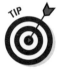

If all you need to do is crop the photo, click the Fix button and choose Crop from the Photo Fix options menu. This opens the Crop Photo dialog, which contains the Crop tool and other options. You can also choose from one of the presets.

Figure 13-8: Cropping an image.

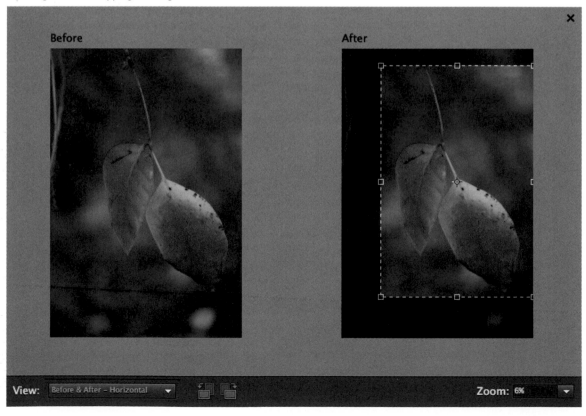

Sharpening Your Images

Images captured by a digital camera are a little soft. This has nothing to do with the camera lens but has everything to do with the camera sensor. Fortunately, you can sharpen your digital images in Photoshop Elements using the Adjust Sharpness command. Photoshop Elements has other commands to sharpen images, but the Adjust Sharpness command does a better job of identifying edges, which means you won't end up sharpening noise or random pixels that shouldn't be sharpened. To sharpen a photo using the Adjust Sharpness command, follow these steps:

1. **In the Organizer, select the image you want to edit and choose Edit Quick from the Fix drop-down menu.**

 This opens the image in the Edit Quick workspace.

2. **Zoom to 100 percent magnification.**

 You can use the Zoom tool's 1:1 button or the keyboard shortcut Ctrl+Alt+0 (Windows) or ⌘+Option+0 (Macintosh) to zoom to 100 percent. When you sharpen an image, you should always view the image at 100 percent magnification.

3. **Choose Enhance⇨Adjust Sharpness.**

 The Adjust Sharpness dialog appears (see Figure 13-9).

Figure 13-9: Using the Adjust Sharpness command.

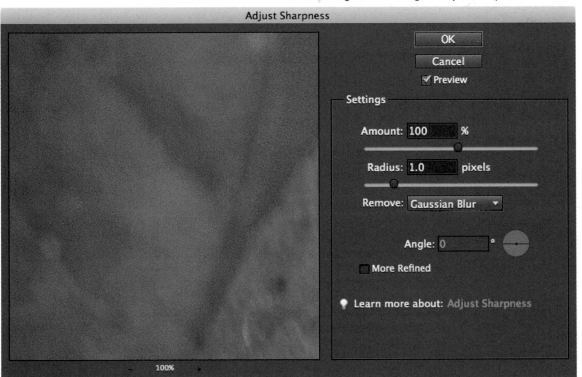

4. **Specify the Amount value.**

You can use the slider to select a value or enter the value in the text field. This value determines the amount of sharpening that's applied to the image. As you drag the slider, the image updates in real time. If any halos appear on the edges, you've oversharpened the image. The value you use depends on your subject, the camera lens, and your personal taste. When you see something you like, stop dragging the slider.

Deselect the Preview check box to disable the preview of the sharpening on your original image, which enables you to see the unsharpened image. Select the check box to see the effects of the sharpening on your image.

5. **Specify the Radius value.**

This value determines the distance from each edge to which the sharpening is applied. If you specify too low a value, the sharpening effect will not be noticeable; too large a value, and halos appear around the edges.

6. **Choose an option from the Remove drop-down menu.**

Your choices are Gaussian Blur, Lens Blur, and Motion Blur. Lens Blur is the best option for digital photographs. However, you can use Motion Blur if you moved the camera while taking the picture. When you choose Motion Blur, you can specify the angle by dragging a slider. Drag the slider until you see the sharpest image possible. Use Gaussian Blur for close-ups.

7. **Select the More Refined check box.**

This option processes the command slower for more accurate results.

8. **Click OK to sharpen the image.**

Saving Your Work

After you edit an image, it's time to save it. You can save your image in any format supported by Photoshop Elements. If you're editing a RAW file, your only option is to save to a different format. If you're editing a JPEG image, save the image with a different filename so you won't overwrite the original image.

1. **Perform the desired edits on your image.**

2. **Choose File➪Save.**

 The Save As dialog appears (see Figure 13-10).

3. **Enter a filename for the image in the Save As text box.**

 It's advisable to give the image a different filename than the original. If you give the image the same filename and save

Figure 13-10: Always save your work.

it in the same folder, you'll overwrite the original. If you don't enter a filename, Photoshop Elements automatically adds the following to the original: _edited-1 (for the first edit). If you don't rename your images,

I advise you to accept the default filename Photoshop Elements gives the image. This prevents overwriting the original.

4. **Choose a folder in which to save the image from the Where drop-down menu.**

By default, Photoshop Elements saves images in the same folder as the original. You can save your work in any folder, or you can create a new folder in which to save your edited images.

5. **Choose from the following options:**

 • *Include in the Elements Organizer:* Accept this default option, and the saved file will be included in the Photoshop Elements Organizer.

 • *Save in Version Set with Original:* This option stacks the saved file with the original in the Organizer. The most recently saved image in the version set appears on top of the stack. If you deselect this option, the edited image is saved beside the original.

 • *Layers:* If the image has layers and you save to a file format that supports layers, this option is selected by default. If the selected file format doesn't support layers, the layers are flattened.

 • *As a Copy:* If your image has layers and you deselect the option to save the image with layers, this option is selected by default.

 • *Embed Color Profile:* This option saves the image with the same color profile as the original.

6. **Choose a format from the Format drop-down menu.**

Photoshop Elements supports many file types. A full-blown explanation of each file type is beyond the scope of this book. Most online print sources prefer the JPEG format, which is what I show you in the upcoming steps.

7. **Click Save.**

If you accept the default option to save the edited image in a version set with the original, a dialog appears, telling you about version sets. After choosing a file format, the dialog changes to reflect the options for the file format. Figure 13-11 shows the options for the JPEG format.

Figure 13-11: Options for the JPEG file format.

8. **Specify the image quality in the Quality text box.**

JPEG is a *lossy format,* which means the image is compressed, and information is lost. The default image quality option is 7, which creates a medium-size file with good image quality. If you're printing the image, choose a quality of 10 or higher.

9. **Choose from the following format options:**

 • *Baseline ("Standard"):* This option works well for print and for the web.

- *Baseline Optimized:* This option yields good image quality, but it applies a bit more compression. Choose this option when file size is a concern.

- *Progressive:* Choose this option for web images. This option loads the image into the browser in stages. The first stage gives the viewer an idea of what is to come. With each stage, the image quality improves. When you choose this option, the Scans drop-down menu becomes available. Choose the number of scans from the drop-down menu. The default option loads the image in three stages (scans). You can specify as many as five scans.

10. Click OK.

Photoshop Elements saves the image.

You can also save your work for the web by choosing File⇨Save for Web. This opens the Save for Web dialog. This command guides you through the process of saving an image for use on the web. When you save an image for the web, you must first resize it to a dimension less than 640 pixels in width with a resolution of 72 pixels per inch. Save your photos in the JPEG format with High quality.

Archiving Your Work

Your computer is a mechanical piece of equipment. Like a car, it will fail, and it will fail at the least opportune moment. If you have hundreds or thousands of images on your computer and your hard drive decides to self-destruct, your images are lost. You may be able to recover them using a data-recovery service, but why spend the money when you can archive your images and restore them when needed? You can back up your Photoshop Elements catalog to a hard drive. I recommend saving to an external hard drive that is used for nothing but archiving images. Take the hard drive offline when you're not using it. Archive your Photoshop Elements catalog by following these steps:

1. Launch the Organizer work-space and then choose File⇨ Backup Catalog to Hard Drive.

The Backup Catalog to Hard Drive dialog appears (see Figure 13-12). Your choices are Full Backup and Incremental Backup. When you back up for the first time, you need to perform a full backup. After the initial backup, use an incremental backup. When you do an *incremental backup,* Photoshop Elements compares

Figure 13-12: Specify the backup option.

the source drive on your computer to the previous backup. New files from the catalog are added, and old files that have been changed are updated during an incremental backup.

2. **After choosing the desired backup option, click Next.**

 The Destination Settings section of the Backup Catalog Wizard appears (see Figure 13-13).

3. **Select the destination drive from the available drives listed in the Select Destination Drive section.**

 This is a list of available drives on or attached to your computer. I strongly suggest you back up to an external drive. If you back up to your computer hard drive and it fails, the backup is worthless.

Figure 13-13: Choose the destination.

4. **In the Options section, specify the following options:**

 - *Name:* Enter a name for the catalog or accept the default name: My Catalog.

 - *Backup Path:* This option is available if you're backing up to a hard drive. You can browse for an existing folder or create a new folder.

 - *Previous Backup File:* This option is available when you do an incremental backup. Navigate to and select the original backup file.

5. **Click Save Backup.**

 Photoshop Elements backs up the image files and the associated data to the specified folder.

If you ever need to restore the catalog, choose File➪Restore Catalog from Hard Drive. After you invoke the command, you'll be prompted to locate the backup file and then specify where to restore the files.

Creating Photo Books at Blurb

If you'd like to see your nature photography in a custom photo book, you can make this a reality by visiting Blurb (www.blurb.com), a popular online portal for creating and selling photo books. You can create a great-looking photo book using Blurb's BookSmart software, which you can download for free from this URL:

```
www.blurb.com/make/booksmart
```

After you create your book, you can upload the photos to Blurb directly from the BookSmart software. You can also create a custom book in an application like Adobe InDesign and upload it as a PDF. After you upload the book, you have 14 days to place an order for it. Blurb offers hardcover and softcover books in the following sizes: 7 x 7 inches, 10 x 8 inches, 12 x 12 inches, and 13 x 11 inches. You can also upgrade to premium paper. The minimum number of pages for a book is 20, and the maximum number of pages you can put in a book is 440. You can put multiple photos on a page using BookSmart templates or using your own software.

You can also choose the option to make your book public after ordering one copy. When you make a book available to the public, you can specify the selling price. When your book sells, Blurb sends you the difference between your selling price and their established price plus a small handling fee.

Sharing Your Photos on Flickr

If you don't know how to create a website, or don't have the inclination to create a website, you can still display your work online. There are several websites you can use to show your work online. Flickr (www.flickr.com) seems to be one of the most popular.

After you set up an account at Flickr, you can upload your photos. You can also join one or more Flickr groups, which are communities of photographers who have interests in specific photo subjects or styles. Flickr is a great way to get feedback on your work from site visitors and other photographers. With a free account, you can upload two videos (90 seconds in duration with a maximum of a 500MB file size) and 100MB of photos with a maximum file size of 10MB per photo, each month. (With a paid account, you can upload much more.) If you resize your photos to be web friendly in an application like Photoshop Elements, you can upload a lot of photos each month. Figure 13-14 shows the Flickr photo stream of your friendly author.

Figure 13-14: Strut your stuff at Flickr.

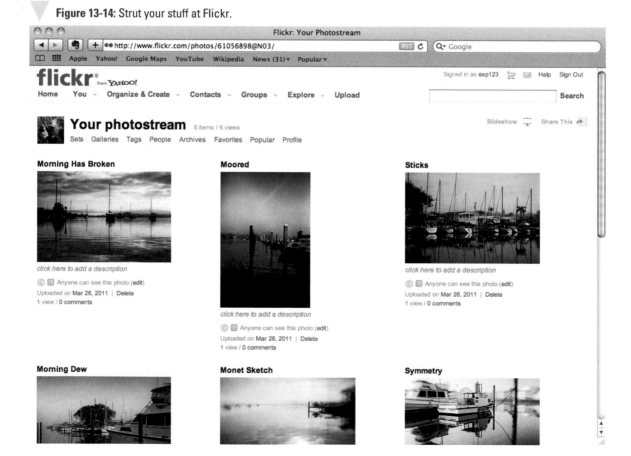

Sharing Your Images on Facebook

Facebook is a social media hot spot. If you aren't on Facebook, you may think of it as a place where teenagers hang out and exchange information or as a place where soccer moms hang out so they can keep tabs on their teenagers or promote their children's teams. But Facebook is much more than that. Major corporations use Facebook to promote their products. Professional authors and photographers use Facebook to promote their work. Aspiring photographers also use Facebook to commune with other photographers and display their work.

If you don't have a Facebook account, you can set one up for free by visiting www.facebook.com. When you set up an account, you can share some information about yourself, such as what you do for a living, your likes, your birthday, and so on. You can also upload a photo to use as your avatar.

After you set up a Facebook account, you can start posting to your wall, invite other photographers to be your friends, add images to your page, and much more (see Figure 13-15). Keep in mind that Facebook is a social network, so be social. Don't just create it and then never refresh or add to it. How boring!

Figure 13-15: Show your work on Facebook.

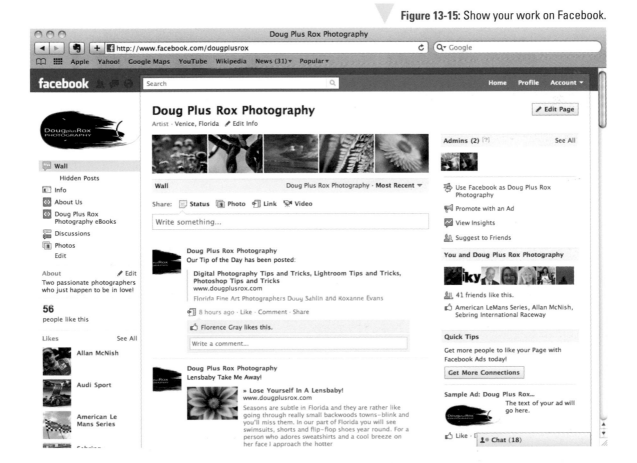

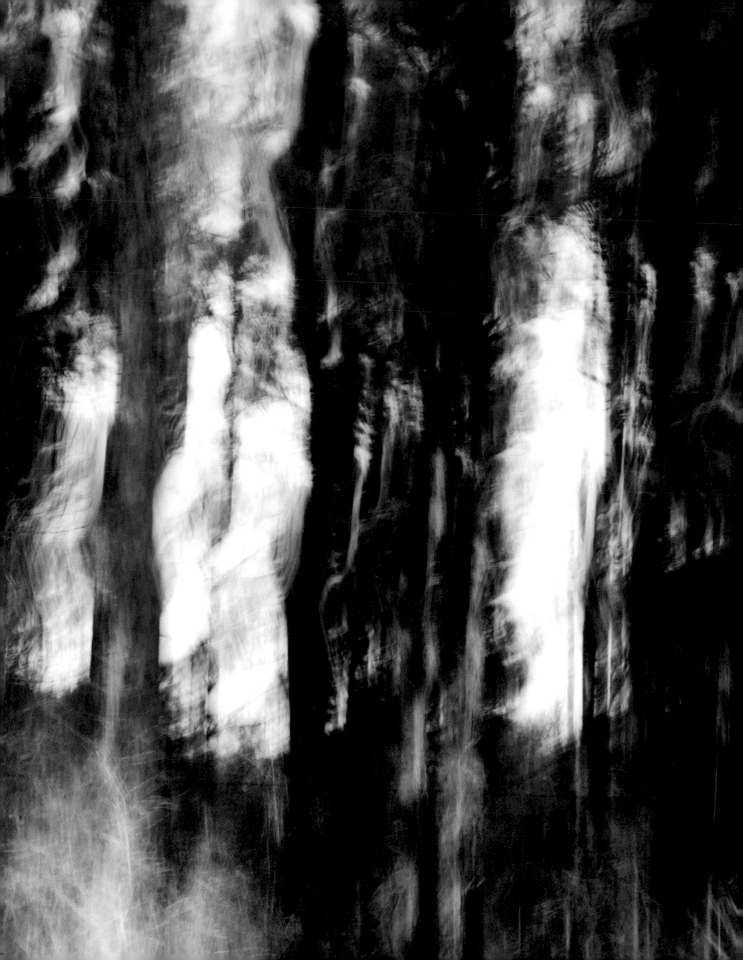

Ten Troubleshooting Techniques: What Would Ansel Do?

In This Chapter

▶ Avoiding overexposure

▶ Rescuing a boring image

▶ Avoiding underexposure

▶ Simplifying the image

▶ Establishing focus

▶ Darkening the sky in a sunset image

▶ Fixing a bright image

▶ Getting color right with a white balance adjustment

▶ Distinguishing the subject from the background

▶ Shooting photos on a windy day

Digital photography is truly a technological masterpiece. You point a camera at something, press the shutter button, and less than a second later, you have an image on the camera LCD monitor. This is the genius of digital photography. It's also the curse of digital photography.

The immediacy of digital photography leads many photographers to think they can just point and shoot and the law of averages will give them some good shots. Although this is true, you get much better results if you put some thought into your photography. Use your viewfinder as a critical evaluation tool. Don't simply give it a casual glance and then fire away.

The previous chapters have armed you with a full-course serving of techniques to create better nature, wildlife, and landscape photographs. But you still have technology to deal with. The camera does the best it can to deliver a pleasing image, but occasionally you have to change a few things to correct what the camera did, or improve it. In this chapter, I show you ten ways the camera might not deliver an image that matches your inner vision and the troubleshooting techniques you can use to fix them.

My Image Has Blown-Out Highlights

Your camera has a built-in meter that measures the amount of light in the scene and chooses settings to serve up what the camera thinks is a properly exposed image. However, when you photograph areas that have deep shadows and bright highlights, the tonal range can be more than the camera can handle. The result: You end up with the brightest areas of a scene blown out to pure white. When that happens, you have no detail — zip, zilch, nada. You can enable a warning that displays blown-out highlights as blinking areas of white, also known as "blinkies." Okay, so what do you do when you see blinkies? Here are four things you can try to correct the problem:

- **Hide the sun behind a tree,** or wait until a cloud covers the sun if you're shooting directly into it (see Figure 14-1).

- **Use a graduated neutral density filter** to darken the sky if you're shooting into the sun.

- **Enable exposure compensation** and reduce the exposure.

- **Move away** until the sun is not in your image. Often, moving a few feet will correct the problem.

Figure 14-1: Photographing into the sun without blowing out highlights.

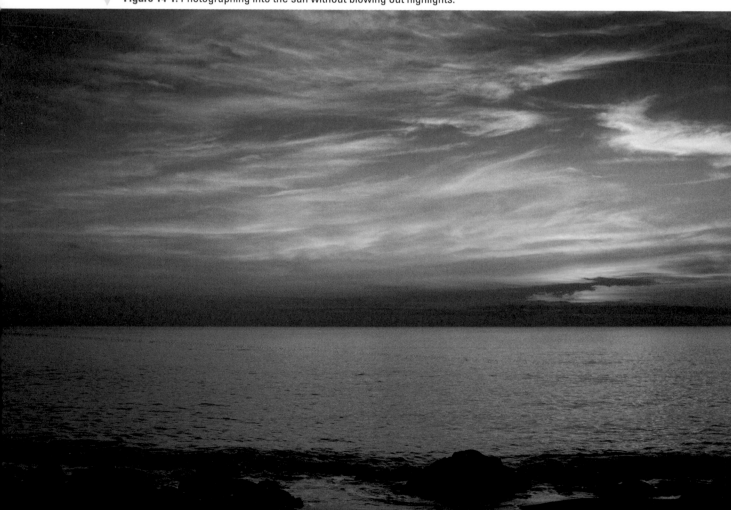

1 Captured a Boring Scene

You can be in the most beautiful place in the world and still take a boring picture. Many photographers have a tendency to pick the low-hanging fruit and end up with a mediocre image. If what you see in your viewfinder or camera LCD monitor doesn't excite you, it won't excite anyone else either. When you're in a beautiful area, it's easy to get carried away with the beauty of the area and shoot some boring pictures. Here are four strategies to help you add some pizzazz to a boring scene:

- **Move.** Changing your vantage point can make all the difference between a mediocre image and one that gets the attention of everyone who views it.

- **Zoom in.** When you zoom in, you include less information and give viewers something that's easier to digest.

- **Change your composition.** Move the camera to the right or left until some interesting elements appear in the viewfinder.

- **Add something.** Look around for interesting elements to add to the scene. A branch or some leaves strategically placed can add interest to the image.

The Image Is Too Dark

Most of the time, the camera errs on the side of caution and serves up an image that is too bright. Sometimes the camera does just the opposite and gives you an image that is darker than the scene before you. When this occurs, here are three things you can try that may alleviate the problem:

- **Use exposure compensation to increase the exposure.** Increasing the exposure will brighten the image but may blow out some highlights to pure white. However, this is the route to go if there is important information in the dark areas of the scene.

- **Lock exposure on the part of the scene that is the most important.** Check your camera manual to see if locking exposure is an option for your camera. On many cameras, move the center auto-focus point over the area of the image that is the most important, and then press a button to lock the exposure at that point of the image. Note that this may adversely affect the exposure for other parts of the image.

- **Move to a slightly different vantage point.** When an image is too dark, the camera is compensating for a very bright object that takes up a large portion of the frame. For example, if you're photographing a scene late in the afternoon and a large part of the scene is bright sky, the camera will choose settings to properly expose the sky. If the sky is the most important part of the image, the camera is making the right choices. If the sky is not the most important part of the image, move to a different vantage point or recompose the image so that the sky is not the predominant part of the image.

The Image Is Too Busy

The old Zen axiom "Less is more" applies to lots of things in life, including photography. If you take a picture and include too much information, your viewers won't have any visual clues to lead them through the image — or worse yet, the image will be so busy that it won't have a focal point. Even though you're looking at the photograph through a small LCD monitor, you'll still be able to tell whether you have an interesting image. If you shoot a picture and there's too much information, try one or more of the following remedies:

- **Zoom in.** Zoom in until unnecessary objects are not visible in the viewfinder (see Figure 14-2).

- **Change your vantage point.** Moving a few feet often gives you a totally different image. Move a few feet and then put the camera to your eye. Repeat until you see something interesting and then take a picture.

- **Change lenses.** Many photographers think a wide-angle lens is the best way to photograph a landscape. However, if you don't have a prominent object in the foreground, the amount of visual information the lens can capture overwhelms viewers. When you switch to a longer focal-length lens, you include less information and have larger objects for the viewers to latch onto.

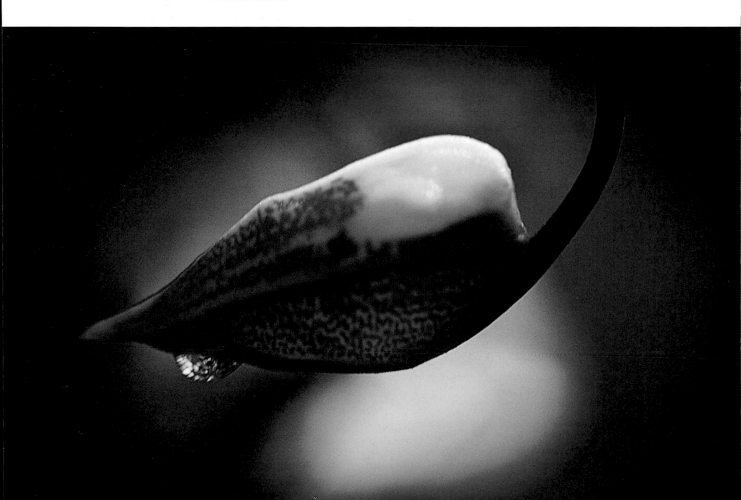

The Subject Is Not in Focus

There's nothing worse than an image where the subject is out of focus. This often occurs when you shoot with a large aperture. If your focus isn't spot-on, the entire image appears to be out of focus. However, if you have one object in focus, you give viewers something to latch onto. When you review images on your camera LCD monitor, zoom in until you can see details. If the details aren't in focus, try one of these fixes:

- **Choose a faster shutter speed if you're shooting in Shutter Priority mode.** When you're photographing a moving object, you need to use a shutter speed that is fast enough to freeze action.

- **Choose a larger aperture if you're shooting in Aperture Priority mode.** A larger aperture lets more light into the camera, which also increases the shutter speed.

- **Increase the ISO setting.** If the light is dim, increasing the ISO setting makes the camera more sensitive to light, which increases the shutter speed.

- **Lock focus in a different spot.** When you photograph an object such as a flower or an animal, I suggest you switch to a single auto-focus point. Position the auto-focus point over your subject. If you're photographing an animal that is stationary, place the auto-focus point over the eye that's closest to the camera. Press the shutter button halfway to achieve focus and, with the shutter button still pressed halfway, move the camera to achieve the desired composition. Then take the picture.

- **Switch to continuous auto-focus mode if you're photographing a bird in flight or a moving animal.** When you switch to this mode, the camera updates focus as the animal moves.

The Sky in My Sunset Is Too Bright

Sunsets are wonderful scenes for photographers (see Figure 14-3). However, a sunset with a beautiful landscape often has a wider range than the camera can handle. The camera compromises and delivers an image with a properly exposed landscape but a sky that is way too bright. When you see an image like that on your camera LCD monitor, here are five things you can try:

- **Use a graduated neutral density filter if the sun is still fairly high in the sky.** This filter darkens the top of the sky without changing the colors. The filter gradually lightens until it lets all the available light reach the sensor.

- **Use a reverse neutral density filter if the sun is near the horizon.** This filter darkens the sky near the horizon and gradually lets all the light reach the sensor at the top of the frame.

- **Hide the sun behind a tree or wait for a cloud to partially eclipse the sun.** When you hide the sun, you decrease the dynamic range so that the camera can correctly render the dark areas of the image and the sky without too much of a compromise.

Figure 14-2: Sometimes less really is more.

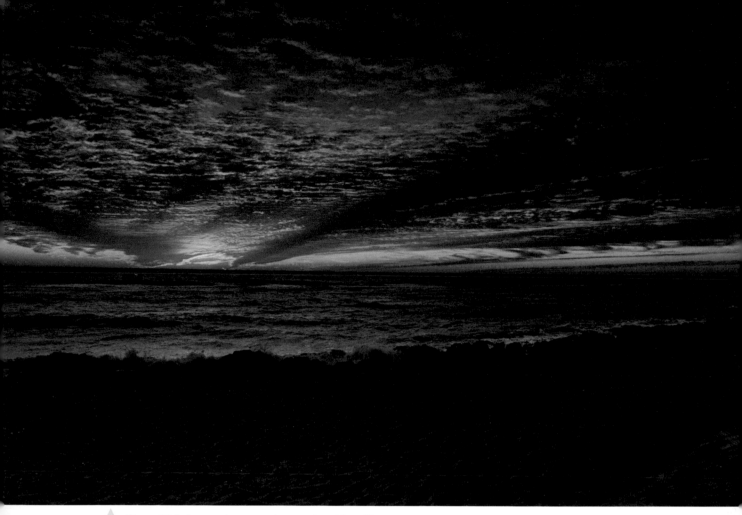

Figure 14-3: A properly exposed sunset is a thing of beauty.

- Bracket exposures and merge the exposures in a photo-editing application. Most cameras will let you capture three bracketed exposures with a range from –3 EV to +3 EV. For more information on shooting HDR images, see Chapter 12.

- Use exposure compensation to decrease the exposure. When you decrease the exposure, the sky will be darker. Depending on the scene, you may have to decrease the exposure enough to render the landscape and foreground objects as silhouettes.

The Image Is Brighter Than the Actual Scene

When you photograph a scene after the sun sets, or early in the morning before the sun rises, the camera thinks the scene should be brighter than it actually is. The result: The camera automatically cranks up the exposure. Your only defense

is to employ exposure compensation and decrease the exposure until the images you capture are the same brightness as the scene in front of you. As the sky gets brighter, you have to decrease the amount of exposure compensation. When the sky gets darker, you have to increase exposure compensation. As your photo shoot progresses, pay careful attention to your camera LCD monitor and adjust the amount of exposure compensation you use as the lighting changes.

The Colors Are Wrong

The human eye perceives white as white in any lighting scenario. Your camera has an option known as Automatic White Balance, which attempts to balance the colors in the image for the current lighting conditions. This works most of the time, but when it doesn't, white objects may have a green or orange cast to them. When you review an image and notice that the colors are wrong, do a bit of detective work. Notice what type of light is prevalent. For example, if you're photographing in the late afternoon and the colors don't have that wonderful golden hue, the camera has selected the wrong white balance for the job. The solution for this problem is to manually select the white balance preset that is closest to the current lighting condition.

The Subject Blends into the Background

This problem crops up often when you're photographing wildlife. Animals like deer and some birds use the natural foliage as camouflage. They tend to congregate in areas that closely match their coloration. Alert photographers notice the shape of the animal and take a picture. The resulting photograph doesn't do a good job of depicting the animal because it fades into the background. You have three possible solutions for this problem:

- **Wait patiently until the animal moves to an area where it doesn't blend in with the background.** The danger is that you'll lose the shot because the animal gets spooked by your presence and bolts.

- **Move to a slightly different position.** Look for a spot that places the animal against a slightly different backdrop and hope that the animal doesn't dart away while you're moving.

- **Shoot wide open — that is, use the largest aperture of your lens.** If the animal or bird is far enough away from the background, your subject will be in sharp focus and the background won't, which makes it easy to spot the animal or bird in the resulting photograph (see Figure 14-4).

If you choose the last option, make sure you focus on the eye that is closest to the camera. If the eye isn't in focus, you've lost the shot.

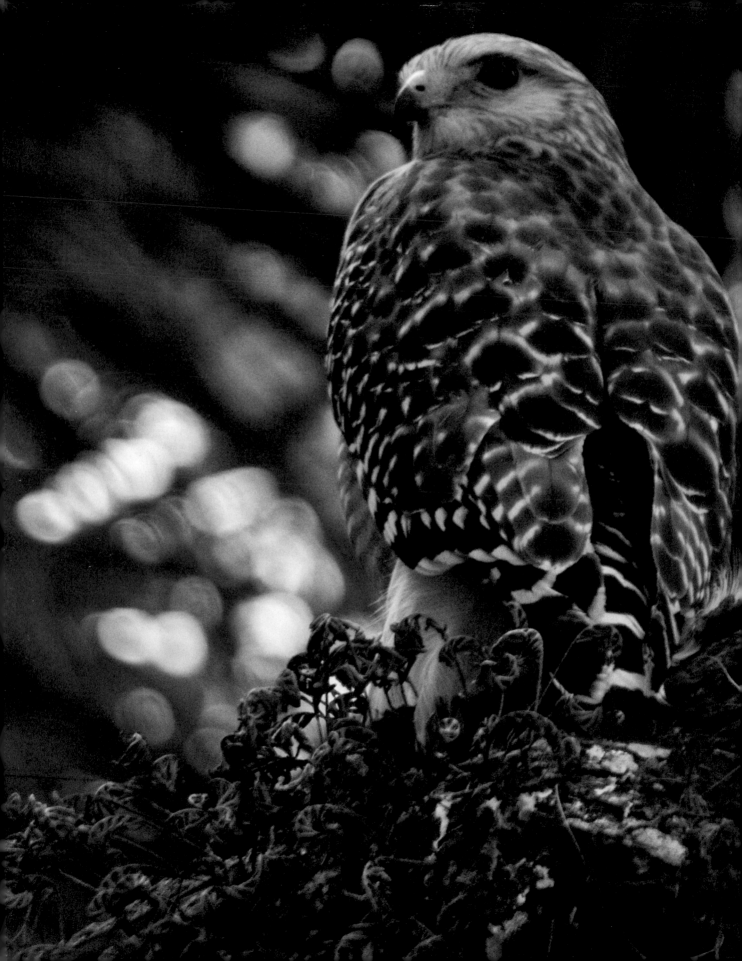

1 Want to Shoot a Close-Up on a Windy Day

When you put a macro lens on your camera — to get a close-up image of a flower, like the one shown in Figure 14-5 — you end up with an extremely shallow depth of field. This means your focus has to be spot-on; otherwise, you end up with a blurry image. Add wind to the equation, and your chance of getting a sharp image decreases even more. The alternative is to come back when it isn't so windy. Another alternative is to use your photographer buddy as a wind block. Tell her to stand upwind from the flower. If you don't have a photographer buddy with you, switch to Continuous Drive mode and manually focus. Press the shutter button and take several pictures. One of them is bound to be in focus.

Figure 14-5: Photographing flowers on a windy day.

Figure 14-4: Separating an animal from the background.

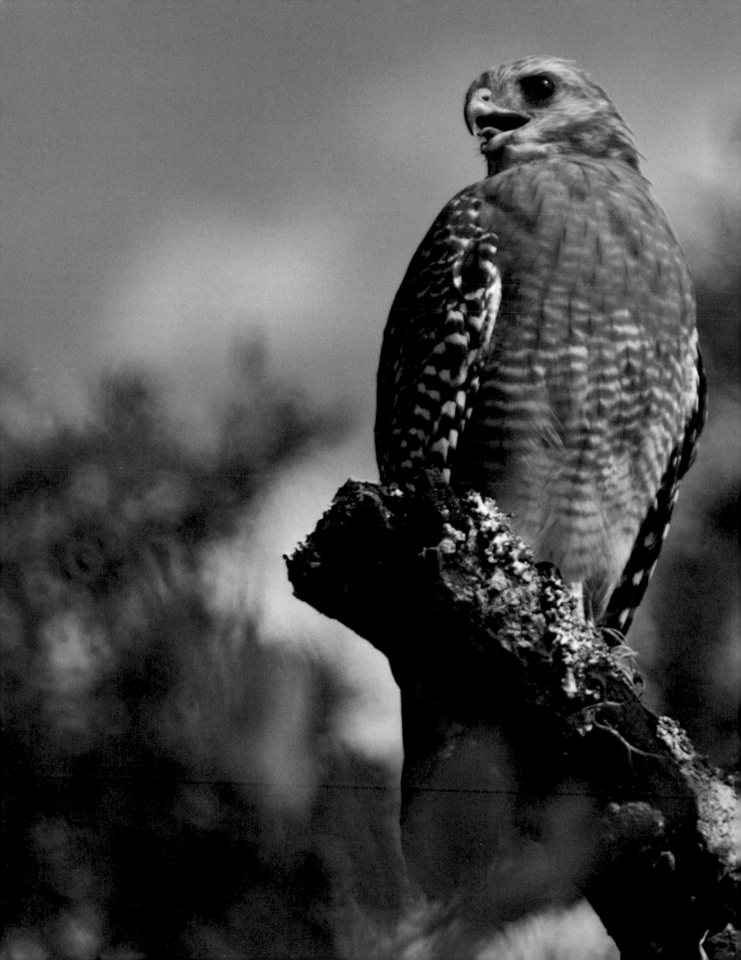

15

Ten Landscape and Nature Images

1 learn by looking at other photographers' work. It inspires me to shoot different things or to shoot the objects I'm currently shooting in different ways. In this chapter, I show you ten of my favorite photographs. I tell you what inspired me to take the photograph, the settings I used, and how I composed the photos.

A Fog upon the Bay

California is a wonderful place to visit. The state has diverse landscapes and wildlife. If you're in the San Francisco area, take a trip across the Golden Gate Bridge to Mount Tamalpais. You'll be rewarded with a stunning view of San Francisco and the Golden Gate Bridge, plus you'll see some wonderful vistas on the way to the mountaintop. I photographed this image on the trip down from the mountain. The fog was thick on San Francisco Bay, but it was clear on the mountain. I spotted this lonely tree and knew I had to stop and get a photo of it. Instead of recording detail in the landscape, I decided to underexpose the image to render the tree and mountain as a silhouette, which also showed more of the fog detail and saturated the sunset colors. See Figure 15-1.

Camera settings

- **ISO setting** *100:* I had plenty of light; I didn't want to risk a noisy image by increasing the ISO.

- **Exposure compensation** *–1 EV:* Experience told me that this would be enough to render the trees and mountain as a silhouette.

- **Focal length** *105mm:* I zoomed in until I got the composition I wanted.

- **Aperture** *f/16:* I decided on a small aperture so that the silhouette in the resulting image would be crisp and leave plenty of detail in the fog.

- **Shutter speed** *1/160 of a second:* I was glad that the aperture and ISO combination yielded a shutter speed fast enough to render a blur-free image. I admit that even though the lens has image stabilization, my arms were a bit tired after carrying the camera around all day. I welcomed the extra insurance of a relatively fast shutter speed.

Composing the image

I placed the horizon line in the lower third of the image to draw the viewer's attention to the lonely tree on the right side of the image. The tree also intersects a power point according to the Rule of Thirds. The slope of the hill also guides the viewer through the image.

Post processing

To make the sunset colors pop, I added a bit of saturation to the image. I also did a little bit of cropping to tighten up the composition.

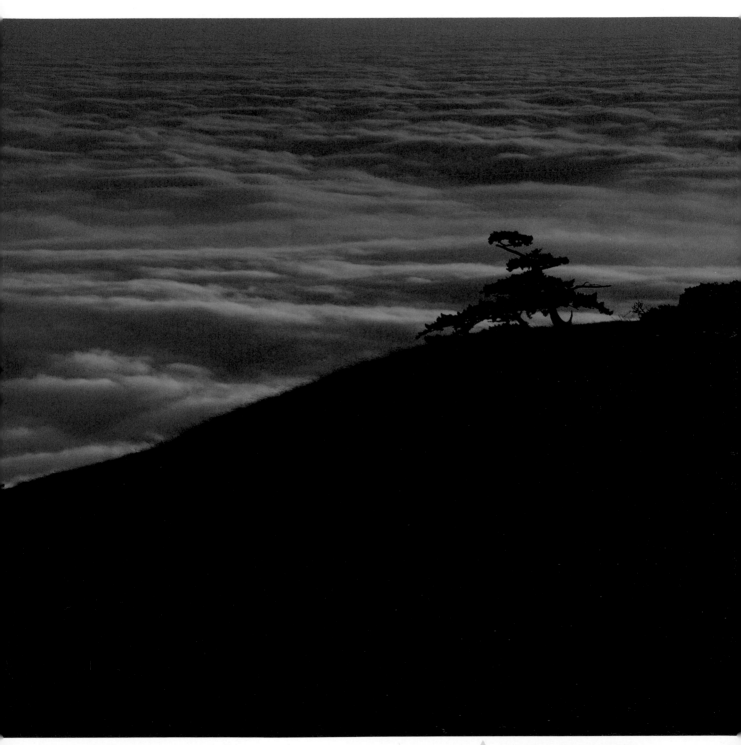

Figure 15-1: A Fog upon the Bay.

Walking in Ansel's Footsteps

Visiting Yosemite in the late fall was an incredible experience. The leaves were turning color and the weather was changing. A storm was approaching during our last evening in Yosemite. We stopped in Cook's Meadow to capture a few images. As the clouds shrouded Half Dome, I could imagine Ansel setting his 8 x 10 view camera on a tripod, waiting patiently for the clouds to assemble, and then taking the picture. I picked what I considered to be the perfect vantage point and took this picture, shown In Figure 15-2.

Camera settings

- **ISO setting** *100:* This image is the result of merging three bracketed exposures in HDR Efex Pro, which can increase noise (hence, the low ISO setting).

- **Exposure compensation** *0 EV:* I never use exposure compensation for the scene, because the camera meters it when creating images for an HDR merge.

- **Focal length** *24mm:* This was the ideal focal length to capture the grand landscape with plenty of detail.

- **Aperture** *f/16:* I wanted a large depth of field so I'd have detail in the grassy foreground all the way to the mountain.

- **Shutter speed:** It varies because the image is composed of three exposures.

Composing the image

I placed the horizon line in the lower third of the image to draw attention to the beautiful tree that is on the right side of the image. The tree on the left side of the image and the mountain on the right side of the image serve as a frame to prevent an escape route from the image. The final image is an HDR blend of three different exposures to capture the wide tonal range and subtle colors.

Post processing

The images were merged in Lightroom 3 using Nik Software's HDR Efex Pro (www.niksoftware.com/hdrefexpro/usa/entry.php). I started with a preset that rendered a realistic presentation of the scene without making the details overly harsh.

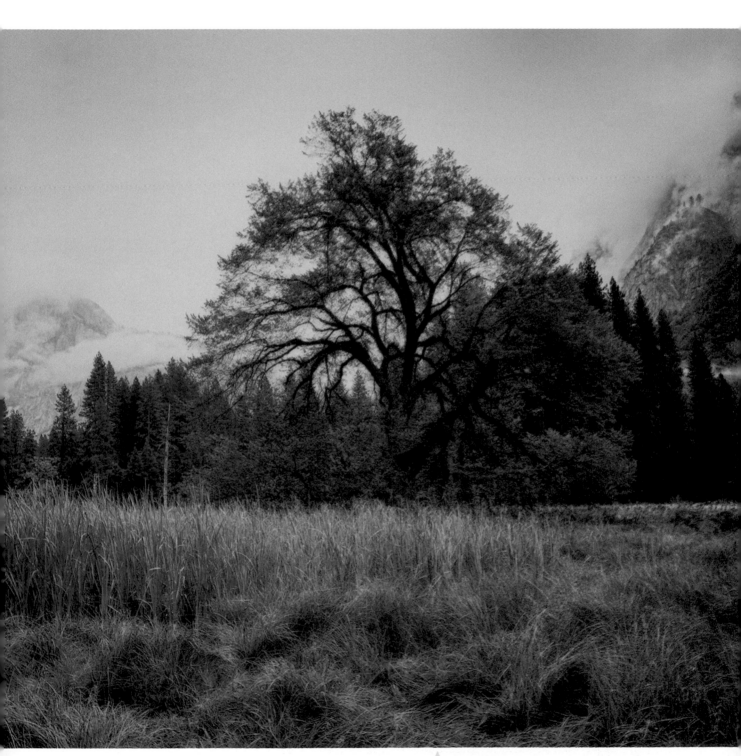

▲ **Figure 15-2:** Walking in Ansel's Footsteps.

Mackerel Sky

Sunsets are special in Florida. In the winter, cold fronts blow in from the north. When a storm front approaches, we get some angry weather, and then the skies get clear. Sometimes after a front passes, humidity in the high atmosphere brews a wonderful confection of clouds. This is known as a "mackerel sky." This image was photographed a few minutes after the sun went down. When I saw that the clouds didn't reach all the way to the horizon, I knew the sky would be on fire a few minutes after the sun set. I took a series of exposures after the sun sank below the horizon. The final image (see Figure 15-3) is an HDR merge of three bracketed exposures.

Camera settings

- **ISO setting** *100:* HDR processing can increase image noise. Always use the lowest ISO setting when shooting HDR exposures.

- **Exposure compensation** *0 EV:* You don't need exposure compensation when you shoot an HDR image. Accept the metering the camera gives you and then bracket the exposures using your camera menu.

- **Focal length** *24mm:* I wanted to capture as much of the wonderful sunset as possible. That said, I used my shortest focal length.

- **Aperture** *f/16:* I wanted a large depth of field so I'd have detailed sky as well as the water in the bay.

- **Shutter speed:** It varies because the image is composed of three exposures.

Composing the image

I set my tripod low to place the horizon line in the lower third of the image. I moved until the angled banks of the clouds converged on a power point according to the Rule of Thirds. The orange reflections on the bay provide an entryway into the picture.

Post processing

I merged the images in HDR Efex Pro. After merging the images, I did a bit of judicious cropping to get rid of unwanted objects at the sides of the image and tighten the composition.

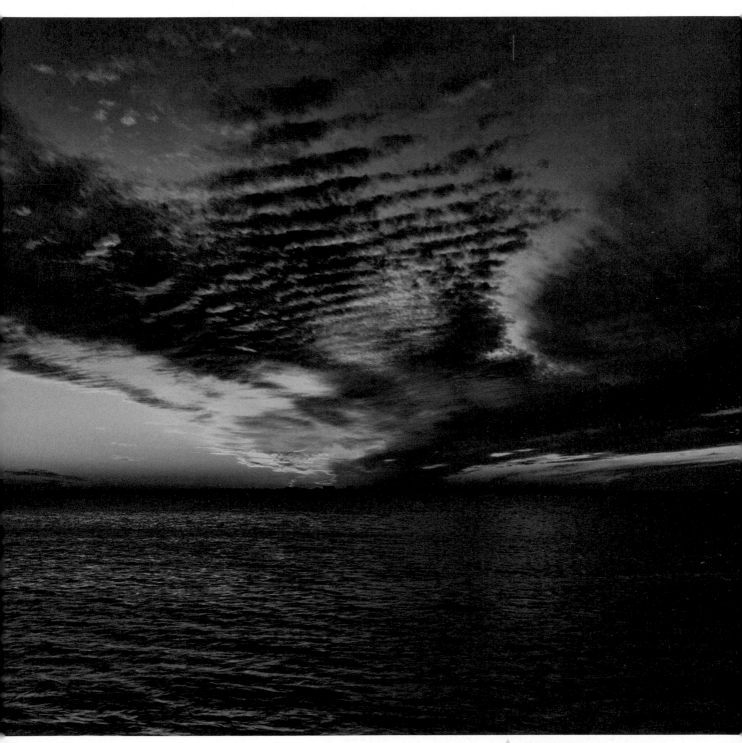

Figure 15-3: Mackerel Sky.

Take the High Trail

This image (see Figure 15-4) was photographed in Myakkac River State Park near Sarasota, Florida. The park is beautiful with many miles of trails; this is what the "Real Florida" looked like before developers polluted the skyline with a glut of condominiums. This trail meanders through a lush meadow dotted with lovely trees. The sun was sinking low and I had decided to turn around, but I was curious to see what was around the next bend. I rounded the next bend and was rewarded with this wonderful scene. When I saw the lovely clouds in the sky, I added a polarizing filter to the lens I was using. The filter darkened the blues and made the clouds more prominent.

Camera settings

- **ISO setting** *100:* I had plenty of light, so there was no need to increase the ISO setting to achieve the desired aperture and shutter speed.

- **Exposure compensation** *–1/3 EV:* I underexposed the image slightly to saturate the lovely wheat color of the grass and enhance the blue sky.

- **Focal length** *24mm:* I wanted to capture as much of the scene as possible, so I used my shortest focal length.

- **Aperture** *f/8:* With a wide-angle lens, this f-stop gave me an acceptable depth of field.

- **Shutter speed** *1/30 of a second:* This shutter speed coupled with Canon's superior image stabilization yielded a blur-free image.

Composing the image

I composed the image so that the dead tree was on the left side of the image, serving as a visual anchor to draw viewers into the picture. This is one of the rare times where the horizon line is almost in the middle of the image because I thought there was equal visual interest in all parts of the scene. The shadows on the right side of the image draw attention to the trail, which curves in the distance. I also used a polarizing filter to darken the sky and make the clouds stand out.

Post processing

I increased the saturation slightly to make the colors pop.

Figure 15-4: Take the High Trail.

Sanibel Sentinel

Florida's Sanibel Island is a treasure-trove for the nature photographer. Ding Darling Refuge is full of birds and other native wildlife. After spending an afternoon in the refuge, we took a short drive to the Sanibel Lighthouse. The beach around the lighthouse is littered with driftwood, and there's a huge osprey nest near the lighthouse. One blustery January day, the sun was sinking low; with the high clouds, it looked like the sunset would be spectacular. I found what I thought would be the ideal vantage point and shot several pictures as the sun got close to the horizon and then dipped below it. This image was photographed a few minutes after the sun set (see Figure 15-5).

Camera settings

- **ISO setting** *800:* This was a result of the lack of light. Fortunately, my camera has a full-frame sensor, which gave me a relatively noise-free image.

- **Exposure compensation** *0 EV:* The camera got the exposure spot-on.

- **Focal length** *40mm:* I zoomed in until I saw the composition come together in the viewfinder.

- **Aperture** *f/6.3:* I wanted to use a smaller aperture, but I didn't have enough light and didn't have my tripod. However, I knew I'd still have a decent depth of field with this f-stop and a 40mm focal length.

- **Shutter speed** *1/25 second:* I would have preferred to mount the camera on a tripod with a shutter speed this slow. However, Canon's excellent image stabilization and a steady hand resulted in a blur-free image.

Composing the image

The lighthouse was a focal point in this image, so I placed it on a power point according to the Rule of Thirds. To draw attention to the colorful clouds, I placed the horizon line in the lower part of the image. I didn't place it in the lower third because I liked the reflections in the water.

Post processing

In addition to saturation, I straightened the horizon line, which originally was crooked because my arms were a bit fatigued after carrying the camera all afternoon in Ding Darling Refuge.

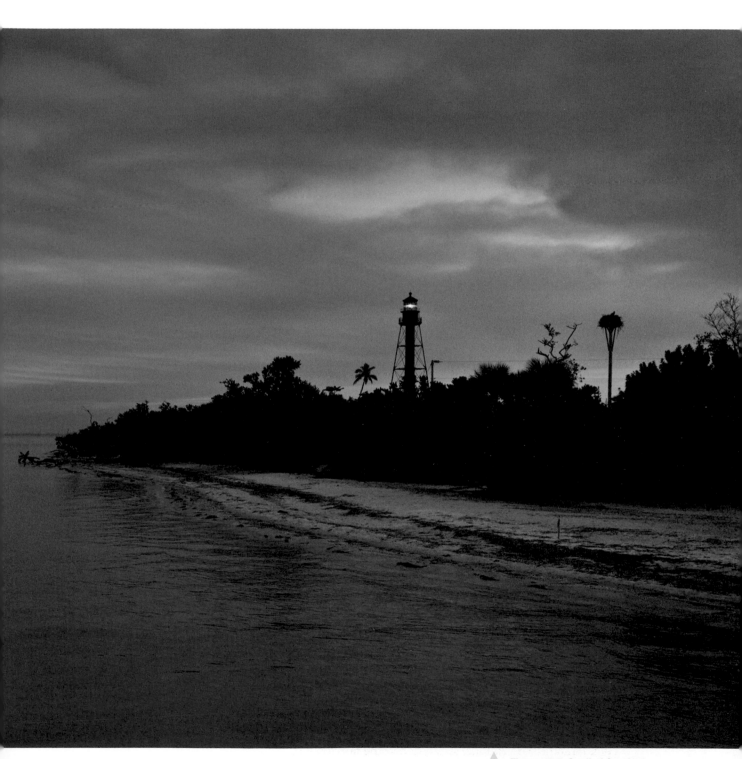

Figure 15-5: Sanibel Sentinel.

Myakka Fields of Gold

Florida's Myakka River State Park has many wonderful vistas. In the winter and early spring before the rains come, the grass is dry and brittle, a wonderful wheat color. I saw this lonely tree in the river of grass and stopped to take a picture. See Figure 15-6.

Camera settings

- **ISO setting** *100:* I had plenty of light, so I used a low ISO setting to ensure a noise-free image.

- **Exposure compensation** *–1/3 EV:* I underexposed the image slightly to saturate the colors.

- **Focal length** *32mm:* I wanted to include a lot of visual information. I started with the widest focal length for the lens and then zoomed in until I saw the composition I wanted.

- **Aperture** *f/20:* I wanted a large depth of field to reveal detail from the foreground to the distant trees.

- **Shutter speed:** A speed of 1/60 of a second was fast enough to ensure a sharp image when handholding the camera. Canon's excellent image stabilization also contributed to the sharpness of the image.

Composing the image

The tree is the center of interest in the image, so I chose a vantage point that placed the tree on a power point according to the Rule of Thirds. I used a polarizing filter to darken the blue in the sky. I also crouched down to place the horizon line below the middle of the image to draw attention to the beautiful sky.

Post processing

This image looked good as it came out of the camera. I added a little saturation to make the sky and wheat colors pop, and I did minimal cropping to tighten the composition.

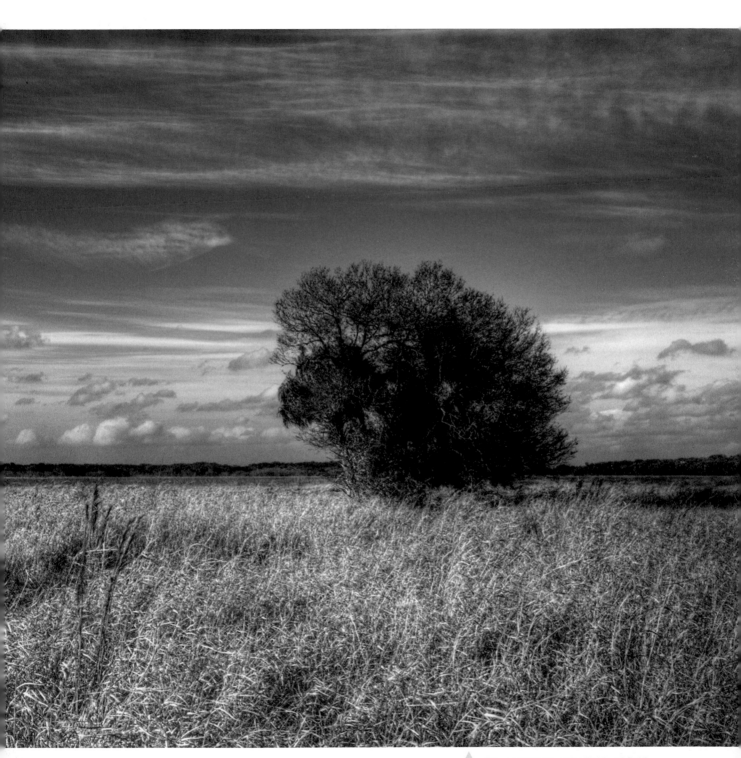

Figure 15-6: Myakka Fields of Gold.

The Hawk Speaks

Red-shouldered hawks have a distinct cry, which can frustrate a photographer to no end. You hear the hawk, but you can't figure out where the creature is. When you do find one, you're rewarded with some wonderful photo opportunities. This critter was squawking up a storm and then we spotted him. I zoomed in as tightly as I could and captured the image (see Figure 15-7).

Camera settings

- **ISO setting** *400:* Even though it was bright, I needed a higher ISO to get a fast enough shutter speed to handhold the long lens.

- **Exposure compensation** *0 EV:* Normally I like to underexpose an image to saturate colors, but I didn't want to lose detail in the bird's eyes and beak.

- **Focal length** *480mm:* The bird was high in a tree. I walked as close to the tree as I could without endangering myself and then zoomed in as tightly as I could.

- **Aperture** *f/6.3:* This is wide open for this lens, which threw the background out of focus and made the bird more prominent in the resulting image.

- **Shutter speed** *1/1000 of a second:* The combination of a higher ISO and large aperture gave me a fast shutter speed, which would be useful to capture a picture of the bird in flight if he decided to fly away. I also switched to continuous drive mode so I could take a series of pictures of the bird.

Composing the image

I knew I couldn't get close enough with the lens I had and would need to crop the image in post processing, but I still instinctively placed the bird on the right side of the image. I prefer to shoot animals at their level, but his level was about 20 feet higher than my level, so I pointed the camera up and started shooting. Luckily, I had the camera in Continuous Drive mode and captured several images when I pressed the shutter button. This was the best of the lot.

Post processing

One luxury of a camera that captures high-megapixel images is that you can crop away almost 40 percent of the image and still have a shot that can be printed as an 8 x 10. For this image, I cropped in tightly to make the bird the focal point. I also saturated the colors and sharpened the image.

Figure 15-7: The Hawk Speaks.

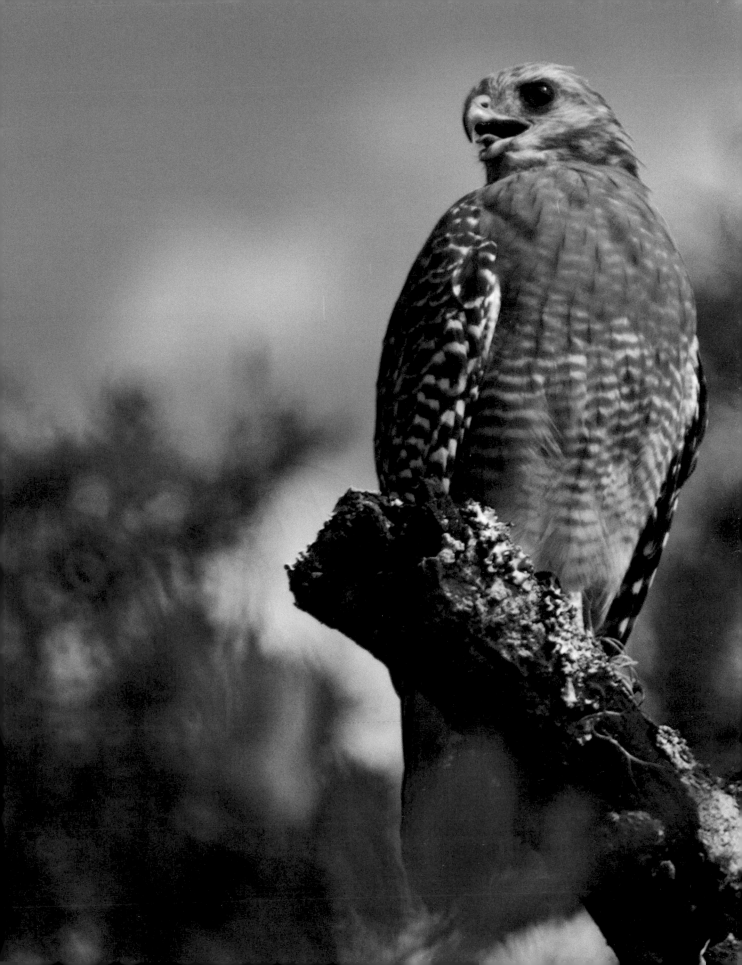

Mellow Yellow

The plan was to do a photo shoot on Gasparilla Island, but Mother Nature intervened and it rained; actually it poured down rain. We waited out the storm in a quaint little ice-cream parlor. The rain stopped, but the sun never came out. On our way back home, we spotted these yellow flowers growing up a wall. We stopped to investigate and were delighted when we found beads of water on them. After a quick switch to the Lensbaby Composer with the Double Glass Optic, I started taking some pictures, including the one in Figure 15-8.

Camera settings

- **ISO setting** *500:* The combination of an overcast sky and smaller aperture forced my hand, so I opted for a higher ISO in order to get a faster shutter speed.

- **Exposure compensation** *0 EV:* Lensbaby images have plenty of color saturation, so I took what the camera gave me. The overcast skies and water also helped to increase saturation.

- **Focal length** *50mm with a +4 Macro extension:* The Lensbaby Macro extensions do a wonderful job of getting in close and still delivering a good image.

- **Aperture** *f/4.0 aperture disc:* Every Lensbaby optic except the Pinhole/Zone Plate and the Sweet 35 use aperture discs. I knew this aperture disc with the Double Optic would give me a fairly sharp image with a large sweet spot.

- **Shutter speed** *1/160 of a second:* A faster shutter speed is useful when photographing any kind of close-up.

Composing the image

This one was pretty much a no-brainer. I got as close as I could to the flower with the lens and macro extensions and took the picture. The dark foliage around the flower serves as a frame to direct viewers' attention to the flower.

Post processing

I added a vignette to darken the edges of the image, and I increased the saturation to make the colors pop. Mellow Yellow, indeed.

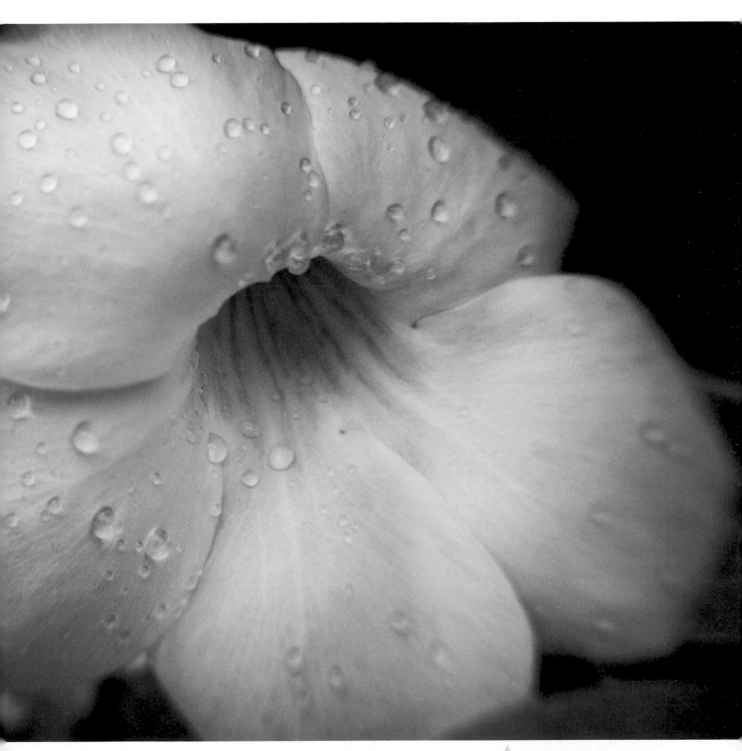

Figure 15-8: Mellow Yellow.

Black Skimmer

Myakka River State Park is home to many species of birds and other wildlife. One day while we were photographing in the park, we noticed these birds swooping low on the water. We identified them as black skimmers using our handy Audubon field guide. The bird skims the water with its beak open to capture its food. We noted the birds' flight patterns and positioned ourselves to capture some images. The shot in Figure 15-9 was the best of the bunch.

Camera settings

- **ISO setting** *320:* I increased the ISO in order to get a faster shutter speed.

- **Exposure compensation** *0 EV:* The camera gave me a good exposure that yielded images with saturated colors. This is one of the benefits of shooting in late afternoon when the light is diffused and a warm golden color.

- **Focal length** *480mm:* The bird was fairly close to shore, but he's also a fairly small bird. The long focal length gave me the reach I needed.

- **Aperture** *f/6.3:* This aperture gave me a sufficient depth of field to reveal detail on the bird and a fast shutter speed.

- **Shutter speed** *1/1000 of a second:* I wanted a fast shutter speed so I could handhold the camera and freeze the bird's motion. I also switched to Continuous Drive mode, to take a series of shots, and Continuous Auto-Focus, so that the camera would update focus as the bird flew toward me.

Composing the image

When you photograph birds in flight, all you can do is point the camera and hope for the best. Fortunately, the bird was flying at a slight angle to me. I panned the camera with him and snapped several shots. This one lined up perfectly.

Post processing

I increased the saturation slightly, especially the reds to make the bird's beak stand out. I applied minimal cropping to tighten the composition.

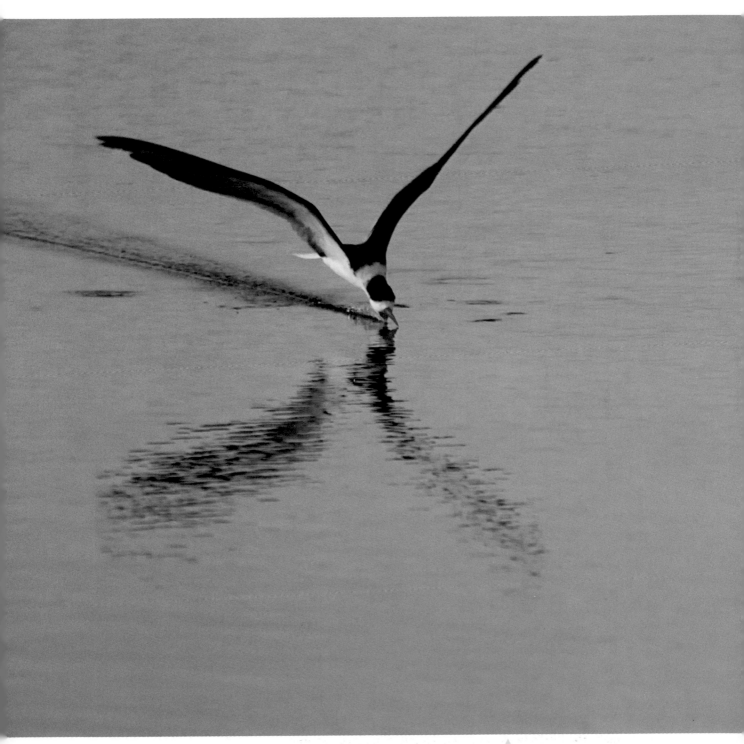

▲ **Figure 15-9:** Black Skimmer.

Sunset in Paradise

Caspersen Beach in Venice, Florida, is just a few miles from our home. I can walk out the front door, look at the clouds, and determine whether it's worth driving to the beach to photograph the sunset. This picture (see Figure 15-10) was photographed in winter. Winter in Florida is a tough job, but somebody's got to do it.

Camera settings

- **ISO setting** *100:* I had plenty of light, so I went with a low ISO setting.

- **Exposure compensation** *–1/3 EV:* I underexpose sunsets slightly to enhance their colors.

- **Focal length** *17mm:* I used a wide-angle focal length to capture the lovely expanse of beach and the clouds.

- **Aperture** *f/10:* This aperture yields a large depth of field when used with a wide-angle focal length.

- **Shutter speed** *1/40 of a second:* This shutter speed was more than fast enough to handhold the camera with this focal length and still get a blur-free image.

Composing the image

I photographed this image with an extreme wide-angle lens that is the 35mm equivalent of 17mm. I also used a polarizing filter to enhance the clouds and make the sky darker. I surveyed the scene and crouched low to include some big rocks in the foreground. A large object gives the viewer a visual anchor, which is especially important when you take pictures with a super wide-angle lens. I placed the horizon toward the bottom of the image to draw the viewers' attention to the sky. I also included a fisherman in the picture for a sense of distance and scale.

Post processing

I increased saturation to make the colors pop and did minimal cropping to tighten the composition of the image.

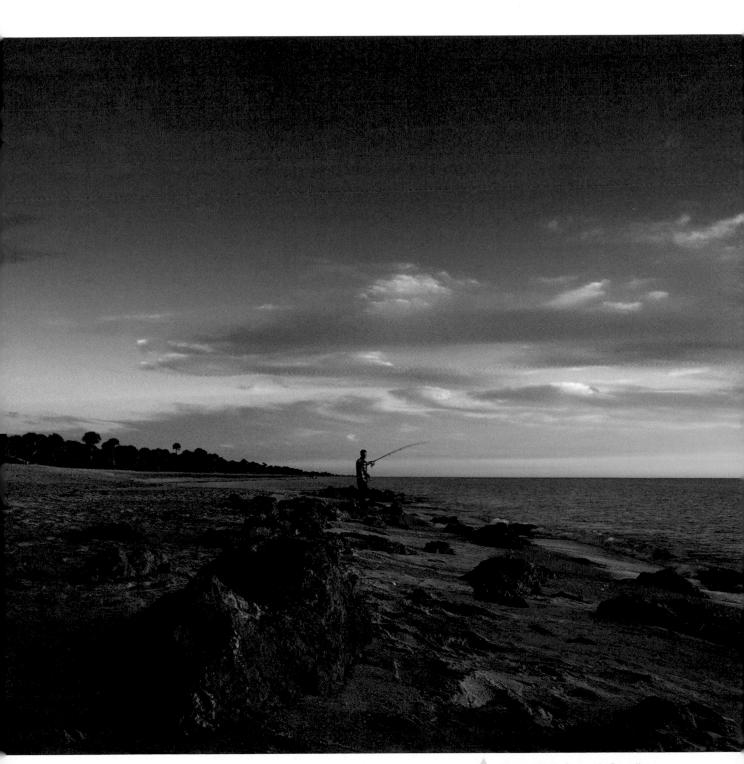

Figure 15-10: Sunset in Paradise.

Index

Apple & Macs

iPad For Dummies
978-0-470-58027-1

iPhone For Dummies,
4th Edition
978-0-470-87870-5

MacBook For Dummies, 3rd
Edition
978-0-470-76918-8

Mac OS X Snow Leopard For
Dummies
978-0-470-43543-4

Business

Bookkeeping For Dummies
978-0-7645-9848-7

Job Interviews
For Dummies,
3rd Edition
978-0-470-17748-8

Resumes For Dummies,
5th Edition
978-0-470-08037-5

Starting an
Online Business
For Dummies,
6th Edition
978-0-470-60210-2

Stock Investing
For Dummies,
3rd Edition
978-0-470-40114-9

Successful
Time Management
For Dummies
978-0-470-29034-7

Computer Hardware

BlackBerry
For Dummies,
4th Edition
978-0-470-60700-8

Computers For Seniors
For Dummies,
2nd Edition
978-0-470-53483-0

PCs For Dummies, Windows
7 Edition
978-0-470-46542-4

Laptops For Dummies,
4th Edition
978-0-470-57829-2

Cooking & Entertaining

Cooking Basics
For Dummies,
3rd Edition
978-0-7645-7206-7

Wine For Dummies,
4th Edition
978-0-470-04579-4

Diet & Nutrition

Dieting For Dummies,
2nd Edition
978-0-7645-4149-0

Nutrition For Dummies,
4th Edition
978-0-471-79868-2

Weight Training
For Dummies,
3rd Edition
978-0-471-76845-6

Digital Photography

Digital SLR Cameras &
Photography For Dummies,
3rd Edition
978-0-470-46606-3

Photoshop Elements 8
For Dummies
978-0-470-52967-6

Gardening

Gardening Basics
For Dummies
978-0-470-03749-2

Organic Gardening
For Dummies,
2nd Edition
978-0-470-43067-5

Green/Sustainable

Raising Chickens
For Dummies
978-0-470-46544-8

Green Cleaning
For Dummies
978-0-470-39106-8

Health

Diabetes For Dummies,
3rd Edition
978-0-470-27086-8

Food Allergies
For Dummies
978-0-470-09584-3

Living Gluten-Free
For Dummies,
2nd Edition
978-0-470-58589-4

Hobbies/General

Chess For Dummies,
2nd Edition
978-0-7645-8404-6

Drawing
Cartoons & Comics
For Dummies
978-0-470-42683-8

Knitting For Dummies,
2nd Edition
978-0-470-28747-7

Organizing
For Dummies
978-0-7645-5300-4

Su Doku For Dummies
978-0-470-01892-7

Home Improvement

Home Maintenance
For Dummies,
2nd Edition
978-0-470-43063-7

Home Theater
For Dummies,
3rd Edition
978-0-470-41189-6

Living the
Country Lifestyle
All-in-One
For Dummies
978-0-470-43061-3

Solar Power Your Home
For Dummies,
2nd Edition
978-0-470-59678-4

Internet

Blogging For Dummies,
3rd Edition
978-0-470-61996-4

eBay For Dummies,
6th Edition
978-0-470-49741-8

Facebook For Dummies, 3rd
Edition
978-0-470-87804-0

Web Marketing
For Dummies,
2nd Edition
978-0-470-37181-7

WordPress
For Dummies,
3rd Edition
978-0-470-59274-8

Language & Foreign Language

French For Dummies
978-0-7645-5193-2

Italian Phrases
For Dummies
978-0-7645-7203-6

Spanish For Dummies,
2nd Edition
978-0-470-87855-2

Spanish For Dummies,
Audio Set
978-0-470-09585-0

Math & Science

Algebra I For Dummies,
2nd Edition
978-0-470-55964-2

Biology For Dummies,
2nd Edition
978-0-470-59875-7

Calculus For Dummies
978-0-7645-2498-1

Chemistry For Dummies
978-0-7645-5430-8

Microsoft Office

Excel 2010 For Dummies
978-0-470-48953-6

Office 2010 All-in-One
For Dummies
978-0-470-49748-7

Office 2010 For Dummies,
Book + DVD Bundle
978-0-470-62698-6

Word 2010 For Dummies
978-0-470-48772-3

Music

Guitar For Dummies,
2nd Edition
978-0-7645-9904-0

iPod & iTunes
For Dummies,
8th Edition
978-0-470-87871-2

Piano Exercises
For Dummies
978-0-470-38765-8

Parenting & Education

Parenting For Dummies,
2nd Edition
978-0-7645-5418-6

Type 1 Diabetes
For Dummies
978-0-470-17811-9

Pets

Cats For Dummies,
2nd Edition
978-0-7645-5275-5

Dog Training For Dummies,
3rd Edition
978-0-470-60029-0

Puppies For Dummies,
2nd Edition
978-0-470-03717-1

Religion & Inspiration

The Bible For Dummies
978-0-7645-5296-0

Catholicism For Dummies
978-0-7645-5391-2

Women in the Bible
For Dummies
978-0-7645-8475-6

Self-Help & Relationship

Anger Management
For Dummies
978-0-470-03715-7

Overcoming Anxiety
For Dummies,
2nd Edition
978-0-470-57441-6

Sports

Baseball
For Dummies,
3rd Edition
978-0-7645-7537-2

Basketball
For Dummies,
2nd Edition
978-0-7645-5248-9

Golf For Dummies,
3rd Edition
978-0-471-76871-5

Web Development

Web Design
All-in-One
For Dummies
978-0-470-41796-6

Web Sites
Do-It-Yourself
For Dummies,
2nd Edition
978-0-470-56520-9

Windows 7

Windows 7
For Dummies
978-0-470-49743-2

Windows 7
For Dummies,
Book + DVD Bundle
978-0-470-52398-8

Windows 7 All-in-One
For Dummies
978-0-470-48763-1

Available wherever books are sold. For more information or to order direct: U.S. customers visit www.dummies.com or call 1-877-762-2974. U.K. customers visit www.wileyeurope.com or call (0) 1243 843291. Canadian customers visit www.wiley.ca or call 1-800-567-4797.

DUMMIES.COM

Wherever you are in life, Dummies makes it easier.